Terrace
Books
Madison, Wisconsin

TERRACE BOOKS, a trade imprint of the University of Wisconsin Press, takes its name from the Memorial Union Terrace, located at the University of Wisconsin–Madison. Since its inception in 1907, the Wisconsin Union has provided a venue for students, faculty, staff, and alumni to debate art, music, politics, and the issues of the day. It is a place where theater, music, drama, literature, dance, outdoor activities, and major speakers are made available to the campus and the community. To learn more about the Union, visit www.union.wisc.edu.

PUREBRED & HOMEGROWN
America's County Fairs

Drake Hokanson & Carol Kratz

TERRACE BOOKS
A TRADE IMPRINT OF THE UNIVERSITY OF WISCONSIN PRESS

This book was published with support from the National Farmers Union Foundation
and from an anonymous donor.

Terrace Books
A trade imprint of the University of Wisconsin Press
1930 Monroe Street, 3rd Floor
Madison, Wisconsin 53711–2059

www.wisc.edu/wisconsinpress/

3 Henrietta Street
London WC2E 8LU, England

5 4 3 2 1

Printed in Canada

Library of Congress Cataloging-in-Publication Data
Hokanson, Drake, 1951–
 Purebred and homegrown : America's county fairs / Drake Hokanson and Carol Kratz.
 p. cm.
 Includes bibliographical references and index.
 ISBN 978-0-299-22820-0 (cloth : alk. paper) — ISBN 978-0-299-22824-8 (pbk. : alk. paper)
 1. Agricultural exhibitions—United States. I. Kratz, Carol. II. Title.
 S554.H65 2008
 630.74'73—dc22
 2008011963

For Sally Kratz, who loves a good story,

and

to the memory of Ralph Brotz,

who loved the fair

•

Contents

Preface

We wrote and photographed this book on the American county fair in part because there hasn't been a detailed treatment of this significant subject in some seventy years. Despite the fact that millions of Americans put on, participate in, and attend agricultural fairs every year, libraries hold only a scattering of articles and books pertaining to this important institution. Many of the few recent books and nearly all newspaper accounts seem to take a rather limited "biggest-pumpkin," "five-legged-cow" approach that ignores the richer stories and deeper significance that infuse almost any fair in the country. We thought it was time to look deeper.

Few, if any, important American cultural and historical institutions have similarly escaped the attention of scholars and authors, and we thought this rich and far-flung topic needed a bright flag planted in fresh, distant ground to signal forward others who might be tempted to study the fair. Researchers in every field love to say that more research is needed on their pet subject, and we therefore and hereby encourage historians, journalists, sociologists, photographers, folklorists, preservationists, and other inquirers to set out for the fair. It is a fertile subject, nearby and rich with possibility and nuance. What we have done here is merely a start.

Similarly, few fairs have recorded or preserved much of their own histories, and few local historical societies have many holdings related to their fairs. Fairs are understandably focused on getting ready for next year's event, and county historical societies are usually too strapped for money and volunteers to expend much time collecting photographs, premium books, and newspaper clippings, much less ribbon collections and oral histories. As scholars and fair geeks, we urge those involved with fairs and historical societies to take a more active role in acquiring and safeguarding stories and artifacts of their fairs. We have some ideas about getting started. Contact us via the publisher if you're interested.

Because the topic has been neglected, we thought it important to cover as much ground—temporal, geographic, and thematic—as possible and so opted to study as many aspects of the fair as we could in all regions of the country. Daunting, yes, but the experience was exhilarating each time we walked through the gate of a new fair. We hope you'll decide that what our necessarily broad-brush approach lacks in depth it makes up in scope and storytelling.

Creating this book was a joy and a great deal of work. The fieldwork alone amounted to some forty thousand miles of travel to fairs and research collections in several corners of the nation, and our transcribed interviews and field notes amount to more than a thousand pages of single-spaced text.

Because fair season is short, in any given year we could attend only a limited number of fairs, usually in a targeted region, and thus to get to a reasonable sample of fairs across the nation, our fieldwork had to extend over a decade. In this book we have reported what we found at the time we visited a given fair. Things change, of course, and some things that were true when we visited may no longer be so. Our goal has been to reveal something of the larger nature of the fair in the late twentieth and early twenty-first centuries, and if a fair has built a new livestock barn since our visit, it's probably not reported here.

As far-flung as our field research was, it still reflects only a sampling of the 2,230-some county fairs in the country, and we apologize in advance if your favorite isn't mentioned. As much as we love them, and as much as we would have liked to, we simply couldn't get to all of them. But don't give up—as devoted fair groupies, we're still likely to show up. We selected fairs to visit not because they were the biggest or smallest or because they had some unique event (though we found many unique events); we went to the fairs we did simply because they were going on when we could get there. Thus, our sample was shaped by the randomness of the calendar and the caprice of geography. We think this approach gave us a more impartial view of America's fairs.

But rest assured your fair is in this book. Throughout our research we looked not for the odd but for the universal in America's fairs, that which is common to fairs

everywhere: the people, events, and ideas that make our fairs what they are. Though you'll read about oxen in Massachusetts, elephant ears in Michigan, and the carnival in several states, these stories reveal the nature of all our fairs, not just those highlighted.

And last, we wrote this book to encourage Americans to visit and take part in their county fairs—not just the one close to home, but fairs from coast to coast. Ride the rides and try all the food, but more important, enter a cabbage or a cake in your local fair and volunteer to park cars. If you're on the road during fair time, take in the local fair in a new part of the country. The dyed-in-the-wool Mainer will learn a lot about fairs, the nation, and Texas by spending a few hours at a fair there, and vice versa. But at any fair, close to home or across the country, we also urge you to observe the serious work of a pie judge, to sit with the crowd in the rodeo stands and watch the changing color of the evening sky, to lean on a gate in the barn and ask a twelve-year-old about her horse, and to listen for the chance reunions of neighbors all across the fairgrounds. The fairs of the country are made of people, places, and deep stories. They belong to all of us, and they remind us of what's plain, strong, and good about our nation.

Acknowledgments

Like county fairs themselves, a book about county fairs is the result of many volunteers freely giving their time and knowledge in the service of something rich, enjoyable, and seen as useful in the long term. We are forever in debt to the hundreds of "fair-minded" people who sat for our questions during their busiest week of the year, provided historical documents, found us a place to camp—even took us home for the night—and introduced us to hundreds of others who so graciously showed us their fairs.

Our field notes are long and detailed, but we talked with thousands of people during the research for this book. We apologize if we've left anyone out. As much as we've enjoyed creating this book, meeting all of you has been our real joy.

For undying devotion to your fairs and your consequent assistance to us in all manners and ways, we thank Ed Abbott, David Alexander, Wallace Alexander, Jim Allen, Sandra Amadon, Laurie Asmussen, Mary Ann Bannerman, Barney Beer, Dale Bennett, Karen Bonomo, Robert Bosco, Charles Bowman, L. Evan Brooks, Leslie Burckard, Brian Butko, Peter John Camino, Mary Jo and Bill Carter, Ron Clark, Deborah Cole, Diane Conway, Mary Crewel, Betsy Crouch, Greg Cunningham, Dennis Cupp, Ellen Daniels, Neil Daniels, Cheryl Davidson, Alisha Davis, Mildred Davy, Tom Devereaux, Frances Dew, Bill and Carolyn Diller, Annie Fagundes, Frank Fagundes, Meggie Fagundes, Michele Fagundes, Molly Fagundes, Scott Fasken, Julie Faulkner, Chuck Felix, Becci Field, Vincent Terry Fitch, Linda Foster, Dennis Fowler, Paul Fox, Bob Fredrick, Sarah Fuller, John and Margaret Gammon, Jane Grabarski, Bob Grems, Arthur Griffiths, Gary Grub, Monty Hamilton, Herb Harder, George Harris, Michael Haubner, Neil Haugerud, Tracy Helms, Betty Hessler, Debra Hintz, Kent Hojem, Helen Hornby, Charlene Hornung, Helen Houts, Ona Hunt, Eileen Hunter, Jay Jessop, Cathy John, Dick and Joanne Johnson, Lynn Johnson, Suzie and Henry Johnson, Paul Juckem, Father Don Karlen, Asel Kennedy, Agnes Kinney, Bonnie Klasinski, Carolyn and Dick Konstanzer, Richard Koontz, Henry (Renny) and Stella Leworthy, Teena Lutz, Susan Marino, Anne Mauer, Herb Maust, John McIlvain, Shari Miller, Van and Joyce Moe, Jim Mollhoff, Vicki Monsen, Thomas Morgan, Myrna Muehlberg, Tom Mullinix, Jim Naile, Rita Natale, Marlys Neldner, Kim Nguyen, Archie Nichols, Rose and Hervy Ostiguy, Betty Overly, Frieda Parker, Jim Parker, Sandy Pipes, Anthony Porcelli, Phyllis Porcelli, Bill Pracht, Mike Price, Earl Prough, Deborah Reader, Pat Rice, Edna Riley, Roger L. Roberts, Michael Aaron Rockland, Bob Ruby, Sheila Sanders, Louis Santillo, Bill Sautter, Corky Schaefer, John Sell, Sharon Semans, Lori Shoemaker, Russ and Sommer Sidell, Robert Silk, Raymond Sligh, Rich Slingerland, Tim Smiley, Janie and Hill Snyder, Donna Speltz, Marla Stello, Ross Stenquist, Dana Stiles, Julie Storm, Jo Sullivan, Carl Trainor, Stacey Turner, Laura Turner, Jerry Underwood, Mo Vint, C. Darrell Wade, Newell Wagoner, Kevin Wahlert, Mildred Walker, Jean Walleser, Kurt and Debbie White, Pat Wojcik, Larry Wollert, Jo Woodbury, Neva and Norris Wooley, Gary Wyatt, Debra Daehn Zellmer, Mark Zellmer, Jill Zimmerman, and Marvin Zylstra.

Our thanks to our dear families and friends who supported our persistence and peregrinations, listened to these stories in their raw form, and helped us shake off the fairground dust. We offer our thanks in particular to friend Richard Beilke, who kept us on task by asking at every opportunity: "So how's the fair book coming?"

Several research institutions, organizations, and at least one corporation played a significant role in this project. Without our great museums, libraries, and associations, plus helpful private businesses, books of substance would be impossible to produce. Among others, we are grateful for the timely and capable research and photographic assistance of the Berkshire (Massachusetts) Athenaeum; Berkshire County (Massachusetts) Historical Society; Denver Public Library; Dodge County (Wisconsin) Historical Society; Library of Congress; Michigan State University Libraries; Museum of Western Colorado; State Historical Society of Iowa–Iowa City; University of Wisconsin–La Crosse Murphy Library; University of

Wisconsin–Madison Memorial Library; University of Wisconsin–Madison Steenbock Agriculture Library; Vernon County (Wisconsin) Historical Society; Western Fairs Association, Sacramento, California; Winona County (Minnesota) Historical Society; Winona State University Library; Wisconsin Historical Society, Madison.

Special thanks go to manuscript reader Jerry Minnich; to Steve Chambers, Western Fairs Association, for his on-the-road fair help; and to The Fair Publishing House and the Michigan State University Museum for the gracious use of their fine fair art. We also thank friend and artist Mary Gordon for her enthusiasm for this project. Her enduring faith in our work made this book come alive.

Last are two people without whom this book could not have been written. Bob Williams, friend and fair specialist at the Wisconsin Department of Agriculture, supported this project from the beginning, read the manuscript, and helped out like a good fair volunteer at every turn. Julie Avery, friend and curator at the Michigan State University Museum, early on volunteered her expertise on the American agricultural fair and has provided advice, research help, editing skills, and encouragement from start to finish. We are forever grateful.

PUREBRED & HOMEGROWN

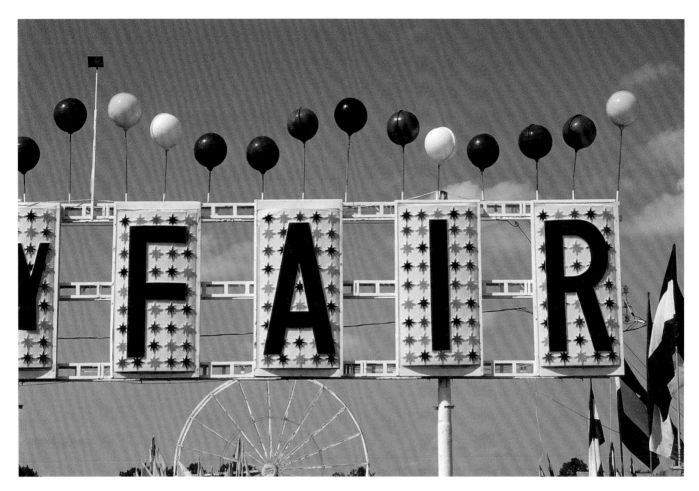

Fairs rely on glitz and color to attract fairgoers, like this fair gate at the Elberton 12-County Fair in Elberton, Georgia.

1. Fair Time

ON THIS WEDNESDAY MORNING OF FAIR WEEK, it's getting humid and dusty in the tiny admission booth at the drive-in gate of the Chautauqua County Fair. It's not busy yet, but it will be later. John McIlvain leans out his window as a woman pulls up.

"Hi, how ya' doin'? Need tickets? Have tickets?" John asks as she rolls down her window. He collects her money, hands her tickets, and spiels off the day's events from memory.

"Park anywhere?" she asks.

"Well, unless the deputy is out there," he says. "Then you park where he says. He has a gun."

John helps out at the fair every year but spends his workdays as a local sixth grade teacher. Today he stands in the booth with his cooler, a radio, cashbox, and a lawn chair for the rare moments when he can sit down. Around his waist is a carpenter's nail apron for tickets; in his fist, a roll of bills.

The drone of the nearby New York State Thruway is a constant reminder of the world outside the realm of the fair. Chautauqua County anchors the western tail of New York State, hugging the shore of Lake Erie. The county is known for dairy production and as the birthplace of the other great American outdoor summer

Farm Security Administration photographer Ben Shahn found this succinct gesture showing the way to a central Ohio county fair in August of 1938. Photograph courtesy Library of Congress

event—the Chautauqua. On this day the comfortable old fairgrounds simmer in deep shade between the town of Dunkirk and the thruway. Only blaring midway music and the throbbing generators of the carnival are loud enough to drown out the truck roar that never stops.

"What's the charge?" asks the elderly man in the next car.

"It's six dollars a person, general admission—that includes everything," John explains. "It's like a smorgasbord—you don't have to go on the rides, you don't have to go to the grandstand, but you have to pay to get in."

One by one, cars, pickups, delivery vans, minivans, occasional motorcycles, and even semis pull up to his window, and each time he patiently answers questions and explains how much things cost, where to park, where not to park, and how to find the concessionaires. Many vehicles are full of bouncing kids.

"Is it going to rain?" worries one woman.

"No!" replies John. Relieved, she swings in to park.

"The kids are always excited," says John. "Parents aren't always in the same boat. In the evening you've got a lot of high school and college kids looking for a place where other kids are gathering. And there are people just looking for the beer tent. We get quite a crowd for the demolition derby. I see a lot of my students, ex-students, ex-teachers, people from all over the county that I only see once a year. Lots of biker types, too. We get a real cross section of society." He turns to his window, hands across tickets and change. "Thank you, sir!"

John waves a couple of delivery trucks through, and

then Judge Michael Pietruszka, candidate for New York State Supreme Court, pulls up and hands John a pile of Buffalo Bills season schedules to hand out to customers.

One man drives back and forth through the gate several times as he hunts parts and tools to fix a starter on some vehicle someplace on the grounds. He stops each time to explain what he's doing, and each time John waves him through. In fact, anybody with a good reason to get in without paying—the pop vendors, a refrigeration repair guy, commercial exhibitors—gets waved through by John.

A couple guys in a pickup pull up to the booth and inquire about automotive events. John tells them the demo derby was the night before last and that the Joie Chitwood Auto Thrill Show was the grandstand event last night.

"Bummer," the driver says. "Is the fair about this same time every year? We come up here for a week of walleye fishing anyway, so I'm glad to know you guys are here."

John gives them information about how to get the fair schedule year to year. He finishes with, "Thanks for coming to the fair."

"There are still people that come in to look at the barns and see the animals; you might not see them otherwise," John tells us. "People are interested in the crafts and stuff in the floral hall. And then there are some that are interested in a cheap amusement park. Six bucks to ride all day is not a bad price."

This year at the Chautauqua County Fair, advance tickets are $5, weekday at-the-gate tickets are $6, and

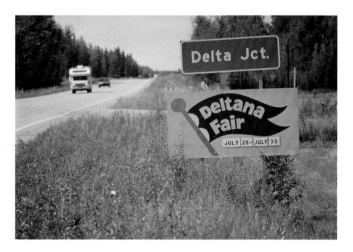

Agricultural fairs span the nation. Here at Delta Junction on the Alaska Highway, a sign beckons long-haul travelers off the road to see the ATV races, pan for Alaska gold, ogle the wild Alaska blueberry pies, and congratulate the winners in the canned moose meat competition.

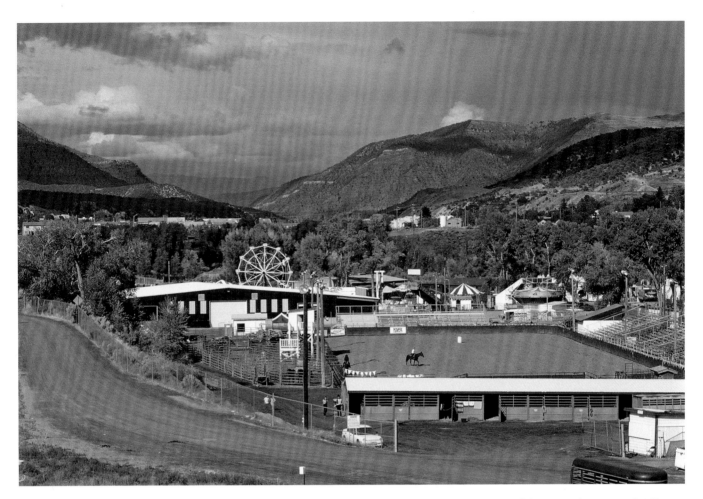

The Eagle County fairgrounds in Eagle, Colorado, holds high-priced land on the fast-growing western slope of the state and caters to a shrinking agricultural population as condos and new homes sprout in the valley and on the hills. Any county fair must have its own fairgrounds, and some are challenged by development pressure.

Friday through Sunday tickets cost $7. Before the advent of advance tickets, John would sometimes take in $10,000 during a shift, but now it's less than half that.

Another carload stops, gets tickets, and pulls into the parking lot.

"I used to know that kid when he was in third grade," says John. John does carpentry during the summer, but takes fair week off to work here. It's getting hot in the ticket booth.

"One week." He says it shaking his head. "If the fair was two weeks, I wouldn't come back. Sometimes we work as many as twelve to fourteen hours a day. I've been here for about twelve years."

But he clearly enjoys it.

"This is a people business. If you don't treat people nice, you're not doing your job. And it makes it fun for you."

Another customer pulls up.

"Hi, how ya' doing? Need tickets? Have tickets?" Cash in, tickets back. "Yeah, park anywhere off to the right, unless the deputies are over there. Then park where they tell you—they've got guns."

Inside the gates at the Chautauqua County fairgrounds on this July day, the familiar sounds of a classic agricultural fair rise against the thruway noise. In the livestock barns, cattle doze in front of big fans while the P.A. announces the next livestock competition; the big rides whine and bang as carnies test them for the afternoon crowds; cheap electronic music beeps from midway games; somewhere a kid cries, and high above, a brisk south wind stirs the summer leaves.

Along the midway a carnival worker named Eric waits in his game booth for business to pick up. He claims

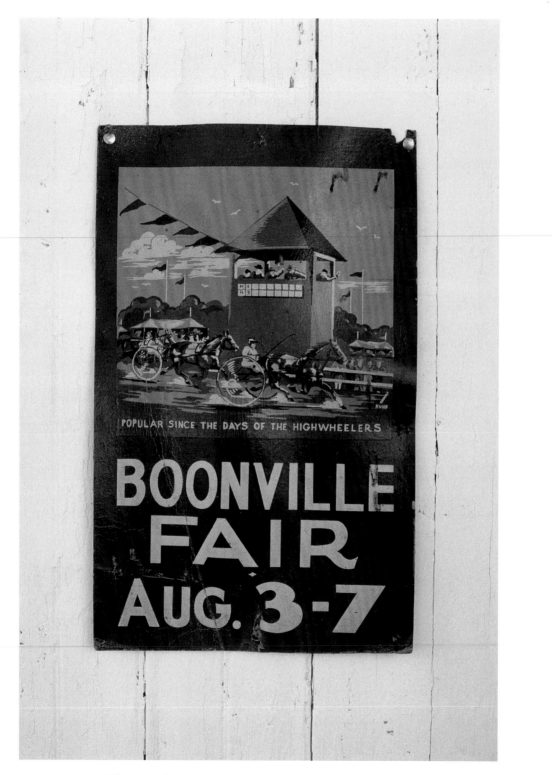

Old fair poster from the Boonville–Oneida County Fair, Boonville, New York.

to know why fairs are so popular despite the diminishing numbers of people in agriculture.

"This is not just my opinion—it's the truth about it," he says. Eric describes the rat race, people working harder and earning less, their chaotic lives. People come to the fair to escape, to forget their cares, he says. Noticing passersby, he gestures and says, "See what they're doing? They're *smiling!*"

This could be almost any county fair from coast to coast. Every year from midsummer to fall—fair time, people call it—people like John and Eric run the gates and the games at the likes of the Sonoma County Fair in Santa Rosa, California, the Union County Agricultural Fair in Union, South Carolina, or the Appanoose County Fair in Centerville, Iowa. Across the country the pattern is similar, the tradition strong, colorful, and rich.

Inside the gates of almost any county fair, the irritations of the outside world—job, bank account, dental appointment—dim and then disappear in the face of the fair's sensory possibilities: flashing, loud, familiar but exotic, deep-fried, manure-scented, both trashy and clean-cut in turn, dusty (unless it rains), fly-infested (always flies), sometimes pastoral and grotesque at the same time, spinning, cowboy-booted, hard-sell, soft-serve, purebred and homegrown, thoroughly American, county fair.

The animals! See them before the barns close. Tired rural 4-H and FFA kids who've eaten too many hotdogs and pork burgers wearily fork over sullied bedding for fresh. Dairy cows, sleek show steers, and new calves all point tail-first at sleeping babes in strollers pushed by suburban couples who've seldom seen a cow close up, especially not this end. Nearby a pair of farm boys recline suspiciously on hay

Interesting food is a component of any fair, including the Vernon County Fair in Viroqua, Wisconsin. Food stand architecture varies from the cozy, shown here, to drab steel pole buildings, to slick metal and glass trailers.

bales, nonchalantly holding a length of fishing line thrown across two rafters farther down the aisle, and on the far end a rubber spider twitches—just at eye level. In the barns are bleating sheep, slumbering hogs, fuzz-ball rabbits, lavish chickens dressed for an Edwardian ball—never the stew pot—and even llamas. Implacable, they ignore all passersby. Not so the goats; they push forward to introduce themselves like the encyclopedia salesmen in the commercial building just past the Porta-Potties.

Get some vinyl siding, or a tattoo, a key ring from the hospital, a water purifier, a lightning rod, a yardstick, a plastic bag from the army that says "Be all you can be." Watch a fast talker under a headset slice and dice and sell you Ginsu knives that never dull. Be there when the woman selling the miracle lint remover steps across the aisle to the Seeing Eye Dog booth to borrow some dog hair for her demonstrations. Pellet stoves, blown glass figurines, ear hair removers, panel gates, pole buildings, miracle drops for miracle cures, blood pressure tests, Gideon Bibles, Republicans and Democrats—even emus—something for everybody.

Food? Watch the eyes of the fairgoers; they've waited all year for this, and they will either plan their caloric intake and money outgo carefully or forget them altogether and go whole hog.

The variety of food at fairs across the country is nearly infinite, but the Chautauqua County Fair provides a good sample: try Tony's Delicious Sugar Waffles or Fowler's Taffy in a dozen flavors, including wild cherry, chocolate, and wintergreen; stand and watch the folks at Santillo's Genuine Italian Sausage grill dark sausages, onions, and peppers, or get a hotdog from the Patriot Drum Corps trailer, a plate of spaghetti—complete with garlic bread—from Spaghetti Eddie's, and wash it down with an "Original, Genuine 'Eroquois' old-

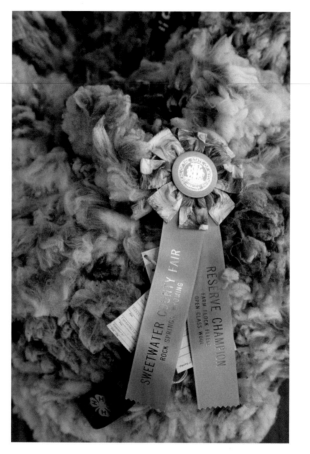

Wool is important to Wyoming, and showy ribbons are important to the fair. Nothing says county fair *like the classic rosette ribbon.*

fashioned birch beer on tap" from a bunting-draped booth. Merritt Wines sells wine slushes, and Rinconcito Criolla offers a full menu of Spanish food. Stop by Grim's Fudge in the commercial building. Look around for booths, stands, and trailers selling gyros, curly fries, chicken wings, bison burgers, fish and chips, popcorn, fresh-squeezed lemonade and orangeade, soft pretzels, onion rings, Philly steak, stromboli—and, of course, the old standbys, cotton candy, ice cream, and funnel cakes.

Maybe there's a rodeo tonight, a demolition derby, or country music concert. One look at the crowd filling the fairgrounds and migrating toward the stands is enough to tell which. Overalls mean tractor pull; black cowboy hats mean country-western music.

The announcer's voice rises above other fair sounds. Then, the roar and smoke of big engines, or the cry of the crowd and dust from livestock, or maybe a steel guitar sound check emerge from the grandstand.

Maybe there's a petting zoo, a strolling magician on stilts, an Old West Shoot-Out at eight thirty, barn tours, the "what is a farm?" exhibit, the Department of Natural Resources tanks of local fish and rattlesnakes, and maybe even a lurid sideshow for "Zambora, the Ape Girl—She is still alive!"

In the evening the teenagers emerge, all carefully groomed to look as if they don't care how they look. They circle and cruise, drawn to the pulsing midway like moths to the grandstand lights. Brittle, feigning casual, they watch without looking, hoping to catch the attention of a boy or girl from that other town down the highway, hoping that love bowls them over like the pyramid of chipped white plaster milk bottles in the game nearby, presided over by the kid who hawks to every passing local.

The fair is rows of carnie stick joints, rows of church-

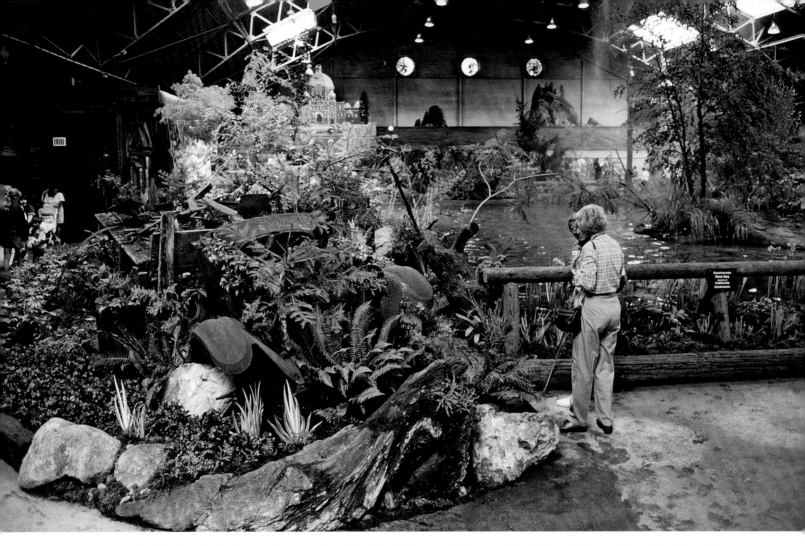

Horticultural and garden displays are always popular at fairs, though few are as elaborate as this exhibit at the Sonoma County Fair in Santa Rosa, California, which includes a waterfall, a whale mural, and a recreated landscape scene complete with a rusted truck.

basement tables and chairs at the Methodist food stand, shelves of pies and hams, lines of ribbons, lines of black Angus gripped by tidy kids, all under the steady gaze of the cattle judge; circles and arcs of throbbing rides full of screaming—and sometimes sick—riders; chorus lines of vegetables and home canned goods, an explosion of summer flowers in the horticulture building.

It's dark now, but the glare of the fair blots out any stars. Bare yellow bulbs sway in the night breeze; judges bend, intent on contestants' breads, embroidered aprons, cucumbers, country crafts, blurry snapshots of the barn cat. All across the grounds are sad tattoos and hopeful faces, chance reunions; a 4-H chicken dinner in your stomach, cow pie on your shoe, the taste of dust, the squall of animals, farm kids and town kids in white and green 4-H outfits, summer

night air with a breath of endless possibility, of endless summer; everywhere rich icons of old rural ways, of country life; a sense of pride for the neglected agricultural center of things, a firm hold on tradition, a sense of what's best about us all, and a sense of coming change: the county fair.

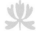

WE WENT LOOKING FOR THE COUNTY FAIR, to take the measure of an American tradition in a nation of changing priorities. In our road atlas we circled fair locations and

penciled in fair dates, and then set out over the course of many summers to sample some of the thousands that bloom out of the fairgrounds dust each year. Our interest was not in the biggest or smallest or most unusual fairs, but the fairs in the middle, the workaday fairs that could better suggest the pulse and health of the whole institution. Certainly we wanted to find what was unique about a given fair, but more important was what was common to agricultural fairs all across the country. We traveled by Chevy and sometimes by Cessna, but whatever our mode, our tent went up within the grounds or as close to the fair as possible. With a cookbox and campstove (one should not live on fair food alone), we slept under the kiddy roller coaster, amid the carnies' tents and trailers, among the 4-H kids and parents, in the infield of the racetrack, among the cattle, and right next to the poultry house. The latter offered the worst night's sleep; the lights never went off, and the over-achieving roosters announced the sunrise all night long.

Our pattern was pretty simple. Once we crossed a county line inbound (by road or air), we started watching for the Ferris wheel. For strangers like us, it was often the best beacon to locating the fairgrounds. Sometimes we'd contact the fair management ahead of time to let them know we were coming; most of the time we'd just show up. Our first stop was the fair office to say hello, describe our project, leave a business card, and ask, among other questions, is there anybody or anything we should definitely see at your fair? The answer was always yes and was always the beginning of a geometric progression of people, interviews, documents, events, photographs, and experiences that combined to become a rich experience and our individual take of a particular fair. We were welcomed at every fair and were invited into homes on occasion for a night in a real bed.

Camping on the fairgrounds ensured easy access to the whole of the event; we were around early enough to eat pancakes with the farmers at the church stand and late enough to catch the teen dance, to absorb everything a fair had to offer. Audiotape, notebooks, and film recorded the voices, the events, the odd moments, and something of the specific personality of a given fair, on this day, this year.

No matter how many weeks we'd been on the road going from fair to fair, no matter how many fairs we'd visited in the prior days, as we approached the gates of the next fair, there was a tingle of anticipation about the experiences to come. Will it be cream puffs? A lumberjack show? Roast beef dinner with all the trimmings on Sunday in the 4-H hall? A display of a thousand dahlias? Maybe the sight of the Pacific Ocean from the Ferris wheel, or the color of the rodeo arena in the low evening sun. Every fair offered a banquet for the senses, and in an age of artificial experience, the county fair may be our last, best, minimally mediated sensory adventure.

Many fairs open on Thursday and close on Sunday, meaning intense work and hard travel for us to get to two and sometimes three fairs in four or five days. Our shortest visit at a fair (except for a couple that didn't start when the schedule said they would) was a few hours; our longest, four days. Many of the slower fair days from Monday through Wednesday saw us cross a couple states to be ready for the fair cycle to start again. Early in the week on the road between fairs, we often passed carnivals en route to their next setup, glitzy rides folded and secured, sometimes a row of giant plastic bears lashed to a semitrailer, bobbing oddly in the slipstream. Occasionally we would have a couple free days before a Wednesday startup and would retreat to a state park or a national forest campground in the mountains to catch up on our notes, eat lots of salad, and let our ears rest. The fair, after all, is a noisy place. In all, we logged some forty thousand miles and visited some ninety fairs in thirty-five states.

On the long road between fairs and at campsites, staring into the campfire, we considered the nature of the American county fair. Especially in a modern and national sense, the fair is an odd event, a curious tradition. It is part agricultural show and competition, part harvest festival, neighborhood block party, educational program, local trade show, circus, amusement park, family vacation, reunion, and food festival. The idea of the agricultural fair sprang from an urge to improve agriculture and manufacturing for

> **One pair of sunglasses, a cigarette case, a sweat-shirt, a coin purse, a set of car keys, and a nine-by-thirteen-inch cake pan, stripped clean of all but cake crumbs.**
>
> *—Items on the lost and found table at the Winona County Fair, Winona, Minnesota*
>
> •

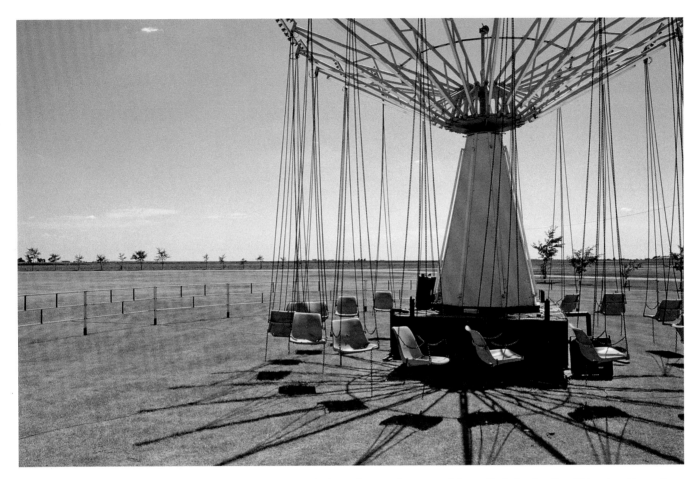

Small fairs on the Great Plains have trouble booking carnivals due to the great distances and the small take for the effort. This swing ride awaits the evening crowd at the Lane County Fair in Dighton, Kansas, during a drought year.

a growing nation, and it still clings to its educational ideals. Today, despite the fact that agriculture has been pushed to the margin of the national conversation, you can mention the words *county fair* to almost anyone—including those who live in suburbs and big cities—and hear stories about the time they won the blue ribbon for pickles ahead of their snooty neighbor who'd been winning for years, or about the time all the sheep bolted as one from the show arena when somebody's tractor backfired, or about the pretty girl who came and bought an ice cream cone from you every day at the Methodist church food booth.

We pondered the differences between a county fair and other outdoor events. What distinguishes an agricultural fair from, say, Oil Heritage Days or the Meyersdale Maple Festival, the Bark Peelers' Convention, the Shade Gap Picnic, or the Goschenhoppen Folk Festival, to use a few Pennsylvania examples? What are the necessary ele-

ments of a real county agricultural fair? We asked fairgoers and exhibitors what a county fair must have to make it a fair, and the requisites that people counted out on their fingers were remarkably similar from coast to coast. In some cases, just to set the parameters, people told us first about something that a county fair was not—a craft show or livestock exhibition—and then they got down to specifics. What people told us a fair must have to be a fair supported our own observations.

First, a county fair has to have livestock, even if you have to pay people to bring them, as at least one fair in the Northeast does. Without livestock, the fair is either something else—such as a *festival*—or is dying. Bring dairy cows from the next county if you have to, but just get them here. People from country and town alike come to the fair for many reasons, and even though the townsfolk spend most of their time elsewhere on the grounds, most of them make

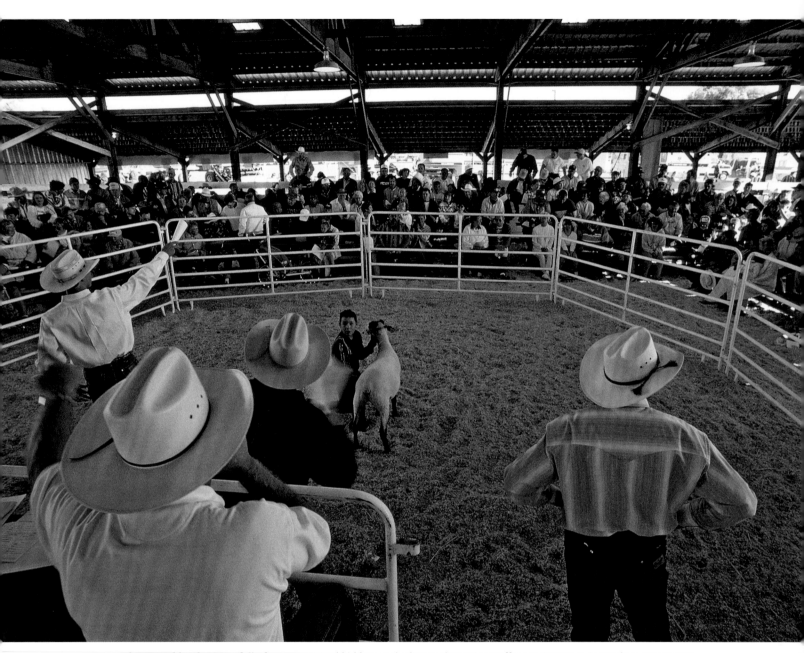

The arena bleachers are full of spectators and bidders at the livestock auction, Jefferson County Fair, Madras, Oregon.

a pass through the livestock barns to see the pigs, cows, horses, and chickens. This connection between the fair and farm animals dates from the very beginning of American fairs and continues, despite the fact that most agricultural animals are now raised under factory conditions that are altogether disconnected from the county fair.

Though they may be situated at the edge of the grounds where truck access is easier, the livestock barns and the show arena are central in importance to any county fair. There is always activity here, and many non-livestock fair events are scheduled so as not to conflict with the dairy show or 4-H swine showmanship or the English riding competition. At even small fairs the animal events draw large, mostly local and devoted crowds.

On the outskirts of Madras, Oregon, for example, tucked in the shadow of the high Cascades, sits the Jefferson County Fairgrounds. At 6:00 p.m. sharp on a Saturday, the last day of the fair, the show arena bleachers are packed, and much of the rest of the fairgrounds nearly empty as the livestock auctioneer warbles into the microphone and gestures to the hometown crowd. This is the 4-H and FFA livestock sale, the climactic event of the fair. In the show ring between the auctioneer and the spectators, kids and their animals circle, one kid and one animal at a time, as sheep, beef, and swine are sold for market to the highest bidder. The kids, both boys and girls, wear jeans and western shirts; some wear their 4-H white outfits, or, if a few years older, their dark blue FFA (formerly Future Farmers of America, now just FFA) jackets. Clean and sharp, they circle with their animals.

The kids have trained for this, just as they have practiced grooming and showing their animals in competition. This auction is the payoff for many months' work, and the girls and boys are determined, professional, and eager. As they circle the arena, smartly directing their animals, they fix their eyes on the crowded stands, not for a nod from Mom or Dad, but to encourage those in the bleachers to show a hand to push the bidding higher. A good price brings not only good money to a young exhibitor but also a badge of honor for a hard job done well. The slanting afternoon sun shines through the yellow dust in the air, and the place is taut with expectation. Everyone knows this is the most important event of the entire fair. Not only will people talk about it at the dance tonight (the last event of the fair), but the memory will also last all year until the fair comes around again.

At the Jefferson County Fair in Oregon or at the Rockingham County Fair in Virginia, or at almost any fair in between, fair organizers and exhibitors understand that the animals are the *sine qua non* of the fair, the feature that reminds everyone that the fair is about agriculture, and agriculture has to do with animals. Though necessary for any fair, livestock are not in themselves sufficient. Not every event with livestock is a county fair; take, for instance, a dairy cattle show. Fairs require other things as well.

To be an agricultural fair, it must be an annual event—no more or less often—and it must be held around the same time each year. Fair exhibitors and fairgoers must rely on it and anticipate it. The county fair, like birthdays, religious holidays, harvest time itself, marks a point in the cycle of the year, a return once again to a familiar and cherished place on the calendar. The cycle of seasons means more to agricultural (and horticultural) people than to city slickers, and the fair is still an integral part of that cycle to most farmers and ranchers. The appearance of billboards and newspaper ads announcing the local fair prompts recollections of last year's event and sparks anticipation of favorite foods available nowhere else, a stroll down the midway, or the need to get ingredients for this year's cake entry. And in all but the South, where fairs are held from fall through winter into spring, news of the coming fair whispers that fall is not far away.

It seems obvious, but a *real* fair must be held on a fair *grounds,* a more or less permanent home for the event each year. It can't be held in a parking lot, as some fairs have tried, and unlike the circus, a county fair can't just set up in a hayfield at the edge of town. There have to be at least a few buildings that are dedicated fair buildings—barns, exhibit halls, grandstands—even if they are used the rest of the year to store boats and campers, and the grounds often used for other events during the remaining fifty-one weeks of the year. A fair might stage some of its events down on main street (many have parades), but the big happenings and the main exhibits have to be on the fairgrounds.

A county fair must have competition, lots of it, and except for a few events like rodeo team roping, it is individual competition. This marks a significant difference from the other arena where competition thrives in America—local sports. Team events like high school basketball and weekend soccer draw active, vocal crowds, a far cry from the solo blue ribbon browser who strolls through horticulture and reads every tag to see who raised the best hollyhocks. In pies, quilts, sheep, equestrian events, rabbits, painted plastic model cars, antique tractor restoration, baled hay, okra—even canned moose meat—the fair thrives on a subdued but still sharp sort of competition. After all, rural folks don't much like bragging—at least out-in-the-open bragging. Without competition, a fair is probably a festival. As Arthur Griffiths, president of the Monmouth Fair Association, Monmouth, Maine, said recently about competition at fairs in years gone by, "My carrots are better than your carrots. My cucumbers will outcuke your cucumbers. And occasionally, my horse can beat your horse." It's the same today.

Competition is central to another key aspect of the fair: home arts, including canning, baking, horticulture, and crafts. Traditionally home arts is the center of the woman's realm at the fair, and this area is still more female than male, though pie and petunia entries with men's names no longer raise eyebrows. For entrants female or male, this area is the result of much planning and generates vigorous interest at fairs across the country. And at most fairs, a crowded home arts building is

as sure a sign of a successful fair as good gate receipts.

A carnival? Not necessarily. Hundreds of small fairs, especially in the Great Plains where distances are great, gate receipts small, and carnival operators few, either don't bother, or set up their own homegrown carnivals with rides scrounged from around the country. Nevertheless, some sort of participatory amusement or novel entertainment is essential. Without at least a baby contest, a strolling clown who makes balloon animals, or a dance, the thing won't measure up as a fair.

Interesting food that you can't get at home is an important part of fairs, but it's also important to festivals and other events. Baseball isn't baseball without hotdogs. Every fair we attended offered novel eats, from the cornucopia at the Chautauqua County Fair to wine tasting at the Amador County Fair in California. On the small side—but still qualifying as interesting food—was the single tiny snack trailer parked near the show arena at the Rice County 4-H Fair in Lyons, Kansas, where the kids lined up to get drinks, funnel cakes, and popcorn. Apart from the watermelon feed that followed the livestock auction, it provided the only food at this fair.

Every state but Delaware and Hawaii has county fairs, or the equivalent. Even tiny Rhode Island has 2, and Pennsylvania brings in the record with 113 if you throw in some *township* fairs and *community* fairs. Louisiana has parishes and Alaska has boroughs, but a regional fair in Alaska or a parish fair in Louisiana fills the same social and economic role for a given region as something called a county fair in Kansas. There are *country* fairs and *district* fairs, and a number of *town* fairs, but what nearly all of them seem to hold in common is an agricultural focus and an area of influence that ranges from town-sized to regional.

Forty-eight states boast a state fair; only Rhode Island and Connecticut do not. State fairs are markedly different creatures, and we've not included them in our research. In most states they're certainly agricultural, but because of their size and status as *state* fair, most are big and comparatively impersonal affairs that angle toward more commercial events and exhibits, big-name entertainment, and state promotional agendas, and thus lack the homespun local focus and the individual personality of county fairs—which are a couple of the big reasons we started this endeavor in the first place.

By our count there are some 2,230 agricultural fairs in the country including county (the vast majority), district, parish, borough, plus a handful of ag-focused local fairs and state fairs. On the basis of annual listings in *Amusement Business,* state travel and tourism info, plus data from regional and state fair associations, our estimate is just that—an estimate—because fair listings obviously miss some and include others that aren't really agricultural fairs. And we certainly weren't able to visit all of the nation's fairs to see if they measured up agriculturally: Only two chickens in the whole livestock competition?—don't count this one.

The National Association of Counties rings up a total of 3,066 counties (including Louisiana parishes, Alaska boroughs, and some city districts), which means some 800 to 900 counties don't have a county fair. An exact number for county fairs is elusive because some so-named town and district fairs serve as the county fair, and because a number of counties have *two* county fairs. In tiny Frontier County, Nebraska (population under 2,800), both the Eustis Agricultural Society Fair in Eustis and the Frontier County Fair in Stockville just down the road take place every summer. Local folks tell us it's a holdover from county seat battles between the two towns years ago during which each town started its own fair (each the *official* county fair) to solidify its position, and that even today there are hard feelings between the fair boards.

It's no surprise that not every county has a fair, nor is it a surprise that agricultural fairs are unevenly distributed across the country. The New England states, plus the intensely agricultural midwestern states—Ohio, Minnesota, Wisconsin, Illinois, Kansas, and Iowa—as well as the tier of intensely agricultural West Coast states of California, Oregon, and Washington support the largest number of fairs. These states, in fact, all have more fairs than they do counties owing to long tradition, the proliferation of local fairs, "junior" fairs, district fairs, and the like. Wisconsin, for example, has seventy-two counties and seventy-seven

> "This race is sponsored by the Midway Motel, the Midway Motel. If it weren't for the trees, you could probably see it from here."
>
> *—Grandstand announcement at the harness races, Vernon County Fair, Viroqua, Wisconsin*

agricultural fairs, not including the state fair. Wisconsinites, like other folks in large parts of New England, the Midwest, and West Coast, have deep agricultural roots and support their fairs. We call these states "fair-minded."

Other strong agricultural states rate in the second tier of fair-mindedness by virtue of having an agricultural fair for some 80 to 100 percent of their counties. These states include the likes of New Jersey, Nebraska, Utah, New York, Michigan, Indiana, Arkansas, Missouri, and Wyoming.

The states having the lowest fair-to-county ratio are mostly southern states. South Carolina, Louisiana, Texas, Georgia, Mississippi, and Alabama come in among the bottom ten of the list with an agricultural fair for only 40 percent or fewer of their counties (parishes, in the case of Louisiana). Despite the fact that Alabama has a higher agricultural output than Oregon, Alabama sports only fourteen county or district fairs spread out among the its sixty-seven counties; Oregon has thirty-seven fairs for its thirty-six counties.

We suggest a couple reasons for the small numbers of fairs in the Deep South. First, the county fair sprouted from a New England seedbed and, like most agricultural practices of the nineteenth-century Northeast, was carried west by migrating agrarians through the Midwest and eventually to the West Coast. But through much of the nineteenth century, a time of vigorous development in agricultural fairs, the Mason-Dixon Line was not especially porous to ideas from either side, limiting the establishment of agricultural fairs in the Deep South. In addition, the county fair was not well suited to the agricultural practices of antebellum plantations and postbellum sharecropping, thus likely reducing local incentive to start them.

And because of nearly year-round growing seasons and varied crop types in the Deep South and Southwest, many agricultural products today are harvested at times other than fall, blurring the impulse to celebrate the general harvest. Besides, it's often too hot in late summer or early fall to have an outdoor fair, leading many states south of Tennessee to have their county fairs between October and May. Both these circumstances dilute the idea of "fair time" and probably have inhibited the development of county fair tradition.

This doesn't mean that the celebration of agricultural traditions is any less strong across this region. They are expressed in events like the Georgia Blueberry Festival, the Old Tyme Farm Days Thanksgiving in Live Oak, Florida, the Louisiana Pecan Festival, or the Whole Enchilada Fiesta in Las Cruces, New Mexico. Just as it's hard to find a crayfish festival in Minnesota, it's harder to find a county fair in Mississippi.

What is surprising about the distribution of agricultural fairs is the dense concentration of fairs in New England. Tiny Connecticut, with eight counties, has a whopping thirty-two fairs; Maine with sixteen has twenty-three; New Hampshire with ten counties has twelve fairs. And Massachusetts, the birthplace of the American agricultural fair, has fourteen counties and thirty agricultural fairs. To look at it another way, Massachusetts has a fair for every 261 square miles of the state, be it city, suburb, or truck farm; Iowa, one for every 542 square miles of its corn and soybeans; and fair-poor Texas, one for every 4,224 square miles of its cotton and rangeland.

Thus a map of the contiguous forty-eight states shows a strong concentration of fair-minded states sweeping from New England through Pennsylvania and broadening across the Midwest, and a tier of similar strong states on the West Coast. The interior West is a smattering of strong fair states and less strong ones, which likely has more to do with the economics of livestock raising and population loss on the Great Plains and in the interior West than a cultural interest in fairs. The weakest states swing from North Carolina west through Georgia, Alabama, Mississippi, Louisiana, Texas, and New Mexico. New Mexico may be a special case: Strong Hispanic traditions of agriculture and its celebration may have dampened the interest in Anglo-based county fairs. New Mexico has but ten fairs for its thirty-three counties.

But what of New England, where fairs remain plentiful, strong and well attended? It isn't agriculture that makes the fairs thrive here—the region is more urban than most of the rest of the country, and the agricultural center of the nation long ago moved west and south. Nonetheless, exhibitors in New England still flock to their numerous fairs with everything from draft horses, quilts, pies, samplers—and today, the occasional llama and emu. It's not agriculture; it's not entertainment; it's not education. What draws New England to its fairs is simply deep and abiding tradition.

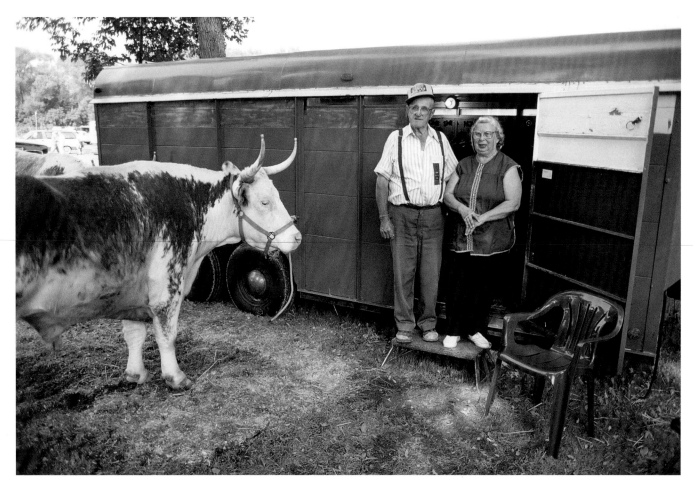

Hervy and Rose Ostiguy with Turk (or is it Lion?) next to their combination camper and livestock trailer at the Adams Agricultural Fair, Adams, Massachusetts.

2. Fair-mindedness

Oh, yes; I met more of my in-laws at the first fair after we were married than I did at any other single time. People would have a picnic basket full of food. The blankets were spread out along the racetrack, and we had grandmas and grandpas and cousins by the dozens. It was family reunion time.

—Helen Hornby, superintendent of crops and vegetables at the Vernon County Fair, Viroqua, Wisconsin

NEW ENGLAND IS THE SEED GROUND of the agricultural fair, and the Berkshire Hills of western Massachusetts marks the place of first emergence. Traditional ways run deep here in the cool valleys, and fairs are part of the long familiar patterns of things. The first modern agricultural fair was held here in Pittsfield in 1811; there have been fairs in the region for almost two hundred years. By now the generations of strong-handed farmers and self-reliant women have mostly passed on to be replaced by teachers and software developers. Despite the changes, many elements of the first fairs are still found at today's fairs. It

turns out that nothing better expresses the tradition of the American agricultural fair than livestock, and no animal better expresses that tradition in New England than oxen, the gentle-eyed beasts that reach back into the earliest years of our agricultural past. After all, they played an important role at the first agricultural fairs in the country.

As the crow flies across the Berkshires, it's only sixteen miles between the village square of Pittsfield, where the first modern American agricultural fair was held, and Adams, where one of the newest is held every year at the edge of town. While the temporal difference between that first fair and today's Adams Agricultural Fair is almost two centuries, the bonds of tradition between the original Berkshire fair and the thirty-some-year-old Adams Agricultural Fair are thick, strong, and flexible, like the time-darkened leather straps that bind a pair of oxen to an old-style head yoke.

On a comfortable day at the Adams fair, Hervy Ostiguy steps behind his pair of brown and white oxen, Turk and Lion, and hooks the free end of a heavy chain to the tongue of the stoneboat loaded with fifty-five hundred pounds of concrete blocks. Hervy, looking for all the world like the retired guy next door, moves with the ease and deliberation of accustomed action. He pauses, chats a moment with the crew standing ready with tape measure, then moves around to the front of the team. He scrutinizes their stances, their alignment with the stoneboat. With the tip of his whip, he taps a hoof or two; the quiet animals shift their weight and feet to position themselves for a hard, quick pull. The crowd is small, attentive, comprised mostly of the families of the pullers.

Ringside, Rose Ostiguy has her eye pressed to a video camera viewfinder. Her sleeveless floral smock reveals fleshy arms perfect for mixing up cakes and opening gates. Her position at the far corner of the pulling ring gives her a diagonal view and distance enough to get the whole pull. She talks in a low, PGA tournament voice: "We are at the Adams Agricultural Fair, thirty-two hundred pound class, pulling at fifty-five hundred pounds." After more than five decades together on the oxen-pulling circuit, Rose usually knows what Hervy is thinking and what he will do next.

In the ring Hervy faces the animals and, assured they are ready, steps quickly backward in the direction he wants them to pull. Striking the ground between them with his twisted whip, he calls, "Come 'ere, Lion! Come on! Come on!"

The chain snaps tight, the oxen's haunches compress, and their rear legs seem to shorten by half as their muscled chests and backs swell under the strain. They and the stoneboat begin to move the way a steam locomotive does, by power overcoming inertia: slowly at first, then with a burst of momentum. The stoneboat grinds across the dirt, easily making the six feet necessary for a successful pull. Hervy stops them to save them for the next pull in this competition: six thousand pounds. The crowd applauds politely. Satisfied, Hervy rubs Turk's and Lion's faces.

The oxen stand motionless as Hervy walks behind them and unhooks. His easy, purposeful manner mirrors the animals' natural patience and deliberate pace. After securing the chain, Hervy turns his back on them without a look or word and walks to the side of the competition ring. Turk and Lion follow on his heels, and Hervy never looks back; he knows they'll come along, just as they always do. Though other competitors use two or three people in the ring to manage their sometimes balky oxen, Hervy works his alone. All contestants are allotted three attempts to pull at each new weight, and some need all three, but this well-trained trio used but one at this weight.

Rose puts her camera down and says, "Their head yoke is Canadian style. We bought them in Nova Scotia

> "We have some families in Bourbon County—this is their vacation. They come and buy the yearly pass; they're here every night; they don't miss a single event. I don't think they cook at home the whole week. It's hot dogs and cotton candy for the whole week, and they're here at five in the afternoon and at midnight when we're trying to put it to bed."
>
> —*Jim Allen, treasurer, Bourbon County Fair and Horse Show, Paris, Kentucky*
>
> •

For almost two hundred years farmers have ogled the latest farm machinery at the local agricultural fair, here at the Clay County Fair, Spencer, Iowa.

The yoke is a rigid red and white beam carved to match each animal's horns and head shape; the long leather straps bind it to their horns, much as one might tie a boat line to a dock cleat. Each year Hervy whittles a bit of wood off the beam to account for the animals' growth. Studded black leather pads rest on the oxen's foreheads, contrasting with their wooly white faces. Around each neck hangs a rectangular cowbell that clangs with each synchronized step. Rose says, "See how they have bells on them? Now, if they didn't have the bells, they'd look undressed.

"When Hervy goes hunting up in Maine for a week, I take care of them. While he's gone, they're good, but the minute he drives in the driveway, they know it's his truck and they start hollerin'. They know it's him. He's good to them and they are good to him. It all depends how you treat your animals."

The oxen are considerably better dressed than Hervy in his twill workman's pants and blue suspenders, short-sleeved shirt, four buttons left unfastened, revealing a sleeveless, ribbed undershirt. He wears a blue baseball cap, and the thick copper bracelet on his right wrist hints at rheumatism. Maybe it is in his seventy-seven-year-old back, which he broke working construction years ago.

On their way to the sidelines, they meet the incoming drovers and their pair of taller oxen on the way to pull next. Insistently, but not cruelly, one man snaps his whip at the head of his team; another walks behind, managing the chain and slapping a haunch when necessary. This team of two humans and two bovines moves in a halting zigzagging motion, the animals distracted, reluctant. Four of the five teams here today are harnessed in the more common neck, or bow, yoke, an arrangement typical in the States. For better or worse, it allows for more movement of the oxen, and the animals take good advantage of it. Readying to pull, the oxen teams move erratically,

and that is their style of yokes. These are Hereford and Durham mixed. Up in Canada they call them Grays, but we don't find gray in them. I'd call them roans if anything. These are ten years old. See, that yoke won't fit on any other pair of oxen, just them. You'd be surprised, as old as they are, how every year he has to trim the boxes. See, the horns fit right in those boxes. Then there is twenty-five feet of strap that they strap the yoke on with."

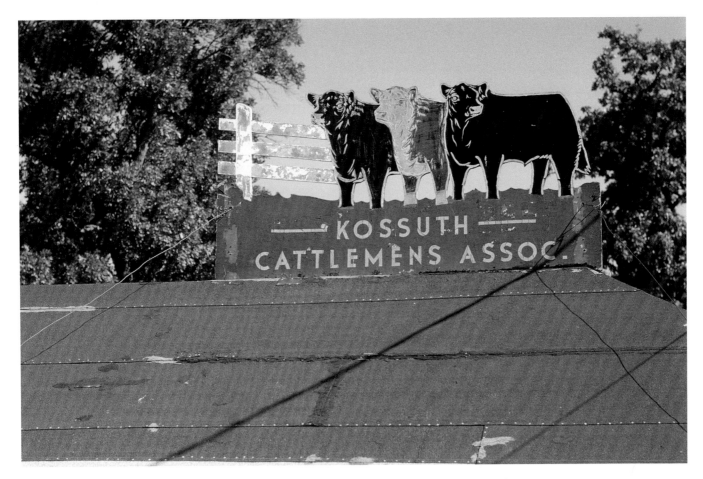

Proud steers preside over the Cattlemen's food stand at the Kossuth County Fair, Algona, Iowa.

stepping sideways, shaking a head to shed a fly, stretching to nibble an itch. Of course, the movement of one has a marked impact on the stasis of the other. Teamsters yell commands and shove on oxen, making this dance more of what a spectator might expect from an oxen event, comprised as it is of two or three people, plus two animals weighing about a ton and a half, standing on eight feet. It looks like a first tango lesson, a tipsy polka at a wedding dance. In contrast, every time Hervy, Turk, and Lion come up to pull, they waltz "The Blue Danube."

A handful of drovers and teams wait along the chain-link fence for their turn to pull. In contrast to the oxen, a nimble red tractor rumbles back and forth, returning the stoneboat to the starting line. After each round, and with the ease of modern hydraulics, it piles additional weight on the stoneboat. Apart from the busy tractor, the entire event moves only a little faster than the oxen; contestants lean on

the fence, sit in aluminum lawn chairs, and chat as their animals swish flies and ruminate. No last minute strategizing or jumping to Plan B for the next pull: It is muscle against mass, single elimination. Either they move the stoneboat the required distance or they don't.

Between pulls, Hervy sits in his lawn chair, Turk and Lion standing like marble statues at his right shoulder. While not siblings, they are both offspring of Hereford cows and Durham bulls, and they bear the rich and dappled brick red and creamy white of their mother. Their identicalness is arresting, and observers are bound to scan the two for assurance that this isn't some sort of magical two-headed beast. The head yoke means that when one head moves, so must the other. But what explains the impression that the sum of their movements seems synchronized like that of a chorus line? In motion or at rest, their legs assume similar positions. They look like identical plastic

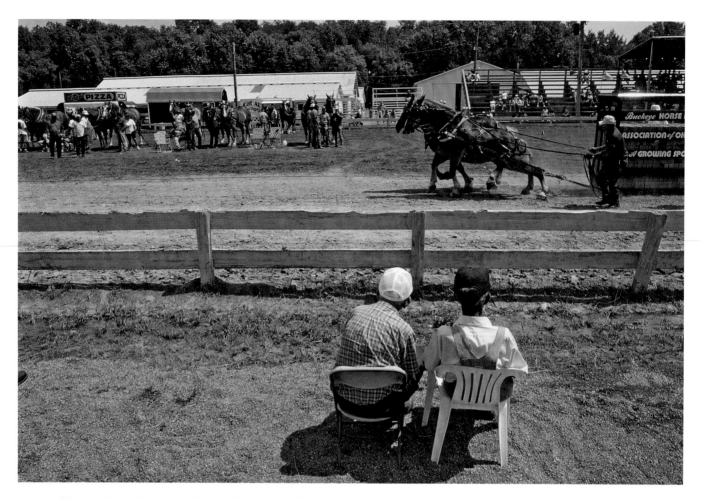

Draft horse pulls have been a part of county fairs since long before these two eager spectators were born. Holmes County Fair, Millersburg, Ohio.

farm animals shaken out of the box. The only way to be sure is to watch their eyes: when one animal blinks, the other might not.

For more than fifty years Hervy Ostiguy has been buying, selling, raising, trading, training, and pulling oxen, numbering now more than 250 teams. Here at the Adams Agricultural Fair he is the chairman of the draft oxen pull. Both he and Rose have dedicated a large part of their lives and affections to these once common animals.

Rose tells us, "We went to a fair once and there were five and a half teams there that he had sold to different people—five, and an odd one to somebody. We have named them everything: Ketchup and Mustard, Salt and Pepper—everything, just to give them a name, especially when he has gone through so many of them. We have had a lot of enjoyment with them. We take in twenty or twenty-one fairs a year. Well, not in the last two years; we're cutting down."

Hervy does not so much drive his oxen as lead them to perform a task embedded in their memories, their muscles. They respond not to the threat of the whip, but out of loyalty and constant training. At home on the Ostiguy farm, they work almost daily pulling logs out of the woods. Hervy thinks this constant work is what makes them so cooperative in the pulling ring—they're just used to it.

While others as far into their retirement years as Hervy and Rose might relax in Florida, they travel to fairs across the Northeast to compete and to convene with others who keep and work oxen. Instead of a motor home with a slick name that evokes the romance of travel, the Ostiguys fixed up a livestock trailer to accommodate all four of them. Hervy and Rose have small cooking and sleeping quarters in the front, Turk and Lion have their stalls in the back.

"We are able to go anyplace and stay as long as we

want," Rose explains. "As long as he's got them with him, we don't have to worry about someone at home taking care of them."

The pulling competition has now reached seven thousand pounds, and several teams have been eliminated. After watching the drovers and teams pulling before him, Hervy rises from his lawn chair and moves from his shady spot on the east edge of the pulling ring and starts toward the center. Turk and Lion fall in behind him without a word or look. Hervy's pace, slow by human terms, is intuitively linked to that of his team. Walking, the two oxen seem even more to be one creature as their eight legs move in synchrony. "They walk just like soldiers, step by step," Rose whispers.

Hervy walks ahead and to the left of them, making a wide turn to come around in front of the stoneboat. His track has the precise radius to bring the oxen into the proper position for hooking up, and Turk and Lion stop and stand steady. Once they are hooked up, he is in no hurry to pull. He stands at the rear, looks at them, at their legs, exchanging a word or two with the guys near the boat. Always moving on the team's left side, he circles to the front, stands facing them, strikes the ground with his whip, calls to them, and backs in the direction they are to pull. Once again they compress into the load, pull, and lift, and the stoneboat grinds forward for a successful pull.

Hervy is pleased with this heavy pull by his team, the shortest oxen competing today. They are in good form, and Hervy is not disappointed that they aren't able to move seventy-five hundred pounds in the next round. Only one team does, putting Turk, Lion, and Hervy in second place. Later Hervy says, "I don't care if I win, as long as I can put on a good show for the people."

Fair tradition includes comfortable old buildings and organizations that have played big roles in the fair for decades. This architectural detail is from the 4-H dining hall at the Watonwan County Fair, St. James, Minnesota.

Rose has been a source of support through all these years of oxen pulls all over the region: emotional, physical, and, almost certainly, nutritional. After the pull, and in unspoken tradition, the pullers are invited to the Ostiguys' trailer for a "lunch."

"I've got everything made for them," says Rose. "I've got salads—potato salad, macaroni salad; I've got ham and all kinds of stuff."

Inside the trailer is a four-burner stove, a small table, shiplike cupboards, shelves, and upholstered benches for company. Towels hang in handy spots, and a piece of cord strung along one wall is hung with prize ribbons. Rose shows us around her tiny kitchen. "I've got every spice I ever need to use."

If these events are, for Hervy, about oxen, they are for Rose about people. Rose moves about the galley while Hervy unyokes, feeds, and waters the oxen and ties them to the trailer. In minutes, Rose sets out the lunch: macaroni salad, potato salad, fruit salad, seafood salad, sliced cheeses and meats, potato chips, buns, sliced cucumbers, and onions.

Once animals and equipment are put away, people amble toward the Ostiguys' trailer in the shade near the pulling ring. Hervy calls out, "Get yourself something to drink. How 'bout a beer or something? Soda? She's got it all set up; all you gotta do is help yourself." Near the trailer are folding chairs and TV tables, soon occupied by the faithful. There is deep friendship in easy conversation and reverence for the Ostiguys among oxen people as the pullers push their hats back on their heads and balance paper plates on their laps.

"I was at home on a farm," Hervy tells us over a plate of food. "We'd hook up our Holsteins and then we'd get to mowin' or rakin' or haulin' hay. I was nine years old. We used to stand on a grain box, my sisters and me; it would take three of us to put the yoke on." He describes how he'd crawl up on the beam of the yoke across the animals' necks, and his sisters would push the U-shaped neck pieces up through the holes and he'd secure the pins.

"I've had 250 pairs in the last forty-eight years," he continued. "I bought a pair once, a red one and a roan one. I gave twenty-five hundred for them. A guy said to me, 'You fool, what are you gonna do with that red one? He'd kill you if he could get ahold of you.' So, one morning I was eating breakfast. I heard a commotion. I had a piece of toast in my hand when I went out to untie him. He reached up and grabbed the toast with his mouth. I saw that and thought, 'Ahhh, now I know what you like.' So every morning I used to bring him two, three toasts. I got so I could do anything with him."

Hervy pauses and Rose fills in, "I didn't tell you about my hobby yet, did I? I collect salt and pepper shakers. I have over nine thousand pairs." Of course, she has several pair that are oxen. Recently a man cleaned out his mother's home and brought her forty-one pairs. To her great pleasure, only four were duplicates of what she already owned. "I just love collecting them. Hervy has his oxen, and I have my salt and pepper shakers. If I go out and find a salt and pepper shaker—oh, I just feel fine!"

As salads and sandwiches disappear, it's evident that this communion is the Ostiguys' way of giving thanks for good lives. They talk of their children and grandchildren and of a new great-grandchild. They talk of friendships made and cherished over long years of fairs and oxen in New England. A potluck at one fair, an anniversary cake at another, and a pig roast at Rose's favorite fair of all: the Fryeburg (Maine) Fair. "I'd give up twenty fairs for one week in Fryeburg. When I get there I say to the man, 'Well, I'm here for my Florida vacation.' It's true." And she has no regrets. "Sometimes my husband says, 'Oh, these people did this and did that.' Sometimes he thinks we missed out on something, but I don't. We did what we wanted to do, and this was our thing. And I think we've had a full life."

Little by little, the other pullers drift off to care for their animals. Rose puts the food away, and Hervy strokes Turk and Lion as he gives them a bit more to eat. The warm rituals of certain deep, unspoken traditions have been fulfilled for another year.

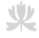

TRADITION—INDIVIDUAL, FAMILIAL, AND INSTITUTIONAL—is the universal force at every fair we attended. Like gravity, it is ubiquitous, essential, affecting all things, welcome, but seldom considered directly. At the fair, the steady pull of tradition always bends decisions, assumptions, and actions both large and small toward notions of the past. The agricultural fair is as deeply steeped in tradition as any American endeavor, as much as holiday celebrations and religious practice. Tradition is the fair's foundation and chief organizing principle.

As Hervy's strong hands bind his oxen to the yoke in a long series of motions, he does so in a ritual of deeply learned actions practiced throughout a half century. This act of harnessing oxen is comforting for its commonness, is nearly sacramental, and somehow nullifies time, making the action of winding and lacing long leather straps

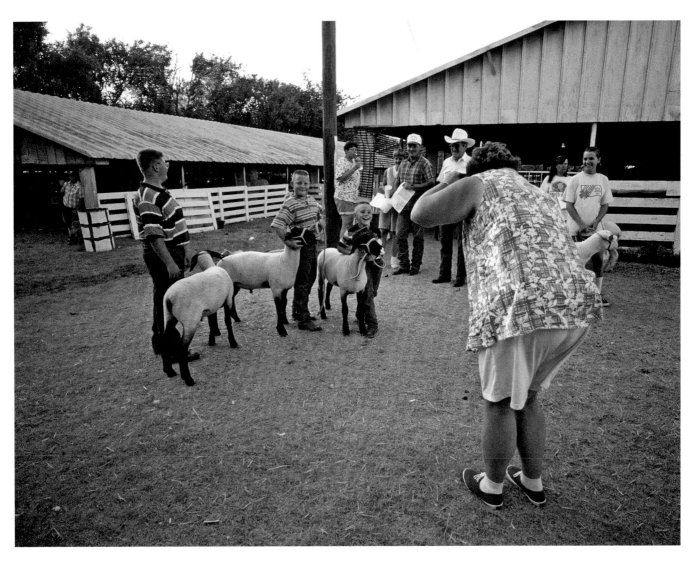

Fair memories are passed from generation to generation and are enhanced by the requisite photos taken of the ribbon winners. Rice County 4-H Fair, Lyons, Kansas.

round and back across the animals' horns the same act as every other time he's done it across five decades. And, in a way, his actions bind him to other drovers who, in centuries past, yoked their oxen to pull trees out of the primeval forest of Massachusetts, to plow the new ground, and to show at the commonwealth's early fairs.

We found tradition's deep patterns and satisfying rhythms among almost all fair participants we talked with. When weary carnival operators tear down the Ferris wheel at the end of the fair for the tenth time in as many weeks, when the local dog kennel passes out yardsticks to passersby in the commercial building, when the jelly judge samples each preserve and writes on her card, when the livestock auctioneer gestures to the crowd as he fast-talks his way through the sale of another hand-raised market lamb, or when Rose lays out her table of salads and sandwiches, then—and throughout ten thousand other acts— we're witness to the core rituals of the fair.

Long tradition is important to Bill Diller of Illinois, for example. We visited with him and his wife, Carolyn, on a sultry day at the Bureau County Fair in Princeton, Illinois.

"We got married on August 14 so we could take a

week's trip and be back in time for the fair," says Bill.

Carolyn quickly adds, "So I knew going into this what it was going to be."

Says Bill, "The fair, back when I was a kid, used to give an award for the guy or gal who had been coming to the fair for the longest consecutive time. One summer I was at church camp—I was probably twelve or fourteen years old. It happened to run fair week, and I said, 'I got to come home, because I don't want to break my string.' My dad had carried me to the fair when I was a baby, so I came home on the bus from just north of Antioch, Wisconsin, just so I could be here."

He laughs and adds, "But my three years in the air force blew that record!"

Bill has participated in the fair since he was a kid. "I showed a pony out here in—let's see—I was just looking the other day at my ribbons—1945, '6, and '7. Then I got into high school, started playing football, and kind of lost interest. Got too big for the pony."

But he came back. He's been treasurer, but "treasurer is way too confining. You get locked up in the back room and sit there. I like to watch the fair." These days he's assistant secretary of the fair board and superintendent of concessions. For comparison and new ideas he's traveled to almost all of Illinois's one hundred-plus agricultural fairs. "Any way you count them—size, acreage, attendance, income—we'd rate in the top twenty. A few people would place us in the top ten or right in that area. So there are still eighty fairs that are not as nice as ours, and I don't think I am taking a biased look at it." He and Carolyn also own and run a fudge stand at the Bureau County Fair.

"I don't know if most people have the orientation to tradition that some have. Carolyn is very tradition oriented. She's the one who did the fair history book. Her dad has been involved for years and years, and her grandfather has been involved for years and years. You know, I'm sixty-two. When I start thinking back and remembering, I feel older. And yet, when I get out here, I feel a lot younger. I'm a little stove up, and I've got a little arthritis. I thought, 'Am I gonna be able to take this?' But I haven't slowed down all week. I enjoy it so much."

Not surprisingly a family tradition of attending and working at the fair plays a big role in people's lifelong commitment to their fair, especially if it continues across generations. This is equally true in any state. At fair after fair, we were directed to so-and-so who has been involved with the event forever and whose ancestors were helping out before dirt was invented.

Just such a tip led us to Helen Hornby. We found her at her post, sitting serenely among the open class exhibits in the classic fair-style crops building at the Vernon County Fair in Viroqua, Wisconsin. She is in her eighties and wears a bright fair ribbon that reads "I'm a 4-H Alumnus." She has been general superintendent of crops and vegetables since 1967. As fairgoers browse among ears of sweet corn and bulbous squash (Vernon County's September fair is the last fair of the season in Wisconsin), she tells us about her ties to the fair.

"I started in 4-H back in 1923. At that time we lived in Wood County, and I went to the Central Wisconsin State Fair in Marshfield. I showed a calf in the round barn and vegetables on the second level of the round barn."

When she married, her father gave the newlyweds five chickens, and they raised and showed Barred Plymouth Rocks. When Helen and her family moved to Racine, Wisconsin, she took up the leadership of a 4-H club there, and over time all seven of her kids worked in 4-H. After the family moved back to Viroqua, she served on the fair board for twenty-one years.

Helen talks of her daughter JoAnne, who works with her every year in the crops building at the fair. "Oh yes, my daughter; she's fair-minded.

"I have twelve grandchildren, seventeen great-grand, and three great-great-grands. In fact, two of my granddaughters, one from Kenosha, one from Union Grove, are here now, with one of the great-grands. They're here for the fair. One of my great-grands from Racine was here working with me Thursday, keeping records for the judges. My granddaughter, mother of the one who was here with me Thursday, and her husband from Union Grove are both 4-H leaders. We are all involved."

Including Helen's father and her great-grandchildren, five generations of her family have worked at the fair.

"I don't know what I would do if there wasn't a fair," Helen tells us. "I look forward to it. Working here, I'm always glad when it's over. But I look forward to it, and I enjoy it while I'm here. I'd be lost without it."

Thus tradition is not just about the past; it is also about expectation, about anticipation of what next year's fair will be like. Tradition explains why almost everybody goes to the fair. Bill and Carolyn already plan to be at next year's fair, and Helen Hornby and her daughter JoAnne will once again watch over the crops building and its exhibits—and they'll do it as they've done it for years.

Of course, fair tradition is also something larger, something invested in the institution of the fair itself. To a large extent this tradition is the accumulation of all the work of people like the Ostiguys, Dillers, and Hornbys of the county fair universe—"fairmakers" we call them—

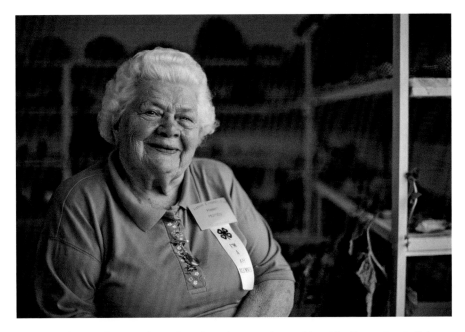

Helen Hornby, general superintendent of crops and vegetables at the Vernon County Fair, Viroqua, Wisconsin.

it's the demo derby that pays the bills.

Karen Bonomo, a fair boss at the Sweetwater County Fair in Rock Springs, Wyoming, knows this as well as anybody. During a short break in her hectic fair week schedule, she sits in the shade with a lemonade and talks about the challenges.

"I'm concerned about the cookies, the doilies, the quilts, and the real homey-type things," she explains. "Everyone seems so busy around here; I don't know. Summers are short. And people are all on computers and all on the Internet, so we're going to learn; we're going to try to see what the public wants.

"I think people are interested in all the new trends—and we do try to bring them in—but 90 percent of them come to see a cow up close, or a sheep. No matter how far advanced we get in technology, I think they'll still want to see the animals."

Yet institutionally much of what happens at any fair happens simply because of long established pattern—year-to-year momentum. "We've always done it this way," fair people say, without needing to add: "And we like it." Some traditions, like the Pig-N-Ford races at the Tillamook County Fair in Oregon, wherein pigs are hauled around the track in the grip of lead-footed Model T Ford drivers, began so long ago that nobody knows just why or how they started.

Teena Lutz is a fair board member at the Anderson County Fair in Garnett, Kansas, and understands this problem well.

"Yes, there is a lot of tradition to the fair, and sometimes it's hard to fight tradition when you're trying to make some changes," she tells us. "Tradition is good, but there are times when we need to make a step in a little different direction. Say you've got an event that you've always had—the music show. It's never made money, but you've always had it. 'We've always had it; we've got to have it,' people say. We do a lot of things that don't make money, but when it's putting you two and three thousand dollars in the hole, it's time to take a good hard look at it. We have it in the stadium, and it's hot; it's July, and these people have access to wonderful performers in Kansas City for not that much dollar difference from what we need to charge them here to break even. So we didn't even try to go down that road this year."

but the larger traditions of the fair cross even more generations than Helen Hornby's family. Fairs have always clung to the old ways, which means they change slowly, and some things at fairs are hardly different since the beginning. For instance, the first agricultural fairs in the country sponsored livestock and domestic arts competitions complete with premiums. Horse racing has been part of the fair since the early days, and even motorized events, "iron on the track," like auto daredevil shows, have been on fair bills for a hundred years.

But every fair board and every fair manager knows that the fair is a business. Tradition is important, but you can't always take it to the bank. Those who run the fair struggle with the strong and opposite pulls of tradition versus the need for new events, updating, and improvement. We saw this most clearly in discussions about how to encourage participation in traditional fair events and in discussions about fair buildings. How can we get more home canning entries? Should we tear down the leaky, old, board-and-batten exhibits building and replace it with a much-cheaper-to-maintain steel-clad pole building? Fair bosses must put on a fair every year that feels like a good old county fair, but one that also makes enough money to pay the bills and leave a little extra to get next year's fair going. Fair operators know that people come to see the cows, but

Fairmakers and fairgoers alike tell us that a fair's old-time flavor is a main reason they participate or visit. Despite the glitz and cheap entertainments, the fair is a throwback, a clear connection to a simpler time before modern troubles, a tie to our idealized agricultural past.

Tim Smiley, chairman of the poultry department at the Rockingham County Fair in Virginia, idealized the fair in terms we heard echoed coast to coast, painting a rosy picture that overlooks the fact that the cops do get called to the fair pretty often.

"I think fairs go back to basics again," he says. "It relates to families. We are all the time seeing crime and all the bad aspects of the world. But you come to the fair, and it is a weeklong thing. You never have any fights, you never have any crime, that I know of. It is kinda like everybody gets back to basic levels of families. You'll see that as you go around. People get their morals back a bit, for a week, and get back to basics."

Tradition can even be the impetus to bring a fair back after disaster. On March 29, 1998, a huge tornado raged through St. Peter, Minnesota, devastating most of the town, including the Nicollet County fairgrounds on the north end. Of twenty-six fair buildings, fourteen were wrecked, and every one of the rest was damaged. Damage was estimated at seven hundred thousand dollars.

By fair time in early August, a miracle of cleanup and rebuilding had brought the fairgrounds back to something approaching normal. Repairable buildings sported new metal exteriors and roofs, and a clean new building had risen from the debris. The grounds looked rough and smelled of fresh paint and new concrete. Workers were still at the task on opening day. A display presented news clippings and photographs of a disheartening shambles of shredded buildings and smashed cars. A T-shirt read: "The road to success is always under construction. Rebuilding Nicollet County Fairgrounds, Nicollet County 4-H, 1998."

Dick Johnson, fair board chairman, pointed out the deep gouges and dents in the heavy steel door of the fair office and described the process of getting the fair back on its feet.

"Right after the tornado, a couple of fairs offered to let us have our fair on their grounds," he explains. "But nobody wanted to do that. They would rather put up tents so we could have it on our own fairgrounds. And I was sure that we were gonna have to.

"With the fair being here this many years, and all these 4-H kids and their parents who have been at the fair all of their lives—well, it's one of the highlights of the summer. I have lived here all of my life. I know so many people throughout the county, and this is the only time that you see them!

"We had a fair board meeting about ten days after the tornado. Usually when the fair board meets, we only have the board there. There were about sixty people at that meeting. They were quite enthusiastic."

Fair board member Julie Storm was at that meeting.

"I think it is a summer event—like Fourth of July—that people do not want to give up," she says. "We discussed it on the Monday the fair board met after the tornado. Scott County and Brown County had both offered their fairgrounds for the Nicollet County Fair. Dick Johnson asked us what we would like to do. In one voice they said, 'We want to keep it here. We'll work hard to do it.' And they did. This is our 127th year."

(left) As evening turns to night, fairgoers eat and converse in one of the several food tents at the Fayette County Free Fair in Connersville, Indiana. Because much of the fairgrounds is a city park, the fair makes good use of tents and retains an atmosphere much like that of early American fairs.

Clay County Fair, Spencer, Iowa.

3. Some Tincture of Envy at the Farmers' Holiday

The eyes of America are fixed with interest on the successful result of this novel experiment;—should it succeed, the example of this society will be the fountain from which other similar societies will spread in every direction; eventually pervading the United States, adding blessings to our descendants, and a permanent support to our national independence.

—Elkanah Watson, letter to the
Berkshire Agricultural Society, 1816

IN JUNE OF 1807, ELKANAH WATSON MOVED to the country. Whether he was tired of city ways he does not say, but he is clear about his desire for rural life: "I was induced, at the age of fifty, to hazard my own, and my family's happiness, on the experiment of seeking '*rural felicity*,'—a life I had for twenty years sighed to enjoy."

A tireless, innovative, and successful businessman, an enthusiastic patriot and skilled promoter, Watson was born, in his own words, "within rifle-shot" of

Plymouth Rock. He had marched in the Revolutionary War and advocated canal development for transportation in the new nation. Now he turned his eager attention to agriculture. Watson and his wife left their home in Albany, New York, and bought a farm—an estate, really—near Pittsfield, Massachusetts, and Watson became a gentleman farmer. The farm boasted 250 acres of cropland, pasture, and orchard and was graced by a comfortable home. He once referred to his estate as "elegant." Watson was in no sense a "practical" farmer. As one historian put it, "There was more powder than hayseed in his hair."

Watson quickly began experimenting with improved swine, sheep, and cattle. From the start he was less interested in profits from his agricultural enterprises than in the notion of agricultural improvement for the region and for the new nation a mere twenty-five years after the end of the American Revolution. Watson had lived and traveled widely in Europe, had seen advances in crops and livestock there, and upon returning to the United States had been struck by the poor condition of its soil, animals, and farming practices. While much of Europe was reaping the benefits of improved agricultural practices, most American farmers still knew little to nothing about selective breeding of sheep, cattle, and swine and less about seed stocks, soil nutrients, and tillage methods. According to historian Wayne Neely, "Sheep breeding had received some encouragement from colonial assemblies in an effort to stimulate the home production of wool and woolen cloth, but fleet-footed razorbacked hogs that could be captured only with a gun ran wild in the woods, and cattle were valued chiefly for their hides and fat and a scanty flow of milk."

As a devoted patriot who wished to be as independent of England as possible, Watson was particularly concerned about America's inferior sheep and primitive means of cloth production, which fostered dependence on English woolen cloth. Homespun clothed the backs of most people in the new nation, and the superiority of English cloth was evident. In 1807 a second war with England loomed on the Atlantic horizon, and Watson, like others of the day, saw the necessity of improving the quality of American sheep herds and of developing woolen mills—and agriculture overall—

as a way to better the nation itself, uplift the average farmer, and as his patriotic duty.

That first fall Elkanah Watson acquired a pair of fine-wooled Merino sheep for his farm in Pittsfield. Word of their superiority had spread from Europe to the States, and a fever was building in part because the Spaniards had closely restricted their export. Watson's ram and ewe were likely the first of their kind in Massachusetts. Hoping to inspire the local agricultural population to consider these expensive but superior wool producers, Watson announced that he would exhibit them for all to see "under the great elm tree in the public square" in Pittsfield. To his pleasure, they brought curious farmers and their wives to town in

Healthy Hereford cattle, a powerful steam traction engine, and a sturdy new exhibit building all speak of progress at the fair in this 1902 fair poster.
Courtesy The Fair Publishing House, Inc. Collection, Michigan State University Museum

great numbers, but more important, Watson, the gentleman farmer, found himself in conversation with farmers whose hands, unlike his own, actually tilled the soil. Wrote Watson later: "I reasoned thus,—if two animals are capable of exciting so much attention, what would be the effect on a larger scale, with larger animals? The farmers present responded to my remarks with approbation.—We became acquainted, by this little incident; and from that moment, to the present, agricultural societies, cattle shows, and all in connection therewith, have predominated in my mind,

agricultural and manufacturing society of New York State, knew that these groups could do little to improve the general lot of American agricultural practice. On both sides of the Atlantic these were *learned* societies, gatherings of educated men who often owned large tracts of land, cultured men with leisure and education that allowed them to experiment, men who presented papers at fine banquets and earned expensive prizes for inventions and the development of successful new practices in tillage, crops, or animal husbandry.

Watson wrote that some of the American societies "pursued the British model—which was not congenial to the genius of our country. Although conducted by gentlemen of the highest respectability, and of ardent patriotism, yet they relied almost exclusively, on the yearly publication of a book; and sometimes by holding out liberal premiums, to excite a spirit of emulation."

For example, in 1791 the Philadelphia Society for Promoting Agriculture offered "a gold medal for the best essay, the result of experience, on the breeding, feeding, and management of cattle, for the purpose of rendering them most profitable for the dairy, and for beef, and most docile and useful for the draught." Clearly not the sort of thing the average farmer might attempt.

Cereal crops on exhibit at the Sweetwater County Fair, Rock Springs, Wyoming.

These societies were irrelevant to large-scale agricultural improvement across the nation, according to Watson, because they made no place for the ordinary farmer and the ordinary farm family who raised the crops and livestock to feed the nation and who had little education and little opportunity to learn about progress. Often suspicious of "book farming" anyway, common farmers simply proceeded as they always had—on hearsay, trial and error, and habit.

greatly to the injury of my private affairs."

Agricultural societies were nothing new. They were common in Europe, and were becoming more common in the United States as the country sought to improve its own agricultural practices. But Watson, a member himself of the

Fairs weren't new either. Twelve of the thirteen original colonies had held European-style market fairs to sell livestock and other goods, as well as to indulge in horseracing, see traveling performers, and engage in "home-made"

sports. In the first decade of the nineteenth century, the Washington, D.C., area saw several fairs for the promotion of the rural and domestic economy. Some of them offered prizes for such things as the best bull, the best woolen cloth, the best knit stockings. President James Madison himself attended at least one such fair. Sheep shearings were also popular about the same time and featured gentlemen sheep raisers discussing breeds and fleece quality, and the hired hands competing to see who could shear sheep the fastest. But these, too, were society events; the most popular of them was put on by George Washington Parke Custis, the adopted son of George Washington, at his Arlington, Virginia, estate.

Though he writes nothing about it, Watson must have seen something in those farmers that day in 1807 on the village square in Pittsfield. Did they and Watson, as agricultural people have done for centuries, stand and lean on the pen, look at the livestock, and talk of better yields and the weather? While no one could have missed the class divide between them, there must have been some clear understanding, some sense of shared purpose. Whatever the scene and sense of change, Watson must have understood these farmers' native ability and a desire for better times, and he must have felt that through these men there might be a way to improve not only the lot of the farmer, but of the whole nation on the brink of war.

A few months later, during the winter of 1807–8, Watson addressed the farmers of Berkshire County and presented an idea for a new kind of agricultural society. With their help he wished to create "an Agricultural society, which will ultimately embrace all the respectable farmers of the county, who will bring to this common fund, like bees to the hive, their stock of experience, for the good of the whole."

Some years later, looking back on the events of the time, he wrote that the nation needed "a different organization, to seize upon the human heart, to animate, and excite a lively spirit of competition, giving a direction to

Elkanah Watson.
Courtesy Berkshire Athenaeum, Pittsfield, Massachusetts

measures of general utility. . . . To do this,—some eclat was necessary—music, dancing, and singing, intermixt with religious exercises, and measures of solidity, so as to meet the feelings of every class of the community, and keeping a fixt eye on the main object, all tend to the same great end, promoting agriculture, and domestic manufactures."

His call was heard, and in 1810 Watson and twenty-five farmers and local residents sponsored a successful livestock show in Pittsfield, a show put on for the benefit of the common farmers of the area. During that event, Watson and other husbandmen decided they should form a permanent county agricultural society, and a year later, in August of 1811, the Berkshire Agricultural Society for the Promotion of Agriculture and Manufactures had its first meeting. Elkanah Watson was elected president.

Then, on the last Tuesday and Wednesday of September 1811, the new society sponsored what most scholars consider the first modern agricultural fair in the United States. And while it differs in a few respects from modern county agricultural fairs, that first event, carefully shaped by Watson's ideas, set a pattern for fairs that persists today. Modern fairgoers, if transported to Pittsfield in 1811, would recognize many elements of this new kind of fair.

The event, which Watson called a Cattle Show (the term *fair* would be applied in years to come), opened on September 24, and by all accounts the sun rose on a beautiful New England autumn day. Fairgoers and exhibitors funneled toward the village square on foot, on horses, and in wheeled conveyances, driving cattle and sheep and hauling the occasional "mechanical invention." Watson estimated the crowd at three or four thousand, a substantial gathering for this village in the hills. The Berkshire society had built an enclosure for livestock on the square. A number of "booths for the sale of refreshments and Yankee notions had sprung up like mushrooms," according to a local history. The society had approved the inclusion of "innocent amusements," and on the south side of the square next to

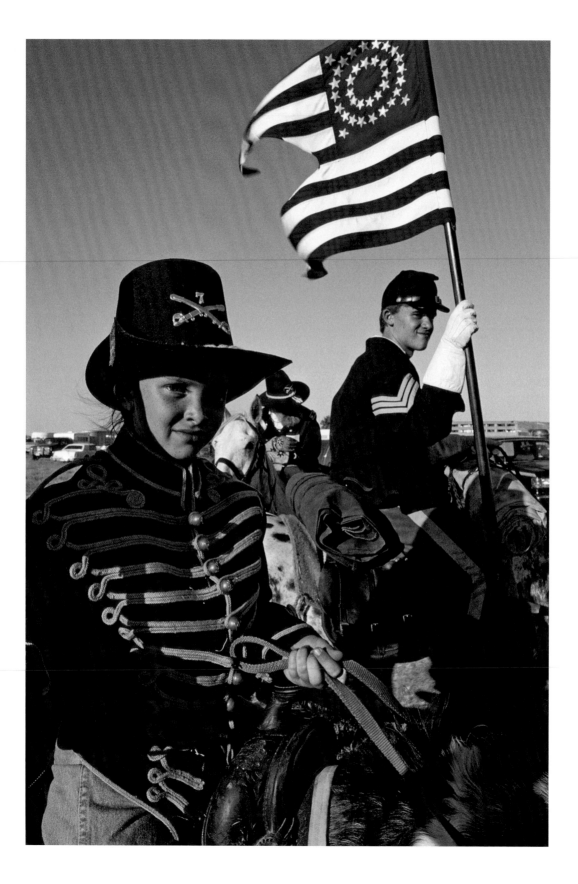

Captain Pepoon's tavern, an operator had set up a primitive amusement ride called an aerial phaeton, or fandango.

At eleven that morning, fairgoers gathered in the village church to hear Watson's opening address. The crowd was likely surprised to see Watson falter at the podium. He wrote later, "It was with infinite difficulty I could command my nerves, to commence and proceed in my address." Watson claims that his nervousness was the result of this being his first-ever public speech, which is surprising for so public a man as Watson. A more likely cause was the deepening political rift that divided the nation and probably separated Watson from many in his audience. While all who gathered here would have agreed about the need for agricultural improvement, the arguments about a second war with England raged loud in these days. Watson strongly supported going to war to end England's domination of trade, while most of those in the gallery opposed it. A great tension must have filled the room, but if there was hostility in the crowd, Watson ignores it in his writings.

With effort he gained control of his voice and began by telling those assembled that he was unsure he was the right man for the job: "Having spent the greater part of my life in cities—with the exception of the last four years—it would have been more proper to have placed a more experienced farmer at the head of an institution which promises such important benefits to the community at large." But he'd do his best, he told them. "I will endeavor to make good by my zeal and exertions, what I am deficient in experience, in the honorable profession of a farmer."

He spoke of the poor state of agriculture in Berkshire County, comparing it to the advanced practices of England and the rest of Europe. He talked of soil exhaustion; of better breeds of cattle and swine; of new strains of wheat, potatoes, and rye; and of his intention to help farmers of the county plant madder, used to make dye. And, of course, he promoted Merino sheep for their superior fine wool and predicted great growth in local woolen manufacturing such that "the future wealth and respectability of the County of Berkshire will be built on that substantial foundation."

Finally, knowing he could not avoid it, he turned to the deepening divisions about war, referring to it as the "party" problem: "Although the spirit of party has found its way into every other public object in this country, I can solemnly declare, no shade of its deadly poison has as yet, to my knowledge, entered into this institution. . . . Let us . . . one and all, for the honor and happiness of ourselves and our country, cultivate a more liberal spirit of political charity towards each other, and leave every man responsible only to his God and the laws of the land. . . . Let us then, with one voice and one heart, join hand in hand, on this auspicious day, like a band of affectionate American brothers, intent only on the welfare and happiness of our common country."

The *Sun* of Pittsfield called it "a judicious and well-timed Address" and reported that it met with "unanimous approbation." The war would come, but for the moment the divide between patriots and loyalists was bridged by the common need for better farms, crops, and animals.

After the speech the Berkshire Agricultural Society awarded twelve premiums worth a total of seventy dollars for the best oxen, cattle, swine, and sheep, and by noon the crowd filed out into the public square to form a procession—likely the first county fair parade in history.

Like any good parade, it was led by a brass band, in this case the Pittsfield Band. Next came sixty yoked oxen connected by chains and pulling a ceremonial plow guided by the two oldest farmers of Pittsfield. What splendid symbols! Sixty oxen, the great beasts that helped clear the forests of New England and pulled the colonial plows, passing before the crowd made clear the great power of agriculture in Pittsfield. And the old men, who had first settled in the area fifty-nine years earlier and had fought in the French and Indian War, instantly tied this fair parade to already deep American agricultural traditions.

Next came the farmers of the county, followed by a wagon-mounted spinning jenny with forty spindles, in full operation and tended by workmen as it rumbled by. Then a proud display of the products of the county: great rolls of cloth, muskets, leather, anchors, all with the flags of the United States and the Commonwealth of Massachusetts flying above them. There were marshals on gray horses, pomp, color, and patriotic appeal. Last came the officers and members of the Berkshire Agricultural Society, their hats decked out with heads of ripened wheat as a proud symbol of the new society and its premier event.

It must have been a grand event in this Massachusetts village under the clouds of threatening war. Some said it was the biggest crowd ever assembled in Pittsfield. It was an appeal to citizens, whether for or against war with England, and it may well have been the first time anybody stood by the road to applaud the common farmer as he

(left) Krystee Heimbuch awaits her moment to ride across the arena in the Grand Entry for the rodeo at the Dawson County Fair, Glendive, Montana. Throughout the history of the fair, grand entries and parades filled with Indians, pioneers, farmers, soldiers, and cowboys have helped reinforce our notions of who we are.

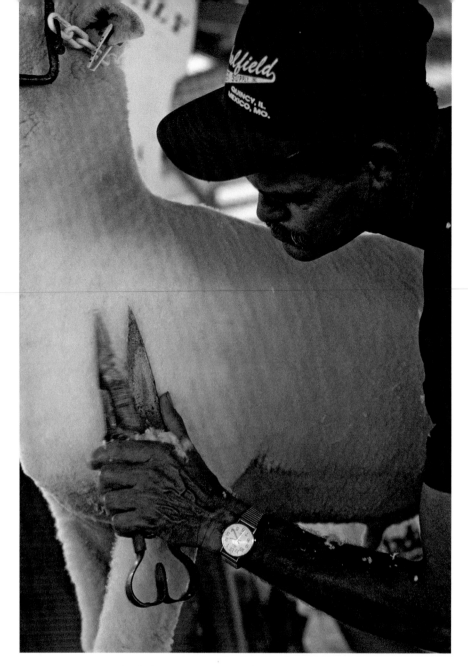

In an activity that harkens to the very birth of the agricultural fair, Stanley Jesse fits his ram prior to competition at the Boone County Fair, Columbia, Missouri.

success, the society decided it should be an annual event.

By the next year the Berkshire society had realized that the participation of women was essential to long-term success, and at the 1812 fair the directors announced a special cloth show to be held in January 1813 for the interests of the women. This effort was tied in part to the then-common preindustrial practice of spinning wool and weaving cloth at home—a key component of "domestic" manufacturing—and Watson must have understood that the farmer was much more likely to get involved in the work of the society if there was something in it for both him and his wife, thus doubling participation. The Berkshire society announced it would award "several valuable premiums of silver plate" for domestic manufacturing of such things as woolens and linens. As advertised, in January the society prepared the hall and displayed the entries. As the hour of the premium awards neared, the hall was devoid of women to claim them, and Watson grew nervous. They had entered their cloth, but possibly the mores of the era prevented their attendance or, as Watson suggests, fear of ridicule for being involved in this bright new thing that might fail miserably. As the time drew nigh, Watson grew distraught. In his memoirs he writes: "I left the Hall, and with no small difficulty prevailed on my good wife to accompany me to the house of exhibition. I then dispatched messengers to the ladies of the village, announcing that she waited for them at the Cloth Show.

passed. Watson certainly understood what was at stake and what he must do to create cooperation in divided times. This parade, the forerunner of every fair parade since, had the effect of any successful ritual in that it bound the participants in a shared experience that imparted importance and dignity to the cause, the larger event. Wrote Watson later, "It was splendid, novel, and imposing, beyond any thing of the kind, ever exhibited in America." With such

They poured out:—the farmers' wives and daughters, who were secretly watching the movements of the waters, also issued forth,—and the Hall was speedily filled with female spectators and candidates for premiums. This was one of the most grateful moments of my life."

For the next fair, in October 1813, the women's cloth show was incorporated into regular fair events. According to Watson, "Since that period, the females have

taken a conspicuous lead in promoting domestic manufactures; they have also added to the popularity of the society."

Watson's "Berkshire model" for agricultural societies and fairs is simple and, like so many innovations, is not so much the product of a bolt of fresh inspiration as it is a new recipe made from mostly familiar ingredients in a new combination, ingredients tried with less success elsewhere. Colonial market fairs, the Washington, D.C., fairs, and the sheep shearings are prototypes for Watson's fair; he was familiar with them, and he was likely influenced by them.

Two new ingredients in the mix for success were his notions that agricultural societies and fairs should be for the education of ordinary tillers of the soil and that they should be social events. Membership in the Berkshire Agricultural Society was open to any man who was not "notoriously intemperate" and who paid the dollar per year dues. Watson writes, if a bit floridly, about his ideal: "the merry peals of numerous bells . . . the farmers' flags waving in triumph on the hill tops, and in the valleys,—the exhilarating music,—and above all the gladdened countenances of vast collections of people, were proud demonstrations of the respect in which agriculture is held, in thus celebrating the *farmer's holiday*."

The average New England farmer of Watson's day lived in an isolation that would surprise a Nevada rancher today, and exhibitions on the Berkshire model provided ample opportunity for social interactions among people with considerable shared interest. Watson's background with sheep had earlier taken him to sheep shearings in the United States where he observed wool shearing contests and, more importantly, the inherently informal and social nature of these popular events. The participants were gentlemen and ordinary livestock men who gathered to talk sheep, watch the contests, and learn about the latest innovations.

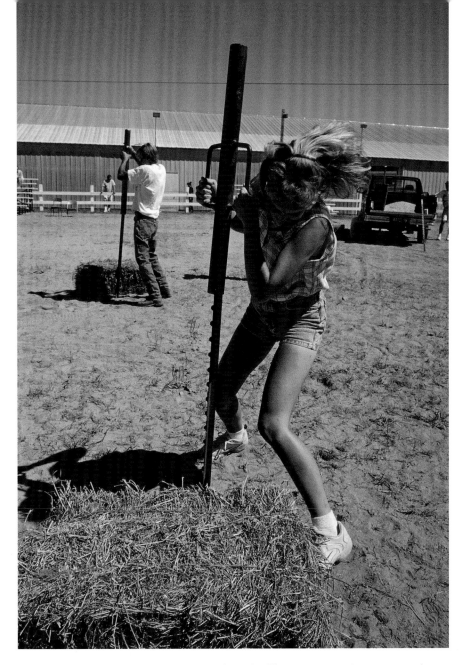

Women's roles at the fair have changed considerably since Watson's time, as seen at the Farmer Super Olympics at the La Crosse Interstate Fair, West Salem, Wisconsin.

No doubt Watson's Berkshire model was shaped by what he'd seen among them.

The awarding of premiums for livestock, crops, and items of domestic manufacture is another key of Watson's model. This idea originates in the earlier learned agricultural societies in the United States and England and their awards for experimental work. For Watson, premiums were an essential tool for education and agricultural

improvement, and he was specific about their nature. They were to be silver plate awards—inscribed bowls, tumblers, tea apparatus—and were to be accompanied by a certificate, suitable for framing. Watson was stern about this. In his instructions for establishing societies and fairs he writes: "If the premiums are paid in cash, it soon disappears, and is forgotten; if in plate, they remain proud family mementoes."

He was also adamant about how premiums were to be awarded. The names of the winners must be kept a "profound secret, or the effect is destroyed." In October 1820, Watson attended the fair in Troy, New York, where he was asked to provide the formal address and then award the fifty-five premiums. In a ceremony of solemnity hard to imagine today, all gathered in the church at midday and heard Watson's two-hour-long speech. Evidently he was no longer bothered by stage fright. Done at last, he began working his way through the premiums, one by one, announcing them slowly and distinctly for effect, calling on committee chairmen to report in each area as he went along. All the while at his elbow stood the church pastor sternly checking each one off the list. As each name was read, the awardee stood up in the church, and two marshals approached him or her bearing the premium and certificate and handed them over with considerable ceremony. Though it must have taken all afternoon, Watson reports the anticipation was palpable.

If handled with a sense of drama, the awarding of premiums always produced a great effect, according to Watson. "Our constant aim was not only to excite an ardent spirit of emulation among the candidates for premiums; but to impress the minds of the audience, and produce some tincture of envy, so as to call forth more extended efforts."

Far in the past, but still antecedent to his agricultural exhibitions, were the great commercial and livestock fairs of Europe, venerable institutions that extended back further than anyone could discern, great events where people bought and sold goods and animals, ate and drank, saw acquaintances from afar, got the news, were entertained, and went home already anticipating next year's event. Watson was well versed in the history and workings of these fairs, had attended cloth fairs in Leeds and Halifax, and as a businessman certainly understood their importance to commerce. But from the start the Berkshire model was not a commercial model; certainly some livestock changed hands, and from the start the fairs encouraged vendors of many sorts, but they were not market fairs. Social intercourse, informal education, and a resulting agricultural improvement were Watson's goals; America had other venues for agricultural commerce.

Like any good plan, the model evolved in the years after the first fair in 1811. Existing features grew more elaborate and new ones were added. Few were dropped as unsuccessful. The second Berkshire fair, held in 1812, featured a much larger premium list, which increased competition and participation, and an opening prayer. Hoping to encourage greater participation by what Watson referred to as "the graver class of the community," he inveigled a reluctant minister to offer a prayer prior to the main address and premium awards. Watson writes that it was "an animated, pastoral prayer, which was, probably, the first that was ever made on a similar occasion." By the third fair in 1813, the premium list had grown to sixty-three awards for agricultural products, domestic manufacture, and livestock, and the society had added a formal ball as the closing event. It was well attended: "The officers of the society, and many respectable visitors, attended to give countenance to the measure. This was a proud day for Berkshire. Our country being now in the midst of war, the measures of our society had already so extended domestic manufactures, as to afford large supplies of clothing for our armies."

In his writings of 1819 and 1820, Watson laid out his model in detail for those interested in starting their own societies and launching fairs. He was specific, if a bit dogmatic.

First, the fair must be held for no less than two days. It takes the morning of the first day just to get the livestock to town and penned up. More important, a one-day fair has no momentum. "The public mind is left in a vacuum," according to Watson. While it would be some years before most fairs would have permanent grounds, Watson was emphatic about their acquisition. He suggested that local residents might donate two or three acres for this purpose, preferably on a hilltop, certainly for visibility, perhaps for drainage. Watson advocated the construction of "neat permanent pens" for livestock on the fairgrounds and the use of nearby appropriate halls for the display of domestic manufacturing, implements of husbandry, and agricultural products. He provided an octagonal plan for eight pens, each pen being a wedge-shaped piece of the whole, and an elevated platform—"seven feet high," writes Watson—for a band in the center of the octagon, an American flag waving above. A church was to be used for the main events, including prayers, odes, and the awarding of premiums.

At dawn the first day of the fair "let flags be displayed, and a merry peal rung, to rouse the dormant energies of the community." At precisely 10 a.m. the society should meet and select judges to be added to the standing committees—out-of-town judges, if possible, to minimize

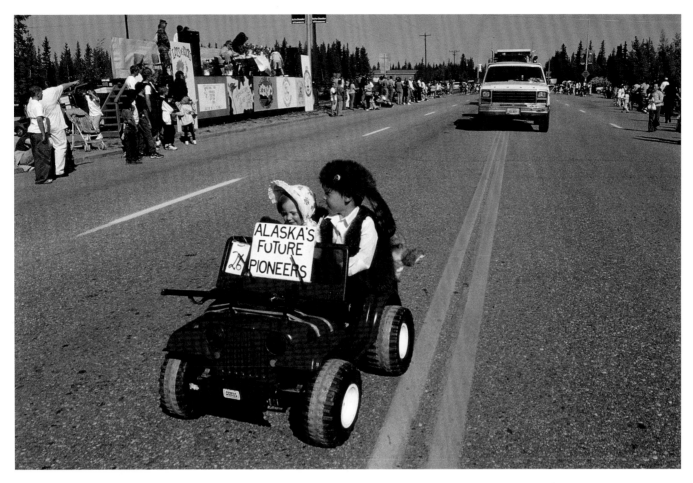

The image of the pioneer endures in updated form in the Deltana Fair parade, Delta Junction, Alaska.

bias. From that time on the secretary of the society should be available to accept membership dues of one dollar per year. Noon should be the deadline for all entries, and at that time the exhibit areas are to close and judging shall begin. "At 4 o'clock . . . ploughing matches should be started in great style. This, and viewing the products of agriculture—the animals—manufactures—implements of husbandry, &c., and the duties of the several committees . . . will completely consume the first day."

The second day should begin with a procession that includes members of the society carrying flags bearing emblems of agriculture and manufacturing, a band, honorable members of the community, including clergy, and a plow. The parade is to end at the church where the central events of the exhibition are to take place. The program, according to Watson:

1. Ode
2. Prayer
3. President's Address
4. Second Ode
5. Secretary, or a Vice-President, to proclaim premiums
6. Music.

And the arrangement of the church was of great importance as well. "A stage being erected in front of the pulpit . . . covered with a decent carpet. Place on the middle of this stage, a half round table, covered with green cloth, on which let your glittering articles of premium be displayed to the best advantage."

Elkanah Watson even gave thought to accommodating farmers from the hinterlands. He suggests that local

agriculturalists ought to open their homes to farmers from farther afield—and the agricultural society should arrange that they be fed: "As farmers are or ought to be great economists—the committee should contract for a plain homespun dinner—not to exceed fifty cents each—no wine or liquor, except beer or cider." Such home stays would increase the exchange of information and decrease the isolation of farmers.

While Watson was apparently not a teetotaler, he emphatically opposed hard liquor. Section 17 of his example bylaws states in part: "As the dreadful vice of intemperance is extending in a manner disgraceful to the nation, it shall be made the duty of the members of this society, individually, both by precept and example, to discountenance this pernicious practice, by all the means in their power." In the same breath, however, he goes on to promote the increase "of orchards, the culture of barley, and the use of malt liquors."

For Watson's curious mind there were endless topics that an agricultural fair might address, endless questions that the experience of ordinary farmers might help answer. What times are the best for seeding of winter and summer grains? How much seed per acre? What soils require thick or thin seeding? He wanted to know about the durability of fruit trees, the best layout of a farmstead, new grass species, the best way to feed livestock, use of manures, proportions of timberland, the most profitable management of dairy cattle, and "any new implements of husbandry." But for Watson, more than anything else, the fair was to be something farmers wanted to attend. "It is all important the first exhibition should be as interesting as possible. It will give confidence, and respect to the society; thus inducing respectable farmers generally to become members."

In September 1818, Watson, nearly done with his work creating agricultural societies and fairs, attended the fair in Jefferson County, New York, and waxed about an ideal fair opening event. His satisfaction and pride are evident, and his hyperbole foreshadows all the florid fair promotion ever since: "Nothing could exceed the effect which was produced at their distinguished exhibition in September last. The Governor, the gentlemen making the agricultural tour with him, the officers of the society, and a fine band of music, were on the stage elevated about seven feet, placed in the centre of the pens; the national flag was flying over their heads, and all the animals in full view. At a little distance, were in readiness, several ploughing matches; at a signal given, the ploughs were started—the band of music struck up '*yankee doodle*,'—and an immense crowd of spectators were highly animated by the novelty, and splendor of this scene—they rent the air with acclamations of joy."

As for the Merino sheep that had started all this fuss, Watson ruefully notes in his memoirs that early in the Merino craze he had bought a buck for $375, at the peak of the fever repeatedly refused $1,000 for it, only to sell it later when Merinos had become common in the country for a mere $12.

Of all the things Elkanah Watson accomplished in his life, he was most proud of his work on behalf of agriculture. He died at age eighty-five in Port Kent, New York. His epitaph reads: "Here lie the remains of Elkanah Watson, the founder and first president of the Berkshire Agricultural Society. May generations yet unborn learn by his example to love their country."

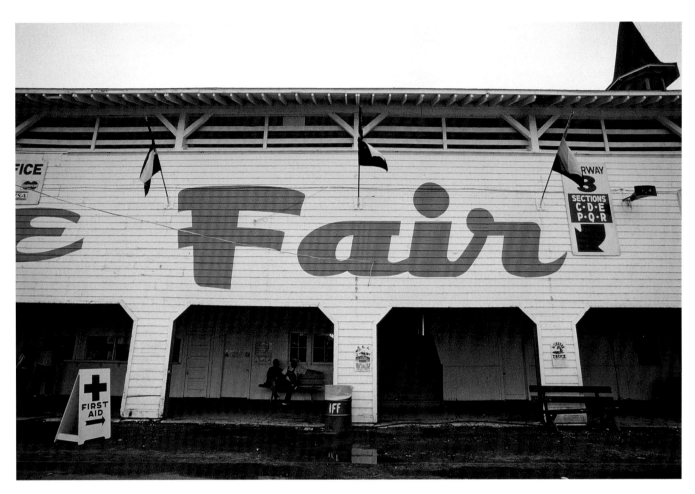

Ionia Free Fair, Michigan.

4. Rural Felicity

REMARKABLY, THE AGRICULTURAL FAIR that Elkanah Watson created has changed little in essential pattern despite almost two hundred years of agricultural modernization, continual revolutions in rural life, and wind shifts in national character that would flabbergast even so forward a thinker as he. That the fair would persist at all in the face of a forty-fold increase in population and a profound reversal of rural versus urban population is a testament to the suitability of the agricultural fair and its role in the traditions of American life.

By 1820 agricultural societies fashioned on Watson's Berkshire model had been organized by citizens in all New England states except Rhode Island, and the idea had spread as far south as the Carolinas and as far west as Illinois. Farmers were beginning to embrace the idea of agricultural improvement in hopes of raising their standard of living—and that of the nation. While societies sponsored dinners and other events, from the very first their main task was to put on an annual fair, a sometimes difficult task for many of them. Local interest on the part of farmers was one problem. Farm markets were still uncertain and transportation difficult, meaning better yields might not mean better income. Why improve the breed of swine if the pork goes no farther than a farmer's own table? A larger problem for agricultural societies was money, which was then—and still is—a key variable in the equation of the fair. At issue was state support for societies and fairs. As strapped state governments cancelled their funds for agricultural societies and their fairs, societies withered. A number maintained their activities and sponsored growing fairs, but most languished as farmers stayed home to put food on their own tables. So despite their early popularity, by 1835 most of the agricultural societies formed in the first flush of Watson's enthusiastic efforts had slipped into inactivity or had disappeared altogether.

The rebirth in societies and their fairs came from several factors beginning about 1840. Perhaps first was the accelerating wholesale move of agricultural people out of the Northeast and Atlantic Seaboard into the new and richer lands of the trans-Appalachian frontier. Leaving their exhausted soil and rock-clogged fields for the promising lands from Ohio to Minnesota—and a bit later, Oregon and California—these settlers took with them plows, animals, and the seedling idea for agricultural societies and agricultural fairs on Watson's model. The broad, cleared lands from Kentucky to the rolling hills of Missouri were soon dotted with robust farms, and it wasn't long before the Midwest saw agricultural fairs appearing in newly minted counties.

Increased state support was also an important factor. With improving economic conditions after 1840, state governments, earlier convinced of the value of agricultural societies and fairs, began to provide modest funding toward premiums and operating expenses. Fairs then, like fairs today, often operated on a thin margin of profit, making even meager state support important to survival.

By this time the mechanical and domestic industry portions of fairs had begun to wane in the face of growing industrialism in the nation. Wool spinning and weaving were shifting over to expanding mills, and the improvement and manufacture of windmills, firearms, and all the new things of the nineteenth century were given over to smoky factories.

Also significant was the fact that by the 1840s America was becoming more urban, which invigorated cash markets for food and other agricultural products. For example, in 1790, a scant 5 percent of Americans resided in towns or cities larger than twenty-five hundred people; by 1860 nearly 20 percent of Americans were urban dwellers. As a result, demand for food from the farming regions increased as more efficient transportation systems arose to carry those farm products to the cities. By 1850, even as the canal era was closing, steamboat trade on the inland rivers was at a peak, and the railroads were quickly establishing supremacy. New markets and cheaper transportation spurred the farm economy and in turn accelerated a revolution in crops, livestock breeds, agricultural practices, and especially agricultural implements. What better place than at the fair could the farmer see the new Shorthorn cattle, McCormick's new reaper, and John Deere's new steel plow?

Watson's fair model proved especially well suited to the needs of families on the farming frontier. For these isolated people, agricultural societies and fairs helped meet the need for social contact as well as for new information about agricultural practices, crops, livestock, and machinery. By 1858 agriculturists from Maine to the new state of California had formed county and state agricultural and

The local band strikes a jaunty pose in this early stereo photo from the 1875 Vernon County Fair, Viroqua, Wisconsin. Bands were an important draw for early fairs but waned with the advent of recorded music in the twentieth century. The new building in the background was likely the first permanent structure on the fairgrounds. In this early year, stumps dotted the fairgrounds, and most events were conducted in tents.

Courtesy Vernon County Historical Society

Remarkably, the Vernon County Fair still sports a band. This informal community band belts out favorites between heats at the harness races.

horticultural societies, but in Ohio, Indiana, Illinois, Wisconsin, Minnesota, Iowa, and Michigan the doughty farmers had beat all by getting into the agricultural society business right after digging the well and roofing the cabin. While these states had but 28 percent of the nation's population, they boasted 49 percent of the agricultural societies.

Especially in the Midwest, farm families from back east worked to create something familiar in a new place. They built towns with familiar architecture, named them for places back home, planted trees where there were none, and spawned fairs just like Watson's.

The growth continued across the nation. In 1858 the U.S. government listed 912 agricultural societies; ten years later the list had grown to 1,367. This period from about 1850 to 1870 was what historians call the golden age of the agricultural fair.

It was the golden age not just because of the mani-

fold expansion of agricultural societies and fairs, but because in this era before experimental farms, agricultural colleges, and farmers' mobility in the form of the automobile, fairs provided the greatest share of new agricultural ideas and education and the best social event for growers across the country. To improve their practices, farmers and ranchers of the era had to rely on trial and error, intuition, neighbors' advice—and the fair. And according to fair historian Wayne Neely, "Christmas, the Fourth of July and the county fair, varied by the occasional picnic or circus, long remained the traditional holidays of rural America."

Walworth County, Wisconsin, provides an example. By 1859 the county agricultural society was putting on a rip-roaring fair, an event likely better developed than most other fairs in this eleven-year-old state. The railroad offered half-price transportation to the grounds, and, if contemporary newspaper accounts are any indication, fairgoers

enjoyed themselves. There were military bands, Morgan horses, new farm wagons, sewing machines, both long and fine wooled sheep, and plenty of speeches by candidates for office. A Mr. Preston, president of the county agricultural society, gave a speech about the history of their fair. Though the Walworth County Fair was only nine years old, there is no reason to think it was a short lecture. Among cattle were Shorthorns, Durhams, Devons, crossbreeds, and native stock. No doubt to great local satisfaction—and perhaps to no one's surprise—the local Elkhorn Coronet Band took the twenty-dollar premium for best band in the county. No one went hungry owing to dining halls and tents sponsored by the Congregationalists, Methodists, Universalists, and Episcopalians. There were exhibit classes for flowers, vegetables, and fruit and a display of "female equestrianship." Most likely the big happening of the fair was the ten-dollar "shake up" purse race lost by trotters Columbus and Honesty and won by Roan Tiger with a time of three minutes and six seconds. And at the end of it all, the Walworth County Agricultural Society paid its bills and happily banked $686 to grubstake next year's fair.

Along Watson's model, most county fairs of the time were two-day events in the fall, usually held on permanent but undeveloped grounds just outside the county seat. Especially west of the Appalachians, the few permanent buildings were supplemented by tents, outdoor pens, and other temporary structures. In these days before paving, whatever the conditions of the fairgrounds otherwise, the fair came in two flavors: muddy or dusty. By the time of the Civil War, most fairgrounds were enclosed by a fence that allowed the sponsoring society to charge an admission fee, an important source of income for fairs by this time. Perhaps the racetrack and stables held one side of the grounds, the exhibit tents and livestock pens the other. Before the Civil War, sideshows and games of chance had been kept outside the gates where these camp followers of sorts did a fine business in cheap amusements and geegaws. After the war, the camel's nose of the carnival began to push under the perimeter fence, aided in no small part by the discovery by fair operators that they could make money by charging vendors and sideshow men for space inside and collecting a portion of the take.

The Civil War temporarily dimmed the activities of agricultural societies across the country and all but extinguished them for societies in the hungry South. Agricultural fairs had had a foothold below the Mason-Dixon line before the hostilities; after Appomattox, they recovered only a little, likely owing to wartime and postwar economic devastation, and perhaps to increased hostility to northern ideas during Reconstruction. The postwar period saw fairs reinvigorated in the Northeast and the Midwest, with the growing farm states from Ohio to Iowa solidifying their reputation as the nation's most "fair-minded" states. Farther west, fairs began to appear along the Pacific Coast and in Utah, where Mormon agriculturalists, many originally from the Northeast, established societies and fairs of a pattern they knew well.

In the postbellum years, the county fair became defined by three primary components: educational exhibits, horse racing, and the carnival. According to geographer Fred Kniffen, each of these elements has a discrete history, but they merge to become inseparable and key components of the fully fledged county fair for the next hundred years. Then, as now, many smaller fairs lacked a horse track and had but few carnival attractions, but the prototype, the personality, of fairs nationwide was nevertheless set. This trinity was to define the county fair until the latter half of the twentieth century when the importance of horse racing began to wane.

But these three components have not always worked well together. From the time of the first call-to-post or the first shell game at an agricultural fair, the inclusion of horse racing and the carnival has divided fairgoers, fair boards, and local communities and sparked philosophical debates about the nature of the fair. It should be purely educational, say the idealists. The fair is no place for gambling on horses and unseemly entertainment, say the moralists. Perhaps, says the fair board, but we have to make enough money to paint and open the gates next year. Meanwhile, fairgoers packed the grandstand with race programs in hand and lined up five deep for the patent medicine show.

Perhaps the best sense of a county fair in the 1870s, especially in the growing agricultural Midwest, comes from author Hamlin Garland, who paints a picture of the early Cedar Valley Fair (now defunct) in Iowa circa 1871 in his memoir *Son of the Middle Border*, and of a remarkably

> "We are spending the week here. Band's playing and crowd's rushing."
>
> —*1906 postcard from the Fond du Lac County (Wisconsin) Fair*
>
> •

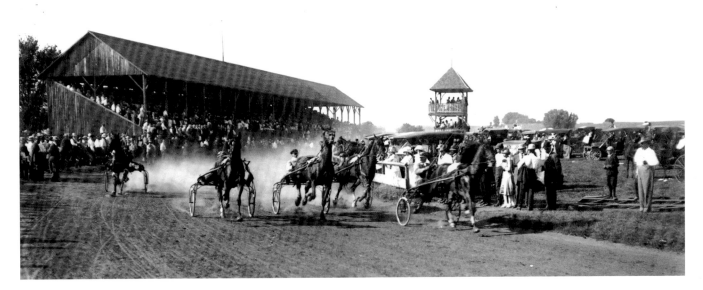

In this classic 1912 photograph from the Dewitt Fair, in Clinton County, Iowa, the ponies are still bunched as they round the first turn, and specta-tors press close to see how their favorite is running.　　Photograph by Fred Kent, courtesy Fred W. Kent Collection, State Historical Society of Iowa–Iowa City

similar fair in his fictional *Boy Life on the Prairie*. Both accounts focus on the experiences of preteen boys and emphasize their awe at myriad novelties, the excitement of a horse race, and youthful infatuations.

"It came late in September and always lasted three days," writes Garland in *Son of the Middle Border*. "We all went on the second day (which was considered the best day), and mother, by cooking all the afternoon before our outing, provided us a dinner of cold chicken and cake and pie which we ate while sitting on the grass beside our wagon just off the race-track while the horses munched hay and oats from the box."

In *Boy Life on the Prairie*, protagonist Lincoln and his younger brother Owen, both farm boys to the finish, arrive at a fair clearly based on Garland's boyhood Cedar Valley Fair. After paying their twenty-five-cents admission, they ride their horses into this magic world in a state of great anticipation: "While the people were pouring in at the gates, the boys rode slowly round the grounds to see what was displayed; on past fat sheep and blooded stal-lions and prize cows and Poland-China pigs; on past new-fangled sulky ploughs, 'Vibrator' threshing-machines, and so on. The stock didn't interest them so much as the whirligig and the candy-puller, and the man who twisted copper wire into 'Mamie' and 'Arthur' for 'the small sum of twenty-five cents, or a quarter of a dollar.'"

Even as an older man Garland vividly recalls in his memoir how as an Iowa boy he was transfixed by Doctor Lightner's "magic oil" wagon, his assistants, and their musical sales pitch, and especially by the younger assis-tant, a sad and beautiful girl who sang and played guitar. Garland stopped to listen to these three smartly dressed, exotic travelers. Between songs the good doctor extolled the virtues of his patent medicine, and Garland's eyes fell on the girl who sat listlessly with the guitar in her lap star-ing at nothing until the next number began. But when she arose to sing, her voice was a "childishly sweet soprano" that mingled with the other voices "like a thread of silver in a skein of brass. I forgot my dusty clothes, my rough shoes,—I forgot that I was a boy," writes Garland. "Absorbed and dreaming I listened to these strange new songs and studied the singular faces of these alien song-sters." Who was this girl, he wondered? Why was she here? He had never seen this kind of sad allure.

Certainly he was struck by the girl and her melan-choly countenance, but not by her lyrics. He recalls them thus:

They're hangin' men and women now
For singing songs like this
In the little old log cabin in the lane.

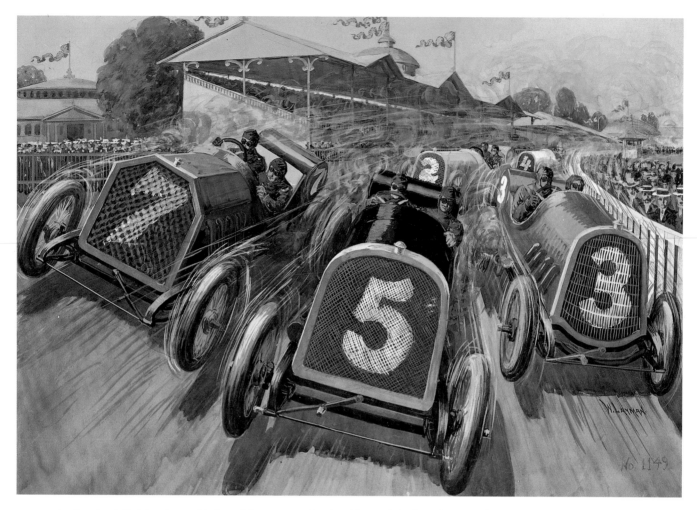

Another classic first-turn image, this time of the auto races that drew big crowds in the early twentieth century and so thoroughly displaced horse racing at most fairs across the nation. This artwork was done by W. Layman, artist with the Fair Publishing House in Norwalk, Ohio, in 1912.

Courtesy The Fair Publishing House, Inc. Collection, Michigan State University Museum

Nevertheless, to his "sensitive, farm-bred brain," this was art that opened windows to a larger world he'd not yet seen. "The large, white, graceful hand of the doctor sweeping the strings, the clear ringing shout of the tenor and the chiming, bird-like voice of the girl lent to the absurd words of this ballad a singular dignity. They made all other persons and events of the day of no account."

Though the experience had been forty years earlier, and the doctor, by the time of Garland's writing, had likely gone on to his great reward, and the girl, by then probably a woman of sixty-five, in his mind they would always be young, beautiful, and full of grace.

The varied crowd on the grounds always caught Garland's attention, and some he observed likely became char-

acters in his fiction. The young Garland met up with his friends and noticed a strange new air to the girls he'd known so long, a haughtiness apparently brought on by the special event and their new dresses that made them aloof, foreign.

Meanwhile, Garland's Lincoln and Owen, chafing in new, ill-fitting suits and homegrown haircuts, share a banana—the first one they've ever seen—fend off the town bully, listen to a smooth-talking salesman of collar buttons and lamp chimney wipers, and get a look at the new Norman breed of horses. Then, at the last minute, Owen discovers himself a substitute rider in a spirited race of local fast horses. The owner of a fleet mare named Gypsy has discovered that his intended rider is too light and, with

Owen's father's permission, recruits Owen to ride. The owner says to him, "You needn't be afraid. When once she's off, 'Gyp' is perfectly safe."

"I don't think he's afraid," remarks Owen's father. "You tell him what you want him to do, and he'll do it."

In the world of late nineteenth-century fiction, earnest boys triumph before enthusiastic hometown crowds, and Owen is no different, winning the second of two heats after beating out the town bully who tried to cut him off on the backstretch. Gypsy's delighted owner puts five dollars in Owen's hand and tells him, "I'll give you ten dollars to ride Gypsy at Independence."

But Owen's parents intervene. "No, this ends it. We don't want him to do any more of this kind of work."

Evening was nigh, and much too soon for young boys—or girls or adults, for that matter—their one-day holiday was finished, and "in a continuous stream the farmwagons passed out of the gate, to diverge like the lines of a spider's web, rolling on in the cool, red sunset, on through the dusk, on under the luminous half-moon, till silent houses in every part of the country bloomed with light and stirred with the bustle of home-comers from a day's vacation at the Fair."

With uncommon perspective, Garland sums up his fair—and perhaps every fair on the frontier—in *Boy Life on the Prairie*: "The country was new, and the show was not great, but it called the people together, and that was something."

Owen's parents reflect the era's common moral ambivalence about horse racing. A terrible sin to some because it encouraged gambling and engendered cheating, a great pleasure to many others because it lent real excitement to the farmers' holiday, and most important of all, a great attendance booster and cash cow for fair boards, horse racing has probably caused more controversy than any other fair topic, more, even, than alcohol or the carnival. Of course, horse racing had been part of many fairs since well before the Civil War, and it had long had a practical agricultural function. In the days when horses provided the only means of travel in rural reaches of the nation, their speed and endurance were important, and horse racing clearly helped breeders select superior animals.

The irony of the 1859 Walworth County, Wisconsin, fair featuring a race that included a trotter named Honesty was probably not lost on fairgoers who knew that cheating and rigged races were not rare in the era. As fairs developed, and the sport of horse racing grew more serious, the stakes rose, the temptation for chicanery increased, and the debate grew more shrill. In Ohio at about the same

time Honesty ran for the Walworth purse, one wag remarked that those who complained most about horse racing were those whose horses were too slow to win. In Iowa, the state agricultural society reported that "the trotting horse pays his way, and is almost the only thing that does. . . . It is a fact that thousands come, pay their fee, and go straight to the amphitheater to see the trots, without whose fees premiums could not be paid to other classes."

As the stakes in horse racing grew, fair boards worked hard, sometimes quite awkwardly, to keep the undesirable professional elements out and to keep local, supposedly less-corruptible local riders and animals in. In Michigan, at least one agricultural society limited racing entries to horses "not used for sporting purposes," another to horses "not trained upon a track." Determination of these attributes seems difficult at best.

Others suggested that horse races ought be avoided altogether and replaced with alternate equestrian competitions. J. F. Laning, in his 1881 book *How to Manage Agricultural Fairs*, suggested such crowd pleasers as contests for "Fast Walking Horses, Well Broken Horses, Graceful and Easy Riding Horses." Meanwhile, fairgoers headed over to the next county where the fair held regular "hoss trots" as usual.

The last third of the nineteenth century was a time of great advancement in agricultural practices, and the fair continued to play a central role in bringing the new ideas to farmers. But increasingly the fair had help in that realm. Two important events occurred in 1862: passage of the Morrill Act, which allowed for the creation of land grant colleges, and the establishment of the U.S. Department of Agriculture. With these steps, agricultural research and education would soon become more rigorous.

Agriculture was becoming more specialized as well, and many organizations—some that would be permanent parts of the fair and others that would sponsor their own fairlike events—formed from about 1865 on. According to historian Neely, wool growers, dairymen, and poultry raisers formed their own groups, and horticultural societies branched off as well. Between 1870 and 1900 as many as fifty breed associations formed to record pedigrees and promote their own purebred stock. The fair became, according to Neely, "an agency through which a hundred other associations make a popular appeal."

The immediate world of the farmer was changing, and the fair responded accordingly. For one thing, agriculture was rapidly becoming mechanized. While fairs in the early decades of the nineteenth century encouraged the invention and exhibition of laborsaving machinery, fairs in

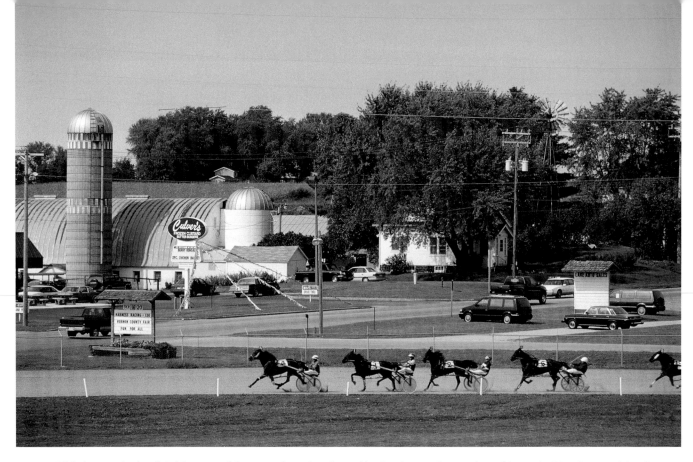

While horse racing has faded from most fairs across the nation, thoroughbred racing remains popular at fairs on the West Coast, and the afternoon harness races always draw a crowd here at the Vernon County Fair in Viroqua, Wisconsin.

the later decades displayed inventions now produced by growing implement companies like McCormick and John Deere. Farmers came to the fair to see the new steel sulky plows and reapers, entrenching a tradition of equipment shopping that continues to this day. Farmers were also becoming more political, forming organizations to redress inequities in markets and transportation costs; the Grange and the Farmers Alliance, among others, stepped up to organize, educate, and socialize agricultural people. Most often, they sponsored booths at the fair to air the issues and sign up members.

The fair also played a significant role in improving the aesthetics of small town and rural life, especially on the frontier where materials and inspiration were in short supply. Fair scholar Julie Avery, who chronicled the arts at several Michigan fairs, writes, "During the last half of the nineteenth century, the county fair was often the only place where citizens in rural and small communities could see a collection of artworks." And what a collection it was. As farm families' spare time grew a bit with the advent of laborsaving machinery, farm women—and men—created

needlework, taxidermy, paintings, locomotive models, quilts, bible stands, musical instruments, and even wreaths made of human hair. As fresh ideas went home with fairgoers, parlors, bedrooms, and kitchens bloomed with new ornament.

Fairgoers' tastes in events were changing, too. Oratory and political speechmaking were falling out of favor, despite the increased political awareness of farmers. Hamlin Garland, by then a well-known writer, returned years later to his old Cedar Valley Fair in Iowa as speaker of the day, and with considerable anticipation passed through the gate of the old fairgrounds on the last day of the horse races. He tells it best: "The event, even to me, was more inspiring in anticipation than in fulfillment, for when I rose to speak in the band-stand the wind was blowing hard, and other and less intellectual attractions were in full tide. My audience remained distressingly small—and calm. I have a dim recollection of howling into the face of the equatorial current certain disconnected sentences concerning my reform theory, and of seeing on the familiar faces of David Babcock, John

Gammons and others of my bronzed and bent old neighbors a mild wonder as to what I was talking about."

What people wanted was more amusement, and that mostly meant the carnival or midway.

Throughout agricultural fair history, most people knew that no matter how instructive the event might be, few came to the fair just to see crops, animals, new machinery, and educational exhibits. Something fun was always necessary to get folks in the gate. But just how much fun? Military bands were one thing, but how about hootchy-kootchy girls? Alcohol? Gambling? In his day Watson had been careful to walk the narrow line when he scheduled "innocent amusements" for his fairs by including vendors, singing, and dancing—but no hard liquor. Every fair manager since has had to balance the need to earn cash against the possibility of offending local standards.

Just how far could fair amusements go? For decades church leaders, purists, temperance societies, and just plain folks who saw rigged carnival games and indecent sideshows railed against the general moral degradation apparent at the fair. At the dedication of the Iowa state fairgrounds in the middle 1880s, speaker J. B. Grinnell made his position clear: "I would bar the gates forever to gamblers, jockeys, whiskey venders, and oleomargarine frauds, and leave reptilian monsters, with acrobats, pigmies and fat women to the showman, Barnum. Then write over your portals, dedicated to art, animal industry and agriculture."

"The Spectator," a columnist in the *Outlook*, attended a county fair someplace in the country in 1910 and reported on the amusements: "An 'old plantation' show, with colored clowns walking the tight-rope, was another Midway feature; and Mademoiselle Somebody had a platform and gave dances more remarkable than beautiful. There was an aeroplane show, and a balloon ascension also. But the most singular feature, and one that drew the largest crowd of agriculturists, was the Australian Snake-Eating Girl. There had been some question about the advisability of this attraction, and the Spectator's cousins had objected in vain. Certainly it drew; yet to pay to go in and look down into a tank where a savage-looking lady in nondescript costume bit into dead snakes, howling mournfully as she did so, was surely a waste of money, even with wheat at a dollar a bushel. Just opposite a flour company served out free all day the most enticing hot griddle-cakes and biscuits—a study in contrasts not planned by the management, but none the less striking for being unpremeditated."

In 1918 John McMahon asked in *Country Gentleman*, "What is the correct mixture of amusements and instructive features in order to make a well-balanced fair? It is easier to get a recipe for Liberty bread. A certain amount of molasses is necessary to catch flies, but if you smear molasses all over intelligent people they get disgusted and go home."

But both Grinnell and McMahon overestimated the tastes of fair crowds. Year after year fair sponsors and operators watched entertainment-starved farmers and bored townsfolk fall in line for two-headed calves, palm readers, bicycle races, and lavish fireworks displays with names like "The Burning of Chicago" and "Last Days of Pompeii." A few fairs even sponsored head-on train wrecks, sometimes to the injury of spectators. And the Australian Snake-Eating Girl must have done all right; she was still around to have the immorality of her act decried in another article eight years later.

Rigged carnival games were a special problem. It's impossible to know how

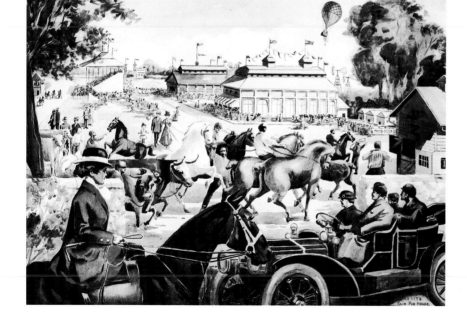

The iconography of the American agricultural fair has been shaped in part by the millions of posters, display cards, rosettes, and ribbons produced by The Fair Publishing House of Norwalk, Ohio. Established in 1880 and still the largest producer of fair-related printing, Fair Publishing created this especially elegant view of the generic American fair about 1910.

Courtesy The Fair Publishing House, Inc. Collection, Michigan State University Museum

prevalent they were, but nothing suggests they were rare. According to the *Orange Judd Farmer* in 1917, "If a farmer's neighbor cheated him out of as much money as some of the gambling devices cheated the fair visitors, they would be enemies for life." There were ample numbers of fair operators and local law enforcement men who looked the other way in exchange for a cut; sometimes the owner of a picked pocket blew up, but mostly fairgoers went along with the idea of throwing their money away on weighted dice, rigged roulette wheels, and sleight-of-hand shell games. Despite suspicions, they still tried to beat the game, and usually kept quiet out of embarrassment when they got fleeced.

Gradually through the last decades of the nineteenth century, and well into the beginning of the twentieth, and despite the ups and downs of the national economy, county fairs worked to stabilize their finances, improve their yearly events, and build permanent buildings on the fairgrounds. Depending on the local attitude toward horse racing, a wooden grandstand along the track might come first, with stables for the trotters and pacers, or an exhibit hall, or sometimes a show arena or livestock barns. Expert judges, rather than local and amateur ones, became more common in livestock judging, reducing claims of unfairness and gradually improving the competition—and probably the livestock. The fair saw new educational opportunities as agricultural college exhibits and farmers' institutes set up shop on the grounds.

And year by year the role of women grew. While they wouldn't show up participating in draft horse pulls or on the fair board until much later, farm and town women expanded home arts, floriculture, wholesome entertainments, and the social events of the fair. The importance of education was never lost on the women as they ran home canning demonstrations, painting classes, and women's riding events and worked hard to keep the unsavory aspects of the fair to a minimum. By the end of the nineteenth century, the nature of agricultural fairs coast to coast was shaped as much by women as by men.

According to geographer Kniffen, by 1912 the nation boasted 1,702 agricultural fairs. As had been the case some sixty years earlier, they were concentrated in the Northeast and Midwest, but had also taken strong hold across the agricultural parts of the remainder of the nation. They had returned and strengthened to some extent in the South, but were still noticeably absent in the dry, nonagricultural parts of the West, including Nevada, Arizona, and New Mexico.

Meanwhile, the debate over horse racing continued unabated into the twentieth century, and much of the antiracing fervor found its voice in the agricultural press, which argued for cleaning up the fairs. Few writers described the evil of horse racing as well as Tom P. Morgan in his tongue-in-cheek reminiscence in a 1919 issue of *Country Gentleman*. In earlier days of the fair, he said, horse racing was an activity incidental to the main work of the event: "We still had the idea that the purpose of the fair was the betterment of the products of the farm through friendly rivalry and so forth. . . . But before we knew it the tail was wagging the dog."

At Morgan's fair, the management built a judges' stand along the track, "and pretty soon it was filled with thick-necked men who didn't take their cigars out of their mouths when they talked and consulted stop watches and viewed the most exciting race without emotion. The grand stand was enlarged a good deal and generally filled to capacity. Bookmakers set up their pedestals, and thin, snaky-eyed young men appeared, giving sure tips on how to bet. Horses came from all over, and one that nobody had bet on would win and just about clean the home folks out of their money."

The practical argument for horse racing disappeared with the arrival of the Model T. Once farmers started coming to the fair—and going almost everyplace else—via automobile, the domestic usefulness of fast horses ended, and supporters of the sport had to admit that folks came to the races because they wanted to see the ponies run. And while horse racing remained popular with fairgoers from coast to coast, auto racing soon began to elbow onto the ever-busy track.

Elkanah Watson would have recognized and understood the American county fair of, say, 1920. The livestock were all there, and the competitive show ring; educational exhibits abounded, as did proud displays of the bounty of the land. The speeches and singing had pretty much disappeared, but there were banners and pennants and glitz galore. The "aerial phaeton" had expanded to include carnival rides and midway mischief. Likely he would have been dismayed at the eager crowds at the racetrack, and appalled by the Australian Snake-Eating Girl. But he would have been very pleased by an important new element of the fair, a new group of people who would bring new energy to the fair throughout the twentieth century and into the twenty-first. By 1920 the county fairs of America were filling up with boys and girls, and their earnest work would reshape fairs forever.

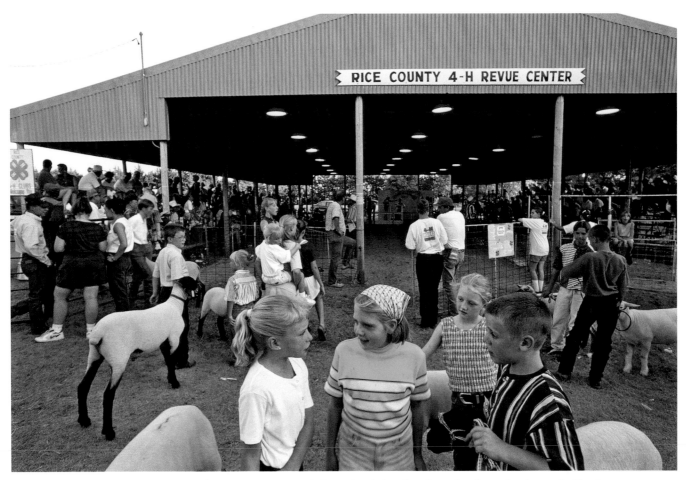

For decades American agricultural fairs have been noisy with the work and play of youth, nowhere better than here at the Rice County 4-H Fair, Lyons, Kansas.

5. From Rickrack to Rockets

When a girl becomes eloquent over cabbages, peanuts, corn, tomatoes, pumpkins or sweet peas, something has been added to that girl's experience.

—Joe S. Trigg, Iowa newspaper editor, 1904

Centralia Corner Kids
Little Brokenstraw
Villenova Vikings
Chrowes Corner 4-H Club
Chautauqua Snowdrifters
Levant Live Wires
Clymer Eager Beavers
Busti Shamrocks
Sherman Kountry Kids
Silver Creek Grape Stompers
Puckrum Pushers

—4-H club names at the Chautauqua County Fair, Dunkirk, New York, a few of the ninety thousand 4-H clubs in America

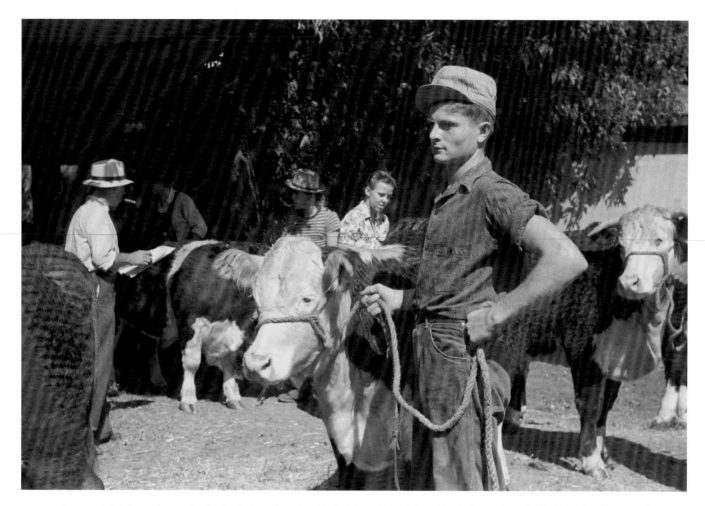

A young 4-H club member awaits the livestock auction at the Central Iowa 4-H Club Fair, Marshalltown, Iowa, in 1939. His heroic pose underscores the importance of youth at America's fairs since the beginning of the twentieth century.

Photograph by Arthur Rothstein, Farm Security Administration, courtesy Library of Congress

KIDS SUFFUSE EVERY PART of every agricultural fair today, except the beer tent and some of the seamier sideshows. Youth are the major competitors, the key market for the carnival, and the primary beneficiaries of the grand sensory experience of fairs across the country. Much of what young people do at the fair—except their carnival fun and just hanging out—comes from club and other group work. The Girl Scouts might set up an exhibit or sponsor a food stand, the horse club will have its yearly contests (most of the participants being teen girls), church youth groups might put on a talent show, and if the FFA is active in the county, its members will participate in livestock competitions in the arena.

By far the biggest youth endeavor at the nation's fairs is 4-H. Since its beginnings in 1902, this organization has

become an essential component of the fair. Today it is at least as important as horse racing was in the nineteenth century. With its agricultural ties and learn-by-doing philosophy of youth development, 4-H has prompted kids to learn with their hands to plant and harvest crops and gardens, feed and train livestock, collect and label bugs, and make construction paper posters and the occasional Popsicle stick fruit bowl. For more than a century members have curried, cultivated, collaged, baked and refinished, photographed, quilted, written about their results, and proudly shown off their work at fairs across the country.

In 1902 an overalled Karl Hertzinger, a member of the precursor Boys' and Girls' Agricultural Experiment Club of Springfield Township, Ohio, posed for a photograph beneath his tall-tasseled corn. His club, among the first of

FROM RICKRACK TO ROCKETS

its kind, analyzed soil acidity on the home places of members and carefully recorded land information about levelness, drainage, and suitability of the soil to grow clover. A hundred years later, Christal Wilmot, a 4-H-er in Furnas County, Nebraska, created a family tree project entitled "Faded Memories of Aunt Lena." Christal lined a wooden shadow box to display her aunt's keepsakes, which included a locket, antique dress gloves, a piece of tatting, and a small cameo photograph of Aunt Lena taken in the early 1900s. Christal explained in the accompanying text: "Aunt Lena was a bit of a free spirit. She and her silver-colored camper traveled over many highways following Ed's death (her second husband). Many hours were spent fishing, quilting and canning."

Throughout its history of getting kids' hands involved and often dirty, 4-H has found its perfect showplace and competition arena at county fairs across the country. The fair provides a culminating event for 4-H-ers' efforts that year, an endpoint in the cycle and the encouragement to go on to something new. Exhibiting and competing at the fair offer not just a popular public venue for the kids, but also the focus of a deadline and, for those with animal projects that go to auction, possible financial rewards. As it is for other fairgoers, this event is a celebration, as witnessed by the afternoon hose fights at the livestock washing stands and the lineup of kids for the rides. And a reunion: watch at any fair for the clutches of girls and boys perched on straw bales in the livestock barns, relaxed, teasing, talking.

A child doesn't have to be in 4-H, FFA, or another organization to participate in the fair. School displays are common and fill an exhibit building to the ceiling at the Sheboygan County Fair in Plymouth, Wisconsin.

Quite possibly the fair benefits even more than the kids. Dennis Cupp, general manager of the Rockingham County Fair in Harrisonburg, Virginia, says they are the backbone of his fair's volunteer workforce. Like other fair managers, Cupp knows that every kid who hauls in a poster project on taking care of hamsters brings along an appetite, hungry parents, maybe some grandparents too, who all ring up gate receipts, buy rides, and fill the grandstand. The 4-H cattle, swine, rabbits, chickens—even reptiles—fill the livestock barns, something that's getting hard to do at some fairs. Any day's fair schedule will list 4-H arena events, demonstrations, and judgings, each of which brings people through the entrance gate. Lots of fairs have a 4-H food booth staffed by eager kids and their parents, and fairgoers stop to buy ice cream and support the local clubs. Some families spend the entire week at the fair with the family camper parked on the back lot among 4-H neighbors, and for the week it becomes the vacation cabin.

Perhaps most important of all, 4-H at the fair provides a seedbed for new generations of people to put it on in years to come. Almost all the fairmakers we met, from board members to vendors, have childhood memories of

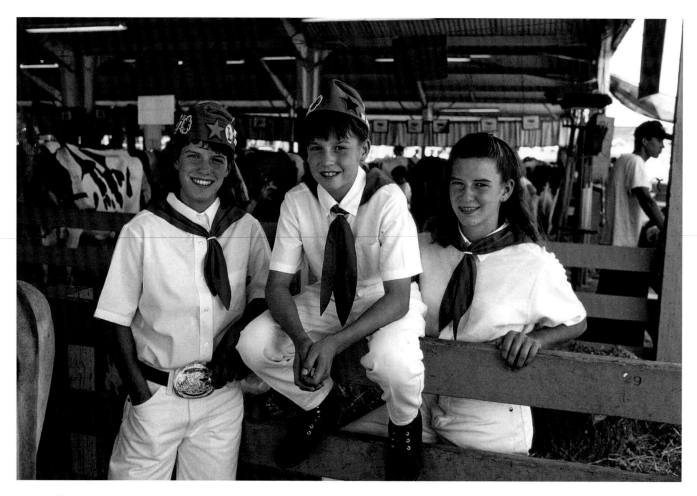

The Fagundes sisters, Annie (left), Meggie, and Molly, take a moment's rest on a busy show day at the Merced County Fair, Merced, California.

the fair, and many of them tell stories of being in 4-H as kids. The vast majority of county fairs across the nation incorporate 4-H exhibitions and competitions, and a few fairs, especially in the Midwest and Plains, call themselves the Such-And-Such County 4-H Fair and exist primarily as a venue for county clubs' events.

In our fair travels we found no better place to learn something of the nature of 4-H than at the Merced County Fair in Merced, California. It's 11 a.m. on a July Wednesday under a cloudless, breezeless California sky, day two of the fair as Meggie Fagundes, age eleven, readies her pig, Pumba, for the show ring. Meggie has been up since five this morning, has fed and washed Pumba, and is now applying finishing touches. Despite the fact that the pig squeals indignantly and greatly outweighs her, Meggie talks quietly to Pumba as she cleans its ears with baby wipes.

How long does it take to prepare her? "Depends on how ornery the pig is," replies Meggie, shaking her head.

Pumba's protests add to the din and hot dust of the swine barn. Other pigs squeal in response to similar insults amid blared announcements calling the next class to the show ring, mixed with kids yelling and laughing. The 4-H and FFA kids nervously prepare their swine; some herd them out to the ring while others return to their pens, having finished their round. Plastic garment bags hang from nails in the rafters for a quick change from work clothes to show clothes. Today the animals will be judged, and in a few days they will be auctioned at the fair and sent to market.

The hog pens are fenced and about eight feet on a side. Most share three walls with swine neighbors. Robert Frost may have had pigs in mind when he wrote what he

did about good fences. The animals prefer to lie against the wire mesh separating them, and their ample bodies bulge through the openings, inciting occasional noisy disagreements. Mostly they lie quietly on the clean wood chips and sawdust. The bedding is cool, keeps them clean, and is easily brushed off just before showing. With the final prep done, Pumba relaxes, but Meggie grows nervous, eager to get the showing over.

Meggie's mother, Michele Fagundes, brushes her youngest daughter's shoulder-length brown hair. The girls' father, Frank, will be here later today after work. Mom talks quietly to Meggie about Pumba, her preparations, the upcoming competition. The conversation seems aimed at relaxing Meggie, to reassure her that she is ready. While she has previously shown other animals, this is the first year she has shown hogs, and though she has two older sisters to learn from, Meggie is the first in the family to show swine.

Michele knows she will have to be on her toes today if she is to see all three of her daughters show their animals for judging. Annie and Molly, thirteen-year-old twins, have livestock projects, too. But as if to make it complicated, this year each of the three girls shows two different species of animals, including dairy cows, swine, and sheep. Meggie is dressed for the show ring in a crisp white blouse, white jeans, and boots. A green neckerchief is drawn through a ring at her neck. Diagonally across her back and chest is a dark green sash dotted with patches and the 4-H cloverleaf. Michele clips her hair into a barrette, and Meggie tucks it under her kelly-green envelope-style hat, leaving a fringe of bangs in front and showing off the pins and patches on the hat that mark her accomplishments in 4-H.

The three girls are members of the local McSwain 4-H Club. Having been in 4-H for several years, and because parents Michele and Frank have cultivated it in them, the Fagundes girls are entirely responsible for all the preparations of the animals, and of themselves. They know when they are due in the show ring and keep track of the tools and other equipment, plus groom and prepare their animals for judging. Michele explains: "When our kids each started in 4-H, we told them they can only do one animal the first year; they have to get used to it. And Meggie

wanted a pig so bad—I tried to discourage her because we already have sheep and cows. And you can see how busy it is for us at the fair. We finally said okay. If that's the animal she really wants, who are we to decide? If she is willing to take care of it—so Pumba came home, and she has been just delighted. She just loves this little guy! And she's in theater at the same time. She's in a play. And today she had to make a judgment call—do I go to my play, or do I show Pumba? Actually somebody else could show her pig for her, but she said, 'Absolutely no way; I'm showing my own pig. I'll give up my play.'"

Michele, a school curriculum planner, says that 4-H teaches kids that they can do things. "I'm a firm believer in this. You build self-esteem in people by letting them do things that will lead to success—you don't build it by telling them they're great if they haven't ever done anything to prove that to themselves. It teaches them a lot—it teaches them camaraderie, it teaches them how to work together, teamwork. As the kids get older, in high school, you will see the results."

Meggie pulls her spray bottle and currycomb from her back pocket and again primps Pumba, not so much with purpose as out of habit. Her mom explains that the kids want to make sure they place high enough "showing for grade" to be able to attract good bids at the animal auction later in the fair. Michele pauses to listen to the loudspeaker. "That's my daughter Annie going back in for junior yearlings. This is a hard call; I've got to decide, do I stay here or go there? She's going in for junior champion for the heifers, so I probably better go there. Meggie has awhile here. I think I can make a move."

As Michele walks quickly toward the dairy barn and its show ring for Annie's dairy heifer competition, the sunny areas between the barns are alive with kids, animals, and parents. She greets 4-H kids and other 4-H parents and gets the word on how other kids are doing in their competitions in other buildings. On this day at the Merced County Fair, the place clearly belongs to the kids.

"Thank you Birdies Restaurant for buying my 1995 Pen of Three Broilers —Emily Fleming."

Sign on chicken cage at the Holmes County Fair, Millersburg, Ohio

•

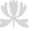

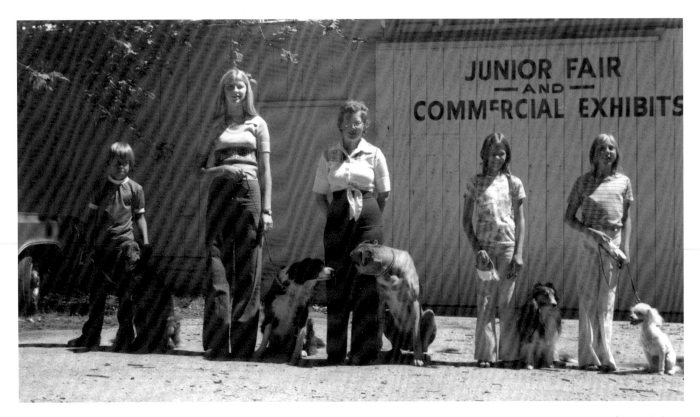

With cute dogs and cute kids, plus a large opportunity for comic mishap, dog obedience competitions are always crowd pleasers at fairs, including this one at the 1976 Vernon County Fair, Viroqua, Wisconsin.

Courtesy Vernon County Historical Society

ALTHOUGH 4-H EMERGED FROM THE ACCUMULATION of ideas and efforts of many people across the country in the early twentieth century, one man and one event signal its beginning. The man was Albert Belmont Graham, and the event was the first meeting of his Boys' and Girls' Agricultural Experiment Club in Springfield Township, Ohio, in January of 1902.

Graham was superintendent of the rural Springfield Township schools and supervised some five hundred pupils scattered in twelve schools. He was an experienced teacher with a strong science background and a practical approach to teaching. Like many education leaders of the time, Graham sought reform in educational practices that would benefit students and society—and in Graham's case, rural society. A proponent of Dewey's "learning by doing" philosophy, he once asked a group of teachers, "Who cares for a correspondence course in swimming?"

On that winter day, Graham gathered some thirty boys and girls and began to teach them science through its practical application. Each student brought a soil sample

from the home place, and Graham taught them to test its pH using litmus paper from the local drugstore. The club met monthly and proved popular. Soon Graham had the kids conducting seed germination tests and exploring fat globules in milk through microscopes. That spring, as a club activity, eighty-three boys and girls planted and tended experimental plots of corn on their farms.

As they do in 4-H today, the kids kept detailed written records of their experiments, and in this case submitted them as reports to Graham himself. The youth elected officers who conducted the meetings. The club was coed and racially integrated. Businesspeople and parents provided resources and shared their expertise.

Another important component of Graham's program was the presentation of results to the public, and the Clark County Fair provided exhibit space and admiring crowds as early as 1902 and apparently from then on.

With his early success, Graham sought to expand his program and sought help from the Agricultural Experiment Station at Wooster, Ohio, and from Thomas F. Hunt,

dean of agriculture at Ohio State University in Columbus. By the turn of the century, land grant colleges and universities were applying science to farming through research conducted at their experiment stations. There they accumulated knowledge about increasing crop yields through seed selection and soil preparation, about improved livestock production, and about farm economics. But exporting these ideas to the farm was difficult. Most farmers were suspicious of newfangled ideas in part because the stakes of a crop failure were so high. What worked one year was done again the next, and anything that failed was remembered forever. Isaac P. Roberts of Cornell University said, in 1889, "Farmers, like other people, hesitate to believe and act on theories, or even facts, until they see with their own eyes the proof of them in material form." The agricultural colleges had a hard sell, but through their growing extension services, they were using demonstration plots, farmers' institutes, bulletins—and the county fair—to advance agricultural science and to make their case.

At Ohio State, Thomas Hunt saw Graham's request for assistance as another avenue for spreading better agricultural knowledge and an opportunity for mutual benefit. He referred Graham to the Agricultural Student Union, which worked with the Agricultural Experiment Station at Wooster conducting crop experiments. They responded by providing Graham with sacks of four varieties of seed corn to be planted by the young club members. Yields for each could be compared with the variety their fathers planted. Graham also obtained free vegetable seeds and encouraged the club members to grow them for home use and for sale.

Similar youth agriculture clubs germinated quickly across Ohio in large part due to Graham's stumping for the cause. At teachers' and farmers' institutes he presented his key message: "Not only must provision be made for the three R's, but for the three H's as well; the head for a wealth of information and knowledge, the heart for moral and spiritual strength, and the hand for manual dexterity and skill." In a few years health would be added, making the four H's of 4-H.

Of course Graham wasn't the only person to start an agriculture club for youth. In the fever of national educational reform, many rural people wanted improvement

and created boys' corn clubs, girls' home culture clubs, canning clubs, pig clubs, dairy clubs, and baby beef, poultry, and garden clubs. Wouldn't an education more focused on agricultural matters help kids who were eventually going to take over the farm? And wouldn't it help stem the flow of young people to the cities? And perhaps most important, if today's farmers were slow to accept new practices, why not educate those of tomorrow? Boys' and girls' agriculture clubs sprang up all over the country, and by 1904, Ohio alone boasted sixteen.

The same year Graham started his club, another school superintendent, an O. J. Kern of Winnebago County, Illinois, combined the wisdom of the Illinois College of Agriculture with the energy of thirty-seven boys to grow corn and sugar beets, a new crop for northern Illinois. And in 1904, G. C. Adams of Newton County, Georgia, where cotton was king, held a "corn contest" for schoolboys. His purpose was "to interest the farmer boys and have them show their fathers how we can succeed on the farm, even when cotton is seven cents per pound." In the same years, Iowa saw two counties adopt the club concept under the leadership of two schoolteachers, one in Page County, the other in Wright County. These counties are the birthplace of the 4-H cloverleaf emblem, first three-leafed, then four.

In *Straight Furrows: A Story of 4-H Club Work*, Clyde Duncan tells it best in his story of meeting the county extension agent for the first time. In 1913 he was a farm kid in northeastern Arkansas plowing cotton with a mule and a bull-tongue plow when R. R. McPherson, one of the country's first county agricultural agents, made an almost messiahlike appearance as he "walked with long strides in the hot afternoon sun down the long, straight furrows and came to me," writes Duncan. McPherson told Duncan he wanted to start a corn club. They had been successful in the past few years in the North, he said, and "I want to be the very first in the South to start it. Club work—corn club work—is great. It is something new for country boys. I am trying to get enough of you young fellows between the ages of ten and eighteen to form a club here in this community. We want to hold meetings and plan exhibits at the county fair this fall. We want to work it around so we can arrange prizes

for the best acre of corn grown in this county!"

Duncan got religion and planted his acre with seed from the best of last year's ears, and through the summer tended his test plot. At the fair in mid-October, he won a blue ribbon and two ten-dollar premiums.

"Tears came into my eyes," he writes. "I had never before seen such money, and never before a blue ribbon which looked so large and pretty."

And through his growing interest in club work, Duncan "became enjoined to a pig—a round spotted individual of doubtful ancestry, but all pig, nevertheless. Every movement that pig made during the next nine months went into a crisp, new record book, which my county agent had furnished for that purpose. The big New York bankers never kept more accurate records of their assets and liabilities than I did of the daily doings of Old Spot."

At the federal level, too, there were advocates of club work. During the years 1908–10, the U.S. Department of Agriculture appointed two field agents, Oscar B. Martin in South Carolina and O. H. Benson in Iowa, to work with boys' and girls' clubs. Benson brought to Washington the cloverleaf that became the now-familiar emblem of the clubs' vibrant offspring, 4-H. By 1924 it was a well-recognized symbol.

The work of youth clubs got an enormous boost in 1914 with the Smith-Lever Act, which legislated national guidelines and provided funding for the Cooperative Extension Service to extend the educational work of the agricultural colleges and county agents. Club work was to get 20 percent of the earmarked funds, and a portion of the county extension agents' time was to be devoted to assisting them, a role that persists today.

In 1917 Congress passed the Smith-Hughes Act, providing for the establishment of agricultural education for high school students and adult farmers. This vocational approach to agricultural education gave rise to the Future Farmers of America, which has long been a school-based program, in contrast to 4-H, which is not.

Meanwhile at the fair, youth clubs played a bigger and bigger role, drawing a whole new segment of the population through the gates, into the barns and exhibit halls, and to the midway. By 1920, the *Ohio Farmer* opined that "the boys' and girls' club work is the life blood of the present-day fair."

AS MICHELE FAGUNDES ARRIVES at the cattle arena, daughter Annie, age thirteen, is leading Pepper, her Jersey yearling heifer, toward the ring for the competition. Annie's composure is half self-assurance, half shyness. Pepper's is typical cow: half contented, half bored. Annie wears a big oval silver and gold belt buckle, a prize from a previous fair and a bit oversized for her slender adolescent frame. With two more 4-H years under her belt than sister Meggie, Annie sports more pins and patches on her hat, including ones for dairy and leadership. Earlier today she and Pepper won second place in the 4-H Jersey Female/Summer Yearling category, qualifying her for this chance at Junior Champion Yearling Heifer. Her red ribbon is tucked into her hip pocket. It might prove useful in catching the eye of the judge.

In this championship event, the first and second place ribbon winners from several earlier yearling heifer competitions compete for grand champion and reserve grand. The yearling heifers vary in age (designated senior, winter, junior, or summer, depending on birth month), and in breed; they include Holstein, Friesian, Jersey, and the catchall AOB—All Other Breeds. Like many aspects of judging at fairs across the country, to the uninitiated, the distinctions and patterns are confusing. But the specifics are outlined in the Merced County Fair Exhibitor's Handbook. Here, as at all fairs, the handbook, or premium guide as it's often called, is the exhibitor's bible.

In the ring Annie joins some ten other kids leading scrubbed young animals. The FFA kids look sharp in their "national blue" corduroy, waist-length jackets embroidered with the large FFA emblem in "corn gold" on their backs. The 4-H boys and girls wear white shirts and white jeans, and many have a 4-H green scarf knotted at the collar. These are symbolic colors: white for purity and high ideals, green for life, youth, and nature. To the spectators, especially the nervous but beaming parents, the crisp, clean kids and well-fitted cows are a symbol of what's right with their world.

The kids lead their animals in a merry-go-round circle, keeping their eyes fixed on the judge as he scrutinizes the heifers in profile and watches their movements. The exhibitors are nervous, eager, imploring, proud, all at the same time, and keep a tight rein to preclude animal shenanigans. The judge is a big man in jeans and a summer straw cowboy hat. Tooled into the back of his belt is "Max." Occasionally he asks one of the kids to stop or turn or start, and he does so in a quiet voice. In the bleachers Michele chews gum and talks quietly with acquaintances, the video camera at the ready should Annie get moved to the winners' row.

The bored heifers and their earnest escorts are now parked, side by side, in the center of the ring, and the arena falls silent as the judge walks back and forth in front of, and then to the rear of, the lineup, closely comparing bovine attributes, and then mentally ranking them. The announcer breaks the silence by announcing that the judging will stop for lunch after the next event and resume at 1:00 sharp. Michele has turned on her video camera and watches through the viewfinder. The judge selects three heifers, but not Annie's, and moves them to the center.

At last he speaks. "I think I have a consideration for junior championship. Let's give these young people a big round of applause. I thought we had a very nice Jersey heifer show this morning in the 4-H division. There is some real quality out here, even in some of those standing around the ringside there, but I think I have three heifers out here today that combine the dairy-ness, and the depth and angularity, the correctness of top line and rump that I like to see in our heifers." He explains that as he judges throughout the day, he makes mental notes about individual animals that might be contenders for champion. "As you go through the day, you have other heifers to think about, but I think that the heifer that right away I thought was going to be in contention for junior championship is going to be our Junior Champion today. And that is this young man right down here at this end. So go ahead and lead this heifer down over here so everybody can see her." The bleachers ring with applause. If Annie is disappointed, she does not show it as she applauds along with her fellow contestants.

After the judge points out the qualities in the winning animals, he hands purple rosettes to the owners of the new Grand Champion and the Reserve Grand. From the winners, there is no gloating or grandstanding, nor are there expressions of disappointment from those who didn't place. The 4-H-ers have been instilled with the importance of the process, the idea that their work through the year is what brings reward. Annie is philosophical as she leaves the ring. "I didn't place, but, yeah, it was okay." Her braces flash when she smiles. "I wish I would have done a little better, but maybe next year. There's a lot of

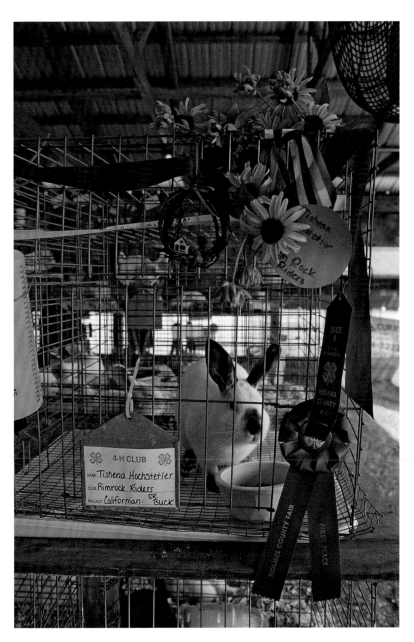

A proud and pretty bunny at the Holmes County Fair, Millersburg, Ohio. Kids devote enormous energy to their much-loved animals.

good showers out there. Some buy their cattle for like two or three thousand; I got her for three seventy-five." Annie's red ribbon from earlier today will be the day's reward.

Michele praises her daughter for her handling of Pepper, and as Annie leads the animal back to the barn, Michele takes a quick leave to head for the pig barn in hopes of catching Meggie showing her pig. Along the way,

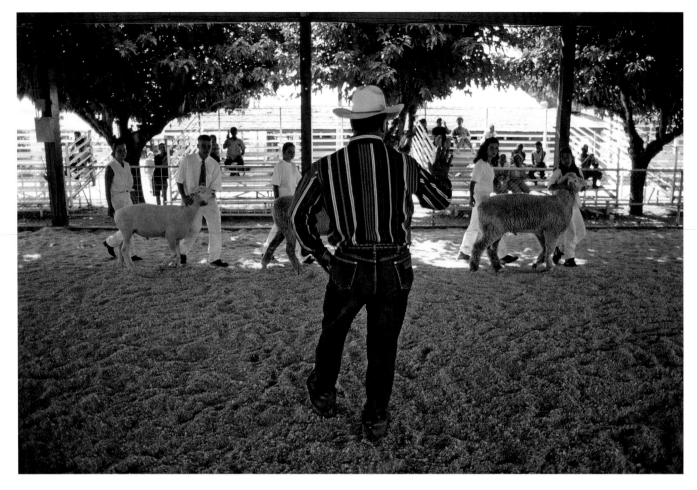

Livestock judging is a tense time for participants, including this group on a hot day at the Merced County Fair, Merced, California.

a loose sheep darts past, bleating, more in confusion than liberation. Close behind sprints a girl in 4-H green and white. A bystander grabs the lead, and the sheep is returned to its rightful owner, who is no doubt wondering what this break portends for the show ring. Is this a premonition of what is to come, or is it a feisty ewe getting it out of her system, now prepared to cooperate?

When Michele arrives in the pig barn, Meggie is on her knees next to her reclining 217-pound gilt, slapping its coarse-haired flank with gusto, but without malice, to get it on its feet for the competition. Pumba is a Blue Butt, a nickname for a cross between a Hampshire and a Yorkshire. This parentage creates the steely, blue-black geographic patches around the eyes and over the flanks with a background of pig-pink skin. At the moment the animal is in the default position for a pig: on its side, head and

neck outstretched, legs extended, maximizing body surface area for cooling.

"Get up, Pumba! C'mon." Meggie's small hand is no match for the sleepy pig, but they both know the drill: Meggie is in charge. Reluctantly, Pumba gets to her feet.

Meggie must keep the animal on its feet until the judging is over, a difficult task. Swine are prone to be prone. Meggie curries Pumba's sparse hair one more time and gives her a spray of Show Sheen. A 4-H boy tells Meggie her green scarf is inside out; she reties it. A friend passes and wishes her good luck. "Thanks." Then Meggie reveals her worst fear: "You don't think she'll lay down in the ring, do you?" Michele reassures her and takes a picture of Meggie with Pumba, ear tag number 442.

The noise level increases in the pig barn as the announcement comes over the loudspeaker: "Exhibitors,

have your hogs ready," then a list of fifteen names is read, including Meggie's. Hogs squeal, people shout above the din, amid a near constant litany of announcements. The exhibitors and their four-legged exhibits move toward the chute that leads to the show ring. Many employ a wooden cane held on the straight end, using the hooked end to tap the sides of the head of the moving pig, ostensibly to keep it moving in something approximating the right direction. Others persuade their animals by following them with a piece of plywood to sweep them forward, or at least to disallow backtracking.

The ring is soon a dusty mixer with hogs and bent-over kids shuffling beside them, switching canes from hand to hand and using pig body-blocks to do their best to keep the hogs moving and in view of the judge. They form a writhing arc in front of the judge who watches from about twelve feet away. Eye contact with the judge is a cardinal rule in junior livestock showing, but so is constant vigilance of the pig, making for a difficult attention split. A kid's momentary look at the judge gives any pig the break it is hoping for. And pigs quickly build momentum.

Michele says, "I think this event has the best showmanship," referring to the work the exhibitors must do to best demonstrate their animals. "It's just so fun to watch! You wonder how the judge keeps things straight. Look at him—he writes things down; he knows what's going on. Watch his eyes." Michele turns on her video camera.

The judge wears a white, western-cut shirt and purple jeans that cover his dusty cowboy boots. His physique is a bit porcine, a fact he admits as he grabs his belly and refers to one pig being a little full in the belly, "like I would be if I were down on all fours." The crowd laughs. He carefully scrutinizes the swine as they mill, giving him multiple vantage points.

This showing is for grade, so as the judge makes decisions, he directs each animal into one of the pens at the side of the ring, separating them into groups one, two, and three. Finishing, he lets his number one choices back into the ring and says, "We like the length of body, the levelness of top; maybe it isn't the heaviest muscled hog in the class. Maybe it isn't the leanest hog in the class, but as far as possessing the combination of muscle and leanness, length of body,

"Would the Pepsi man please go to the bunny hut?—the Pepsi man to the bunny hut."

—*P.A. announcement at the Elkhart County 4-H Fair, Goshen, Indiana*

•

skeletal dimension, I think this pig does it quite well. And that is ear tag number 442, and the little girl who's driving there. She is going to lead off this particular class."

This is Meggie's hog, and Michele cheers above the applause. Meggie looks hot and a little surprised as she shakes hands with another exhibitor, accepts her ribbon, then herds Pumba back toward her pen. Later in the day, after six more classes like this one, the two will go back in the ring and compete with all the others who placed in their classes for Grand Champion or Reserve Champion. Meanwhile, Pumba gets a big drink of water in her pen.

Michele is very pleased for her daughter. "Can you believe it?" she exclaims to Meggie. "There was a lot of competition." She congratulates her daughter, who smiles, clearly proud of the accomplishment and the ribbon. Ever mindful of her other two daughters, she calculates the schedule; with six more classes of swine to be shown, she knows it will be awhile before Meggie is back in the ring. "Now we'll go do sheep!" says Michele.

IN THE HUNDRED OR SO YEARS since its beginnings in boys' and girls' agricultural clubs, 4-H has kept its focus on developing the youth of the nation, but the nature of that development work has changed radically. In the early years, 4-H worked to improve agriculture and home economics for kids who would grow up and live on farms and ranches. Today, 4-H dedicates itself to the development of young people in all walks of life, emphasizing the life skills appropriate for capable, self-reliant adults in a democracy, skills taught through projects of all kinds. These days only a small number of 4-H kids will ever earn their living in agriculture.

By 1960, fewer than half of the kids who participated in 4-H lived on farms or ranches; by 2003 the number had fallen to 10 percent. Nevertheless a full third live in the country or in towns of less than 10,000, and

surprisingly, 25 percent live in cities of 50,000 or larger. Membership numbers are strong at over 1.5 million in almost 90,000 clubs. Nearly a third of the members are minorities. According to 4-H, it is the country's largest youth development program measured in terms of the number of kids involved.

Most people naturally think of livestock projects when they think of 4-H, but in fact only about 30 percent of them involve animals, or plants for that matter. The animal category includes such projects as the "Horseless Horse," which expresses the ennui of many a preteen girl and can be accomplished as easily by a kid living in the glass canyons of Manhattan as by one in the rock canyons of Montana.

These days the nonanimal 4-H projects come from categories with names like personal development and lead-ership, environmental education and earth sciences, citizenship and civic education, as well as the more familiar consumer and family sciences. Since many of the project ideas are developed by local 4-H leaders rather than the national 4-H office, the exhibits at the fair take on a local flavor and range from the apt to the goofy. Young Melissa Ramos of South Dakota displayed "My South Dakota Book" at the Turner County Fair in Parker and dispelled notions of this being a vast land of little but dry farms and presidential faces. Her tidy binder takes subjects alphabetically and highlights historical and geographical topics from border to border. Among other topics, her sleeved pages hold biographies of the infamous Jesse James and of native-born Harvey Dunn, a painter whose work captured Dakota pioneer life. Presumably with her parents, Melissa traveled to many of the sites she describes, illustrating them with her

4-H is lots more than livestock. Alisha Davis shows off some of the projects she entered in the Boone County Fair, Columbia, Missouri.

FROM RICKRACK TO ROCKETS

own snapshots and purchased postcards. A wall poster above the open book describes her research methods, which included writing chambers of commerce around the state, checking out "many books at the library about South Dakota," examining news clippings owned by an older friend, and listening to stories in school.

Perhaps less enlightening, but certainly amusing, was the classic kid-drawn poster at the Atlantic County 4-H Fair in New Jersey detailing the parts of an American cavy. Here was the beast, a great, smooth, blimplike oval, filled with a brush of brown crayon and supported by tiny Charlie Chaplin feet. Or the display by Matthew Herberg of the Norseland 4-H Club in Nicollet County, Minnesota, called "Do bat houses work?" Matt tells us that "bats eat up to six hundred mosquitoes in one hour, or up to their body weight in one night. That would be the same as me eating ninety pounds of french fries in one day, or eating thirty-five large pizzas." That certainly puts it in kids' terms.

There are changes in 4-H that suggest something of the nation's troubled times. In response to them, 4-H has juvenile diversion programs in, for example, Minnesota and Clark County, Ohio, the birthplace of 4-H. Many fairs require animals to be ear tagged and nose printed when they are weighed or entered to prevent switches. Extension agents and 4-H leaders in all regions told us it's getting hard to find good club leaders, and a club leader in Maryland told us prospective leaders must pass background checks. Do they need to be fingerprinted? we kidded him. "Not yet."

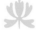

MOLLY SMILES BROADLY when she hears about Meggie's blue ribbon. She is readying her market lamb, Jennifer, for her showing for grade. The lamb is "slick-shorn," rather than carded, because this is a market animal and will be sold at the auction at the end of the fair. Judges need to see the conformation of the market animal to assess the meat.

Around one thirty Molly and fourteen others maneuver their charges into the ring. Instead of using halters and leads, the exhibitors place one hand under a lamb's jaw, the other across the top of the head, and steer it in crude fashion. Some kids have a partner, and when it's time to stand steady, one controls the sheep's head while the other places the feet according to long-established sheep-showing practice. Standing with hind legs stretched out, the lambs twitch and move, and the judge chats quietly with each exhibitor as he inspects each lamb, feeling for good muscle across flanks and back.

One girl notices her untied shoe; the judge holds her sheep and talks to her as she ties it. She smiles and thanks him and resumes her position. She rearranges her animal, getting legs and fleece just right. Another lamb makes a break; her owner makes a dash after it. Other kids reach for it, but, with only one hand to spare, miss it. Molly, taller than most of the kids in the ring, nabs the errant sheep and pins it in the crook of her elbow, still maintaining control of Jennifer. The admiring crowd on the bleachers applauds.

Now the judge has exhibitors walk their sheep around the ring in a circle. As they parade past, the exhibitors' eyes are fixed on him. His pearl-button cowboy shirt, blue jeans, and white straw cowboy hat and his sure and easy way with the sheep and kids give him due authority. One by one he points at the sheep and directs their owners to move them into a line across the center of the ring. He asks those remaining, including Molly, to line up along the side of the ring and moves to take another good look at them. Molly works hard to steady Jennifer as the judge pushes and tests. As he moves on to the next lamb in line, he directs Molly to the middle to join the existing line. Those in the bleachers talk only in low tones as the judge sorts.

Judges arrange animals by their own methods, so no one is completely sure which have made what grade. His task is to sort them into grades one, two, and three for the upcoming auction, with grade one being highest. Often, including today, there are no grade three lambs. All but three of the fourteen are by now in line in the middle, and the judge talks to these three exhibitors quietly and at length. These three are clearly the better lambs. One by one these three are sent to one end of the lineup, and the crowd, including Michele, applauds. The first animals selected were grade twos; Molly is happy to be in grade one, halfway down the ranking. Molly and Michele talk happily about the judging as Molly leads Jennifer back to the sheep barn.

It's midafternoon, and though she hasn't yet had lunch, Michele, lugging her video camera, heads back to the swine barn. This long day of showing will end with Meggie's and Pumba's unsuccessful bid for Grand Champion. Then the girls will feed, water, and bed their animals, head the few miles home to do animal chores there, and then have a late dinner. But despite the long day, the heat, the work, Meggie, who wants to make the most of the fair, asks, "Mom, are we going to the pig races tonight?"

The next day, between competitions and helping their daughters, Michele and Frank Fagundes rest a few

minutes on hay bales near the cow barn and consider what each of their three daughters has gotten out of her years in 4-H. Frank thinks a moment and says, "Molly has probably gotten her management skills, how to manage things, how to do things right. Annie has probably gotten more responsibility—she needs to get more because she leaves stuff all over," he says with a laugh. "And Meggie has found out how to be an individual instead of having two older sisters to compete with."

Frank had to work the day before, but took off the rest of the week to be here at the fair with his family. He works as a commodities trader. Like Michele, he's involved in the girls' 4-H pursuits. "I am doing this because I want to make them better people. I want to show them that there is responsibility, and for that responsibility, there are rewards. If they work hard, they will do well. They've got to be responsible—it makes them better people." He adds that he likes them to be competitive too, but winning isn't the only goal. "I want them to do things on their own. Whatever they want to do, I just want them to do the best they can."

Parental support for their daughters and 4-H goes well beyond fair week and these animal barns. They live on twenty acres that was Frank's grandparents' place and rent additional land. And although they both have day jobs, they raise a little grain and have room for the girls to raise animals. Their truck and livestock trailer bring them all to the fair. Because the girls show different species of animals, it takes two trips "because you can't haul them together in the trailer," Frank says matter-of-factly.

Says Michele, "We never allow our kids to quit. When they start something, they finish to the end, even if they are absolutely miserable. They don't have to do it again, but they always finish what they start. They know that, and they think about it. Now Annie, she's into water polo this summer, and she was exhausted by the last week, but she didn't dare say, 'I don't want to go this last week, Mom.'"

> "I was raised on a farm, but we always supported the farm with outside income. Best tax deductible hobby known to man. We couldn't live in town. They'd lock us up."
>
> *—Forrest Cunningham,*
> *Boone County Fair, Columbia,*
> *Missouri*
>
> •

The girls are enthusiastic about their projects, according to Michele. "I had to clamp down on their activities in 4-H because they were so involved—I mean they had twelve projects—it was nuts. There are all kinds of projects in 4-H; I taught a computer project, there is sewing, ceramics, arts and crafts, all kinds of things."

As an educator, Michele understands the essential role she and Frank play in their girls' 4-H work. They support them and help when asked, but avoid overfunctioning and taking charge when things don't go right. The 4-H animal projects require the girls to make many decisions, be responsible enough to take care of the animals every day, and make sometimes hard choices. And in competition, there is both joy and disappointment.

"If winning was the most important thing," admits Michele, "then we would be out buying expensive stock, which we don't do. Those are the ones that always win. But what they realized last night—we were talking about it—we said, aren't you proud? That is your stock—you've bought your own stock, you are breeding your own stock, and that's a winner right there. It is easy to go out and spend two thousand dollars, if you have it, and bring in the best, but you are not learning how to do it better. It's your own sense of pride and ownership."

Frank agrees. "We're going to send some sheep home with a guy who has had the number one sheep in the state, and he's going to breed ours to their bucks so our lamb crop will be better than the lambs we had this year. That's an experience, too.

"The other reason we do this is because they have to learn to make decisions," says Frank. "Like Michele said, sometimes they ask us, but they're pretty much making their own decisions. There is going to be a time and place when I'm not with those girls, and they're going to have to make the right decision, and that's what scares me more than anything."

A HALF A CONTINENT AWAY, at the Rice County 4-H Fair on the plains of Kansas, the home crowd packs the bleachers as the livestock auctioneer quickly sells the sheep, swine, and beef projects of the county 4-H kids. He calls the bidders by their first names and thanks them for coming. He pauses in mid-sale and tells the crowd, "When you hear an auctioneer talk for a long, long time, you know he forgot where he's at, is waitin' for somebody else to bid, or is trying to remember what happened."

This is a tiny fair at the edge of Lyons, Kansas, smack in the middle of the state, where the windbreak to the west shades fairgoers' eyes against the sun now only a few degrees above the flat and distant horizon. With the sale as background, Rice County extension agent Lori Shoemaker takes a few minutes from what must be the busiest day of her year to talk with a couple of fair researchers about her work with 4-H in the county. She supervises eight clubs with a total of about two hundred members.

"Eighty percent of our membership is probably twelve and under. We get them when they are younger and hope to keep them in—that's the goal, but it's hard with a lot of other things like school and sports and summertime things going on," Lori says. Livestock numbers are down sharply this year; perhaps a fluke, perhaps a trend, but "our quality is still up. I think it's a combination of time and economics and the number of kids—the older kids in 4-H, a lot of them have summer jobs, so they don't have the time to put into it, especially beef projects because that's a long time period, some 180-plus days. Plus, there is the initial cost of the animal and feed and the economics of keeping the project going. It can be a little costly."

Lori explains that 4-H here and everywhere is more than animal projects. "Sometimes kids think, I have to have an animal to be in 4-H, but that's not true. You can go from reading to rocketry to beef steers, horticulture, crops; we have posters—self-determined—that means the kids can do a poster about anything they want—ballet lessons or music lessons, tennis, or a horse project. The clubs do booths and banners; they do 4-H promotion to the community through service projects they've done for their community and the county. Let's see, we have clothing, either the construction part of it or buymanship—and that's for both boys and girls. We do have some boys who sew. Buymanship—that's when they buy their own clothing. With the girls, we call it clothing carousel, and with the boys, it's clothes strategy. Let's see, we have foods, nutrition, food preservation, arts and crafts—they do about anything, and some of the kids are really talented, creative. What else is there? Knitting and crocheting, hand pets—they can take a cat to the fair, or they can do the dog project with obedience and all."

This is a small fair—no carnival, no racetrack, no big-name—or even small-name—entertainment, not even any commercial exhibits. The 4-H displays are housed in the basement of the Church of Christ across the street. "It's air conditioned, so the judges love it," says Lori. The only food venue is a homespun stand on wheels that sells funnel cakes, drinks, and popcorn. The county maintenance sheds double as open-class exhibit buildings; the county trucks are pulled outside tonight. But the display buildings are empty tonight—everybody is packed into the arena and bleachers for the livestock sale.

Lori continues: "I do think we have a strong program here in the county, a lot of good leadership, a lot of strong volunteers. You can see how our alumni keep coming back to support the fair and other activities. 4-H is pretty well known here in the county. We're not huge number-wise, but it's stable and well recognized. I have teachers in the school district that say, 'Hey, I know that kid's been in 4-H just by the way they present themselves, their poise, and their public speaking skills.' It makes you feel like we're doing something good, something right.

"Besides learning to speak on their own two feet, they learn leadership skills, citizenship skills, responsibility. For example, for the fair, I make them write thank-yous to all their sponsors and buyers, and they turn them in to me and I mail them for them, and then they get their premium money. I hold the carrot in front of them. It's important to teach them to be thankful; the sponsors and buyers don't have to come out here and support the kids."

Lori and others have seen to it that the community has ample opportunity to support 4-H and this 4-H fair. Prior to the livestock auction this evening, the auctioneer sold six highly coveted baked items that raised almost a thousand dollars to "go toward the furtherment of 4-H work in Rice County," according to the program. These were the reserve and grand champion entries in junior, intermediate, and senior categories, and apparently bidding was hot. Amy Schmidt of the County Liners 4-H Club turned her whole-wheat bubble loaf into a cool $300 when her two grandfathers pooled their funds and presumably split the pan. Christopher Barta's Mexican orange cornmeal sandies caught the eye of the Rice County commissioners and brought in $150. Matthew Splitter's Italian cream cake brought $275 from Jo's Cakes, a local baker, evidently so Jo can discover Matthew's secret.

The 4-H food auction program reports that last year's auction proceeds were used for scholarships, training, and camp scholarships. In addition, "Twenty 4-H-ers wrote paragraphs about 'Why I Want To Go To Camp' and received five dollars off their camp cost."

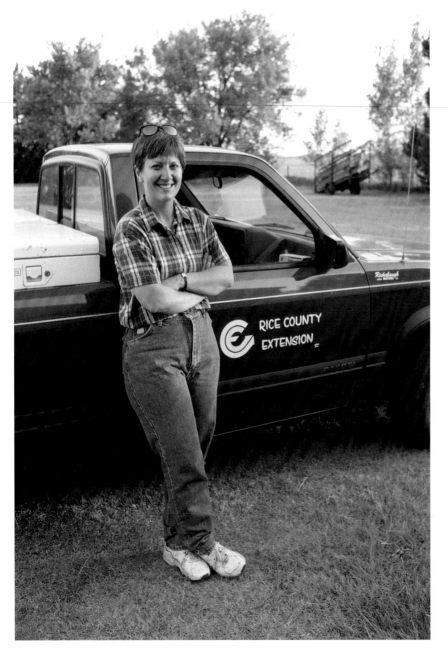

Lori Shoemaker, Rice County extension agent, Lyons, Kansas.

Rice County, Kansas, is a rural and agricultural county. On this night freshly harvested wheat fields stretch like dusty gold in all directions from town. The county population stands at about thirty-six thousand and is dropping, according to Lori and to census figures. Like most farm or ranch regions, Rice County sees its people ebb away to bigger towns, suburbs, and cities as agricultural opportunities wane in the face of ever larger land holdings that support fewer families. And like 4-H clubs nationally and for the last half century, more and more of the kids come from nonagricultural families.

"It's probably fifty-fifty now," says Lori. "Kids are learning that they can have rabbits in their backyards or basements, and some kids who live in town are doing just that. And some families out in the country will share pasture or lots with their friends so they can have their own livestock and share responsibilities and chores and so on. We see a lot of that happening too."

The livestock auction has ended, and as the last crepuscular rays crease the sky, a table appears on the brittle grass south of the arena where Lori and others cut and hand around thick slices of cold watermelon. As the juice pools on the table, fairgoers cluster in conversation, lean on pickup trucks, and spit their seeds into the dry grass. Meanwhile nearby, like a bit of urban theater, a Lyons city cop struggles to unlock a dusty, fair-tired family's car.

Awaiting their turn to perform, these dancers warm up backstage at the Tillamook County Fair, Tillamook, Oregon. Youth events lie at the heart of fairs everywhere.

6. Symbols of Increase

The fair is so widely known in America that hardly anybody knows anything about it. It is as common as the climate and as little understood. Everybody knows something about his own show and practically nothing about the other fellow's.

—John R. McMahon, *Country Gentleman,* July 6, 1918

THROUGH THE TWENTIETH CENTURY, America's two-thousand-and-some county fairs evolved just like any other living institution. Changes in ideas and events were driven by the century-long exodus of Americans from farms to cities, and later, to the suburbs, and by the wholesale revolution in culture from a society at the century's start just discovering the telephone and electric lights to one at century's end addicted to televised sports, the Internet, and 3-D video games. Those who ran America's fairs in 1900 faced the task of constantly finding new things to offer, new gambits within the mission of an agricultural fair that

would keep the fairgoers coming. It's still true today.

But despite the cultural revolutions of the twentieth century and the changes at the fair, the fundamental patterns of the county agricultural fair remained relatively unchanged; fairs at both ends of the century featured competition among neighbors, livestock, rural-style social activities, games and rides, and educational components, all in an annual multiday event on fixed grounds. Owing to the very traditions established by Elkanah Watson in 1811, the key components of the agricultural fair have changed only in degree and not in kind in almost two hundred years.

Another thing that did not change is the participants. Agricultural fairs have always been put on and attended by not only farmers and rural people but town and city dwellers as well. Many fairs of Watson's day were agricultural and mechanical fairs that promoted the involvement of the local machinery builders, carpenters, and the like from town. In addition, since the earliest days, fairs also featured domestic arts, which were and are relevant to rural and town folks alike. Successful fairs then and now have always depended on the collaboration of farmers and ranchers with civic and business leaders. The county seat has resources that towns in the rural reaches do not have, and in most cases farm and ranch people are too few, live too far from the fairgrounds, and are too busy in the summer to be the primary fairmakers. Nonetheless, throughout fair history those who put on and those who attend the nation's fairs each year—townies and country folk alike—share an agricultural bent and talk of deep ties to the cyclic farm year and its seasonal events.

Fairgrounds locations reflect this cooperation. Most appear at the edge of a town, usually the county seat, at a place where the rural landscape abuts the street grid. Very few are deep in the countryside; some are inside towns or cities, mostly because the urban area has grown outward around the fairgrounds. Watson's first fair, after all, was held in the town square.

Farmers and their families—plus the townies—came to the fair throughout the twentieth century for the same reasons they always have and still do: primarily as a social holiday, but also as an opportunity to learn some-

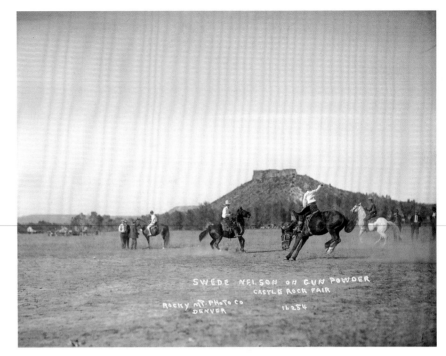

The record is silent regarding Swede Nelson's performance on Gun Powder, but this brief moment is indelibly captured in this turn-of-the century image that suggests the importance of rodeo at fairs west of the Mississippi, even at fairs as small as this one in Colorado.

Denver Public Library, Western History Collection, no. Z 695

thing. By 1925 the more formal parts of agricultural education had been taken over by publications, college programs, and associations, leaving the fair to educate mostly by example and exhibition. To farm families, the fair was in part a measuring stick that allowed them to gauge their own progress in livestock, canning, domestic arts, horticulture, and crops against that of the rest of the agricultural community, and occasionally against state and national standards. Increasingly those standards, those ideas for improvement, came from the likes of agricultural extension and, by the 1930s, the soil conservation agencies, both of which sponsored exhibits at the fair. Breed associations increased their influence as well by showing off best examples of such breeds as Hereford cattle and Suffolk sheep.

The agricultural and horticultural components of most—if not all—fairs held strong through at least the first half of the century, but by 1970 many fairs in intensely agricultural counties had begun to see animal numbers and farm families' participation decline as farm production grew more corporate and more concentrated. Farm implement manufacturers and dealers continued to use the fair as a place to hook the farmer on new machines, but as

SYMBOLS OF INCREASE

time went on, fewer farmers stopped to kick tires and look at price stickers. Early in the century, equipment dealers drew crowds of farmers to see single-share, horse-drawn walking plows; by century's end, the few dealers still in business drew mere handfuls of farmers to see ninety-foot-wide, thirty-six-row planters drawn by giant four-wheel-drive tractors costing upward of $270,000.

Throughout the century fairs provided plenty of entertainment. "Aeroplane" demonstrations were wildly popular until about World War I, and barnstormers sold thrill rides for a while in the years after, but by the Great Depression aviation had become common enough that fair promoters had to look for other ways to pack their hayfield parking areas with Model T Fords. With the exception of the occasional staged train wreck or a stunt pilot crashing a Curtis Jenny into a barn on the infield, fairgoers were treated to the usual—but perennially popular—horse races, band concerts, vaudeville and circus acts, and, in the West, rodeos. Auto racing drew big crowds from its start at the turn of the twentieth century as brave drivers on noisy machines set and broke speed records on the fair circuit. By the middle of the century, auto racing—by then mostly "stock car" racing—had begun to displace horse racing at many fairs. Gambling on the ponies was frowned upon, if not illegal, in most states, and besides, equine lap times didn't improve year to year like those of the ever-faster automobiles. Tracks couldn't easily accommodate the racing of both horses and cars, and at many fairs, cars won out.

With the growth of youth participation in the early decades of the century, fairs gradually became more family oriented, and usually the first step was to squeeze out the morally questionable elements. Fair board members and concerned citizens worked to eliminate snake oil pitchmen, booze and beer, shell games and three-card monte, along with rigged carnival games and the hootchy-kootchy girls. Quiet resistance came from perennially cash-strapped fairs that depended on the income generated by the sin trade. The beer tent reappeared at some fairs after the repeal of Prohibition in 1933. It was always controversial

and always made money, though drunkenness was never attractive to families coming to the fair. Nevertheless, at least one fair sponsored a beer-drinking contest not long after suds regained legal status.

In good times fairs built new grandstands, exhibition halls, and show rings; bought land and expanded; paved walkways; and improved race tracks. In bad times they slashed expenses by hiring cheaper, often local, talent, relying more on volunteers, and holding on the best they could. Despite bad times in the Great Depression, some fairs put up new buildings with the help of the Works Progress Administration. Many of these sturdy halls still host exhibits today.

Fair attendance rose and fell with the weather, the economy, wars, and things as unrelated as polio and television. World War I, like the Civil War, brought the suspension of some fairs and an emphasis on patriotism in those that didn't close. Fairs stressed getting by with less, collecting scrap metal, and pulling for the doughboys over there. The Depression saw the cancellation of a number of fairs, especially in the Dust Bowl regions, but by all accounts those that held on through the dry years were important to farmers, ranchers, and townspeople. If nothing else, misery

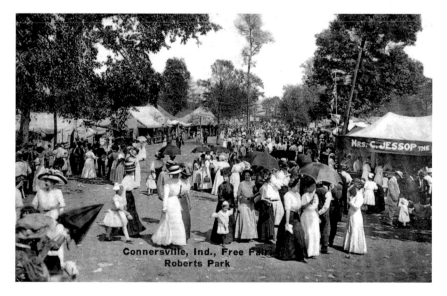

From the appearance of the well-dressed women in the postcard, this fair, now the Fayette County (Indiana) Free Fair, was the place to be seen in the summer of 1914. Caroline Jessop, "lady confectioner," holds a prime location for her tent, and business was no doubt brisk. Notable here and in many early fair photographs is the presence of litter. This fair is still held every year in Roberts Park in this now litter-free grove of trees that has grown more beautiful with passing decades.

Courtesy Charlene Hornung

loved company as poor-as-dust folks shook their heads at barely measurable commodity prices and outboasted one another on how little rain they'd gotten. Many fairs reverted to earlier patterns that emphasized simple agricultural, horticultural, and homemaking exhibits with minimal premiums. World War II brought more suspensions of fairs; shortages, including gasoline and tires, made getting to the fair difficult, if the county had one.

No sooner did the war end when the polio epidemic of midcentury frightened people away from crowds, especially during the highly contagious warmer months. Some thought cotton candy was the agent of transmission, but in any case many would-be fairgoers stayed home—and apparently many of them watched their fuzzy black-and-white televisions instead. Through the 1950s fair managers fretted that television was sapping fair audiences. But least one fair, the Saginaw Fair in Michigan, embraced the new medium. According to *Billboard*, the 1954 fair hosted a television studio in a tent that broadcast from the fair all day for the whole seven days. It must have been a gate booster because the fair planned to set up a bigger tent for the next year's fair.

Nor were outrageous events extinct. *Billboard* reported that in California the Calaveras County Fair planned to set off four simulated atomic bombs at its 1955 fair. According to the fair manager, fairgoers would have the opportunity to see at close range the effects of an A-bomb without the radiation hazard. If the event ever took place, *Billboard* failed to report on it.

By midcentury fairs were beginning to book musical performers, especially country music groups, in their grandstands to boost gate receipts. Vaudeville and circus acts were waning in the face of television, and, as always, managers and fair boards sought something new to fill the stands. The alliance between country (later, country-western) music and the fair proved beneficial for both industries. Country concerts acted as sort of a farm league for up-and-coming performers and as a potential money maker for fairs. By 1975 some larger county fairs had evolved into big-name entertainment venues with a still-important but lesser agricultural component attached, and many smaller fairs had begun to bank heavily on the income country-western, or occasionally rock, concerts could provide. During fair season, musicians packed their steel guitars and left Nashville and L.A. for county and state fair grandstands across the country.

By the 1960s the realm of women at the fair had begun to expand beyond floriculture and home arts areas as females appeared in small numbers on fair boards and in other positions of power. Many women, of course, had run farms and ranches and knew how to organize events, and gradually gender made less and less difference in key roles where eager volunteers are concerned. If you volunteered, you got the job. And today, perhaps as a reflection of the attitudes of rural people, no one turns a head when the pork judge or chief maintenance person turns out to be female.

THE COUNTY FAIR IS AS AMERICAN as, well, the county fair. Like fast food, fall football, the strip mall, blockbuster Hollywood movies, and jazz, the county-based agricultural fair sprang from American soil to become something peculiarly American, and ultimately to embody and stand for certain aspects of the nation itself. Though some of its components have roots in Europe, the county fair is a thoroughly American institution and thus reflects deep, often subconscious American values. Of course this isn't especially surprising since festivals and gatherings of all kinds develop in their source cultures to become defining elements of those cultures, ethnic groups, or nationalities. This is the main reason you don't find a Japanese *matsuri*, originally a festival to ensure a good rice crop, in the farmlands of Poland. The county fair became the county fair—and not something else—for historical reasons and for deep cultural reasons, American reasons.

Some American Studies scholars suggest that the things that are most *American* about America are things that move—Calder mobiles and road movies, for example—and things that have an unfinished, perpetually changing quality, like the New York City skyline. There is no master plan for this skyline, but it is a revered and eclectic whole comprised of individual and unique buildings. Not many people would argue that movement and a penchant for change and the unfinished qualities of things are peculiar to America. We probably don't really move around much more than people in other developed countries, but we seem to think about it more and have made it a part of our national character. As to change, it's no secret to any European visitor in any American city with its construction sites and roadwork that we don't leave things alone for very long.

(right) This Grange display at the Thurston County Fair, Olympia, Washington, speaks of fecundity and orderliness.

Fairs express their personalities in many ways, including their main entrance gates. Some are glitzy, some big and impressive, and some you have to open yourself. The main gate at the tiny Butte-Lawrence County Fair in Nisland, South Dakota, is closed because locals know to drive around back.

Of course, the county fair reflects these qualities. Even though fairs set up on the same fairgrounds year after year, movement is integral to several components of the event, especially the carnival. Most parts of the world have their traveling circuses and carnivals, but perhaps only in the States do they achieve the mobility and flexibility necessary to close in one town Sunday night at eleven, tear down, drive three dozen vehicles two hundred miles, set up in another, and have ten rides, eight games, and a half dozen food stands up and running for the next evening's crowd. Fairs exhibit movement in other ways as well. Americans, more than citizens of most countries, love motor vehicles and motor sports, and this penchant is expressed in manifold fashion at the fair in everything from the ever-popular demolition derby to kiddy car rides to the simple fact that almost everybody arrives at every fair by car, truck, or minivan.

Few places express Americans' eagerness for change and tolerance for unfinished space better than a county fairgrounds. Some of the worst look like perpetual construction sites, but even those with mature shade trees and well-worn exhibit halls always seem to have a building under construction, a new entrance gate, or at least a dug-up water line someplace. While many other harvest festivals around the globe might cling to their old buildings and appointments, those who run county fairs, from the presi-

dent of the fair board to the vegetable superintendent, talk about how next year they hope to build a new restroom building, put new stalls in the livestock barn, or add more parking. Of course tradition forms the core of the fair, but next year we'll be happy to have the seventy-five-year-old flower show in the new exhibit building. Fairgrounds are usually near—or just beyond—the edge of town in places where land is less valuable and zoning is less an issue, so there is often elbow room for dreams and follies. Why not move the historical museum out here? How about a county exposition center?

In a similar vein, most fairgrounds are near-perfect displays of American pragmatism, especially in their architecture. A century ago many fairs across the country, especially between Ohio and the Rockies, built barnlike exhibit halls, many on a cross floor plan, some topped with cupolas for decoration and ventilation. A hundred years later many are still in use, like Rogers Hall at the Vernon County Fair in Wisconsin. Today these buildings deserve their historic status, but at the time of their construction they were merely an adaptation of straightforward vernacular barn forms that provided maximum shelter for minimum cost. Unadorned, balloon-framed, gable-roofed, board-and-batten or lap-sided, whitewashed with big swinging doors on the ends, these buildings today provide a distinct old-fair feel and often stand as the traditional centerpiece of the fair. Similarly pragmatic, plain, cheap, and quick to erect is their modern equivalent: the steel-clad pole building that springs up on fairgrounds across the country in every size and for every purpose from restrooms to exhibition center.

However much the fair reflects its American development, it also reflects something larger about who we are. It is woven into American memory and consciousness—and not just our rural, agricultural consciousness, but somehow our core ideas about who we are as a people, or at least who we think we are, or maybe who we think we once were. The fair portrays deep American principles: the primacy of Jefferson's yeoman farmer; the virtue of manual work and practical education; the importance of home and family; the bonds of community across town, across the county, across decades, and once in a while across social classes and racial divides. And mixed in the dust of

every fairgrounds are consequent values: competitiveness, boosterism, volunteerism, and always the celebration of the bountiful harvest.

Many of these are old ideas, holdovers from the nation 150 years ago when the majority of American men and women spent their lives bent to the task of growing food for a hungry, expanding nation. Of course many of the central traditions and rituals of the county fair are quaint and out of date by cyberspace and cell phone standards—but that's part of the attraction of the fair. We don't go to the fair to check out the latest computer games; we go to see the farm animals. And what, after all, is the real purpose of a competition for the best pie? Very few of us bake pies anymore, or raise calves, or even live on real farms or ranches—but at county fairs coast to coast, people still flock through the gates every year, hauling pies and pulling calves in a cornucopic tableau worthy of Currier and Ives.

Larger cultural myths are at work here as well. At one Montana fair the rodeo opens with a historical procession rich with beautiful horses and period costumes, cowboys, Indians, dance hall girls, and sturdy pioneers with covered wagons. The moving montage replays the history of the "settling" of the West, beginning with the Indians calmly walking across and out of the arena, replaced by trappers, the cavalry, and finally homesteaders, never mind the thousands of Blackfoot, Crow, and other tribal members who have Montana addresses.

Historians trace the roots of our agricultural fairs back to European soil, to the great cattle fairs and cloth fairs of medieval times, but this seems a Eurocentric conceit. Periodic gatherings for trade, celebration, social exchange, and informal learning have likely occurred with all peoples as far back as the beginning of trade itself. For

Bolton Hall at the Cheshire Fair in Swanzey, New Hampshire, is a good example of the thousands of plain and sturdy barns built during the late nineteenth and early twentieth centuries on fairgrounds everywhere.

instance, events as diverse as the ancient camel fairs of India and prehistoric Native American trade gatherings bear clear similarities to American agricultural fairs. Rather than tie our agricultural fairs too closely to European ancestor fairs, it makes sense to see them as a natural result of people's need—especially that of dispersed rural people—to get together to socialize once in a while and exchange goods and information. Likewise the carnival grew up alongside the fairs of Europe and Asia, but it also seems a natural outgrowth of the ordinary human desire to be entertained and of the opportunity provided by a captive audience in a holiday mood. Thus the county fair is simply a logical manifestation of certain natural human desires cast in an American small town and rural agricultural mold.

The agricultural fair is a bastion of rural ideals, and it exists in large part to celebrate and perpetuate them. It expresses "old-fashioned country values" better than square dance, home cooking, country music, church dinners, rodeo, the country store, and the one-room school—largely because the county fair often corrals all of them into one big event. It is the greatest instrument in the nation devoted to the perpetuation of the idea that the country is a better place than the city. "No baggy pants here," one 4-H mother declared.

There's nothing very mysterious about rural values. They are well expressed by rural and agricultural people across the country, and are tied to our mythology of the Pilgrims, the sturdy pioneers, and even folks today living "off the grid" in the Alaska taiga. Any city or suburban person who's ever gone to the country cousins' place for the holidays could list country values, as could anybody who looks for the messages in the cultural display of the fair. A large part of the difference between city and country attitudes is certainly perception, not reality, reinforcing a kind of countrified mythology. After all, crime is no stranger to rural America, especially given the explosion of methamphetamine labs across the countryside, and there is no reason to believe that families in cities are less hardy than those on the farm. The real differences are much smaller than most New Yorkers and rural Ohioans suppose, and it's likely that some of the values of rural Ohioans—or Idahoans or Missourians—are a reaction to what they think are the values of New Yorkers. But there are differences nonetheless.

At the top of the list of rural values is the primacy of hard work, plus its calloused handmaidens, self-sufficiency and frugality. Those who put on the fair and exhibit in it are charged with strenuous physical tasks, and most take certain pleasure in them. Hardened hands put up livestock panels, erect the Tilt-A-Whirl, unload the animals, and set up food stands. There's detail work too. Hand-sewn quilts are prized over machine-sewn quilts not just because the former look better, but also because they're harder to make. Homemade pies and cakes, meticulously restored antique farm machinery, a vase of perfect roses all reinforce the idea that by working hard and long, you'll reap important rewards, including the usually understated admiration of your friends and neighbors.

Moreover, the work ought to start early. To those who abide by the ways of country life, mid-morning coffee comes at about eight. In the livestock barns, animals get fed and pens get mucked out early in the morning, and people notice who does it earliest.

Similarly, making do with what is at hand has always been an important rural value because of agricultural people's historical shortage of cash and the comparative remoteness of farms and ranches. Even today agricultural folks summon the John Deere mechanic only for serious things they can't fix themselves. At every fair, rows of home-canned green beans, an FFA welded fence

> "This is my fifty-third year. I started hustling the grandstands at nine years old. Programs, lemonade, popcorn in a Coke case— ya' know, put your stuff in there and hustle. Still do a little of it today. Right now I got one, two, three—three of my sons here. Got two on the grill, one's over there and my wife's on the register, and I sit here and watch."
>
> —Lou Santillo of Santillo Italian Sausages, Chautauqua County Fair, Dunkirk, New York
> •

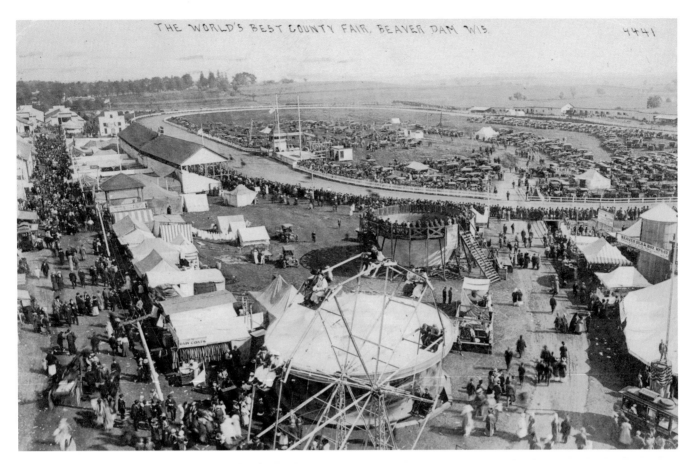

Judging by the crowds in this circa 1917 photograph, the Dodge County Fair in Beaver Dam, Wisconsin, was indeed the "World's Best County Fair." This postcard depicts all that was splendid about fairs of the era: a sunny afternoon, a crowded midway, infield parking packed with autos, a harness race in progress with spectators filling the stands and pressing against the track fence, a merry-go-round, Ferris wheel, food and exhibit tents, and, in the left background, livestock barns no doubt full of the best stock. At center, spectators line the rail of a "wall of death" motorcycle thrill show. Fair time was seldom so sweet.

Courtesy Wisconsin Historical Society. WHi–52403

panel project, and homegrown pumpkins all speak to the lessons of self-sufficiency and frugality.

At the Furnas County Fair in Beaver City, Nebraska, we found an entry in the junior "Furnishing on a Shoestring" category submitted by Sam Gillen, age eleven. His project rehabilitated an old wooden screen door, complete with gingerbread and turned details. Sam's text described the project: "I found this door in an old pig shed. Some pieces were missing, so my friend Raymond helped me make some replacement pieces. Then I sanded, painted, and screened. This will go on the front door of our house. Total cost: $13.60." On the project was a blue ribbon.

Wholesomeness is another rural value, one clearly expressed in scrubbed and well-mannered 4-H and FFA kids. Lots of rural and small-town people, at the fair and elsewhere, will tell you that the city, with all its congestion, noise—including rap music—poor people, and crime is an unlivable place, but out here in the country, it's quiet and safe. Never mind rural crime and rural poverty. A Norman Rockwell illusion is at work here, a harkening back to a traditional way of being a kid that does not include piercings and green hair. Parents speak of "good" kids, young people who know the value of real work, of "honest dirt" and extra effort. Rural boys often wear baseball caps, but the bills point forward, at least when their parents are around.

Agricultural people have long focused a great deal of attention on the home place, in large part because they both live and work there, unlike the commuter who split

Determined girls on sturdy horses are a common element at fairs coast to coast, but nowhere better than in the West. This duo cuts a fine image pole bending at the Johnson County Fair and Rodeo, Buffalo, Wyoming.

time between home and the office. This domestic focus shows up most clearly at the fair when livestock exhibitors bring a bit of home with them as they set up lawn chairs and cots among the animal stalls where the family lives, eats, and sleeps with the livestock for the duration of the fair. Hung overhead are fabric borders, bric-a-brac, and wooden signs that read Green Acres Angus or Johnson Century Farm. Home decorating crafts, canning, baking, and all the horticulture work from flowers to cucumbers also express the value of home. And over in the commercial building, the home focus is reinforced by vendors pitching siding, satellite dishes, insulated windows, spas, ever-sharp kitchen knives, and water filtration systems. Especially since the 9/11 attacks, rural, suburban, and urban Americans alike have turned more of their attention to their homes and their families, no doubt as antidote to what seems an uncontrolled outside world. Home improvement, gardening, and recreational cooking are increasingly popular as we turn inward to nest.

Reflecting a century-long trend, today's fair is a family-oriented place with activities designed for both genders and all ages. The fair not only expresses the wholesomeness of family but also emphasizes cooperation among family members. Kids work alongside parents in

The bright poster printed on cardboard has been an advertising mainstay of the fair industry, and this 1996 example continues the tradition. Farm animals and blue ribbons are ubiquitous symbols of the county fair.

Authors' collection

Subtlety plays no role advertising the fair. Nailed to utility poles, hung in cafe windows, and taped to the walls and windows of local businesses, posters work to draw attention in a busy world. This bright example is from Michigan, 1998.

Authors' collection

the local church food booth; nervous parents applaud from the bleachers during the ribbon awards for children's 4-H animal projects, everyone knowing that the kids did it with parents' help.

It's no surprise either that rural values are expressed in the homespun slogans that fairs often adopt, even if they sometimes seem to overlook the irony, as did the Elberton 12-County Fair in Georgia that one year touted "Farm Living . . . It's the Life" with no apparent recollection of the 1960s sitcom *Green Acres*. Eddie Albert, the TV would-be farmer,

sang "Farm livin' is the life for me!" and Eva Gabor, with her fine dresses and city attitudes, sang in counterpoint "New York is where I'd rather stay. I get allergic smelling hay!" Other catchy themes include "Our Field of Dreams Come True," "Blue Jeans and Country Dreams," "County Fair with a Country Flair," "Rural Magic," and so on.

Of course symbols of rural and agricultural life infuse the fair. Even at large fairs in urban counties, rural stuff reigns supreme, and countrified images and icons of idealized country life decorate every layer of the event.

Stroll through open-class needlework at any fair, for example, and look for the iconographic wall hangings of barns and windmills, often complete with sewn-on denim pockets stuffed with dried weed sprigs. Barns and windmills persist as the preeminent symbols of rural life despite their obsolescence almost everywhere, and blue jeans, whatever their popularity among urban folk, will always stand for country life. And we don't mean the fancy stone-washed ones either; real farmers and ranchers get theirs at J. C. Penney, stiff off the rack like frozen laundry off a December clothesline.

Many of these symbols are quite intentional and self-conscious, and others are a natural consequence of living outside town. A fair parking lot full of beefy and dirty pickups sends a rural message that one full of clean SUVs and minivans does not. The split-rail fence—another obsolete but enduring symbol of rural life—appears on quilts, in 4-H photographs of the home place, and in blue-ribbon paintings, and it does so at fairs in regions of the nation that have known little but barbed wire throughout agricultural history. While country-western music—always popular at the fair—laments the lost dog and the loyal pickup, it also sings of a home in the country far from the noise and discomfort of the city. Sunflowers (real, tatted, drawn, photographed, and painted) show up in the horticulture department and in the arts, while pigs (real and otherwise) laze in their stalls and smile down from the sign on the pork producers' food booth, and jars of homemade jelly, always a sign of rural life (who in the city makes jelly?), draw admiring, would-be jelly makers.

Look for decorated rural mailboxes, Amish-style quilts, cowboy boots (seen coast to coast), farm machinery (new and antique), and a hundred other symbols of rural life. In fact, we found the presence or absence of new farm machinery to be a useful indicator of the "agricultural-ness" of a fair. If equipment dealers go to the trouble to bring tractors, cotton pickers, or combines to a fair, it signifies that real farmers and ranchers (and not just five-acre "farmette" farmers) walk the grounds and might sniff around toward making a big equipment purchase. Fair managers know that having real agricultural machinery on the grounds sends a strong message about the nature of their fair, and they lobby hard with dealers to get them to haul equipment to the grounds.

While we saw western wear and western ways even at fairs in New England, these traditions deepen west of the Missouri River and in parts of the South where rural means cowboy or rancher rather than farmer. In these parts, blue jeans bear the worn pocket circles left by chewing tobacco tins, pickups have hat racks, and shirts on both men and women often sport pearl buttons. But watch for backlash. One western-dressed Colorado fair organizer told us he wears tennis shoes so he won't be mistaken for a truck driver.

The fair, of course, has its own symbols, an iconography of the institution itself. In the weeks before the hometown fair, local promoters hang posters in the cafes and grocery stores; they buy billboards and newspaper ads and in many county towns paint up the store windows on Main Street—or at the mall—to announce the big event. In Moses Lake, Washington, for example, festive paintings of rodeo bucking chutes and leaping broncs appear on the windows of the downtown furniture store along with fair dates for the Grant County Fair. Nearby windows sport the Ferris wheel, merry-go-round, and carnival ticket booth.

Allowing for regional variations like rodeo in the West, these visual elements are similar from coast to coast. Images of livestock show up often, as do blue rosette ribbons and the Ferris wheel, unless there won't be a carnival. On any poster a blue ribbon plus a Ferris wheel plus a pig equals a county fair. Food? Look for pies, jars of jam, maybe corn dogs. Sometimes older elements of the fair make an appearance in ads and on flyers: triangular pennants flying from the grandstand; the horse race; a cornucopia of fruit, grain, and vegetables. Often in the center of the poster is the happy family at the fair: mom, dad, two kids, all smiling broadly, often carrying balloons. Some posters will feature the scheduled country-western or rock performers. Once in a while the demolition derby even makes an appearance, but seldom the sideshows.

Mixed in with the cultural symbolism at the fair is a strong current of volunteerism, which many fairmakers and fairgoers contend is a rural or small-town value. But Americans from all kinds of places—dense urban centers and suburbs included—like to be of use, and we go to great unpaid lengths on behalf of the local symphony, the soccer club, the historical society, and, in particular, the county fair. It's no secret to anyone involved with any fair that the majority of everything that gets done before, during, and after the event is accomplished by people doing it just because they're committed to the fair's success or because they've been cajoled into doing it by a neighbor who's on the fair board. Probably every fair in the country depends on donated labor, equipment, materials, and supplies, and the smaller the fair, the more vital that support. Few fairs would long survive without it.

But it's hard to pin down people's motivation for putting in the long hours. Ron Clark, fair board vice president in Howard County, Maryland, says: "I simply like it. Why do people play golf? I like doing things and seeing things happen."

The Adams Agricultural Fair in Adams, Massachusetts, carries on despite a three-inch rain.

But a woman hard at work frying chickens for the church dinner at the Fayette County Free Fair in Connersville, Indiana, puts it best: "If you're on this committee, the only way you can get off it is to die."

We saw this can-do attitude at fairs across the country, but perhaps no place better than at the Adams Agricultural Fair in Adams, Massachusetts, where we arrived shortly after a three-inch rain.

"It's become kind of a joke," says Pat Wojcik, president of the Adams fair board. "Every time aggie fair weekend comes about, it rains. We're talking about selling raincoats next year." We stand with her in one of the lesser puddles near a sign that reads "Duck game 25 cents a chance—everybody wins!" The neglected plastic ducks are unruffled, but the mud surrounding their wading pool is a considerable deterrent to any fairgoer.

The rain matters more to the Adams fair than most because almost everything happens outdoors or in tents; it has but one permanent building. Today the fairgrounds have disappeared beneath deep puddles dotted with muddy islands.

Concessions manager Chuck Felix squooshes over to talk. His pants are wet to the knees. "Last year, the band left about eleven o'clock, and it had been pouring all

night," he tells us. "One of the farms down south county had brought rare turkeys and sheep. We looked out and they were on a little island with the water gaining on them, so we waded out, got them off the island and into the barn. They didn't want to go. We carried them. There were four of us running around all night keeping the tents up. At that little duck game, the water got so high, the ducks floated out of the pool. We watched them float all the way down the swale and caught them at the other end.

"By morning we were ready to go again, just like nothing had happened. It was great. Ten years of rain we have endured. We are little, and we can survive anything. Today we got three to four inches in four hours, plus we got it all from everywhere else. It just kind of rolls off the mountain. We get used to it after a while. The people who come here are good. They don't worry, they all work together.

"The first year of the fair, we had a major storm the night before opening day. We had no grass—this was all fresh fill. I woke up; I was sleeping on the dance floor. I didn't want to look out. All the vendors were under water. All of a sudden we heard horns. Three of the construction companies in town sent their vehicles. They dumped gravel, they had graders. They knew what was going on, and they fixed it. By nine o'clock we were ready to go. This community is really good at pulling together. Make do with what you got. You can't worry. The sun will come out."

By now nearly every kid and many adults have stripped off shoes and socks and have simply adjusted to the situation. Fair volunteers have laid planks across the bigger rivulets, and the rabbit tent has seen an astonishing spike in traffic because it happens to be on the least wet path across the fairgrounds. And it is getting a bit lighter above the Berkshires to the west.

Chuck talks about how far this fair has come since its establishment in 1974. "This is all fill; it was a swamp. The town gave it to us for one dollar for twenty-five years. The barn was donated by a guy redoing his property. A bunch of people took it down and brought it here, and we put it up. The Masons in town came down and put on the bathroom addition. Other companies gave us telephone poles, laid water. We have an electrician who takes his vacation time to work with us. He's down here, and he doesn't charge us. It is like a barn raising, but it is a 'fair raising'—and it is continuous. Now we are looking at putting up another building next year."

WHEN WE SET OUT ACROSS THE COUNTRY to discover the nature of the fair, we figured that county fairs would be clear expressions of local agriculture, horticulture, and just plain culture. They are to an extent, but what surprised us was the similarities fairs share from coast to coast. A county fair in Georgia, for instance, looks and feels a lot like one in Oregon, and nobody would mistake it for some other kind of event. Part of this family resemblance has to do with the nationwide spread of the fair from the same New England rootstock, and a larger part has to do with the many national organizations and publications that shape fairs and their events. From the International Association of Fairs and Expositions (IAFE) to such organizations as FFA (formerly Future Farmers of America), plus breed associations, horticultural groups, and federal agencies, including the Department of Agriculture, lots of national groups help shape the fair. If the fair in Montana reminds you of the one you visited in Texas, it's because 4-H, among many other groups, has a national program with national standards and practices. Thus, to our surprise, we found dairy heifer competition in western South Dakota, which is a long way from where dairy matters very much. Almost every person who helps put on the fair—sheep judge, dahlia exhibitor, saddle bronc rider, Kirby vacuum salesperson, pizza vendor—has a national organization that at least in part guides his or her efforts.

Of course fair boards and fair managers have their own organizations and publications. IAFE's *Fairs & Expos*, the leading outdoor entertainment trade publication, brings news of the fair industry and tracks news and trends in the likes of big-name grandstand entertainment, insurance, security, and health and safety regulations. Fairmakers also depend a great deal on regional fair organizations, like the Western Fairs Association, and the many state organizations, like the Illinois Association of Agricultural Fairs, to host conferences, fair tours, and contests, and as a venue for fair managers to share innovative practices that boost gate receipts, increase entries, amplify promotions, and even improve parking.

What individual fairs have is distinct personalities. They are the result of regional geography, especially that of agriculture (cattle, peanuts, wine), plus the spice of ethnic tradition (Basque, Norwegian, Polish) and the imprint of the vision of individual fairmakers who have long guided a given fair. Simple geography determines what grows where, and therefore to some extent what shows up in the premium books and at the fair; local ethnicity gets expressed in the food offerings and the open class exhibits. Fairmakers with particular skills or interests, especially

At fairs everywhere, regional variety is expressed by food, the competitive categories in the premium book, and events. Harness racing continues to be popular in Indiana, where good weekend races are a hallmark of a good fair. Elkhart County 4-H Fair, Goshen, Indiana.

long-serving board members, have a pronounced effect. If the fair has a Johnny Appleseed, the grounds will be shady. If the board has preservation-minded members, fairgoers will find whitewashed board-and-batten exhibit halls instead of new pole buildings.

County fairs are wonderful places to explore the nation's regional variations because fairs exist in part to celebrate them. We expected to find corn in Iowa, okra in Georgia, and wild blueberry pie in Alaska—and we did, but that's only the beginning. We found severe weather instructions on the restroom doors at the Winona County Fair in Minnesota, logging equipment in Oregon, plenty of Appalachian crafts in, well, Appalachia. Rodeo gets clear to the East Coast, but for the full effect, you've got to be west of Kansas City. In Alaska at the Deltana Fair, we found prize-winning mukluks and open class categories for canned razor clams, fireweed

honey, pickled grayling ("keep refrigerated"), and canned moose meat. And it must be the only fair in the world that has the Alaska Pipeline crossing its grounds. Fairs in Wisconsin and elsewhere exhibit plenty of ethnic variety. In Vernon County, Wisconsin, settled largely by Norwegians, we found seven entries for lefse and several plates of perfect sandbakkels. Under class G of open class, the premium book lists a category for Nationality Cookies, which must be "other than Norwegian."

Of course foodways express regional differences. To no surprise we found porkburgers in Nebraska, Asian stir-fry and wine tasting in California, southern-cured hams in Missouri, and salmon barbeque in Washington. Foodways are sometimes ethnic, like the Dutch olie bollen, or "fat balls" (we found them in cherry, vanilla, chocolate, and lemon) at some Michigan fairs; sometimes regional, like boiled peanuts

in Georgia or brisket barbeque in Texas; or sometimes local, like Lerch's Donuts found only in Wayne and Holmes counties in Ohio.

The food tastes of fairgoers vary as well, and within a short range. Jay Jessop sells butterscotch corn at fairs in the Midwest. When we ran into him in Indiana he offered his perspective: "Now you go to Ohio or Michigan—it's french fries! Oh, they kill them with french fries. It's amazing. Every state has its thing—well, like in Wisconsin, what is it?—cheese curds. You couldn't give a cheese curd away down here."

Open class and 4-H entries express regional identity as well. The Curry County Fair in coastal Oregon, for instance, has a category for the best plate of pinecones. While many photography entries revel in scenery seen on vacation in Hawaii or Disney World, paintings tend to be done closer to home. At the Howard County Fair in Maryland, the two-dimensional art show included drawings and paintings of the White House, the Statue of Liberty, and colonial houses. In the West look for desert scenes and cowboys; in Maine you will see lighthouses, lobster traps, and moose.

Perhaps the most evident—and enjoyable—example of regionalism we found is the "dairy-ness" so fully manifest at the Sheboygan County Fair in Plymouth, Wisconsin.

In 2000, according to the USDA, some 1,365,000 Wisconsin cows produced more than 2.0 billion pounds of cheese and 2.7 billion gallons of milk, putting the state first in the nation for cheese production and second only to California in milk production.

If fairgoers didn't know Wisconsin was the Dairy State, they'd figure it out quickly at the Sheboygan County Fair. Not only were the barns full of Holsteins, but cow and dairy images were also everywhere. The back of the junior premium book sports a rosette ribbon that bears a pitcher of milk, a wheel of cheese, an ice cream sundae, and a stick of butter. Guarding it all is a stern Holstein cow. Then there is the food. It's easy to find the usual in fair food, including ice cream, but milk seems more prominent on menus than at other fairs, and the Lions Club sells toasted cheese sandwiches. Another stand offers "Hot Wisconsin Cheese," including mozzarella fingers, cheddar nuggets, and jalapeno cheddars at $4.00 per basket. At the Farm Bureau booth, cream puffs jump off the trays at $1.50 a piece, and what everyplace else are called funnel cakes or elephant ears are "cow pies" here, not that the name diminishes their curb appeal in the slightest.

The fair's milking parlor is painted Holstein white and trimmed in black, and it sees a parade of cows for morning and evening milking. After evening milking comes the Milk Mustache Contest. When we visited, there were enough entries for four age divisions. A local dairy donated the milk, while a national cheese producer donated prizes, including little packs of cheese and crackers called Moo Town Snacks. Contestants sported Holstein-spotted attire, and after a rousing "One, two, three, drink!" the winner in the women's division took home a matching set of oven mitts in Holstein black and white, while the winner among the men took home a cap from a dairy genetics firm embroidered with—no surprise—a Holstein.

> "I would bar the gates forever to gamblers, jockeys, whiskey venders, and oleo-margarine frauds, and leave reptilian monsters, with acrobats, pigmies and fat women to the showman, Barnum. Then write over your portals, dedicated to art, animal industry and agriculture."
>
> —J. B. Grinnell, at the dedication of the Iowa state fairgrounds, ca. 1886
>
> •

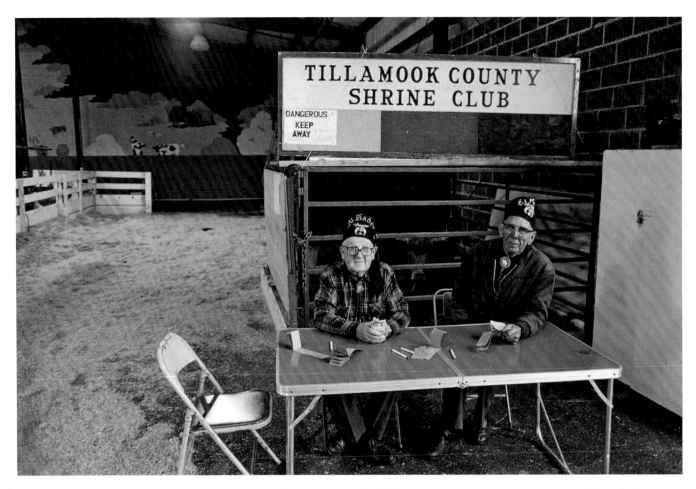

Lloyd Adams (left) and Robert Swenson don't look especially dangerous, but the bull behind them may be. Tillamook County Fair, Tillamook, Oregon.

7. Fair Stories

*The fair is something special in the county. In spite of
all the talk about improving agriculture . . .
it is a pagan outbreak.*

—Sherwood Anderson, *The American County Fair*, 1930

THE NAMES THEMSELVES SPEAK OF AMERICAN-NESS, of a wide land, a complex past, and national icons. Take the Chautauqua County Fair in Dunkirk, New York, for instance. Cooled by breezes from Lake Erie, this fair and its name echo that American festival less enduring than the county fair. Amid Wisconsin's lexicon of Native American place-names is the Calumet County Fair (*calumet* meaning "ceremonial pipe") in dairy-rich Chilton. At the end of a line of place names scattered by Daniel Boone is the Boone County Fair in Columbia, Missouri. In the rolling grassy hills of northern Kentucky is the Bourbon County Fair and Horse Show in Paris; across the mountains is the Union County Agricultural Fair in Union, South Carolina, likely named for uniting church congregations in antebellum America and not sympathy for the Union cause in the Civil War. Far to the west in

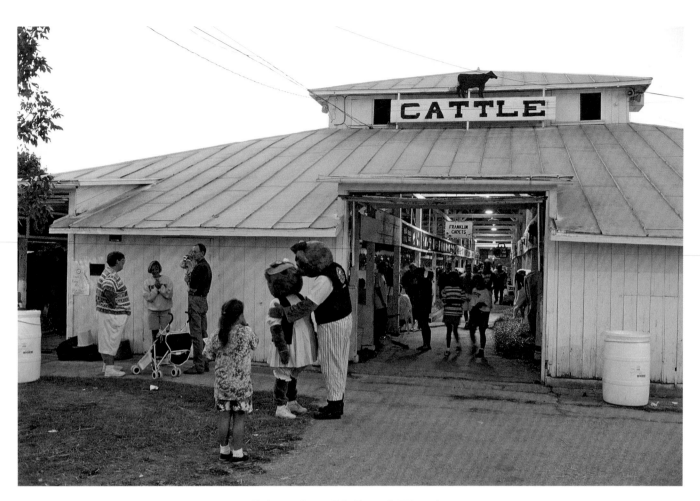

Sheboygan County Fair, Plymouth, Wisconsin.

southern Wyoming, where sweet water is uncommon, the Sweetwater County Fair celebrates in the dry sagebrush north of Rock Springs. Near the Jersey shore is the Atlantic County 4-H Fair in Egg Harbor City. Named for a Sauk chief is the Appanoose County Fair, Centerville, Iowa. American place-names also emerge at the Placer County Fair, Roseville, California, named for gold rush mining; at the Cottonwood County Fair, Windom, Minnesota; and at the Jefferson County Fair and Rodeo, Madras, Oregon, where their motto one recent year was "The West Is Simply the Best."

TO GET THE FULLEST POSSIBLE SENSORY IMPRESSION of a fair, ride the little rubber-tired train that medium and large fairs employ to lug tired kids and retirees up and down the midway from one side of the fair to the other. There are no bad seats, and your feet will thank you for the rest.

At the Sweetwater County Fair in Rock Springs, Wyoming, the sign says Funland Train Rides, and the John Deere lawn and garden tractor, festooned with American flags and a serious fire extinguisher, pulls a handful of little cars done up with canopies, frills, and familiar cartoon characters. It moves at the pace of a senior horticulture superintendent after a long day on her feet. It passes through spheres of sound and scent that rise, blend, and fade as the midway spectacle passes like a nineteenth-century panorama scrolled from

one spindle to the other before a rapt theater audience.

It's early evening, and in twenty minutes the Taylor Dayne show begins in the grandstand. The large crowd is dressed country western with plenty of jeans, light straw hats, and showy belt buckles. A few gather to watch an eager kid riding his BMX bike up and over a well-dented Camero. The overblown announcer echoes off surrounding buildings: " . . . having a great time—I'd like to thank everybody for coming out—thank you very much!" Our train angles between the livestock barn and a vendor who hammers at metal cutout silhouettes of slouching two-dimensional cowboys, all in black. In slow motion we pass a little girl standing stunned in the middle of the midway, forgotten sucker in her hand. Expecting her to drop it, we watch with keen interest until she is swallowed by the crowd. We weave among stalled fairgoers who've just run into old neighbors, classmates, and friends they've not seen in years.

Here's the stand that sells potato guns, then one for ice cream cones at $1.50; on the right are bio-stimulants and the turkey shoot for the Rock Springs Lions Club where a guy in a green shirt helps a little girl aim an air rifle at a cardboard turkey downrange. We pass the Thai Chinese Barbeque stand and a guy holding a Polaroid photo of himself with a tiger, and then on the right, Oregon Trail Catering, which features frozen bananas dipped in chocolate and nuts for $1.50. Weren't they important trail fare in the 1850s? As we pass, people stare at us like we're in the freak show, but they're only hoping to spot old friends. The next sign says "Indian Style Tacos and Elephant Ears," and in the crowds at the stand-up tables is a boy struggling to eat an elephant ear without letting go of his new squirt gun. Then we see a vendor selling straw cowboy hats in lurid purples and reds and greens, complete with feathers. "We're going to see the whole fair," says a woman to another. A balloon pops, and Mom says, "oh-oh," awaiting a delayed cry from her youngster.

We pass the McDonald's NASCAR simulator, complete with yellow arches on the hood, where you can take a spin for two dollars. Next, we go by two obviously drunk men who stand and try to look sober, then the local ambulance, complete with stiff mannequin on the stretcher. The milling crowd stares at the dummy, oblivious to the happy balloons on her IV pole. We turn down the south alleyway, now past a tent selling custom auto grill covers, another selling Cat in the Hat hats decorated with marijuana leaves. Nearby is a booth for the local National Weather Service office, staffed by meteorologists in crisp polo shirts. The long line for beer tickets starts under the sign that says "16 oz. Beer, by the Pound, $2.50." Then spray-on truck-bed liners by Rhino Linings—this is Wyoming after all.

The deep beat of an unrecognizable pop song rises as we approach the karaoke tent, accompanied by the blurred words of a woman vocalist sure of neither the words nor the tune. Then we pass the auto dealers: Chrysler, Pontiac, Chevy, GMC. The pickups draw the best crowds. Now we move past the livestock barn and arena where the announcer's muffled words reverberate in the noisy crowd. Some guy yells, "Hi there!" to an old friend; they shake hands and slap each other's backs. Next we pass a vendor with decoupage wooden clocks cut in the shape of arrowheads and done up in bright Indian motifs: the brave on his pony, lances against the sunset, wolves, a couple bison with Indians.

The little train enters a cloud of dust that hides the petting zoo where little kids mix it up with goats and rabbits, and where parents along the fence wonder about the nearest place to wash little hands. Then we move past the Old West Town, temporarily a ghost town but nonetheless the scene of a dramatic shootout forty-five minutes ago. The false fronts face Karen's Tie Dyes, Incense, and Silver Jewelry, and soon we pass the National Guard tent patrolled by several camouflaged young men and women; the spa dealer; Greek Gyros; and just before the end of the line, the booth for Action Mobile Home Brokers. It's fair time.

> "Actually, to be as bad as we are out there, you gotta be pretty good."
>
> —Rich Slingerland,
> performer with the Indian River Olde Time
> Lumberjack Show at the Boonville–Oneida
> County Fair, Boonville, New York
>
> •

IT'S LATE SATURDAY AFTERNOON, the last day of the Great Bedford County Fair in Bedford, Pennsylvania. Along

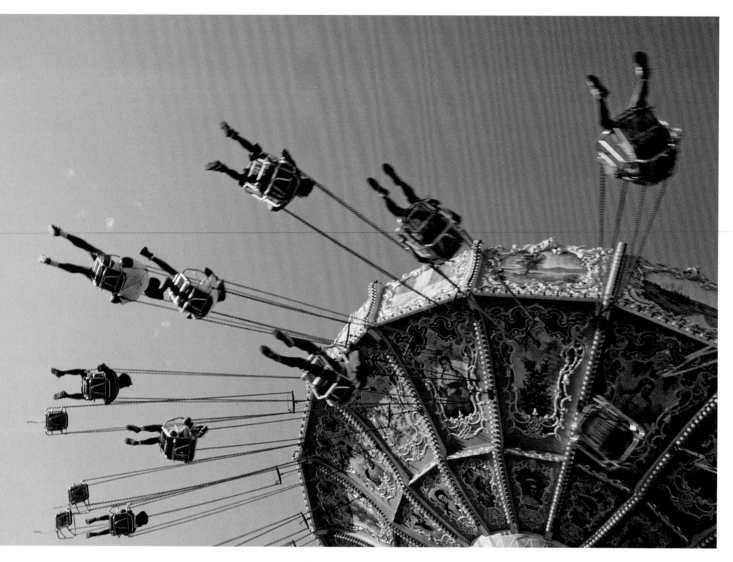

Placer County Fair, Roseville, California.

the north side of the fairgrounds, the racetrack pinches up against the highway, leaving a single path for people to cross between the midway side of the fairgrounds and the aggie side. It's a good place to talk to people and learn about why they come to the fair.

A boy of about seventeen wears an Adidas cap pulled low over his eyes: "The rides, I guess," he says, looking at the ground.

A family of four passes next. Dad is excited about Lee Roy Parnell's country music performance, which just ended. "The show!" he exclaims. Mom puts in, "And the horses . . ." Dad breaks into song: "A horse is a horse, of course, of course . . ." Mom and both kids attempt to silence him with dirty looks.

Tom, a former carnie, ambles by. He says his wife can tell it's carnival season when he starts to get restless. He wears a sleeveless black T-shirt emblazoned with a truck and an eagle. It reads "American Pride." His gray beard fills his face; above it rests a Confederate-style leather cap.

"Well, I used to travel with them. When I got married the second time, I quit. Then I moved here to Pennsylvania and started helping set up and direct traffic, and I worked with the rides. And then I quit it. Now I just come up on Saturdays to see if I see any old friends. I

FAIR STORIES

take care of a beef farm, so I come on Saturday for the beef sale and then stay until it closes." Tom talks about how the carnival has changed and how people don't act respectfully toward one another, don't help one another as they used to. In some ways he'd like to be back, but the carnival has changed so much it doesn't appeal to him. He sports beads around his neck and has a spider tattooed on his left hand between thumb and forefinger. "But I like the hot sausages."

Katie, ten, and her sister Kimberly, seven, exclaim about the funnel cakes and candy apples. Katie wears a daisy crown made at the nature tent, and both girls wave caramel apples as they talk. Their dad, Cecil, says of himself: "Dad's at the fair under duress. He made a deal with Katie yesterday that we would go to the fair if she would help pick up potatoes this morning. We harvested about sixty or seventy bushels of potatoes. She helped picked them up, so at three o'clock we signed off and I said, 'Now it's my turn to honor my part of the deal.'" They operate a small truck farm. "Vegetables are really a minor crop here. This area is heavily oriented toward dairy and beef. Besides me, there are probably only three or four serious vegetable growers in the whole county. And I only have twenty-five, thirty acres."

We ask about Mom.

According to Cecil, "She decided her relaxation was to stay at home."

Katie pipes in, "She's missing a lot."

"She certainly is," Dad replies. "She could have a candy apple too, if she were here."

Little Kimberly puts in that "we might bring her home some cotton candy."

Cecil tells us he works in a hospital laboratory but is "a farmer by generational default." His kids are the seventh generation on their farm. "We have agricultural roots a hundred miles deep." But there are limits. He describes how earlier this spring

Katie had wanted to raise a pig. They responded to an ad that said, "Six pigs for sale," but were too late. Today they walked through the pig barn, and Katie, taking big sniffs, said, "It kinda smells in here, Dad." He replied, "That's the pigs." After some thought Katie responded, "Maybe I don't want a pig."

Ingham County Fair, Mason, Michigan.

What horses think about at the Clatsop County Fair and Expo, Astoria, Oregon.

Cecil says it was well worth the admission price of eighteen dollars just to go through the pig barn and have his daughter convinced she doesn't want one.

Next comes Sue, about forty, with a big ribbon in her hair. "It's somethin' different other than shopping. But it goes up in price every year. I think it's expensive to come here for what you see. I think the games are expensive. After all, all you get is a piece of junk. My favorite is the country-western singers."

A five-year-old girl wearing pink star-shaped sunglasses struggles past, pulling her mother by the arm. "We came to see the animals," says Mom. "She's been pestering me all week to come and see the animals." The girl doesn't so much as glance up as she hauls Mom off toward the animal barns.

Nearby four girls of about sixteen years stand close and look around like nervous deer. All wear cutoff shorts, T-shirts, white socks, and athletic shoes; all have their long hair tied back in ponytails held by carefully chosen hair baubles. They look left and right as if they are worried about wolves, or perhaps eager to see them. Why do you come to the fair?

"Guys," says Angela.

"Guys," says Betsy.

"Guys," says Stephanie.

"Guys," says Alyssa.

Have you seen any?

"Some of my ex-boyfriends," puts in one.

Do you do anything besides look for guys?

"Ride the rides, pet the horses," says one. "Eat. Guys. Food and rides."

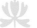

THE VEGETABLE DOLL COMPETITION turns into a horror show after several days in a sun-baked exhibit building. Here, on a butcher paper–covered table, some two dozen figures assembled out of vegetables and fruit decompose—and not so slowly at that. Here's Mrs. Butternut Squash, who sports a first-place blue ribbon. Her nose is a red chili pepper, her ears are peapods, and her hat might once have been a mushroom. Around her ample girth hang the brittle shreds of a lettuce dress. Nearby leans an eggplant chap with a green bean smile and a jaunty Scottish tam made from the top of a red pepper. Close by is a cucumber guy with a small red cabbage head, bent over at the waist, his little cabbage face pressed hard into the white paper. A bit of ooze trickles from the end of his cucumber.

Those made of hardier vegetables are holding up pretty well, but anything with a cucumber spine is now bowing like a guest at a formal Japanese dinner. Most are at least leaning, a good many are leaking, some have escaped altogether, toppling off their posts onto the floor with a splat. Anyone with lettuce, cabbage, or tomatoes is getting icky; some are in advanced states of decay. Fairgoers pass quickly, looking only at the floor to avoid stepping in something. There are wrinkles, flies, puddles, moths, and effusions. And it's beginning to smell like garbage.

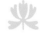

ON THIS THURSDAY NIGHT OF FAIR WEEK, the grandstand show is the local show choir called Spirit of Youth. At precisely 8 p.m. some twenty high school boys and

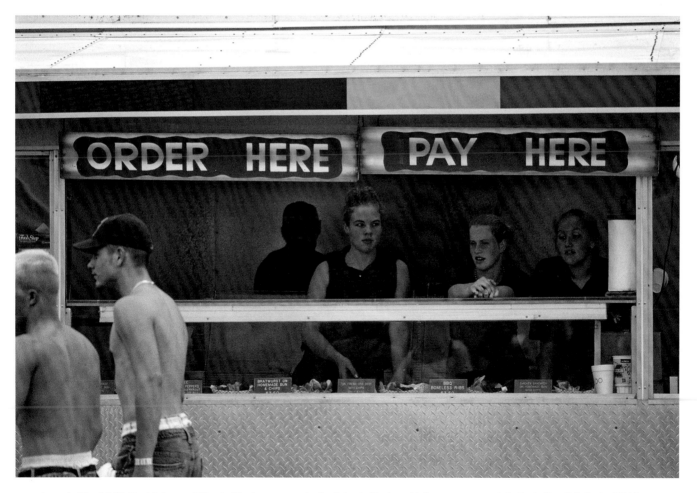

Amanda Blood (left), Roni Sober, and Manda Ward are momentarily distracted by two shirtless young men at the Ionia Free Fair, Ionia, Michigan.

The Familee Thriftway precision shopping cart team, self-proclaimed as "Wyoming's Number 1 Grocery Cart Marching Team," perfects its moves the day before the Lincoln County Fair parade in Afton, Wyoming.

girls in costumes of lime green, mustard yellow, and hot pink, loud with plaids, stripes, and polka dots, take the stage for their program called Seize the Day. As they start their act, it's instantly clear the temporary stage has a serious soft spot at center right. The crowd stiffens as the stage heaves near to the point of folding and the microphone stands swing like telephone poles in a big earthquake. The kids, for their part, sing, jump, and windmill in unison, ignoring their impending doom with undimmed enthusiasm and radiant smiles.

As they segue into their second number ("Beautiful Life"), it's clear this is a serious problem, and scurrying is evident among Spirit of Youth crew members in crisp shirts and clean haircuts, among fair security people in orange hats, and fair board members in their blue shirts and blue hats. They converge at the right edge of the stage and disappear beneath it like dogs under a porch as the troupe emotes and carries on above. During the third number ("Somewhere over the Rainbow"), the lurching becomes so radical that a microphone stand tips and plunges down the stage steps, adding great concussions to the sound mix. By now, of course, nobody pays any attention to the performance; all eyes focus at stage right as lumber and tools arrive.

By the fourth number ("Look to the Rainbow") the crowd is treated to heavy hammering broadcast through-out the fairgrounds via the concussions picked up by the microphones. During the next song ("There's a Rainbow 'Round My Shoulder") a truck with lights on top races up, disgorges a couple big guys—Atlas types—more lumber, and a chainsaw. Can the show go on above the roar of a chainsaw under the stage?

The performers sing, strut, leap, and turn about the stage to the counterpoint of heavy construction, then form a circle, pass colored scarves to the right, to the left, to the right again. The crowd can see the stage is no longer in danger of outright collapse, and the performers regain a modicum of the audience's attention. Meanwhile, the workers are emerging from under, mixing their bright hats and shirts with the costumes of the performers as they enter and exit via the stage stairs. By the time two performers stand center stage and belt out "Anything You Can Do," the emergency carpenters have assembled in a knot near the stage with their arms crossed, looking satisfied with themselves. Seize the day indeed.

IN THE CUTOVER WOODS JUST OUTSIDE Delta Junction, Alaska, within sight of the snowcapped Alaska Range, is the Deltana Fair. The Alaska Highway ends in Delta Junction (or begins, if you have Alaska plates), and every year the fair closes a short stretch of the adjacent Richardson Highway for the parade. The Alaska Pipeline crosses a corner of the fairgrounds (it's below ground in these parts), and the cleared strip makes for good parking during fair week.

More important around here than oil are blueberries, wild Alaska blueberries. At fair time they grow thick along the roadsides and deep into the bush, free for the picking by Alaskans both human and ursine. We are told you should talk loud and bang your blueberry pail to warn the bears. The Deltana Fair exhibits lots of Alaska flavor in exhibits and competitions, but blueberries are to this fair what dairy is to a fair in Wisconsin.

In the Lions Club building, volunteers have finished

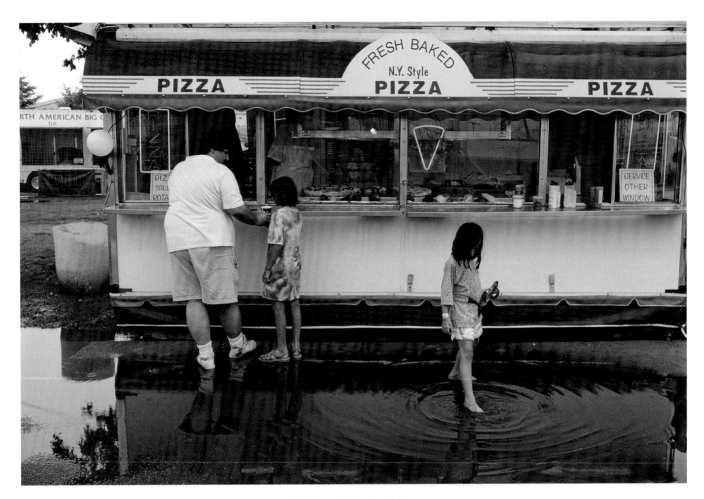

Ionia Free Fair, Ionia, Michigan.

cleaning up this morning's pancake breakfast, and Anne Mauer, superintendent of the wild blueberry pie contest, lays out her tools: knife, spatula, paper plates, and forks, in preparation for the judging, which starts in ten minutes. She tells us contestants must use only wild Alaska blueberries, not store-bought. Wild blueberries are not sold in stores and must be picked. "It's easy to tell," she says. The wild ones are smaller, tarter, and a lot more flavorful than cultivated berries. One year a submitted pie was made with cultivated berries. It was obvious, and it was disqualified.

Anne has won the contest four times since 1988 but no longer enters and has volunteered to be superintendent because she overheard someone say, "Well, if Anne Mauer is going to enter, I'm not going to." Though Anne took it as a compliment, she wants others to participate.

She tells us that a few years ago a traveler camping in the area heard about the wild blueberry pie contest on the local radio station, picked himself a pail of blueberries, rolled out the dough with a Coke bottle, baked his pie in a camp oven, brought it to the fair, and took second place. Anne called radio personality Paul Harvey, who mentioned it on the air.

Turning to us she says, "How about hanging around? Since you're not from town . . . and we might need another judge."

"Carol would be a *good* blueberry pie judge," says Drake.

"Well, I asked at the tourist information center if they would look for a tourist coming through who was going to stay for a while who would be a judge for us," says Anne.

"We're writing a book about county fairs. Carol is an expert."

"Are you really?" asks Anne, turning to Carol, who smiles weakly but does not protest. "Oh, this could be a nice addition to that!"

Drake gives her our card. The other two judges show up. "We have five minutes to go before judging," says Anne.

She introduces us to Roy, mayor of Delta Junction, and to Dave, a local bank manager. Dave is a big guy who regards the three entries on the table with interest. The wild berries are late this year, so entries are down. These are expert-made pies. One perfect crust bears cutout holly berries and leaves, another curved flowers, the third an outline of the state. Anne explains, "The champion gets a fifty-dollar prize and the gold pan. Second place is only a ribbon. The pies will then be auctioned off. I was hoping my husband would do it." On the table near the pies is a polished gold pan—a gold-panning pan, not a pie pan—engraved with "Deltana Fair Blueberry Pie Contest 2000."

With the precision of a Westminster Kennel Club judge, she explains the four criteria for judging: appearance, texture, taste, and cutability.

"Cutability," Anne explains, "means how the filling stands up to the piece, whether it runs out, or whether it is nice and firm. We are going to turn the piece of pie over so you can look at the crust. The bottom crust must be done. And then finally, you are going to taste it. Now I have forks, knives. I have water here in case you want to—cleanse the palate," she says with false gravity. "I'm sorry I don't have any sherbet."

Mayor Roy has begun to take a genuine interest in

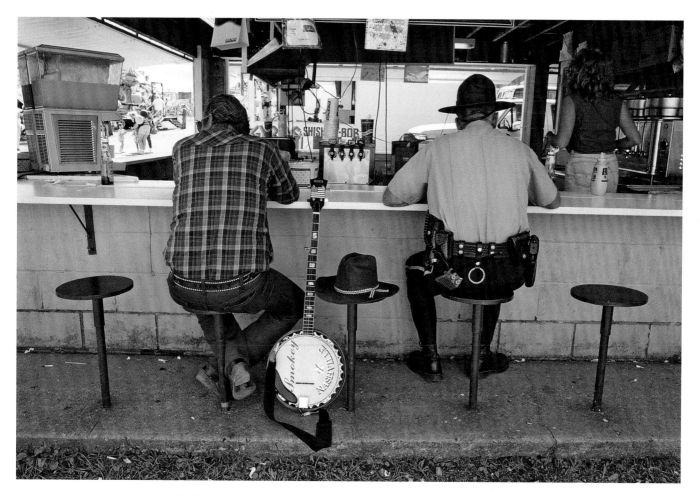

Smokey and the smokey at the Great Bedford County Fair, Bedford, Pennsylvania.

A young contestant does everything possible to ensure her luck in the rabbit judging at the Merced County Fair, Merced, California.

the pies before him. "Now, we don't really have to have this done until five o'clock. We can sit down and eat all of these, right?"

"Nooooo. You have until two thirty."

"We can eat a *lot* in that time . . ."

Anne cuts in, "You are going to make your decision about appearance before I cut the pie. On the scale of one to five."

These now-convicted judges look carefully at the entries and begin marking their sheets. Anne wonders aloud what will happen if there is a tie. The judges suggest they would be able to solve that problem by having another piece, an idea that pleases them but not Anne. She turns to Drake and asks, "Maybe you can be the deciding judge?"

"Yes, I know about blueberry pie."

Dave pipes in, "You know, there are four of us, and one of Anne. But she's got the knife."

Anne brings them back to the task. "All right. The first pie." The judges lean forward.

She carefully cuts a small wedge from the pie, to preserve the appearance of the remainder. Carol says, "You look like you have cut a pie or two before, Anne."

"Just a few," she whispers. "My mother was a pastry cook. All right, that's the cutability of the pie. Now, that is how the pie looks inside. You look at it. And this is how the pie looks underneath." The room falls silent and every eye in the room watches as the tiny piece is divided in three and placed on paper plates and pushed toward the judges.

A mainstay of fair food is the corn dog, but that is only the beginning. Amador County Fair, Plymouth, California.

8. Fair Fare

A clean white tent offered the mysterious attraction of a "Methodist chicken-pie dinner." The Spectator could not puzzle out what a Methodist chicken might be, but he concealed his ignorance and sat down at a long table, where abundant rations of delicious home-made chicken pie, pickles, bread, cake, coffee, and various other good things to eat were served by women evidently of note and importance.

—"The Spectator," *Outlook*, October 10, 1903

It must be the fairgrounds dust. I use all the same ingredients at home to make my biscuits and gravy, but when Dad makes them here, they always taste lots better. It has to be the dust.

—Food concessionaire at the Chautauqua County Fair, Dunkirk, New York

FIXED IN THE MIND OF ALMOST ANY FAIRGOER en route to the fair is food. Most years we attend the Vernon County Fair in Viroqua, Wisconsin, with friends Eric and Nora. Eric is a thin man with judicious eating habits, a picture of

reasonableness, but a certain urgency comes over him as he nears the fair gates, and once inside, he always beelines for the Hub's Fries trailer and joins the queue no matter how long it is. The lightly salted golden fries come through the window in a paper snow-cone cup, to be spruced up with catsup or vinegar. They are somehow delicious beyond all fries sold at ten thousand fast-food restaurants, more wonderful by far than the fries served with sandwiches at nice restaurants and in cozy bars scattered across the local landscape. The oil is fresh, as are the potatoes, but with a french fry there is otherwise not much possibility for variation, for improvement on the basic idea. Eric might claim it's the fair dust that makes them better—we've heard that across the country—but the salient fact is you cannot get Hub's fries at any time other than fair time, and anticipation breeds value—or in this case, flavor. At other times of the year and with little prompting, Eric will mention Hub's fries, and a faraway look crosses his face. Food connects people to their fairs through deep memory and the fondest sensory experience. Good fair food is central to the fair.

Like any expert fairgoer, Eric doesn't stop with fries. For a while he seems to be mindful of caloric intake as we tack from the lemonade booth to the 4-H stand for a hamburger, but by the time we gather up a few boxes of popcorn and maybe a sausage, to finish with ice cream from the local dairy, all restraints are off, and like coyotes deep in the chicken coop, we've given in to every temptation of the evening. And for the next fifty-one weeks we have trouble reckoning the Eric who hardly nibbles fine hors d'oeuvres at parties with the one who abandons all and wolfs at the fair.

There may be fairs where people don't rave about the food, but we didn't find any. Everlastingly delicious fare abounds at fairs from coast to coast—hand-dipped onion rings, corn dogs, ice cream, burgers, taffy, pizza, and enough church dinners to convert any heathen vegetarian to the righteous ways of roast beef, fried chicken, and barbequed pork. Even the tiniest fairs have at least a snow-cone truck, and the biggest, well, they have everything, and most of it on a stick so as not to lose precious time on the midway. In the stick department, look for the usual, like pickles, corn dogs, sweet corn, ice cream, and cotton candy, but keep your eyes open for pork chops and even

walleye. Rarely did we see much of anything that a nutritionist would label healthful, and maybe a couple times we spotted a salad.

"Yeah, well, I've seen people come up with health food and stuff like that," says Monty Hamilton, who sells elephant ears out of an elephant-shaped trailer at the Ionia Free Fair in Michigan. "It's a joke. It's not gonna go. People don't come to the fair for health food." We visited with Monty on a rainy morning as he and his assistant, "Bull" (real name: Bill Sautter), made coffee to ward off the chill and mixed up dough for the day's business. "Lots of fathers come up, and they don't usually care about the fat," Monty says. "But the mothers see us spread corn oil on our hands to spread the dough, and they see that, and say oooh. We

Fair food stands and trailers range from the glitzy and elaborate to the very simple. But don't judge too soon—the small operator may have the unbeatable local treat. La Crosse Interstate Fair, West Salem, Wisconsin.

say, 'That's not oil, ma'am, that's water.'

"It is pretty simple. A little bit of yeast, some powdered milk, some sugar, and a whole bunch of flour. You let it raise up, spread it out, cook it. We've got fruit toppings to put on it. That's all there is to it. People do it at home all the time. But they come to the fair *for* it. It is still a marvel to me. Every day when they just keep lining up and lining up, I just think, unbelievable. We've probably got thirty or forty cents in each one, and that covers stock and everything. And we get three dollars apiece. It is unbelievable

"Bull" Sautter (left) and Monty Hamilton with "Mitch," the elephant-shaped vending trailer, at the Ionia Free Fair, Ionia, Michigan.

He hires several employees in addition to Bull to help out and has only two rules, and they are chiseled in stone: "No stealing, and no messing around with girls." The latter one, he says, is "not much problem for me and Bull."

The bulky cartoonlike trailer attracts a lot of attention both on the fairgrounds and on the road between spots. It's important to Monty's success.

But a flashy food stand is not enough. Monty has worked the circuit for a number of years, knows where the good spots are on any given fairgrounds, knows how to work with fair management, and knows how important a good attitude and a good product are for repeat bookings and good business year after year. Monty explains, "Now at this fair, there are no bad spots. There are people everywhere. But in Hastings, where we just came from, we had the best spot. But there are places there you can set up, and you won't see a soul. I know a guy who shut up halfway through the fair because he couldn't make it. It is a real small fair. I was making a thousand a day profit. This guy was going broke.

"It takes time to get the good spots—and a little bit of finesse. There's no underhanded stuff. You don't have to slide anybody any money or nothing. That is really looked down upon. What you have to do is be polite and courteous. These people—almost every fair board I knew, they can get real tough. But if you are polite to them and don't give them a hard time, you do it their way, there are ways to move you into a better spot, because they open up over the years. So what you do is send them pictures and an application. They got ten stands they are looking at. And they say, 'All right, who we gonna take? There's a square stand, another square stand, lights and flags, lights and flags . . . oh, an elephant! Oh that looks cool. The kids will like that,' and then they let us in."

Monty also knows how to use his simple recipe to sell a quality elephant ear. "We do something that nobody else does, and I don't know why they don't. Everybody else will cook them up ahead, so it is really fast, and they put them under heat lamps. Then your plate turns into a big

how it can be that simple to make that much money and not do anything. And not know anything.

"It's amazing. You spend four years going to college, and you end up in an elephant. People like to call themselves concessionaires, but hell, you can't get away from it—I'm just a carnie."

Bull says, "I walk in and out of an elephant's butt all day long."

"That's his biggest complaint about the job," Monty says.

mess of oil. There are four other elephant ear places here, and they are all crying. They can't make expenses. I am six thousand dollars above expenses right now."

Monty's focus is not altogether on profits. "Bull is real good. One woman will come up and she'll have five kids. He'll look at their shoes, and he'll say, 'It looks like she's struggling.' And he'll make a couple huge ones and say, 'This one we had extra,' and he'll give them away. He does that all the time."

"Well, not *all* the time," Bull puts in.

"But that's okay," says Monty.

"We both agree it's the thing to do," Monty continues. "But we do it every day. I have been poor before, and a lot of people don't have any money. They come to the fair and try to spread an elephant ear between four kids. When you are making as much profit as we are, you can spread it around a little bit. What goes around comes around. The Bible says, 'You reap what you sow,' and that has worked for us. Whether that is the reason why or not, I don't know, but we have been blessed. I don't know why."

A few hundred miles east in a beastly hot trailer full of radiating pizza ovens at midday at the Chautauqua County Fair, mom Phyllis Porcelli and son Anthony Porcelli of "Mom's and Pop's" Spaghetti Eddie's talk about life as concessionaires on the road.

"I'll tell you," says Phyllis as she slices a fresh pizza and waits on a customer. "We lived in Rhinebeck, New York, and we had a pizza restaurant. We were the first pizza restaurant in Rhinebeck. I don't think my husband ever thought about going into the fair business."

But a longtime fair vendor died suddenly, and a friend helped Eddie and Phyllis fill his spot.

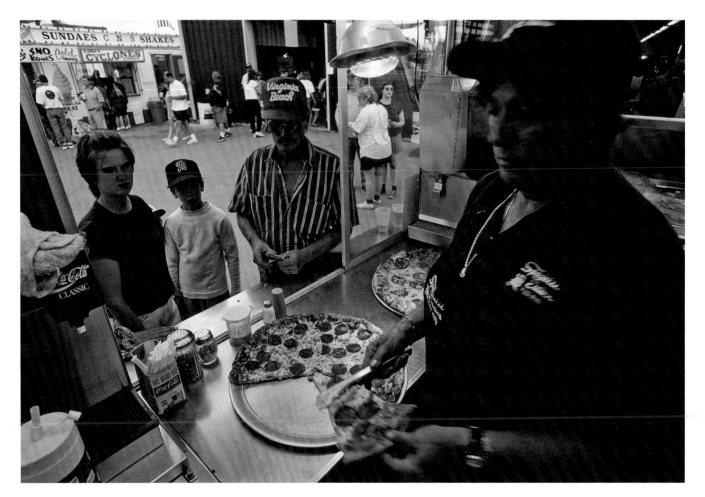

Owner Phyllis Porcelli of Spaghetti Eddie's serves fresh pizza to hungry customers at the Chautauqua County Fair, Dunkirk, New York. Nobody should leave the fair hungry.

"He wasn't even born," she says, gesturing to Anthony. "I just had Eddie, so that was a long time ago."

With success at the local fair and booking help from a satisfied customer, the Porcellis took the next step: "My husband got a step van," says Phyllis.

Says Anthony, a law student, as he slides pizzas out of the ovens, "He put the ovens in the back, framed it all out. It was not a truck in good shape. When they were driving here one time, there were no brakes. My uncle would get out, run out ahead of the van to make sure nobody was coming, and stop traffic so they could get into the fairgrounds."

When we visited with them, the Porcellis were running three pizza units and one Italian deli unit. The pizza unit we visited was large, bright with stainless steel and big windows, and well laid out for as many as nine people to work making and serving pizza, spaghetti, garlic bread, and salads. Nearby is their forty-two-foot fifth-wheel trailer. "To be on the road for so many months, you have to be comfortable," says Phyllis. "It's our home away from home."

Monty and the Porcellis are independent concessionaires like thousands who ply the fair circuit, rounding out the fair's food offerings (as well as the fairgoers) as they set up among the locally run stands and the food vendors who travel with the carnival. Some concessionaires are on the road for most of the year, hitting a string of fairs, festivals, and rodeos. Sites are prearranged, and some have set up at the same events in the same order for years. Many get off the fairgrounds only when they're on the road between fairs. The hours are long, and the working and living conditions are sometimes hard as vendors work in hot trailers at hot fairs and then sleep in cramped campers. On this day Monty and Bull start preparations early in the morning, will open at noon, and won't close until midnight.

Nevertheless, Monty and many others we talked with love the life on the road and its challenges. Vendors told us often how they look forward to seeing friends as they set up year after year at familiar fairs and festivals. A bad location or a rainy spell is tough on the bottom line, but the sun will probably shine at the next fair, and the crowd will line up. People with the right temperament, stamina, and good food business sense make good money.

Anthony Porcelli likes the challenge. "There are a few downsides to this business, but they are outweighed by the upsides. You can choose what fair you want to go to, choose what time you open. I have learned so much about business, and I've learned a good work ethic out here. You talk to any one of these people here, and they are extremely sharp businessmen. You have to be. It is extremely competitive. If you need stability, you can't make it out here."

His mother agrees. "I like it," says Phyllis. "There are times when you are really tired and you just want to throw in the towel. But everybody feels that way, with any job. But I enjoy it because I have met so many wonderful people. At a lot of fairs we play we have a following, so people come looking for us. They know we are going to be in a certain location, and they automatically walk to that spot."

No doubt special food has been an important component of fairs of all kinds since the first human gatherings for trade and social contact. According to J. F. Laning's 1881 treatise on how to improve agricultural fairs, self-respecting fairs ought to have a dining hall for hot meals (perhaps for Methodist chicken pie dinners) and a cold lunch stand for those in a hurry. Other food vendors ought to sell the likes of peanuts, lemonade, popcorn, ice cream, soda water, "hot candy" (taffy perhaps?), cakes, gingerbread, fruits (oranges, for instance, would have been a novelty in this era), pretzels, bologna, dried beef, and bread. Apparently no moralist, Laning also suggested that stands sell cigars and beer.

Fairgoers can find a hamburger at almost any county fair in the country, of course—sometimes a very good one—but as itinerant fairgoers, we always sought the local specialty, the food we shouldn't miss and cannot get anyplace else. No matter the size of the fair, local fairgoers were usually of a mind about the best thing to eat on the grounds. "Have you had a Kronski? You've got to have a Kronski," we were told by several people at the Sweetwater County Fair in Wyoming, and the chewy rich sausage lived up to its praise.

> "It will take about fifty gallons of sauce to do thirteen hundred halves of chicken. Fifty gallons. Put it on with a brush. Takes about six of us to do it. Y'all wantin' the recipe?"
>
> —Charles Bowman,
> chicken barbeque boss at the Rockingham
> County Fair, Harrisonburg, Virginia
> •

And sometimes the food is the only reason they come. At the Monongalia County Fair in Morgantown, West Virginia, the fair treasurer told us that she told a group of fairgoers that Kern's Farm Roasted Sweet Corn stand wouldn't open until the next day, and they said, "Well, then we're going home because we just came for the corn."

Locals at the Fayette County Free Fair in Connersville, Indiana, quickly directed us to two food opportunities: Jessop's Butterscotch Corn and the fried chicken dinner served by Saint Gabriel Catholic Church.

The crisp scent of Jessop's Butterscotch Corn sweetened the shady breeze at this old-fashioned fair in Roberts Park in Connersville as soon as we arrived and led us easily to Jay Jessop and the family's food stand.

"There has been a Jessop's sitting on this location since 1901, since the first county fair here," says Jay. "We started somewhere in the early 1850s; we don't have an exact date. My grandfather came up with this recipe for Jessop's Butterscotch Corn." Jay is the fourth generation in the fair food business; a cousin's branch in the fair food business counts six generations. "I started making cotton candy as soon as I was tall enough to see inside the pans."

Jay's branch of the family works a handful of fairs in the region, including the state fair. "To the best of my knowledge, there has never been an Indiana State Fair without Jessop's." Jay and his family have sold other fair fare over the years, including candy apples and cotton candy, but the butterscotch corn from its secret recipe is the mainstay. They also run a small carnival.

The Jessops know how to attract customers, but they don't use an elephant-shaped trailer.

"In some areas the name helps a lot," says Jay. "Here people just recognize it. It's been here forever."

The other technique is what vendors call "flash." Jay explains, "Just how you stock your trailer, how everything is visible—I mean out here, it's an impulse busi-

Good food sells itself when the customer can see how delicious it will taste. No matter how recent the previous meal, few fairgoers can pass Santillo's Italian sausage stand at the Chautauqua County Fair in western New York without getting hungry.

ness. People act upon impulse, so if they see something, they'll buy it. It's strictly impulse. It's just like in a grocery store. The older gentleman who taught me how to lay out rides and stuff told me there's an art to it. He told me you lay out a carnival just like you do a grocery store. He says you make them walk past everything before they get to the milk and the bread, which is what they came to get. It's the same out here; if you take a game, for instance, and he's got, oh, five or six animals hanging in

Caroline Jessop, "lady confectioner," stands before her concession tent at the Delaware County Fair, Muncie, Indiana, in 1894. She and the family members who flank her gave rise to generations of Jessops who still sell confections at fairs in Indiana. Courtesy Charlene Hornung

it, you're just going to go by, but if you go by one that's just filled with animals, you're going to look. That's flash."

Scheduled dinners, including "end-of-the-fair" barbeques and service club and church dinners, are the best venues for the best fair food. By "dinner" we don't mean food stands where one can get a homemade sloppy joe or hamburger. A dinner is a one-night scheduled event that happens every year at the fair, and fairgoers plan their fairgoing around their favorites. Local groups across the country, especially at medium to small fairs, sponsor beef dinners, chicken barbecues, pig roasts, and the like for the local fairgoing community. Many are donation events with a coffee can right where you pick up your plate.

We found church dinners at fairs from Pennsylvania to the Rockies, and they provide a particularly flavorful connection to the traditions of the fair. Some church groups have been serving their roast beef, fried chicken, pork chops, and sauerkraut to generations of fairgoers, and some of the recipes have been passed down—often orally—unchanged through the "fair dinner" committee for years. To sit at a traditional church dinner at a county fair, in a big tent or a picnic pavilion with butcher paper on the table, is to taste what fairgoers might have eaten at this fair a hundred years ago. Such a fresh, flavorful, and direct connection to the past is an almost spiritual treat.

One of the best is the Tuesday night fried chicken dinner served by Saint Gabriel Catholic Church at the Fayette County Free Fair in Connersville, Indiana, just down the path from the Jessops' stand.

The sun is low but still hot through the high trees of Roberts Park as hungry fairgoers line up for this annual dinner. In this rural county east of Indianapolis, we imagine people don't ever need to stand in line for much, but for this event they seem willing. Ahead is a large old picnic pavilion filled with some hundred picnic tables covered with white tablecloths. With us in line is fair office volunteer Carolyn Konstanzer, who says, "Take a look at the menu there and decide which you'd like to have."

The choices are white or dark chicken, mashed potatoes, gravy, coleslaw or applesauce, roll and butter, drink, and, of course, dessert, all for six dollars.

"Each night a different organization or group has a dinner in the pavilion here," Carolyn tells us. "Wednesday night is the Kiwanis Club's fish fry; Thursday night is the Fayette County Cattlemen's rib eye dinner, and Friday night the Rotary Club will have a spaghetti supper. Saint Gabriel has quite a large congregation, so they have a lot more people to help and everything. They usually sell out. And they're famous for their fried chicken." Carolyn looks down the line. "We're getting closer to the food."

At the entrance to the pavilion, those who request white meat are handed a white Styrofoam plate; those who request dark are handed a beige one. As the crowd moves along the food line, volunteers add items to plates and converse with patrons, most of whom they know. A candidate for county judge and his wife dish out coleslaw and butter with particular friendliness. At four thirty, as the line moves forward, the last of the big lemonade and tea jugs are moved into place, the Styrofoam coolers of chicken are being delivered hot and fast from the Jaycee pavilion down the hill where the meat is cooked, and the acre-sized dessert tables are covered with pies, bars, and brownies, all protected with plastic wrap. Despite the early hour, tables are filling with early-bird diners who want to be certain of getting fed before the food runs out, and the line snakes far up the sidewalk. The rest of the fairgrounds is dead.

The coleslaw is fine, the potatoes real, and the roll could be found in any supermarket bakery, but the chicken is unworldly, dark, crisp, and flavorful, bringing back memories of Sunday chicken dinners from childhood. We've not had chicken this good since our grandmothers were alive.

And the mostly homemade desserts are rich and lavish. Pat and Charlene are in their seventies and lord over a dessert table of stunning delectability, a universe of choices. We wonder how many pies parishioners donated for the feed tonight.

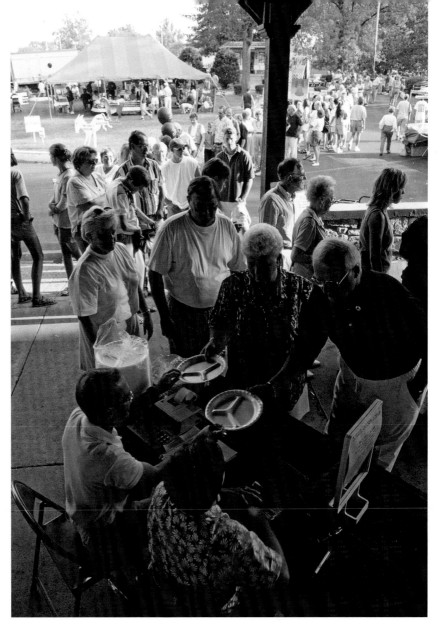

Hungry fairgoers line up early for Saint Gabriel Catholic Church's Tuesday night fried chicken dinner at the Fayette County Free Fair in Connersville, Indiana. Those who want white meat get a white plate; those who want dark get a beige one, an efficiency that helps to serve fourteen hundred dinners in timely fashion.

"Probably about three hundred," says Pat.

"One person called and gave me twenty-five," adds Charlene.

"Plus we have brownies, angel food cake, and whatever," says Pat. "The response is just unbelievable; you just ask and they just come forth."

"Well, I was here at twelve o'clock and there were about fifteen or twenty or maybe thirty pies that somebody

Homemade and delicious, the Sunday noon 4-H chicken dinner at the Cottonwood County Fair, Windom, Minnesota.

"We know what we're doing. Everybody knows."

"We're in charge of the desserts, and we're just here."

Meanwhile at the cooking pavilion down the hill, some thirty men and women fry chicken for the crowd. Helpers provide iced tea to the workers, who converse and work steadily but without haste. Cardboard carpets the pavilion to keep grease and flour from the concrete floor. In a process that Henry Ford would appreciate, the volunteers from Saint Gabriel each have a work station and a task, and in concert produce enough bushels of fried chicken to keep a six-wheeled ATV busy busing full foil-lined coolers up to the dining pavilion.

The first team breaks the birds out of iced boxes, cuts and sorts them into parts—thighs, breasts, et cetera—and moves them to the next station where batches are arranged in large stainless bowls, doused with a "secret

had brought up and set down here," says Charlene. "Then Pat went and picked some up; that was down at the church where we usually tell them to leave them, and then somebody called me on the phone and said I'm bringing twenty-five pies up at noontime, so I had to get up here, and there they were!"

"We thought maybe it was a hoax," says Pat. "But he came through about one o'clock."

Homemade? we ask.

In unison and with a bit of disapproval, both say no.

How many dinners will the church serve tonight?

"Twelve to fourteen hundred," says Pat.

"Close to fourteen probably," says Charlene.

Any leftover pies?

"We may have a few brownies left," says Pat. "We never have any pies left because our best pie bakers come through. Pecan is one of the favorites, and then we have blackberry and raspberry, just all kinds. Peach—fresh peach—and apple."

Charlene reflects a moment. "How many years have we been doing this?"

"How many years have we done it?" echoes Pat.

We heard it's been about eight years.

"Well, that's how long," says Pat.

They talk about how Saint Gabriel Church organizes the annual event.

"They just assume everyone is going to do it again!" laughs Pat. "We don't get asked; it's just assumed."

"We used to have meetings, but now everybody knows what they're supposed to do, and they automatically do it," adds Charlene.

In Elkanah Watson's time, the Minutemen fought the British; today they sell hotdogs, here at the Chautauqua County Fair in Dunkirk, New York.

ingredient" poured out of a nondescript juice pitcher, then salted and peppered. The guy baptizing the chicken tells us that "alcohol is not allowed in the park—you didn't see any, did you?"

Another puts in, "It doesn't make a danged bit of difference what kind of beer you use—it all tastes the same. In fact, we usually use what's not selling well at the Knights of Columbus." The parts are then allowed to rest for a few minutes. "It likes to marinate awhile," one volunteer tells us. Then the chicken is drenched in flour, arranged in cake pans, and stacked ready for frying.

Around the perimeter of the pavilion fourteen homemade fryers roar and bubble, filling the air with the aroma of old-fashioned fried chicken. They are built of steel barrels with propane burners fixed under them and have clearly been crafted to fry in large quantities. Periodically crewmembers grab a cake pan and dump a batch into the fat and time them according to type—drumsticks take longer than wings, for instance. A man uses a spatula in one hand to keep pieces separated while they fry; with the other hand he eats a drumstick.

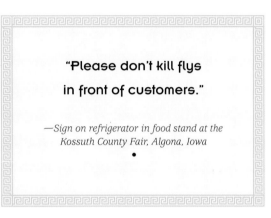

"Please don't kill flys
in front of customers."

—*Sign on refrigerator in food stand at the
Kossuth County Fair, Algona, Iowa*

•

And here is the secret of the flavor. The church fries in lard. A local slaughterhouse saves it, and the Saint Gabriel team uses more than a hundred gallons just to fill its fourteen fryers. The church will fry some twenty-six hundred pounds of chicken this Tuesday night.

When done, the chicken is dipped out, drained, and put into foil-lined coolers for the trip to the dining pavilion. The path between the pavilions runs through the parking area and is cordoned off with yellow No Parking tape. The operator of the John Deere "Gator" ATV takes his job as seriously as that of any Brinks driver. "Well, when I got this thing last year, I figured I'd better make myself a path here; otherwise people just park in the way, and you want to have a straight shot to get the chicken over there."

By far the most common fair food venue is the ubiquitous food stand run by some local group—a service club, the pork producers, a church, and, quite often, the county 4-H clubs. The fare varies from dry-stamped burgers on stale buns to delicious hand-raised and home-cooked roast beef done by volunteers who consider quality and taste and never think of costs and portion control. There is no way of knowing what you'll get; you just have to try them

all. The service is sometimes comically inefficient as a half dozen eager but inexperienced kids scramble for your order only to get distracted and never quite get it to the grownups cooking in the kitchen. Many of these stands are old, but usually clean, examples of what can be called hot-dog stand architecture: a box with big shutters that hinge upwards, often on three sides, providing a shade and space for a narrow counter and a row of small stools. Drinks and cold foods are organized in the center, with a kitchen, usually screened in, at the back. But we found myriad variations, including the 4-H dining hall at the Cottonwood County Fair in Windom, Minnesota, where hungry fairgoers get their food cafeteria style and eat in a screened-in dining hall much like an old-fashioned front porch. But it's the food that drew our attention.

By August the corn is high in southern Minnesota, and gardens are heavy with vegetables that make their way to the Cottonwood County's 4-H clubs' dining hall. On the kitchen door a sign reads "Vegetable donations appreciated: cabbage, carrots, tomatoes, green beans, sweet corn, beets and cucumbers." Today is Sunday with baked chicken and all the trimmings, and at eleven forty-five the screened dining hall is already half full as we step in and are handed a partitioned cafeteria-style tray. Above is a sign that announces the clubs that are working this meal: the Delton Doers, Ann Go-Getters, and Westbrook-Rosehill. One by one 4-H kids fill our compartments with breadcrumb-batter-baked chicken, browned just right; a dome of fancy scalloped potatoes; local sweet corn, creamy and fresh off the cob as a few strands of silk mixed in attest; a slice of bread; homemade coleslaw or homemade cucumber salad; a slice of fresh rhubarb pie; and, finally, silverware wrapped in a napkin that reads Compliments of United Prairie Bank.

This is good whole food, and all of it is fresh, local, and donated in this good garden year. It becomes Sunday dinner on a community scale, and the fans that stir the air above the church basement tables add background to conversations about fair winners, crops, and, always in agricultural communities, the weather.

Unusual food opportunities appear from time to time. Within five minutes of entering the grounds of the Amador County Fair in the Sierra foothills of Plymouth, California, we noticed a flow of people toward the exhibit building where

After the berry pie judging at the Amador County Fair, Plymouth, California.

we learned that the pie judging was ending. Curious, we wondered why this event would draw a crowd.

We join the throng among kids and balloons and guys in Hawaiian shirts, and find the pie superintendents and judges cutting pies and handing out forks and paper plates. The crowd presses forward, seeing nothing but pies. Blueberry, strawberry, strawberry chocolate, raspberry, black raspberry, and mixed berry pies. Ambrosia, the best of the best, a sliver of them all, like blood dripped in shark-infested waters. "Pie-ro-mania," one local calls it, as we surge toward the tables, stab the one-inch slices, scoop them onto limp plates, and plow in.

"Where's chocolate?" one man asks. "Is this the first-place pie?" asks a woman as she digs into a piece. "Nope," comes a quick reply. "It's the one over there with the fewest pieces." A superintendent says, "We're going to have to go to the office and get more forks."

An elderly woman, seated, handbag in her lap, holds her plate politely high in front of her, tea party fashion, eyes closed, savoring each bite, oblivious to the hedonistic pie bolters all around her. She wears a blue polka-dot dress with almost matching blue hat. She sports two yellow stickers, one on her lapel, the other on her hat. Both read "Only You Can Prevent Wildfires."

It is quiet for a few minutes as people push pie into their mouths. It looks more like a pie *eating* contest. The lull soon passes as folks rise and head for seconds, and the incoming flow increases; word has gotten clear around the fairgrounds. The floor is soon littered with plates, forks, and pie crumbs; the pie pans are empty, and those who got here soon enough now wax contented about having eaten a bit of the first, second, and third place pie winners.

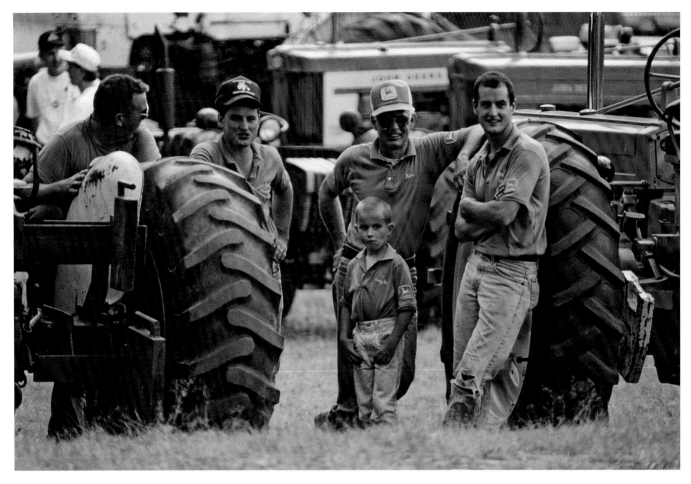

The fair is a formative experience for kids everywhere. Will this young man watching the antique tractor pull at the Cheshire Fair in Swanzey, New Hampshire, ever love any other tractor brand as much as John Deere?

9. Born at the Fair

Gee, you're looking good. You gettin' any rain down that way? How about the grasshoppers?

—What folks talk about when they get together at the fair, according to Bob Ruby, fair board president, Johnson County Fair, Buffalo, Wyoming

It's not a fair unless Esther brings something. If she doesn't bring something, I know something is wrong.

—Agnes Kinney, Dawson County Fair, Glendive, Montana

I know I've had people in the nursing home tell me that, "You know, we used to go to the fair every year. Now here we are. But when we read your column, it makes us feel like we were there. And that makes us feel good."

—Dick Konstanzer, who for forty years wrote a front page column, "Here and There at the Fair," for the *Connersville News-Examiner*, Connersville, Indiana

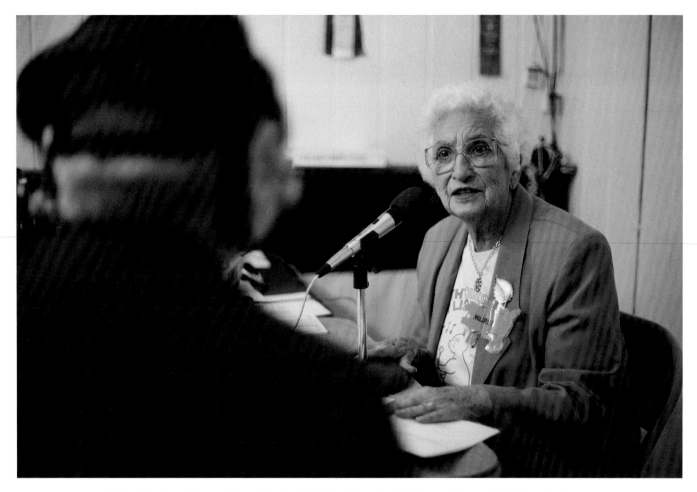

Mildred Davy interviews a willing subject in the KTIL radio booth at the Tillamook County Fair, Tillamook, Oregon.

EVERY YEAR KTIL RADIO OF TILLAMOOK, Oregon, sets up its booth in a high-traffic spot just inside the entrance to the main pavilion at the Tillamook County Fair. With all the commotion of exhibitors and fairgoers, this is a challenging spot for live radio. Passing fairgoers discuss this afternoon's horse races and chat with people who staff the nearby Salvation Army, Ultimate Travel, and Tillamook Bay Community College booths, among many.

The KTIL booth attracts its own crowd as folks accept the station's broadcast invitation to "stop by and see us at the fair." All this might be distracting to a broadcaster less experienced than snowy-haired, petite Mildred Davy, who sits at an elevated table at the back of the booth, headphones on, mouth close to the microphone. She has been live on the air since 1963, and each year during fair week exchanges the solitude of the permanent KTIL studio for the hubbub of the fair.

This morning she hosts her daily half-hour show, *It's a Woman's World*, with guest Ed Meyer, chairman of the board of Tillamook Cheese, a big business and agricultural force in town. She talks with ease and listens attentively in what is more a conversation between neighbors than an interview. They discuss how the company has grown and the local support it enjoys. They cite company milestones, progress, and people who were key to its evolution.

On the lapel of Mildred's kelly green summer blazer a pink paper cutout of a pig proclaims her name, but it's superfluous for Mildred. Never missing a beat, several times a minute she waves and says, "Hi, there," to people walking by. At the end of her conversation with Ed, she brings things around to the present: "There'll be some beautiful animals out here at the fair today," referring to

this afternoon's horse races. "And Ed will be here!"

When her bosses Joyce and Van Moe bought the station in the late 1980s, Mildred had already been doing her own show for twenty-four years. Joyce appreciates what Mildred means to the station. "When we came in," says Joyce, "she was the manager of the station. Van kept that title for her, although he has been doing the managing in a sense. If it hadn't been for Mildred, I don't think our transition here would have been nearly as smooth. We were accepted because she drew people in and said, 'Hey, these are nice people. They're OK.' She's been the backbone of the station for more years than we've been here."

Despite its name, *It's a Woman's World* appeals to both genders. Mildred told us, "There are just as many men who listen as women. The farmers listen. They turn their radios up so loud you can hear them clear out on the road." Van told us that one year when he went elk hunting with a group of Tillamook men, one of them brought along a radio. Out in the mountains, he decided to tune in to see what was happening and caught Mildred's show. The group huddled around the radio listening to her familiar voice and stayed tuned in for the whole program.

Says Van in admiration, "She's the only person I know who can do ten minutes on the color of a blouse." Recently Van and Joyce named the AM portion of the station in her honor with Mildred Berkey Davy's initials: KMBD, 1590 AM.

Local radio and the county fair have long enjoyed a mutually beneficial relationship. Although their numbers have diminished considerably in recent years, hometown radio stations were for decades the medium of choice for farmers and ranchers who tuned in for livestock reports, grain markets, the weather forecast—and to hear news of the fair. Low-powered stations, both AM and FM, often reach just across a county, neatly covering a fair's primary audience. Banners and signs at fair booths and tents often proclaim this or that station as "the voice of the fair." Coast to coast we found on-air talent interviewing reticent 4-H kids dumbstruck by winning grand champion, playing music by the local band to promote the night's dance, and

broadcasting thrill-packed live feeds from the top of the Ferris wheel.

We wait for a break in her show, introduce ourselves, and ask if we might interview her. "Oh, certainly," Mildred says, inspecting her watch. "I have someone to interview until 10:06, but if you could come back then, I'd like to interview *you* on the air."

Born in Tillamook County in 1911, she's a keeper of history, a connector of people, a celebrator of events large and small, and a tireless booster for the county, and for her fair. Each morning as she broadcasts from the fairgrounds, Mildred's voice provides Elkanah Watson's "merry peal rung, to rouse the dormant energies of the community," which he prescribed so long ago to ensure a fair's success.

And rouse she does. Off the air now, sitting on a bench in an exhibit hall, Mildred talks of radio and the fair. "I'll tell you what it does for this fair. I know this, and I am not just talking off the top of my head. If you were to ask the people who drive in that gate—*hi there* [to a passerby]—especially those with a car that didn't have an Oregon or Tillamook plate on it, how does it happen that you are here, they'd say, 'Well, we were listening as we were coming down the Wilson River Road,' or 'We were listening as were coming up Highway 101.' I don't know how many times I've had people come in here and roar up to the booth and say, 'Where's that berry pie you were talking about?' I don't know what television could do with this sort of event. It couldn't have the personal relationship, the personal touch, that radio does."

The community needs the fair, according to Mildred. "I think there are several things that are important about the fair, but the community spirit is the one thing I've had people tell me about over and over. 'I saw somebody today at the fair I hadn't seen for twenty years. My, I never did know what happened to their Aunt Emma.' It's a whole town thing. It probably takes the place of barn raisings, community get-togethers and the Fourth of July celebrations. It brings together people from different generations. And, it's a competitive thing. People like to see what the other person did."

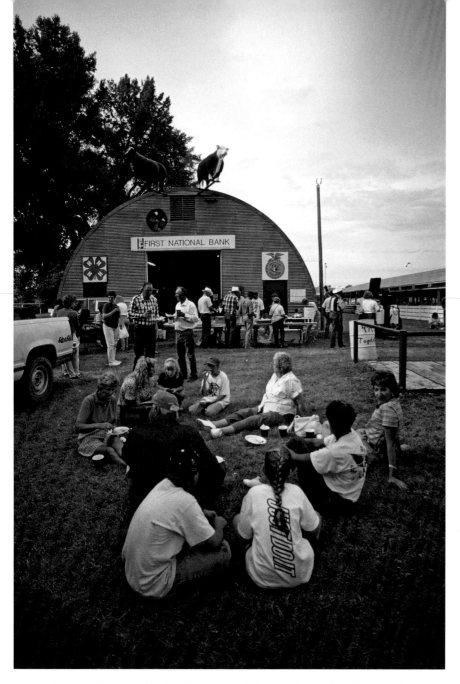

The annual sheep feed at the Johnson County Fair and Rodeo, Buffalo, Wyoming, draws friends, neighbors, and newcomers into a comfortable circle of community.

said one time when my mother and I were commiserating, 'Oh, the flowers are just no good this year. No use taking those; they wouldn't win anything,' and he was just a little guy, and he spoke up and said, 'What do you guys want to do, win prizes or make a good fair?' And that is what a lot of people think; well, this will never win a prize, but it will help fill up the space, and maybe give somebody else an inspiration."

Mildred began exhibiting at the fair in the mid-1920s, when she was twelve or thirteen. "My mother was the greatest supporter of the fair. She entered *everything* in the floral department. She had a beautiful yard and beautiful garden. The dubious honor of getting her entries out here was mine. But I was in it, too. I don't think there has been a year when I haven't exhibited something out here, and encouraged others—the little kids, nieces and nephews, everybody—to do the same."

Mildred's eyes warm and she goes on. "We have this wonderful 4-H and Future Farmers program. I believe we have something like 1,200 members. In this little county, which is known for cows, they have 130 members in the horse club, and 92 of them were judged the other day. Now, you don't think about Tillamook County being much of a horse community, but these kids start out in 4-H and FFA; they raise those animals. We've got the third generation of kids out there showing. I've interviewed their dads, and knew their grandparents who came here from the old country."

Mildred says she's motivated by the good work of others, this year in particular by fair exhibitors' pea plants. "I have the most miserable sweet peas in the world this year, and it was with a great deal of pride that I went over there and looked at those gorgeous blossoms, and I thought, next year I'll do better."

It's important to participate, according to Mildred. "My little brother, who is fifteen years younger than I am,

Though she doesn't mention it, Mildred is known as Mrs. Tillamook County Fair. Her lifelong contribution to the fair was recognized a few years earlier when the Western Fairs Association gave her a Blue Ribbon Award for the best fair supporter. But Mildred looks for the bigger picture. "It wasn't just me they were paying tribute to; it was all the 'me's', all the little old ladies who have helped the fair all these years."

She reflects a moment on her long association with the fair. "It's probably one of the most rewarding things in my life. I've seen it through good years—and, of course, when I was a youngster, what did I know? I just came and had a wonderful time, and when it was over, I cried along with all the rest of the kids."

Although most of them don't have access to the airways, the Mildred Davys of the nation keep fairs active and bright year after year. Some occupy official positions like fair manager or secretary, but most are simply supervolunteers who have taken on some significant aspect of the work of the fair and have made it their own. Many are conspicuous like Mildred, not necessarily because they like the attention, but because they are so fully stitched into the operations of the fair. These fairmakers are the big planners, the year-round boosters, the doers of everything needing doing whose work shapes the very personality of the fair. We met them everywhere; almost every fair has one or several. Pity the poor fair that has none.

We understood the commitment of fairmakers better once we met Donna Speltz on a Midwest-humid July night during fair week in St. Charles, Minnesota. As secretary of the Winona County Fair, she was holding forth behind the counter in the fair office as the door opened and closed without rest, handling all comers with aplomb born of long experience. As she gives us background on her role as secretary, another staffer cuts to the chase: "You were *born* at the fair, weren't you?"

Donna explains, "That's a standing joke. They tell me that with my 4-H and fair experience, I wasn't a blue baby, I was a green one."

Despite long years of service, Donna seems tireless. She's writing a history of the fair and has plans to engage university students to produce a promo video and to conduct exit interviews with fairgoers about how to improve the event.

For Donna and for dozens of fairmakers we interviewed, the yearly cycle ends not with New Year's Eve, but with fair week. Many we interviewed told us the year divides into two parts: fair week and the fifty-one weeks that lead up to the next one. Robert Silk, vice president of the Cheshire Fair board in New Hampshire, depends on the help of his daughter and her husband at fair time. A few years earlier when she announced they were getting married, Robert's rapid response was, "Not during fair week."

Herb Harder is secretary of the Calumet County Fair in Chilton, Wisconsin, a position his father held for fifty years and his mother for ten. He swears the reason he was born the day after the fair was a matter of scheduling. "I think my dad told my mother that she couldn't have me until after the fair."

For those who are always at the fair, the annual event absorbs other life events and traditions. Take Norris and Neva Wooley of the Chautauqua County Fair in Dunkirk, New York, who for many years superintended the sheep barn and, when we met them, were superintendents of the Grange department. For decades the Wooleys have spent their July 27 wedding anniversary at the fair. Says Norris, "Our twenty-fifth anniversary we had right here in this building. We were here working, and all of a sudden, in comes everybody, with a cake and the whole works."

Neva recalls, "We were in the sheep barn, and they called us up here. Our youngest son had gotten in touch with some of our friends in the Grange. He was a bit disturbed because we weren't going to have a twenty-fifth anniversary party, so they'd gotten together and we had a cake. They had all brought tureens, and we had a big dinner."

The county fair is a cooperative community unto itself that legislates, celebrates, polices, commemorates, and even grieves. It is a microcosm of the larger outside community, a mini-nation bounded by the fairgrounds fence. For fair week, the fair office becomes the seat of government, each department or area, a ward. The office

"Step right up! We've got the fastest fish in the West! It's a wet track with fast fish, right here; we've got minnow racing! On Wyoming's only officially sanctioned minnow-racing track, right here at the Sweetwater County Fair!"

—Announcer at the Green River Methodist Church minnow-racing booth, Sweetwater County Fair, Rock Springs, Wyoming

•

Beef exhibitors Nathan Claycomb and Kristy Harshberger explore love at the Great Bedford County Fair, Bedford, Pennsylvania.

publishes the official schedule, settles disputes, responds to emergencies, and coordinates the cooperative efforts of such groups as the Lions Club's pancake breakfast fundraiser on behalf of the local swimming pool or the Pork Producers–sponsored dance that raises money for the food pantry. Fairmakers share tools, skills, materials, time—whatever it takes to make the fair happen. While competition is the operant principle in the jelly judging and at the rodeo, it's cooperation that puts on the fair.

Becci Field, the 1979 Elkhart County, Indiana, 4-H Fair Queen, expressed the idea of this community most simply. We met her pushing her young son in a stroller through the exhibit buildings. She attends her northeast Indiana fair two or three times every year during fair week. "I never miss it," she says. "This is home."

Despite the work of getting everything ready for fair week, fairs endeavor to remember those who have con-

tributed much. This might take the form of a thank-you page in the front of the fair program to honor a retiring board member, or a flowerbed memorial to a pillar of the fair who has passed that year. At the Winona County Fair in Minnesota, each of the five days of the fair is named to honor a living person from the county, leaders in agriculture, business, service, community, and government.

Henry and Suzie Johnson worked for more than thirty-five years for their Cheshire Fair in Swanzey, New Hampshire, and in turn the fair honored them. He was the "lot man," renting the lots to concessionaires, and she staffed the phone. A few years before they retired from their fair duties in 1994, the concessionaires built a small park on the grounds and dedicated it to them. A wooden sign expresses appreciation for their "loyalty, dedication and service" and stands among the trees, picnic tables, and benches where fairgoers sit and rest fair-weary feet.

And it is not just the momentous occasions that get celebrated at the fair. It may be as commonplace as a ninth birthday celebrated at the Sheboygan County Fair in the heart of Wisconsin dairy country. On this Friday night, the milk moustache contest had just finished, and the audience still filled the bleachers, waiting for the adult showmanship competition to begin. A man came to the center of the ring and shouted, "It's Justin's birthday!" The crowd sang as Justin came forward, scuffing the dirt with the toe of his boot. The dairy princess tried to give him a kiss on the cheek, but he ducked it as if it were a kick from a milk cow.

Not all kisses are declined at the fair. For generations American agricultural fairs have been testing grounds for budding love. Young couples meet up and stroll the grounds, finding romantic opportunities on the midway and, at larger fairs, anonymity in the crowd. The giant stuffed animal won at a balloon-dart game has long been a trophy of male valor and new romance. And it's no accident that many rides fit two per unit and use centrifugal force to ensure coziness. Grandstand events provide a nice long evening under the stars for hanging out with your sweetheart. At the tiny Morgan County Fair in Morgan, Utah, Ross Stenquist says, "My girls will pay the entrance fee for the rodeo, but won't see a minute of it!"

There are good-byes, too. On the final night of the Holmes County Fair in Millersburg, Ohio, concession manager Sandy Pipes sat at the open window in the fair office. The demo derby had done its damage, and the crowd at the midway was starting to thin. A fresh-faced young man and his girlfriend, arm in arm, stopped by. "I just came by to say good-bye," he says. He was heading off to college in ten days. He and Sandy discuss how many pairs of socks and underwear he'll need, and how Sandy had helped his sister move to college. "She took four carloads with her," says Sandy. "But I guess you're going to make it in one. Well, good luck. We'll be thinking of you."

Any county fair is a peculiar community: temporary, compressed in time and in place, changing minute by minute, and partitioned into many subcommunities, many of which do not overlap. In full flower this community usu-

ally lasts less than a week and shifts its members as, say, the horse people leave the grounds to be replaced by the dairy folks. The carnival crew, the local Ruritans who run the barbeque, the garden club that handles the horticulture display are all subcommunities that are important to a given fair but may hardly notice one another. Each group has its own roles, and each celebrates the seasonal return of fair week with its own rituals.

As in all communities, subcultures develop. At the Chautauqua County Fair, the carnival (J & J Amusements) and many of the independent food concessionaires have played this fair for many years and enjoy their annual

Romance has always been an important element of fairs across the country. These young lovers were captured at the Imperial County Fair, Imperial, California, in 1942.

Photograph by Russell Lee, courtesy Library of Congress

reunion. Season after season, fair after fair, they set up, work and tear down in their transitory backlot neighborhood, and every year, together with those who manage the fair, celebrate with a potluck meal late one night. It is the equivalent of a block party.

After the lights of the Gravitron have been switched off for the evening, guests start arriving at the red and white striped tent that is home of Santillo's Italian sausage. Those who spent the long day and evening filling food

orders join those who manage the carnival and the local fairmakers to relax at tables, laugh, and share stories.

Phyllis Porcelli, of Spaghetti Eddie's Pizza, explains, "It's an annual thing. It started years ago with a few of us: Santillos, Leworthys, Fowlers, Taylors, and the fudge people, Grims, and a few others. We would bring pizza, somebody would bring something else. Leworthys had this fish they had frozen all winter. We would sit and have a good time."

Tonight, Robin Santillo stands at the two fryers used earlier today for onion rings, now deep-frying huge platters of walleye. Henry Leworthy, honorary director of the fair board, stands at her side, battering the tender fillets.

"Then it started growing," Phyllis continues. "They started charging because it got to be too expensive for one person to foot the bill." Now so many attend that it's more practical to sell five-dollar tickets ahead of time and purchase the fish and some of the other food.

The Fowlers taffy folks haul over their big kettles and gas burners, still warm from making twelve flavors of taffy, and now boil up sweet-as-candy corn-on-the-cob. Spread across the tables are bowls of Italian salad, bread, and a huge pot of beans and bacon, made by Archie, "one of the gypsies" from the carnival. Fair president Alvin Wilson provides venison steaks, and Jim Leworthy, who chairs the fair's carnival and midway committee, contributes venison meatballs in gravy. The Porcellis have brought plenty of their Spaghetti Eddie's pizza, and Grims' legendary fudge draws a crowd. The fair has donated a keg of beer, but the real attraction is the fellowship of people who share this hard work. Talk turns to a colleague who would be here tonight but is hospitalized. As a get-well card, this year's fair poster circulates from table to table and is soon signed by everyone.

County fairs are always reunions, some planned, some not. Reporter Dick Konstanzer, who covered the Fayette County Free Fair in Indiana for years, says, "There always was a saying that if you wanted to see somebody, go to the fair on Thursday night. Thursday night used to be the big night when it was a four-day fair. I mean Thursday night it was wall to wall, and you could see people here that maybe you'd not seen for a year."

Many spoke of this important role of the fair. Dick Johnson, president of the fair board in Nicollet County, Minnesota, explains, "I've lived here all of my life. I know so many people throughout the county, and this is the only time I see them!"

IT'S SUNDAY MORNING at the Boonville–Oneida County Fair in Boonville, New York. At a little before ten, people trickle into a big green and yellow tent identified as the Hof Brau and settle down at picnic tables still sticky with last night's revelries. To the rear, a refrigeration unit hums as it cools the beer trailer, its five beer pulls facing the worshippers. A pianist plays "When Irish Eyes Are Smiling" and "Then There Was You." In front, the sound board and speakers from last night's band bookend an informal altar, draped with a bright green cloth and sanctified with a flower arrangement, complete with a blue ribbon in Department 05B, section 3, class 6, "arrangement of bold colorful flowers."

The local county fair has long been an exciting event for whole families, whether rural or urban, including for this one at the Greene County Fair in Greensboro, Georgia, in October 1941. Farm Security Administration photographer John Delano noted that at the Greene County Fair, white schoolchildren were admitted free one day, African American schoolchildren the next.

Photograph courtesy Library of Congress

Among the homey touches at the Sheboygan County Fair, Plymouth, Wisconsin, is a portable television hooked up to watch the big game.

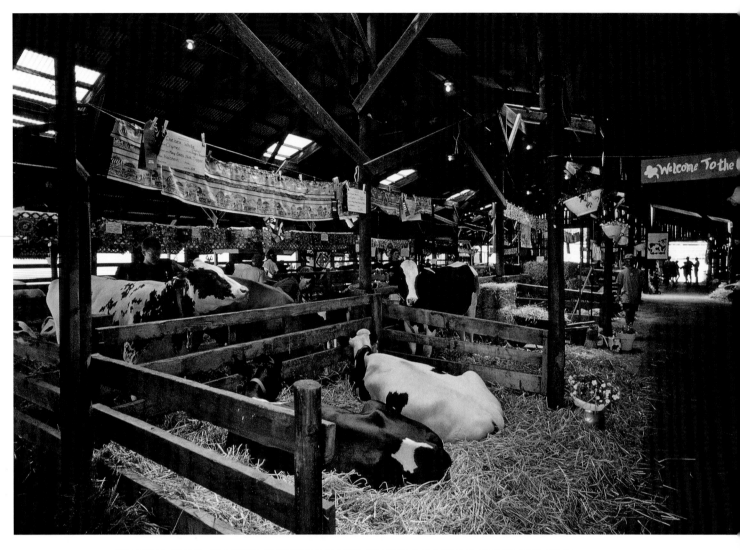

The cattle barn at the Chautauqua County Fair in Dunkirk, New York, is as homey as any barn could ever be.

Just after ten, Father Don Karlen, dressed in priestly black, arrives, and the pianist switches to church music—"Let Peace Begin with Me." Newell Wagoner, fair president, finds seats for latecomers. A baby cries. A mother chides her daughter by reminding her that "this is *still* church." Father Don pulls on his green robe and unpacks his communion chalice as somebody snaps on the string of bulbs hung under the sloping canvas roof.

According to those in the know at the Boonville Fair, this Sunday Mass is a tradition, a special part of the fair that began in 1975 in response to a tragic accident that killed three carnival employees en route to the fair, including the daughter of Bob Coleman, the owner of Coleman

Shows, the carnival which has played the Boonville Fair for many years.

"That was a terrible, terrible day in the history of the fair," Father Don told us later after Mass. "Each year the fair invites me to come back. I don't think there has ever been a time when we didn't have one since then."

Today, the mood is light, and Father Don begins by apologizing for being a bit late and says he'd have used Bob Coleman's good name with the police should he be stopped for speeding this morning. He tells the crowd that this event is "the most ecumenical thing I do all year."

The crowd is mixed and looks altogether local. Some wear T-shirts with dairy cows on them, a few are a

bit more dressed up than the usual folks at the fair, but there are few to no carnival workers. The tent is nearly full with only a couple of standees, including a young man in camouflage fatigues wearing an MP armband; he stands at the back at parade rest. We see him again later next to the Humvee at the National Guard booth.

During communion, somebody starts up a big four-wheel-drive truck for the truck pull at noon, drowning out the music and Father Don for a few moments until it shuts down again. Just before closing, he tells the story of a man who walked into his church in the middle of the service,

sat for a while, then got up to go, though Mass was not yet over. As he walked down the aisle, his trousers fell down. After Mass that day, a parishioner said to Father Don, "I'll bet that's the first time the vicar has ever been mooned." "No," said Father Don; "I've been with the carnival. It's neither the first time nor probably the last."

At 10:50, the service ends as the pianist wraps up with "America the Beautiful," and Father Don proceeds to the beer tent entrance. Next to the sign that reads "No Beer beyond This Gate," he greets the attendees as they disperse into the fairgrounds.

Youth gather in the livestock barn at La Crosse Interstate Fair, West Salem, Wisconsin.

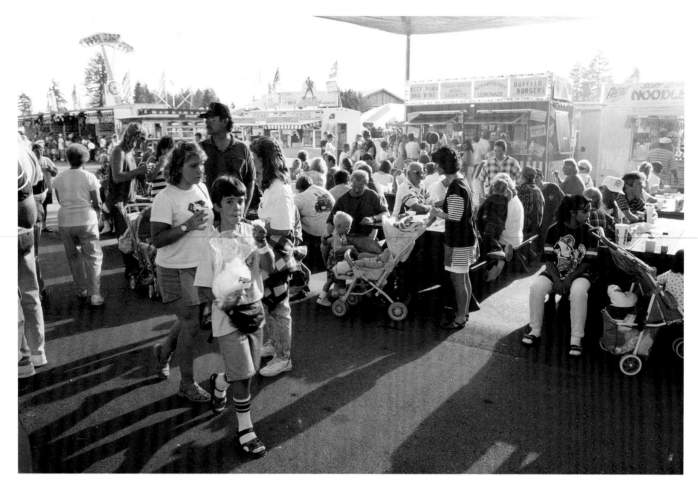

A full food court on a sunny afternoon is a happy sight for any fair manager. Grays Harbor County Fair, Elma, Washington.

10. Bossing the Fair

What most people don't realize is how much has to happen in order for the fair to go on. The panels don't necessarily jump up by themselves, and the manure doesn't necessarily just leave by itself.

—Bob Ruby, fair board president,
Johnson County Fair, Buffalo, Wyoming

That's one headache fair directors love to have.

—Full parking lots, according to Neil Daniels, director
at the Cheshire Fair, Swanzey, New Hampshire

Now comes the entertainment, a very important part of the fair. A county fair without entertainment is like a swimming hole without water.

—*Successful Farming,* 1922

WE MET DOZENS OF FAIR BOSSES on our travels to America's county fairs. Some have titles like fair manager or president, concession manager, exhibits supervisor; some are chair of the county agricultural society, but most of the people who run county fairs are just folks who stepped up when the need arose, and the title came second. A few,

especially those whose fairgrounds are called exposition centers and where events go on year-round, are full-time employees and have comfortable offices complete with support staff, but most get paid for only a few weeks, if at all, and simply volunteer vacation time from their day jobs to see that their fair happens each year.

Most fair offices, like that of Agnes Kinney, manager and board secretary of the Dawson County Fair in Glendive, Montana, are crammed into makeshift spaces, furnished with dumpster furniture, and lined with fly-specked pictures from past fairs. They are the stopping place for inbound UPS packages, hopeful outbound lost and found items (examples: a red high-heeled shoe, an empty cake pan rimmed with frosting, the occasional tear-streaked child, an astonishing numbers of keys), plus the inevitable stacks of premium books and palletloads of toilet paper.

Late on this afternoon of fair week, the air conditioner bellows in the Montana heat, and Agnes dispatches a board member to pick up the rodeo programs. The phone rings, and a businessman from town wants to know if the fair wants those Frisbees (printed with his business logo) as giveaways for the parade and rodeo. Yes, says Agnes, and you can deliver them here any time, thanks. A woman sticks her head in the door and asks, "Agnes, did you get those snaps you said you would?" Yes; she'll get them from her car as soon as she can. A man comes in, and he and Agnes discuss in detail the what and when of water application to settle dust on the arena for the rodeo tonight. As this conversation ends, in walks the guy with a big carton of Frisbees. Before he gets out the door, a woman comes in with an exhibit problem. The folks putting up a syrup art exhibit have discovered that the artwork is all stuck together in the heat, and the room is getting, well, messy. The words *syrup art* seem to cross Agnes's lips, and for the first time, and for only a moment, she stops.

ALL FAIR BOSSES, AT LEAST ALL WHO last very long in the job, are expert worriers and troubleshooters who routinely accomplish several tasks at once, much like the circus performer who spins all the plates on sticks. The best of them, like Newell Wagoner of the Boonville–Oneida County Fair in Boonville, New York, also have an innate understanding of people. He's been fair president since 1964.

"It's an awful lot of work," he tells us one day at a picnic table in the middle of the fairgrounds in the middle of fair week.

"How are you, Jeff?" he calls to a passing volunteer. "How are things going?"

"Rough," comes the reply.

"Well, when things calm down, I'll come over and see what you're doing."

To us Newell says, "He's a contractor, I've known him all my life." He explains that Jeff was instrumental in eleventh-hour repairs to the grandstand to meet occupancy codes.

"The biggest responsibility for a fair manager or president is you have to be a peacemaker. I spend more time—and this year is no different than any other year—just trying to keep the peace. Of course there are certain situations where you just have to throw your hands up and say, 'This is futile.' I do that with a couple parts of the fair."

During fair week most fair managers are like restless cats wanting in, and then out, as they circle the fairgrounds attending to problems, making occasional stops in the fair office to answer questions and the phone. In fact, Robert Silk, fair board member for the Cheshire Fair in Swanzey, New Hampshire, wore a pedometer for the first two days of his fair and found that by early Friday evening he'd already logged 11.5 miles.

Or Sandy Pipes, concessions manager at the Holmes County Fair in Millersburg, Ohio. The phone rang almost constantly in her little office when we visited, but when a couple teenagers stopped and asked if they could make a call, she said, "Sure, you can use it." To us she says, "I'll let anybody use it. When they are on the phone, it's not ringing for me."

As to running her part of the fair, she says, "Every year you make a few mistakes and learn from them. If it's not right this year, we'll fix it for next year. What's hard about it is—like in all things—you have to stay open to change. You tried something, and it didn't work—and maybe it will never work. Maybe you need to look at it in a different way. You can't think that because this is the way you've always done it that this is the only way. It's hard to think different."

The 9/11 attacks raised the specter of terrorism at a large fair someplace, but also raised the worry quotient in general. The *Los Angeles Times* in 2004 reported that some large Southern California county fairs have adopted airportlike security measures, including bag searches and metal detectors. At a fair association meeting in North Carolina, agricultural terrorism expert John T. Hoffman told the gathered fair bosses that "if it's the intent of someone to do something, there's little you can do about it."

Amusement Business reported on his presentation, "Terrorism Assessment: Are You Vulnerable?"

Others, like Steve Chambers, executive director of the Western Fairs Association, take a more positive view and see September 11 as a reason more people need to go to fairs. "What I really believe is that there is an added importance of fairs as a gathering place in the post–September 11 world," he told *Amusement Business* and fair managers at an Illinois Association of Agricultural Fairs meeting. Americans are "cocooning," too much, according to Chambers, and fairs are a great way to buck the trend. "We're a herd animal. When we're separated from the herd, it's not good for us."

But the larger threat may be the fuzzy animals at the petting zoo and, every now and then, the food vendors.

Occasional E. coli cases have been traced back to fairs, where kids handle animals and their droppings, or where fairgoers might eat undercooked meat, though the latter can happen just as easily outside the fair fence as in. Added to this are the "what if" scenarios about hoof-and-mouth or mad cow disease, the occasional brawl in the beer tent, and the anti–street gang dress code that prohibited Hell's Angels' entry to California's Ventura County Fair, and fair bosses everywhere have reason to toss and turn at night. Nevertheless, fairs have long been and remain safe family venues.

Money, of course, is always the factor that determines everything else at the fair, and no fair manager we talked to ever has enough. Many fairs count on a small amount of support from the state or county, but usually it

Fair offices are command central, and the tiny one at the Winona County Fair, St. Charles, Minnesota, is a busy place during fair week.

BOSSING THE FAIR

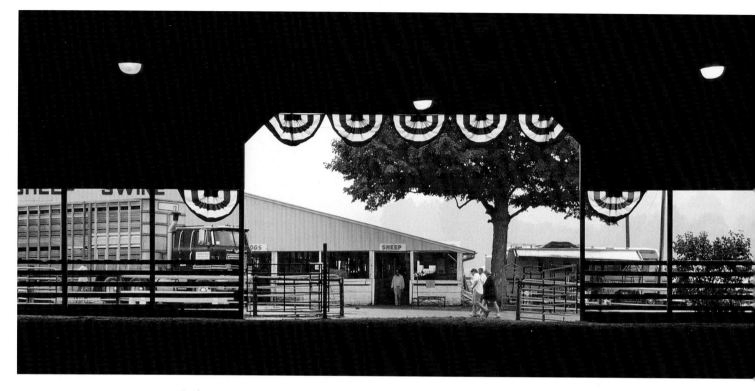

The fair gets up slowly on a foggy morning at the Ionia Free Fair, Ionia, Michigan.

covers little more than part of the premium costs. One exception is California, where horseracing money supports a percentage of fairs' operating costs. At most fairs about half the income comes from admission tickets. "Free gate" fairs make up the difference by charging more from the carnival and vendors.

The Bourbon County Fair and Horse Show in Paris, Kentucky, may be pretty typical of smaller fairs. According to treasurer Jim Allen, "We have some support from the state based on agricultural and horticultural premiums, or premiums paid to agricultural and horticultural events. We also get some support from the state for agricultural and horticultural-oriented improvements to the fairgrounds. The fair is not subsidized per se by the state. In our case it's probably 5 to 6 percent of the budget of the fair. Our fair is not really operated as a moneymaking operation.

"For the adult horse shows there are entry fees, but the prizes are also bigger. We give away some $28,000 each year just in cash premiums—anything from the largest cucumber and the best watermelon to the nicest quilt to the five-gaited championship horse—and another $4,500 in trophies. So it's an expensive proposition. In this

day and time it's hard to figure out how to pay for all of it. We're lucky if we come out with $2,000 to $3,000 left at the end of the year to start the next fair. And that's the whole idea. We don't want to make it into something where we're making scads of money. I don't guess it would be a challenge if we were rolling in the dough—not that we don't want a covered arena!"

And everything is getting more expensive. According to Henry and Suzie Johnson, longtime managers for the Cheshire Fair in New Hampshire, "When we first started, if you grossed $10,000, you made money. Now that won't even pay the cops."

Managers learn to get the most for every dime and try to get in-kind donations for everything from plumbing to printing. Those fairgrounds that also function as expo centers during the fifty-one weeks when the fair isn't running host flea markets, trade shows, and scout campouts. Other fairs cover costs by renting their buildings as winter storage for boats and vehicles.

Soon after we bring up the topic of fair finances, most fair bosses coast to coast talk about the weather—not to change the subject, but because the weather, more

Diehard fans gather early while the band sets up for the evening concert at the Sweetwater County Fair, Rock Springs, Wyoming.

than any other factor, affects their year-to-year cash flow. It always rains buckets on the Adams Agricultural Fair in Massachusetts; likewise the wind always blows during fair week at the Lane County Fair out on the plains of western Kansas, according to Sarah Fuller, county clerk and fair board member. Hot, cold, stormy, windy—fair bosses have seen it all and are always nervous come fair week.

Bill Diller, superintendent of concessions, explains the history-changing effects of the weather on his Bureau County Fair in Princeton, Illinois. "In 1954 I was a sophomore in college. The fair ran Tuesday to Friday then, four days—and it rained solid for four days. I mean it poured. We had mud up to our ankles. The fair literally went broke. They got sponsors and enough help from the bank for one more year because the next year was going to be the hundredth fair. They didn't want to stop at ninety-nine. They said,

'Well, we'll run the hundredth fair and then we'll stop it.' During the hundredth fair, there wasn't a cloud in the sky for four days, and it was cool. The money just flowed in, and it's survived ever since. But it was that close to being dead."

Big-ticket grandstand entertainment is a big worry for the managers of small- to medium-sized fairs because signing a country-western or rock hit maker can balloon a fair's expenses and put the fair at considerable risk. Diller explains, "It's worked very well for us. But at some fairs it doesn't work at all. Many fairs are afraid to try it. The first year we did it big time was Mel Tillis in 1978. All of us had our stomachs right up in our throats from November to May when we started selling tickets. You just don't know. What we've got tomorrow night cost us $45,000, and the most we ever paid before was $32,000. We book in November, but you don't know who is going

to be hot. This guy Billy Ray is *so hot*. He's on the cover of *Country Music Weekly* this week—and he's *here*."

Some years earlier, he says, the fair missed a good chance to book Alabama. "I'd never heard of them. I came home and asked my daughter; she was in junior high. She'd never heard of them either. That was November, and we could have had them for $8,000. By August, everybody in the world had heard of them. The next year, it was going to cost $50,000. So, you win some, you lose some. We hit Randy Travis just right, the Statlers just right. And I never met a nicer lady in my life than Barbara Mandrell. What you see on TV is what you get."

Advance ticket sales are good for tonight's show. "We have probably sold more tickets than we have before, but until I see the final figures, I'm not sure. But the show is paid for, and we've got $4,000 invested in rain insurance—it's paid for; all of our expenses are paid. We may just break even, and that's fine. We still are getting a lot of gate. People are going to pay to get on the fairgrounds, and we get a percentage of the carnival. They spend money there."

Some in the fair business complain that many large fairs— much larger than the Bureau County Fair—have shifted their focus from agriculture to entertainment in pursuit of better gate and grandstand receipts. It's true; at some metropolitan fairs, agriculture has faded in the shadow of big-name events and amusements more akin to those of theme parks and big music performance venues. Others say that fairs must evolve to survive. Agricultural fairs have been changing in response to public tastes ever since Elkanah Watson put on his second one in 1812. It's a logical adaptation and sometimes a good business strategy as American entertainment tastes shift toward flash and dazzle, but clearly something distinctive about the fair is lost if the sound of sheep and cattle disappears in the din of over-amplified music and the hype for Vegas-style acts.

Rodeo packs the grandstands at fairs west of the

> "Yeah, we've got demo derby tonight. For the life of me, I can't understand why people would pay money to see people crash cars together, but it is the only time we fill the grandstand, and it is the only time we charge for the grandstand. We could charge anything and it would fill up."
>
> —*Robert Fredrick, secretary of the Vernon County Fair, Viroqua, Wisconsin*
>
> •

Mississippi—and at some fairs as far east as Virginia—and has been part of most western fairs since their first dusty tent days. Westerners tell us it wouldn't be the fair without a rodeo. Harness racing, long the staple grandstand show of fairs, has waned through the century and has been replaced largely by "iron on the track."

In an odd throwback to the mechanical arts displays and events at early American fairs, our modern penchant for machines and movement gives today's fairgoers a steady diet of monster truck spectaculars, high-performance tractor pulls, the occasional riding lawn-mower pull, classic auto shows like the Joie Chitwood Thrill Show, and of course demolition derby. Some auto events, like the fair-sponsored truck pull where we met Jay Bristol of the New England Pullers, are amateur. Says Jay with a laugh above the roar of trucks, "If you want to bring your pickup out here and ruin it in front of a crowd, more power to you. You can even bring fifty or so of your friends to see you do it."

The demo derby is a peculiar event, part gearhead fest, part actual competition, part recycling effort, but mostly a Roman battle to the last gladiator standing, or moving, as the case may be. It packs them in coast to coast, but not everybody is a fan.

"Yeah, we've got demo derby tonight," says Robert Fredrick, secretary of the Vernon County Fair in Wisconsin one Saturday. "For the life of me, I can't understand why people would pay money to see people crash cars together, but it is the only time we fill the grandstand, and it is the only time we charge for the grandstand. We could charge anything and it would fill up."

Popular in grain-raising states is demo derby with lumbering combine harvesters locked in mortal combat like Star Wars fighting machines. Suitable leviathans are hard to find, but unless the weather goes down on show night, combine demo derby will pack the stands.

Fair bosses are always on the prowl for new features, new elements for the fair that will pry people from

Participants and crew await the signal to pull into the arena for the evening demolition derby at the Boonville–Oneida County Fair, Boonville, New York. The noise and action of crashing cars packs many grandstands at many fairs.

their DVD players and delivered pizza. Their big focus is wholesome family entertainment with a sharp eye toward specific audiences. Senior citizens turn out for sing-alongs, middle-aged working-class men and women for the demo derby, families for the local talent show. And "Twelve- to fourteen-year-old kids do not like Model A car shows," writes Bill Fugate of the Illinois Association of Agricultural Fairs. Extreme sports, including skateboard and BMX bike thrill shows, are growing popular on the fair circuit as a draw for the middle school set—and the parents who bring them to the fair.

Agricultural fairs compete not only with movies rented and viewed at home, but also with theme parks, sporting events, festivals, and concerts of all kinds. Fairs close to cities, like the Morgan County Fair northeast of Salt Lake City, fight it the most. "We're not isolated; people

can be down to a Jazz basketball game or to the symphony in thirty minutes," says David Alexander, fair manager. "And I worry that that's going to be a problem. We had our junior rodeo last night, and it was more poorly attended than ever." But even the tiny Furnas County Fair in Beaver City, Nebraska, competes with the likes of Worlds of Fun in Kansas City—380 miles away.

Newell Wagoner, president of the Boonville–Oneida County Fair, puts it another way: "The fair once was the center of activity in the county. People came a gigantic distance of maybe eleven or twelve miles by horse and buggy, or by car, to go to the fair and talk with their relatives and have a good time. Now, well, how much is going on in the last ten days in the area?"

Rather than compete on the same terms, many fairs look at what they are good at and book entertainment

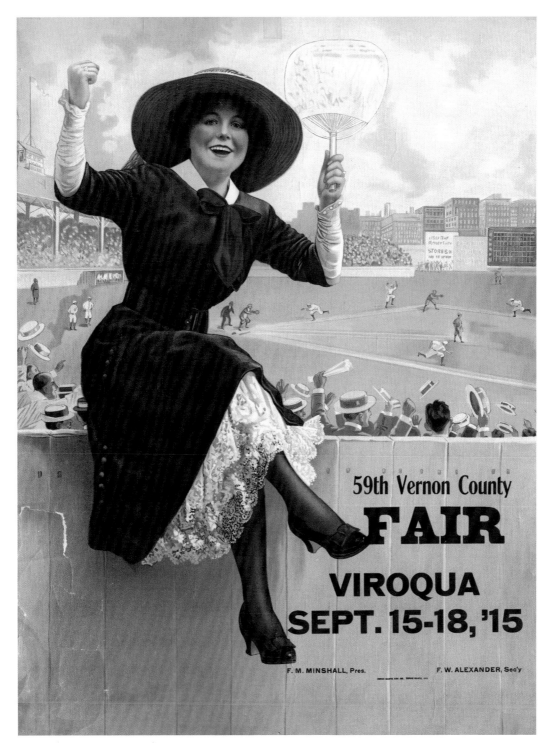

59th Vernon County
FAIR
VIROQUA
SEPT. 15-18, '15

F. M. MINSHALL, Pres. F. W. ALEXANDER, Sec'y

No local who spotted this poster for the hometown fair in 1915 could possibly have believed that those big buildings in the background were actually those of Viroqua, Wisconsin, population 2,000. Fairs have long chosen stock posters and advertising cards to promote their events, had their fair's information overprinted on them, often with charming, if less than accurate, results. But no matter—bright posters like this one always bring people to the fair.

Courtesy Vernon County Historical Society

accordingly. Bob Grems, a marketer we met at Boonville, says that in most businesses you ask, "What's new, what's different that we can promote?" In the agricultural fair realm we should ask, "What's old, what's traditional?" Old is apparently good: In an echo of ancient European fairs, strolling, street-style entertainers are staging a resurgence. Clowns wander fairs tying balloon animals and entertaining fairgoers much as magicians and jugglers once worked the crowds at medieval fairs.

Since fairs range so much in size, and local tastes vary from region to region, there is no such thing as "typical" fair entertainment, but the goal is always to give fairgoers a good show for their money and, if it's a ticketed event, to fill the stands. Whoever takes the stage, they have to be good.

For instance, bellowing chain saws draw fairgoers to the Indian River Olde Time Lumberjack Show at a handful of fairs in the Northeast, including the Boonville–Oneida County Fair, where we caught the act. Mainstays Bob Bosco and Rich Slingerland (aka "Dutch"), ably assisted by Bob's wife, Debbie, and sons Jacob and Robert, and by Rich's dog, Dingo, put on a classic lumberjack ball with chopping, sawing, and climbing contests; ax throwing; and logrolling. Bob, who wields the microphone as well as lumberjack tools, tosses groaner jokes as thick as the wood chips flying from Rich's ax. The show is solid county fair fun performed by champion woodsmen, and one woodswoman, who banter, saw, banter, climb and chop, banter and roll, to audience pleasure in the hot fair sun.

For the finale, the chain saws and axes fall silent as young Jacob Bosco appears dressed in shorts and challenges the older Slingerland, in full lumberjack getup, to a logrolling contest. "It's not a tennis match!"

Fairgoers settle in to watch the Indian River Olde Time Lumberjack Show at the Boonville–Oneida County Fair in Boonville, New York.

BOSSING THE FAIR

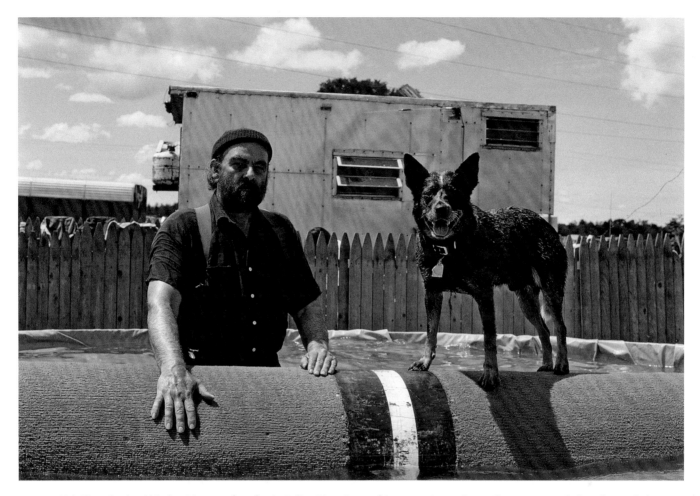

Rich Slingerland and his dog, Dingo, perform for the Indian River show at fairs across the Northeast. They compete in the logrolling tank three times a day, and Dingo always wins.

Slingerland complains seeing his contestant's getup. Bosco then climbs onto the log in the show's seven-thousand-gallon portable pool and proceeds to pull on his trousers, complete with lumberjack suspenders, while hopping on the turning log. Meanwhile, at the sound of splashing, Dingo barks from somewhere in the background. Then both men go at it. Though they do this three times a day, the competition is real, and the audience can tell. As the log starts to turn, Bosco and Slingerland hunch gorillalike and watch each other's feet, turning faster and faster, then slower. The log stops, bobs, and rolls tentatively in reverse; stops; changes direction; and soon they're off the other way, even faster, until finally Bosco loses his footing and splashes in. Sometimes he wins, sometimes Slingerland does.

Let loose from behind the fence, Dingo appears, wound like a mainspring, jumps on the log, barking and goading Slingerland to spin. Soon Slingerland's two and Dingo's four feet blur like those of cartoon characters, until at last Dingo spins his master into the drink. "The dog has four-wheel drive!" shouts Bob Bosco to the applauding crowd.

Says Slingerland later, "Dingo likes to do it. He doesn't like to get wet, but he likes to get on the log. He thinks nobody else ought to be on the log, just him. It didn't take a lot of training. He started on a dry log on land; just spun that. Pretty soon he figured out what I wanted. Then we went to the water. Dingo can outrun me on the land, and on the log." He points out that Dingo can run only forward.

After the show, Dingo's fur remains dry, but another set of wet lumberjack clothes soon appears on the wood

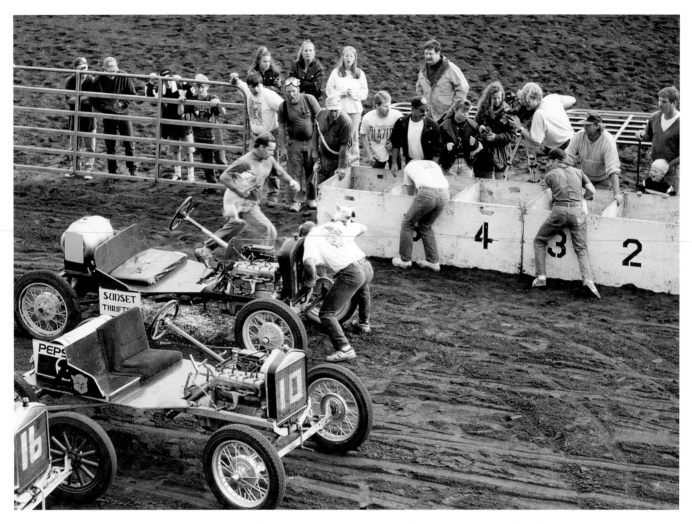

Competition is fierce at the annual Pig-N-Ford championships at the Tillamook County Fair, Tillamook, Oregon.

fence across the back of the small show area. With a sense of humor a good deal dryer than his plaid shirt and jeans, Slingerland says this job is a lot cleaner and healthier than his old one as a diesel mechanic. "I take three baths a day."

Partner Bob Bosco teaches sixth grade during the off months, but he and Slingerland find the time to promote their show to fair managers at fair conventions in the winter. "We go to a fair convention in Syracuse in January, and we go to the Vermont, Massachusetts, Connecticut, and New Hampshire conventions where you set up a booth and sell your 'wares.' It is a lot of fun. The competition is pretty hard, and these fairs have a strict budget. Are you better than the wrestler or the alligator man? We're the lumberjacks! Well, razzmatazz!"

Says Slingerland, who confesses that he owns at least a dozen chain saws, "Actually, to be as bad as we are out there, you gotta be pretty good."

Performing with chain saws and axes has its moments, according to Bosco. "Say a chain saw doesn't start or breaks down—you have to ad lib. Or when Rich does the bit trying to start the chain saw with it between his legs—it has started a few times. That always brings up your pulse. One time we were doing a show against a ten-foot-high fence. We were just a stone's throw from the state highway near Watertown, New York. I think it was one of my sons; he stands back, fires the ax, and it hits the top of the target, goes over the fence, out into the middle of Route 3. It didn't hit anybody, but a TV camera happened to catch it, and they showed it on TV as a ha-ha. The next day the DOT showed up to give the fair board a hard time."

According to Slingerland, people come to the fair for "greasy sausage and the Ferris wheel. They may come and watch our show, but it's not why they came to the fair. We're here to fill in. People are walking around and they've got to have some easy time when they can sit down, rest, catch their breath. That's why fairs hire us."

Bosco adds, "I sometimes think they are looking for a memory. I remember coming here as a kid when I was very, very young with a couple of dollars in my pocket. I walk down here now, and it's the same memories. I watched the Joie Chitwood Show—it's got to be twenty-five or thirty years since I saw it. No offense to Joie, but it's the same show, and people still love it. I mean, how fast can he spin a car around in a circle? You bring your kids back, trying to make the same memories for them that you had when you were here. Go on a ride, kiss your girlfriend!"

Among the best fair entertainment we encountered anywhere on our fair travels was the famous Pig-N-Ford races at the Tillamook County Fair in Oregon. This singular event has drivers of stripped-down Model T Fords careening around the track hanging onto a pig with one arm and driving with the other. Since no other fair does this, the Tillamook fair is justified in calling its runoff event on the third night of racing the world championship.

The stands are packed all three nights, and the competition is fierce. Ownership of one of the Model Ts amounts to a racing franchise, and the cars have been passed down for generations, along with the occasional grudge between families. It goes like this: At the starting gun, contestants sprint across the track to plywood pens containing forty-pound pigs. Dust flies and porcine squeals cut the air as contestants grab their passengers and run to their nearby cars. With a pig under one arm, drivers crank their Fords to life with the other, jump onto the seat (the cars being stripped to the chassis with little more than a bench seat for creature comforts), and roar off for a flat-out lap. In a few seconds they slide to a stop in front of the grandstand and pens, kill their engines, deposit the stunned pig in the pen, grab another, return to the car, crank it up, and go round again, for a total of three chaotic, noisy laps. Each heat is over in the blink of a pig's eye, even with the occasional loose pig, balky engine, and inevitable confusion as the coming and going cars mix it up with drivers crossing the track to their cars.

Most locals agree that this iron-on-the-track event began in 1925, but nobody recorded how it originated. We were told several plausible stories, but no one vouched much certainty. The event seems to draw everybody in the county, plus those from afar and the occasional national TV news crew. And the fair bosses of the Tillamook County Fair, who have all the worries of others who run fairs across the country, at least rest easy knowing that, rain or shine, they'll fill the grandstand for world championship Pig-N-Ford races every night, every year.

> "When you hear an auctioneer talk for a long, long time, you know he forgot where he's at, is waitin' for somebody else to bid, or is trying to remember what happened."
>
> —*Livestock auctioneer at the Rice County 4-H Fair, Lyons, Kansas*

Ticket sales are slow for the moment as the youth of Tillamook County, Oregon, throng the midway.

11. The Show

In 1959, the first year I was sheriff, I thought it best to learn everything about carnivals as fast as I could.

—Neil Haugerud, *Jailhouse Stories*

The California Ring-A-Bottle—come on over, come on in—give it a look, give it a try—ring-a-bottle, win-a-bear—ring-a-bottle, win-a-bear—ring, ring, ring, ring, ring—win, win, win, win, win.

—Endless taped announcement at a midway game, Sonoma County Fair, Santa Rosa, California

People don't realize that we are normal people when they hear the term carnival people. They think we are so different, but once you start talking to them, they look at you differently. When I tell them my son got his master's degree, my daughter graduated and is a certified teacher, and he is going to law school, they are amazed.

—Phyllis Porcelli, Spaghetti Eddie's

IT'S GETTING HARD TO FIND an Australian Snake-Eating Girl at a county fair these days, likewise a hootchy-kootchy show or a palm reader. Sideshows are rare at fairs today except on the coasts and in the South. Gone are the great carnival barkers, the come-ons, two-headed calves, and alligator boys, drowned out by the nation's high-pitched popular culture with its slasher flicks and video games. On our fair trips we found only the likes of Zambora the Ape Girl, the Wall of Death motorcycle thrill show, Skydiving Elvises, and the Parisian Poodles, plus the World's Only Performing Peacocks and Tim Rivers's High Diving Mules, among others. They draw only modest crowds and seem tame and threadbare compared to the delights of Disney theme parks and today's reality shows. But there are still controversies. When we caught up with Tim Rivers and his diving mules at a fair in Georgia, he threw up his hands and walked away. "Just leave me alone," he said. "I don't want any publicity." A little digging revealed that People for the Ethical Treatment of Animals had been dogging his heels up and down the coast.

Instead of looking for titillation, many fairgoers, like ourselves, seek out the nostalgic lurid in sideshows, with a mind to catch some glimpse of the fair entertainment of

*Helga the Headless Woman is still alive in this classic freak attraction at the Wilkes Agricultural Fair, North Wilkesboro, North Carolina,
but such old-time carnival standbys are hard to find at fairs today.*

old, to stand and look at the same Pygmy Mud Man or Fiji Mermaid as did gape-mouthed farmers years ago. Now it's usually just bad taxidermy, a bit moth eaten at that.

Through much of its long marriage to the American agricultural fair, the carnival has carried an illicit taint that repels some fairgoers and fairmakers and attracts a good many more. Even with a century-long push toward kid-friendly amusements at fairs, the carnival still carries a scent of danger on the fast rides and around the sometimes shady-looking characters who run them. Fairgoers still take their chances with the games, and a tingle still surrounds the shooting gallery and the ring toss. At rural fairs across the country, carnival workers are still seen by many locals as a dangerous urban and transient element. Rural kids have been warned for generations to avoid contact with them lest it lead to trouble—or running off with the carnival.

The carnival and the fair have had a symbiotic relationship since the beginnings of American fairs. Even in the years prior to the Civil War when the carnival was kept outside the fair fence, the acts, games, and food stands helped attract people, enriching both institutions. In those days the carnival was comprised of independent operators rather than the organized show companies with their games, rides, and food stands that are more common today.

The World's Columbian Exposition in Chicago in 1893 expanded the range of the carnival's delights and likely added the word midway to fair lexicon. The Chicago fair was split into two distinct spheres: the Court of Honor, or White City, with its classical architecture and high art; and the Midway Plaisance, with its Ferris wheel and pavilions, which featured such delights as a German

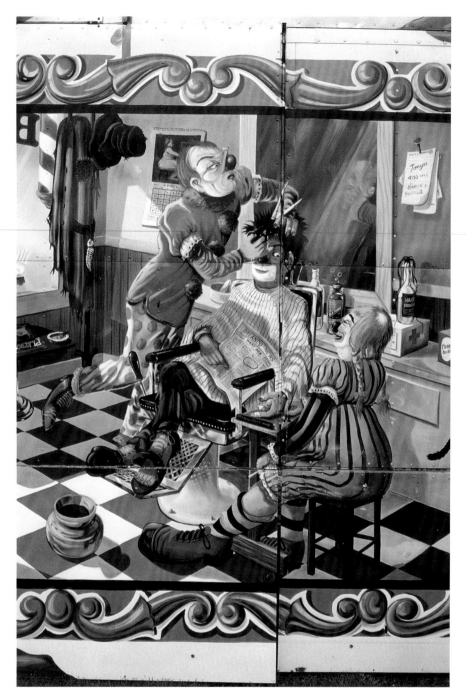

Classic carnival art is rare as well. This clown gets the full treatment in a painting on a glass house, or hall of mirrors, attraction owned by Tip Top Shows and seen at the Sheboygan County Fair, Plymouth, Wisconsin.

beer garden, performing acrobats, and "Little Egypt," a Cairo scene complete with veiled dancers that became the prototype for generations of girlie shows. It wasn't long after the Chicago fair that largely undressed dancers started showing up at county and state fairs across the country under the guise of ethnic shows, along with a full range of amplified sideshows and amusements.

The two realms of the Exposition also underscored a boundary between the educational and entertainment portions of fairs, a division still clear today in both the physical arrangement of most fairgrounds and temporal patterns of the event. There are, of course, many practical reasons to separate the carnival and the agricultural parts of the fair, not the least of which is that the noise of the carnival may upset the animals. Nonetheless, social reasons seem more important. Kids and parents on the aggie side of many fairs told us they never go to the midway, and many people who spend their time and money under the bright lights of the rides and games are seldom seen in the livestock barns.

Most fairgrounds put space between these two key fair elements, and the Great Bedford County Fair in Bedford, Pennsylvania, is a good example. The racetrack holds the middle of the fairgrounds, pushing the livestock barns, show arenas, and horseshoe pitch into the western half, with the carnival midway and the grandstand to the eastern half. Fairgoers squeeze between the curved ends of the track and the perimeter fence to get from one side to the other.

The diurnal cycle of fairs also reflects the difference between the two realms. The aggie side gets up early for the 4-H breakfast and then mucks stalls, feeds livestock, and curries and judges animals. The carnival gets up late, smokes a cigarette, gets the midway going in the afternoon, and lights up the night until well after the aggie side has turned in.

The contemporary carnival—or "show"—with its rides, games, food venues, and the occasional sideshow, has been tamed considerably from that which Hamlin

Sheboygan County Fair, Wisconsin

Garland would recognize from the 1870s. In his time most were a string of sinful sideshows facing a row of rigged games and booze stalls, spotted with dirty food tents and populated by milling shills who "won" the games when ordinary fairgoers couldn't and sheet writers who sold bogus magazine subscriptions. The evolution has been gradual, hard fought, and largely motivated by the century-long movement of fair priorities toward family entertainment.

Moral-minded fairgoers and community leaders have long railed against the evils of the carnival and have probably done so since the first tent show set up alongside the first market fair in ancient Europe or Asia. But especially in the early decades of the twentieth century, with more and more children participating in the fair, reformers moved decisively to clean up the carnival.

One particularly ardent campaign was pursued by *Country Gentleman* magazine beginning in 1922 with a three-part series called "Confessions of a Fair Faker" in which a repentant and unnamed concession operator revealed his sins to the world. The series began: "For ten years I have been a traveling faker. My business was to cheat farmers and their families." With melodrama suitable to the times, he describes the hapless hayseeds who've fallen into his grasp through "sure-thing layouts," "grind stores," and rigged roulette wheels. He detailed the lives of the sad girls in the hootchy-kootchy shows and told how he carelessly sickened numerous fairgoers with his fake red lemonade—made with red dye, the only coloring at hand for his ersatz drink. Dye notwithstanding, his advice about lemonade: "A few dozen lemons will last through a whole fair week. A lemon rind may be carefully fished out of the glasses and used over and over again until it is worn out."

Nevertheless, the Fair Faker looked past an important point when he wrote of one fair where "comparatively few persons were in the buildings that housed the poultry, livestock and farm produce, and domestic-arts exhibits; but

the midway was thronged, and all day the organs wheezed, drums throbbed and barkers barked." Shocking, crooked, or unsanitary, the carnival has always been popular. Most of the fairgoers the Faker described probably suspected "gaffed" games and expected disappointing acts, and still turned out for the privilege of being taken.

Early in 1923, under a headline that proclaimed "A Nation-Wide Indictment of Unclean Fairs," the magazine featured a four-headed dragon labeled "the crooked carnival" slithering from town to town. The heads were labeled Bootlegger, Disease, Gambler, and Cooch Dancer. The article featured a roundup of immoral and unclean acts of carnivals across the country, including one that a newspaper described at an unnamed fair in Texas: "There was the finest collection of thieves and thugs seen in many a day—creepers, pick outs, case ball, set spindles, and knockovers—all working for money. One farmer was gypped out of sixty-five bucks and another out of seventy, both in a few minutes. Plenty of cappers and shills were there, and they did everything to get the money except hit 'em on the head."

Subsequent stories during that year boasted of the strident efforts of a Thomas J. Johnson, legal counsel for the Showmen's League of America, and his endeavors to clean up the carnival. In February he spoke in Chicago to a combined meeting of showmen and fair secretaries. "Your carnivals are contaminated with a poison virus that is crumbling the outdoor-show structure into ruin," he told them. "Unless you clean up and eliminate those among you who are blind to order and decency, the bell will soon be rung for the final curtain to your business." Several states, it appears, were considering legislation to ban carnivals outright.

Johnson then organized the Showmen's Legislative Committee of America and adopted the stern title of "dictator." His committee drew up a list of carnival features that would henceforth be prohibited among the signers of the committee's pledge of fair conduct. Wrote Johnson: "We are saying to every outdoor showman in the land that no matter what kind of a show he operated in the past, here is the chance for him to wipe the slate clean and start again

"Everyone knows that two-headed calves have deteriorated in the past twenty years. Alligator boys, for instance, are virtually extinct, and one seldom sees even a spider woman."

—Phil Stong, "County Fair," 1932

•

with a new deal. If he will come into this organization and sign its pledge, his past sins will be forgiven." It was a long list and it banned such carnival delights as hootchy-kootchy shows, gambling for money, rigged games, liquor of any sort, dope, and all snake-eating shows. With a distinctly racist touch, it also banned all gypsies from "being in, around, or operating, associating or being connected with any form of entertainment or amusement, either indoor or outdoor."

For a while it seemed to work, but naturally some carnival operators balked at the new clean show rules, as did some fair boards. *Country Gentleman* reported that fair secretaries often told one clean carnival operator that his show was too tame. Why not run "wide open" and split the profits with the fair?

For the 1923 fair season, Johnson reported that about two-thirds of the nation's 128 carnival owners signed the pledge. Among those who didn't was one owner of a large and crooked show who told Johnson he'd even rig the kiddy rides to make money: "I've always been crooked and I always will be, and I'd like to see you stop me. I'd put a gaff on the merry-go-round if I could."

Another notoriously crooked carnival man saw the light and jumped on the bandwagon with Johnson and, in language reminiscent of a twelve-step program, said to him, "I thought I had to be crooked, but this is the biggest season I ever had. I never knew there was so much money in being clean and going straight."

In December of 1923 Johnson boasted, "I believe that next season a dirty and crooked carnival will be a rarity. I believe that carnivals have almost come to the end of the crooked trail."

But many showmen stayed crooked while fair boards and the cops either looked the other way or took a cut. Through the next two show seasons, their support for Johnson and his Showmen's Legislative Committee waned as graft—petty and otherwise—increased, and the dictator quit in disgust. "It seems that it is impossible for most of the carnivals to keep straight," he wrote. "And under no

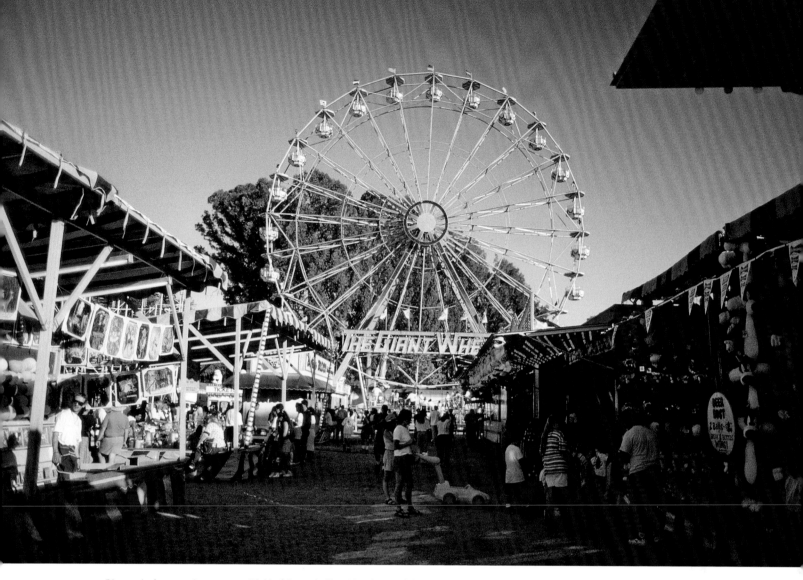

Big carnival companies partner with big fairs and offer rides that rival those in modern amusement parks. This Giant Wheel holds one end of the midway at the Sonoma County Fair, Santa Rosa, California.

circumstances will I continue to affiliate myself with a lot of men who can so easily forget their promises and their moral obligations."

One recollection about how the carnival, the fair board, and the law sometimes interacted comes from Neil Haugerud, who was sheriff in the late 1950s and 1960s in Fillmore County, Minnesota. In his amusing memoir, *Jailhouse Stories*, Haugerud details his education as the just-elected sheriff in this sometimes-shady relationship.

For the kids, he writes, the midway was rides and cotton candy; for adults it was a reunion with neighbors and friends. But for the sheriff it was a high-wire act keep-

ing the show in line with community tastes and balancing law enforcement with the wishes of the fair board.

His education came quickly at his first fair as sheriff. After turning down a hundred-dollar gift from the show operator—no strings attached—supposedly for the inconvenience of policing the fair, Haugerud watched the games carefully on opening night and showed up at the operator's trailer late in the evening with a fifth of whiskey.

Invited in by K. J. Moran, the nervous operator, Haugerud put the bottle on the table and said, "Have a drink. No strings attached. Nearly every game on the midway is a scam. I need to know how they all work."

"They're all skill and luck, Sheriff," replied Moran.

"Bull," said Haugerud.

They sat in silence.

"Games in tents number three, five, seven, and eight don't open in the morning," said Haugerud.

"Okay, where do we start, Sheriff?"

Then, in considerable detail, Moran described his rigged games—or at least some of them—and the graft, including some pickpocketing fortune-tellers. At the end, Haugerud and Moran agreed that no "mark" was to be bilked for more than twenty dollars, unless he had a wife or kids with him, and then the maximum was five dollars.

Moran never booked his show again in Fillmore County.

The next year, according to *Jailhouse Stories*, Haugerud got embroiled with the fair board and a new carnival operator over a wallet that disappeared during a fortune-telling session. It seems that the fortune-teller's wrap had slipped during the sitting, exposing her ample breasts and startling a customer named Dakota. He noticed soon afterward that his wallet was missing and complained to the law. Haugerud went to the operator of the new carnival, a guy named Kirk.

"We have a problem," Haugerud told him. "The fortune-teller's tent has to close, and we need a man's billfold and eighty dollars back."

Kirk protested. "You don't have any proof. Are you prejudiced against gypsies, Sheriff?"

Haugerud then threatened to shut down all the games on the midway.

"You can't do that, Sheriff. I'll go to the fair board. If you shut the games down, I'll shut the whole show down and pull out."

Haugerud backed off, but insisted the fortune-teller had to close, and if the wallet and eighty dollars

Clay County Fair, Iowa.

weren't returned by the next morning, the whole show would have to close.

The fair board went into a tizzy. They convened a meeting with Kirk and Haugerud. Kirk waxed about the good reputation of the fortune-teller, Haugerud stood his ground, and it looked like either way the carnival would pull out in the middle of the fair, wrecking fair revenues.

Moppy Anderson, longtime treasurer of the fair board, told Haugerud, "If you shut this midway down, you'll never get elected in this county again." Other board members nodded in agreement.

Haugerud turned to Kirk and said, "The fortune-teller's tent stays closed. I want the billfold and money back by noon tomorrow, or joints three, five, seven, and nine are shut down." Back in his office, Haugerud wondered if he'd done the right thing.

By noon the next day, Haugerud had heard nothing and walked through the midway, closing the games just as he'd threatened. In reaction to the operators' protests, Haugerud pointed out how each game was rigged, and they quickly acquiesced. But not the fair board. When Kirk said he was pulling out in the morning, Anderson and the board raised hell.

Late in the afternoon, a carnival worker just happened to find the billfold in question, sans cash, on the riverbank and turned it in to Haugerud. He went to Kirk and said, "Now, if Dakota had his eighty bucks, you'd be back in business."

"You're kind of a son-of-a-bitch, aren't you, Sheriff?" Kirk replaced the money, the show reopened, and everybody calmed down. At Haugerud's insistence, the fortune-teller stayed closed, however, and there was no more trouble that year.

According to Haugerud, some shows avoided the Fillmore County Fair thereafter, and among those that

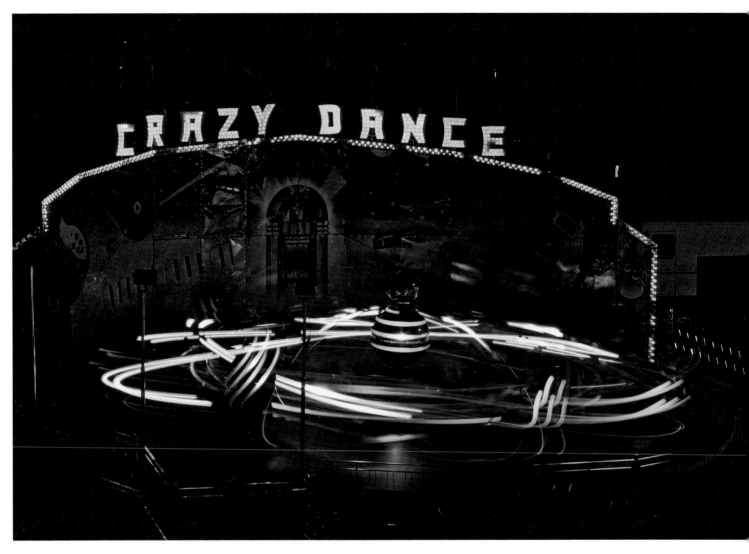

The dance of lights at the night carnival, Ingham County Fair, Mason, Michigan.

continued to play in the county, rigged games disappeared within three years.

Graft in games of chance today seems to be a nearly dead issue. Some games may still be rigged or slanted to favor the operator, but the cost to play is low, and few players are naive enough to imagine they always get a clean shot at the milk bottle pyramid or the balloons pinned to the board. These days most games are aimed at the kids and teenagers and pay off almost every time with "slum": cheap hats, stuffed animals, or trinkets that cost less than the price to play. Likewise real gambling, rigged or otherwise, appears to have vacated the fair in favor of Indian casinos and Internet poker, and remaining games of chance don't attract much attention from the law at a buck a toss.

Nevertheless, the Cleveland *Plain Dealer* reported in 2004 that Ohio's Department of Agriculture aggressively inspects the state's carnivals for cons and rigged games. Like Haugerud, the department knows it's easy to set the basketball hoop low and make it an oval instead of a circle, throwing off a contestant's shot, and it's easy to put extra lead in the milk bottles, making them especially tough to knock off the shelf with a ball.

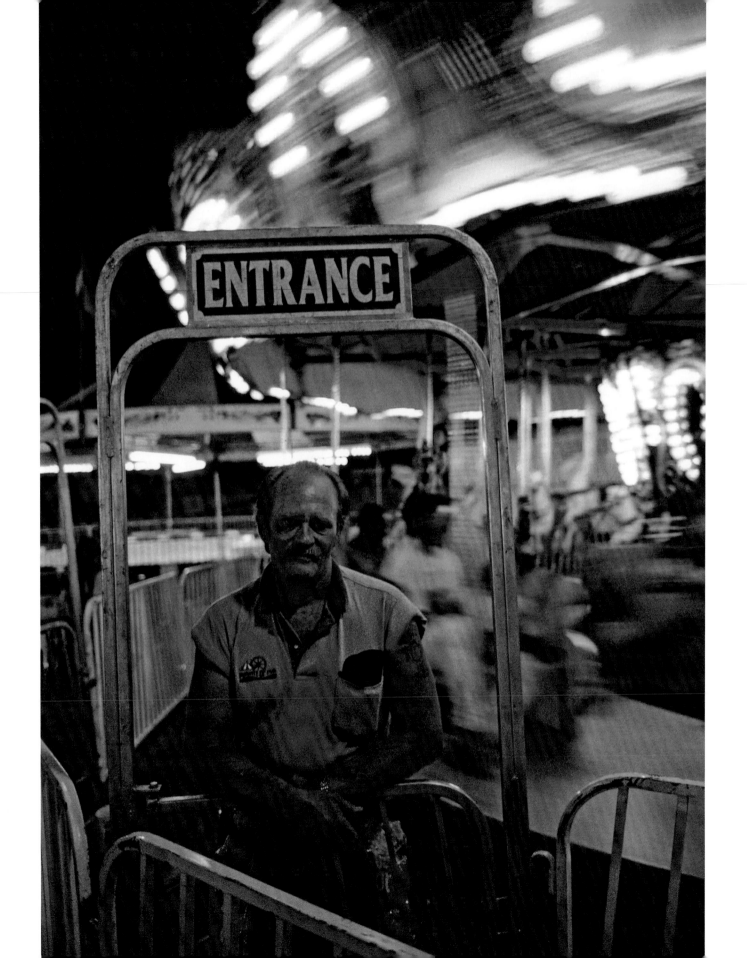

According to the *Plain Dealer*'s interview with Bill Riedthaler, a gambling fraud expert, "You have to keep in mind that you're trying to beat a guy who designed the game you're playing. And most people go to [the] carnival with the mind-set already in place that they will lose. Nobody who gives their kid ten bucks to go to the carnival expects them to come back with twenty."

Nevertheless, most of what we found suggests the carnival is straighter, cleaner, and safer than it's ever been. Safety regulations for rides, insurance requirements, employment law, and health regulations have put pressure on show operators, driving out the weak shows and unsavory food vendors and improving the rest. For example, food vendors, some traveling with the show and some local ones, complained to us about the frequency and detail of county health department inspections that were more rigorous than those for local restaurants.

With the trend in fair amusements turning ever more toward families, nobody has worked harder than show owners to clean up both the image and the reality of the carnival. Late in an evening during fair week, we sat with Bill and Mary Jo Carter, owners of Winchester Amusements, in their fifth-wheel trailer set up at the Rockingham County Fair in Harrisonburg, Virginia. With the midway lights shining through the windows into their living room, they spoke of how the carnival business has always been hard and is not getting any easier. They and other show operators we interviewed have worked hard to run safe, clean operations and to overcome years of bad press in the business, but continue to struggle with many of the same problems that dogged it fifty or a hundred years ago.

"The main thing is safety of the rides," says Bill. "That is our number one concern, safety of the public. In thirty-six years, we've never had a serious accident. Aw, we get some scratches and bruises, but that's all."

Safety is the first thing on the mind of every operator we talked with, mostly for its own sake, but also because of the huge increase in insurance costs and the jump in frivolous lawsuits for suspicious injuries.

"Our biggest expense in the business is insurance," says Mary Jo. "It is absolutely unbelievable. At the fair we're playing next week, a grandmother came up and brought her grandson. She said, 'Last night my grandson was here and he fell down and chipped his tooth.' We asked how it

happened. She said, 'He tripped over that wire right out front.' Well, this is a possibility, but no one saw it, and no one reported it. Besides that, he had no scratches or scrapes on him. So when we sent the report in, we sent a note about what we had observed."

The insurance company investigated and discovered the boy had chipped his tooth playing ball, not at the fair. Employee training, inspections by the state and by insurance carriers, plus an operator's keen ability to head off trouble before it happens are keys to keeping things safe and less costly.

The second thing most operators talk about are employee problems. Most carnivals are family businesses staffed in part by relatives, but few families are large enough to set up and operate an even medium-sized carnival, necessitating the hiring of seasonal and daily local help.

"It's getting tough because you can't get anybody who wants to work those kinds of hours anymore," says Bill.

Says Mary Jo, "That's the biggest challenge—the help. They have to be different to be out on the road with the trucks, running back and forth. They are mostly immature, so you really feel like you have children who are grown, but are still children. You can't tell them to do something and know that it is done. You have to follow up on every single solitary thing you've told them to do."

But the Carters consider themselves lucky. Bill adds, "Actually, the guys we have right now are real devoted. They work so hard. The biggest thing is to get them to put light bulbs in the rides."

Most operators and carnival workers we talked with, including the Carters, spoke of the strong bond of friendship in the business. Just as the fair is a reunion for county residents, it is a reunion for midway operators, workers, and independent vendors who reconnect each year at fairs on their circuit.

"We have a family here—a boy and his mother; both are retarded," says Bill. The mom is about seventy, the son about thirty. "They have worked for us for years. When we go to Luray and Charlottesville, they come and work for us. They are very conscientious and devoted, and we pay them just like we pay all the others. They do a super job. Every year he goes and buys me a coffee cup with his picture on it. When we pulled in Sunday, he was sitting there waiting for us."

There are, nonetheless, plenty of challenges keeping seasonal and itinerant workers sober, straight, and on the job. Show operators always prohibit illicit drugs and often prohibit alcohol among their workers but admit it's hard to police everybody all the time. As one smaller show owner at an eastern fair put it, "Somebody tells us that so

(left) Roger Harris, Merced County Fair, Merced, California. Roger: "This is the best job I've ever had." How long have you had it? "Two weeks."

and so is drinking, and we go down to check it out. I can smell it a mile away. When we close down at night, they usually go to the store and buy a six-pack of beer, most all of them. And as far as the drugs, they know we don't allow it, but I really don't know how to tell. If they are not running the ride correctly, or we get a complaint, then we really watch them." Most shows now require drug testing.

At another fair we met a carnie who emerged from a Porta-Potty one morning and stopped to talk on his way to town for cigarettes. In his late forties, thin and shirtless, he showed off the tattoos, now blurring with age, webbing his torso, arms, and fingers. When we introduce ourselves, he says, "I go by Mike out here."

He tells us he was a "factory rat" for twenty years until the plant closed. He's proud of his clean work record, free of injuries or absences. Then for a few years he "scammed," getting unemployment and doing tattoos on the side. Seven years ago he and his wife started with the carnival and are now running coin and basket toss games. At some venues, Mike has to curl his long ponytail up under his hat.

Like many game operators, he won't demonstrate his own game for his "marks," or players. In animated fashion he details the excuses he uses when customers challenge him to play it. "I just started this game yesterday; I have as much chance doing it as you would." Or, he counts on his older appearance and says, "Now, I been doing this a long time. You don't think I can do this game?" Or, "Sure, I'll do it for you. But it'll cost you five bucks." Or, "See that guy over there?" pointing to no one in particular. "That's my boss, and if he sees me demonstrating the game, I'll lose my job. It is not worth it to lose my job, is it?"

He and his wife plus two other women live in a trailer and a tent. They work for an operator who lets them keep 25 percent of their take. The prior year they kept 33 percent but had to buy their own stuffed animals and other prizes. He prefers this year's arrangement.

They get no medical or dental insurance, so if they get sick, Mike recommends giving a bogus name or wrong address, "so the bill doesn't catch up with you." The dentist is a different story, he says, because they want cash. Mike smiles and reveals a lack of upper front teeth.

There are other headaches in the carnival business. Mary Jo and Bill Carter tell us about setup difficulties and ride breakdowns.

"The spots we play year after year, everything's practically in the same place," says Mary Jo. "Maybe if I stop and think, I can remember where a ride or two was—but he knows where every ride was."

Bill smiles and says, "I step it off. As the rides come in, I just spot them and tell them where to put them so the guys can start setting them up. As I get older, my steps are getting shorter. When I set up down to Maryland, down to Hagerstown, well, see, there's a state law down there that no ride can be within six feet of another ride. I pulled the Rock-O-Plane in and spotted it, and I wanted to move the Zipper a bit, but they didn't move it, so I knew it was going to be pretty close. We hadn't set it up when the inspector got there. He said, 'You're going to be too close on that Zipper.' 'No,' I said, 'I got five and a half feet.' He said, 'You're not going to have that much.' I said, 'I'm going to have five and a half feet. I'll be half a foot short. You gonna make me move that ride for a half a foot?' He said, 'No. Not for a half a foot, but for a foot I'm going to make you.' So we set it up and we had just six foot. He said, 'Don't do that to me anymore!' And I was glad not to tear it down, because that's a tough job."

Experienced operators know how to arrange their rides to optimize business. "When I set up a midway like here, I like to have a horseshoe effect," says Bill. "That seems to work better than anything. The state fair in Virginia just spent millions of dollars to change theirs around to a horseshoe effect. You keep people circulating, and that's what you have to do. If they stand in one area too long, they're not spending money."

And according to Mary Jo, "The merry-go-round always goes in the middle." She tells us that one of their newest rides is computerized and the most prone to breakdowns. Bill elaborates, "When we bought it, the computer programming was a nightmare for us. I have pretty well mastered how to reprogram it now. The second week after we bought the thing, we moved in here, set it up. Got it inspected that day by the ride inspectors. Came back that evening and it wouldn't run. We had advertised with big headlines, 'New Ride Hits the Fair.' We spent eleven hours on the phone with England with them trying to tell us over the telephone how to reprogram this thing. It had lost everything. They finally said they were going to fly in the factory rep from Ohio. He couldn't get a flight right away, so he decided to drive.

"We had a guy who'd worked for us for years and years. He had a computer course. Vernon sits down and he gets this book out [with his hand, Bill indicates a book four inches thick] that tells you how to reprogram the thing. Before the rep from Ohio got here, he had it running. When the rep pulled in, he couldn't believe we had reprogrammed it because he didn't know how to reprogram it himself. He was gonna get on the phone to England. But we got it running."

At the Bourbon County Fair and Horse Show in Paris, Kentucky, Janie Snyder of Snyder and Metts Amusements reinforces the need for safety—and comfort. "You want

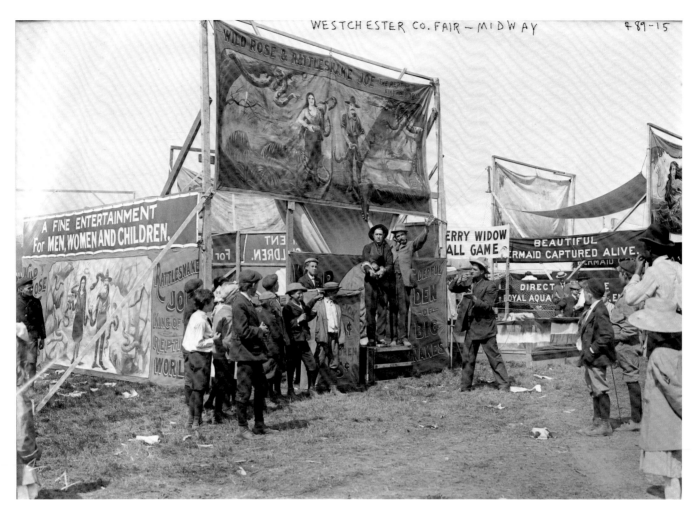

The pitchmen for Wild Rose and Rattlesnake Joe's sideshow draw a young and eager crowd at the Westchester County Fair in New York State. This turn-of-the-century glass plate demonstrates the lurid best of the old time sideshows. Courtesy Library of Congress

people to feel that the rides are safe, and that they want their children to ride them. If they don't look good, don't look as though somebody's been working on them, don't have paint on them, I wouldn't put my child on them, so why would anybody else? We've got chairs for people to sit on and watch their children, umbrellas to cover them when it is sunny or raining. It makes a big difference. If Mama's feet are hurting, she's not going to stay too long; if Mama can sit down and watch her children, they'll stay longer; they'll spend more money. It's good business practice."

Many smaller fairs don't have carnivals. Some fairs don't want them, and some can't get them. Some operators of smaller fairs think the hassle of hosting a carnival with its space needs, noise, and potential trouble offsets any possible monetary gain. Over the years small carnival operations have either left the business or been absorbed by bigger shows, making it hard for small fairs to book a midway full of rides, games, and fair noise. We saw this most in the Plains and interior West, where distances are great and fairs are often tiny, meaning long show hauls for slim income potential. Nevertheless, ever-adaptable fair boards with a bent for amusing the hometown crowd have gotten creative.

Take the Furnas County Fair in Beaver City, Nebraska. It's a small fair in a town of seven hundred people, but important to this county full of corn, sorghum, soybeans, and cattle. The fairgrounds sit out past the school on the hill north of town where the breeze is better on a hot

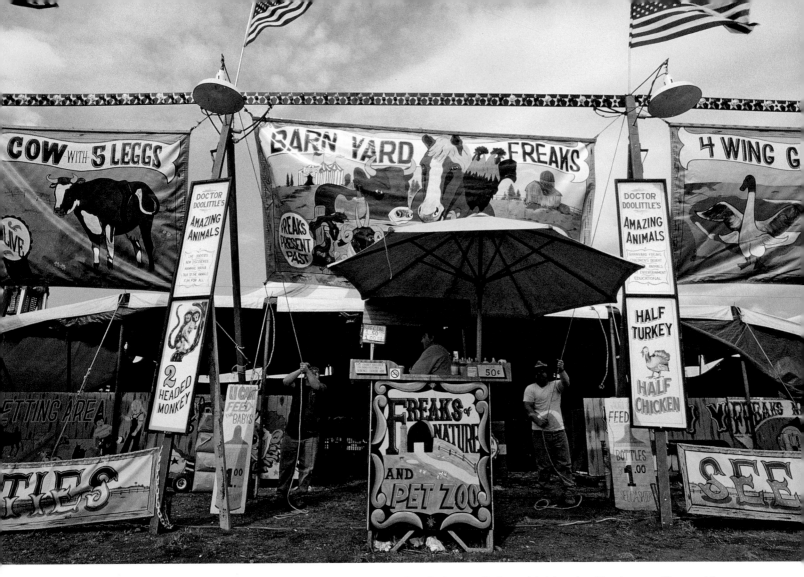

Animal freak shows are a bit easier to find than human ones, though few of either sort display such bright, crisp old-style art, spelling notwithstanding. Great Bedford County Fair, Bedford, Pennsylvania.

morning. By ten o'clock when we arrive, the thermometer has already climbed past ninety-five, and people are holed up in the shade or in the air-conditioned 4-H dining hall.

One year their carnival simply didn't show up. It was the last straw.

"The year before that happened, they had a lot of drug problems with the carnival, and people just got tired of it," says Cathy John, who oversees Furnas County's carnival. So the idea of starting their own carnival was born. "There are several around here—rural communities have gone to that because they can't afford to bring them in, and what they get is not worth bringing in. So people put out the word to see if there was enough community interest to do it."

Cathy's husband was curious about the possibility. "So, my husband showed up at the meeting, came home later, and I asked him how it was, and he said, 'Well, there's a lot of interest.' 'So they're going to do it?' I asked, and he said, 'Yeah,' and as he walked out the door, he said, 'Oh, by the way, I volunteered you for the board,' and walks out the door. 'Oh, good,' I said."

And so Furnas County started their homegrown carnival. "We were all novices," Cathy continues. "We had no idea where to start, where you find those games, or what you do, or anything. We decided we ought to have some officers, and so they asked for volunteers, and I said, 'Well, I don't work, and I know it's going to take a lot of time, phone calls, and paperwork,' and I said I would try to do it.

One of the other board members thought I was crazy.

"And we took off. The first year we bought the kiddy cars, and a family bought a Quonset and inside underneath a pile of rubble they found this railroad train and the track. We found a mangled piece of metal that ended up being our kiddy Ferris wheel. We devised twelve games, and we started. That was five years ago.

"Since then we've gone sort of crazy. We bought a carousel in Arizona; we bought bumper cars in Peony Park in Omaha when it quit. The Ferris wheel came along with the bumper car building."

Cathy says the Bullet and kiddy cars came from the region, and the roller coaster came from a little amusement park in Potter, Nebraska. "We went up, tore it down, brought it here, and put it back up. Let's see. The last one is the Whirl-Away. We just bought it last year.

"The train was built by a couple of gentlemen who used to live here. It was made from Maytag washers, parts of cars, refrigerators—they made it out of *stuff*, which is really wonderful until it breaks down and then you have a real problem trying to figure out what parts they used. We had the rear end go out of it last year, and we never did figure out what it came out of. We're fortunate to have a board member who is a talented welder, and he made some new gears for it. It's got a Model T motor in it, and we've got it all back in working order, repainted, up and going, and that family of the men comes every year to see it."

Rides alone do not complete the show, so the carnival committee figured out homespun games for the kids.

"We're trying new games, different things to keep the kids interested," says Cathy. "Strangely enough, the most popular game is the one with the pop bottles and rings. We went through 120 cases of two-liter pop last year, and this year it's 148 cases, and we'll be lucky to make it through the evening. We've put in two other pop games, and the kids just about wear them out."

The games area also sports a kid's roulette wheel, Skee-Ball, and Shark Attack, a popular game these hot days where kids fill little sharks with water using a super-soaker squirt gun. They've also got a duck pond.

"They just pick up any duck; we don't make them find a particular number. It's for the little ones. They just pick up a duck and go over to the prize bank. We had a new twist this year—three kids who decided they wanted to swim with the ducks. We hadn't had that happen before." She adds that half the games award pop, half award prizes. "Stuffed animals, kaleidoscopes, prisms, yo-yos, kid junk, the more the better. We did add a bulldozer this year, and a dime toss. You have to change; if things don't work, you have to come up with something different."

When we visited the Furnas County Fair, the carnival operation was still sixty-nine thousand dollars in debt, according to Cathy, but between income at the fair, fund-raisers, and help from some big contributors, "they're doing really well at it," says agricultural society chair Jim Mollhoff.

Jim explains how dropping the traveling carnival and starting their own has brought people to the fair, not just to ride and play, but to work. "The carnivals we used to have here didn't interest them because people make a trip or two or three a year to Worlds of Fun. So how can you get them to come over here? Now those same people that could afford to travel and go have fun somewhere else are coming over here and working. There are people that are on welfare and people that are multimillionaires, and they're all working together for the carnival. They do it because when the fair's over, every dollar that's spent here is still here. It doesn't hit the road the night the fair ends. People understand that, and they've turned out in droves.

"It takes more volunteers than you can scare up with a stick. They tried to have two people assigned to each ride and then at least two shifts a night, times four nights. You're looking at several hundred volunteers. So in that respect, we get a terrific number of volunteers out here. A lot of the people that are volunteering to work in the carnival area were people who never used to come to the fair."

> "All fairs are dying; they're lousy places to do business, can't make money at fairs anymore. You see anybody carrying anything? It looks like nobody's buying anything. People came flooding in here while it rained, and then disappeared when it quit."
>
> —*Vendor of Billy-Bob Teeth at the Ionia Free Fair, Ionia, Michigan*

Cathy talks about the social shift that came with their homegrown midway and volunteers who run it. "I don't think people realized how nice it could be until they got this. You see people sitting around and enjoying themselves, more like a social atmosphere, what a fair should be. Norton, Oberlin, and Elwood all have their own carnivals, so it's not a new concept around this area. But it took them about three years to realize how comfortable it is to be able to sit here and drink tea and visit with people you haven't seen."

The night before we visited, the rides and concessions took in fifty-six hundred dollars, according to Cathy. "Thirty-four hundred in ticket sales, and we had the free barbeque last night and still did twenty-two hundred in concessions. It was just astounding."

Volunteers work on the carnival equipment all year, but setting up is getting easier as they gain experience. "It takes us 361 days to get ready for the four days we run it. I don't know how those carnival people do it. It used to take us a week to set up, but now we can do it in a day and a half. We're getting much more efficient. But we don't want to go on the road. I just can't imagine that kind of life, good lord. We have a huge Quonset and use a forklift— I can't imagine doing this out on the road."

Cathy's reply is quick when we ask her what she's learned doing all this.

"Never send your husband alone to a meeting."

(above) Politics at the Fayette County Free Fair, Indiana.
(left) The rides are a little slow on a rainy day at the Bourbon County Fair and Horse Show, Paris, Kentucky.

By 1938 the mutually supportive relationship between local businesses and county fairs was well established and is amply displayed on this fair entrance gate in east Texas.

Photograph by Russell Lee, courtesy Library of Congress

12. Pride and Progress

ou don't use Cool Whip at the fair.

—Second-place pie winner at the Amador County Fair,
Plymouth, California

*I would rather have a ringside seat at a cattle sale
than a box at the opera.*

—E. B. White, 1957

CENTRAL TO ANY AMERICAN AGRICULTURAL FAIR is the theme of old-fashioned progress, of making agricultural, domestic, and community life better tomorrow than it was yesterday. This pattern was set at the first agricultural fair in the nation and persists largely unchanged today. Fairs emerged a few short decades after the American Revolution in a preindustrial land at a time when most Americans had little, and much of what they did own was homespun: coarse, primitive. Food was simple, sometimes of poor quality; livestock was of indifferent breeding, and crops were grown

from whatever seed stock was available. As Elkanah Watson and early fair promoters discovered, the local agricultural fair was a natural institution for the nation's material improvement.

Today's fair embraces the kind of straightforward progress that fairgoers years ago would recognize, a kind that doesn't have much to do with globalization or health care reform. The gardener who runs an Internet art business from home and brings cucumbers to the fair knows that her real progress in life is measured by online sales figures, not by the number of ribbons her vegetables win. With the exception of livestock breeders, most who exhibit and compete at the fair today do so for enjoyment and not because it will directly improve their material lives, as it did nearly two hundred years ago.

This emphasis on progress drives much of the competition and is easily seen in many of the commercial exhibits at any given fair. In fair competition, the central idea is to show off the best the local area can produce in pursuit of not only the *better* thing, but also the *ideal* thing. Thus, every fair hopes to display the county's best examples as solid progress toward the perfect Holstein, flower arrangement, rock collection, and so on. But it goes further. The fair queen herself represents the pursuit of the perfect teenage girl, and commercial vendors advertise the best replacement siding, the acme of modern ever-sharp knives, and the zenith of cure-all vitamins.

Mary Crewel, a horticulture judge at the Sonoma County Fair in Santa Rosa, California, explains, "When you are looking, for instance, at cut flowers, you are not looking for the biggest; you're looking for the best form, the best color, the most vibrant, the best condition, the best growth, to see if it's cut at its peak, its prime. That's what you are looking for when you are judging for blue ribbons. And

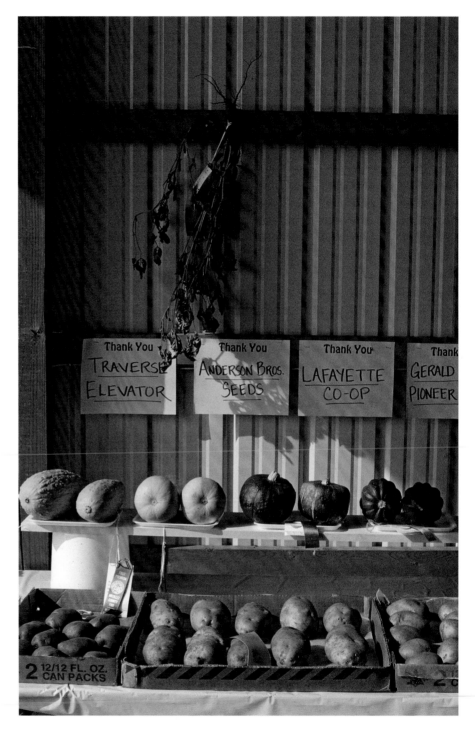

A simple vegetable display at the Nicollet County Fair, St. Peter, Minnesota.

when you're judging for the Best in Show, it's each blue ribbon [winner] against all the other blue ribbons. So you are looking for the most *purrr*-fect specimen."

Even as Watson and the officers of the Berkshire Agricultural Society organized America's first agricultural fair, they recognized that merely inviting farmers to see and show the new Merino sheep, excited as Watson himself was about them, was likely not enough to garner the crowds he hoped for. The event would need spirited competition and prizes of consequence. Thus these earliest fairmakers created competitive awards and had the local *Pittsfield Sun* announce generous premiums of ten

dollars each for the best bull and the best full-blooded Merino lamb, and five dollars for the best oxen, cows, and heifers, mixed-blood and common sheep, and swine. And on that last Tuesday in September 1811, the public square and surrounding streets thronged with people, their animals, and inventions. This pattern, set from the very beginning, proved itself immediately and became a bellwether of the agricultural fair.

Nowadays, fair competitions are not, of course, about farm survival and basic agricultural improvement, and the winning premiums are not so generous, but instead a chance to engage in friendly

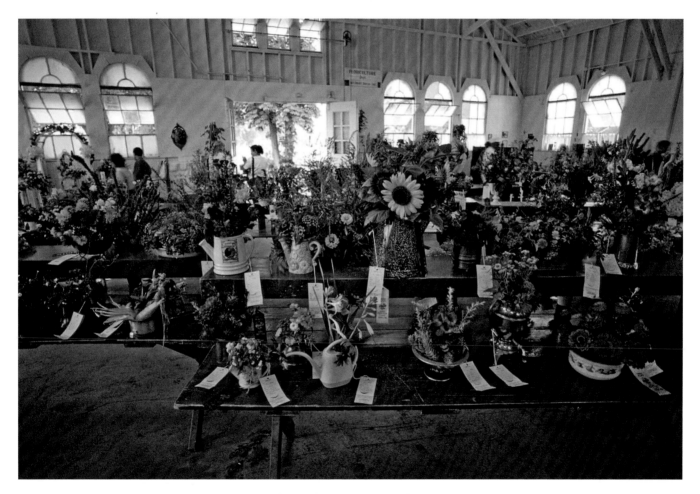

Floral Hall, Ionia Free Fair, Michigan.

competition among neighbors, friends, and fellow FFA and 4-H-ers. Leslie Prosterman, in her look at the midwestern county fair in *Ordinary Life, Festival Days*, analyzes contemporary exhibitors' motivations: "People choose to enter their creation at the county fair because they have made something and they want to show it off. They enter because they became inspired by the fair book or last year's fair, which impelled them to try new ideas or techniques or to outdo their neighbor. Exhibitors show to satisfy the competitive instinct, to get criticism, to learn, and to see how they measure against their peers."

Top among these is the competitive instinct; it resides at the very heart of the county fair. From the veteran dahlia grower to the rookie rabbit raiser, the chance to compete, be ranked, to achieve is a key impulse to participation in the yearly ritual of the fair. It brings fairgoers in through the gates with armloads of quilts, baskets of pumpkins, bunches of fresh cut zinnias, lop-eared rabbits, photographs of pets and trees, zucchini bread, ewe lambs, and a full livestock trailer. An exhibitor feels pride seeing her plate of tomatoes and her jar of raspberry preserves displayed among myriad others on the white painted shelves of the exhibit hall, but a blue ribbon dangling from them gives her bragging rights—at least until next year's fair.

Just exactly who wins those ribbons is rarely a contentious issue, but late in the evening at the Jefferson Township Fair in Mercer, Pennsylvania, an energetic Cathy McCullough enters the fair office.

"I'd like to register a complaint about the blueberry pie judging," she says. "I took third, and my kids took first and second." Her tone of false resentment shifts to laughter and reflects her pride in her kids and the fun the competition gives the family—and now her wider circle of friends. "This is the third year in a row, and my kids look forward to it. I can't wait until one of these years when I at least take second!" She adds that her kids are chiding her a lot this year, saying that a fourth person had entered, a twist that might have left her ribbonless. "Mom, you almost got *beat*!"

Winners at the county fair take home a variety of

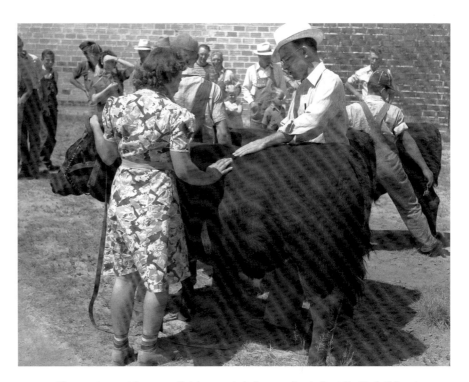

The county agent from an adjoining county judges yearling bulls at the Haskell County 4-H Fair, Sublette, Kansas, in September of 1939. Girls and women have done "men's work" in the agricultural world for generations, including at the county fair.

Photograph by Russell Lee, courtesy Library of Congress

prizes: ribbons, plaques, trophies, platters, and good old cash. Ribbons are the most common accolade for first, second, and third places and might be awarded with or without premium money, usually just a few dollars. At American fairs everybody identifies a blue ribbon as the first place winner, with red and white honoring second and third, respectively. Above blue, oversized rosette ribbons in white, purple, or other colors are awarded for higher levels of achievement. They go to Champions and come in such superlatives as Supreme, Grand, and Reserve. Best of Show takes home one of these sunflower-shaped ribbons, too. And big rosettes get carried home by sweepstakes winners—those who have accumulated the most and highest rank in ribbons in a given department.

The satiny bright ribbon with gold lettering and braided cord is an icon of the county fair, a keepsake for anyone who wins one. In the afterglow of the fair, hard-earned ribbons get hung on the wall, tucked into books, and even sewn into pillows and quilts. A friend told us of his uncle and grandparents who for decades brought entries to the Woodbury County Fair in Iowa, and when the family sorted through the house after Uncle Kenny died,

they found a box of more than four hundred ribbons carefully saved throughout some forty years of entering.

But perhaps the best example of ribbons as keepsakes comes from Marlys Neldner, who has shown at the Winona County Fair in Minnesota for decades. "I started with ribbons about 1957 when I was about five years old, and by 1970, I was all done with the fair and going off to college. Unbeknownst to me, Mom took all those ribbons and sewed them into a quilt. She put all those ribbons in it—even the rosettes. There are your blues, reds, whites, and the rosettes for champion and reserve. In the middle is my white banner for being the attendant for Dairy Princess. It's got 158 ribbons."

How the ribbon came to its place of honor at the fair is a bit unclear, but there are likely precursors. Ribbons are not mentioned in histories of early European fairs, and Elkanah Watson preached awarding silver plate items for premiums at early agricultural fairs in this country. J. F. Laning, in his 1881 book, *How to Manage Agricultural Fairs*, proposed a system of cards and ribbons that doubtlessly provided a prototype. Wrote Laning: "Premium Cards. Cards are usually issued to be attached to such things as receive premiums. The following colors are usually chosen to designate the different premiums: First premium, red; second premium, blue; third premium, various colors. Ribbons of like colors are often used for livestock. . . . Parties are then required to present the card to obtain their premium money . . . and are of no value after the Fair except as keepsakes."

While Laning proposed that red be the color for first place (as is still the case at fairs in Canada), some scholars think the use of blue ribbons for first place, or excellence, derives from a once-important nautical award. The Blue Riband was a prize created in the 1860s and bestowed on the passenger ship making the fastest transatlantic crossing. The speediest ship was given a blue pennant to fly from its mast.

Despite Elkanah Watson's later warning against awarding easily spent money as fair prizes, small cash premiums are common today. Ranging from $0.50 for third prize vegetables to maybe $150.00 for first-prize cattle, the awards make clear that exhibiting at the county fair is no get-rich-quick scheme. At the Wilkes Agricultural Fair in North Carolina, first place peanut brittle nets $6.00, while at the Sweetwater County Fair in Wyoming, the winning entry of Swedish Select Oats, displayed in a full one-quart bottle, earns a $6.00 prize, and the winning pastel landscape merits a mere $1.50.

For the youth who exhibit and compete via FFA, 4-H, and other groups, the payoff for creating an exhibit, or for the daily feeding, care, and training of animals, comes with the attention from the crowds passing through the exhibit hall or livestock barn, and especially with the excitement of the show ring. While we did hear occasional stories about excessively competitive parents buying expensive show stock for their kids to raise as near-sure winners, these more aggressive parts of competition are discouraged in youth shows, and in all of the fair, for that matter. The young exhibitors we interviewed were keen on competing, but largely saw their fair exhibition as a chance to learn from the experience and from the judges. The reward comes in both the process and the result, and the adults involved promote and expect good sportsmanship. Advice dished out in a 1922 issue of the *Ohio Farmer* sums it up in barnyard terms: "Win without crowing, lose without squealing."

But Marvin Zylstra, the extension educator we met at the Cottonwood County Fair in Windom, Minnesota, understands the lasting impact of premiums awarded to junior exhibitors. On a humid August afternoon just before the 4-H awards program, the fair office table sags with trophies soon to be handed out, many of them similar: a marblelike base with a green marbleized pedestal, topped with a gold sheep, horse, steer, or cow. Marvin picks up a Junior Beef Showmanship trophy and says that the little girl who won it came in yesterday to see her trophy. She seemed disappointed that the steer on her trophy didn't match the animal she had showed. "Oh, it's so . . . woolly," she said. Seeing her disappointment, Marvin said, "We'll get that changed for you." She politely protested, "No, its okay." But Marvin had it changed anyway. "She'll be looking at that trophy a long time—until she gets to be eighteen and has other interests, but even then, she'll put it away in a

> "Every kid wants to be part of a gang. I think that 4-H and FFA are pretty good ones to get involved in."
>
> —L. Evan Brooks, fair evaluator, Washington State Fairs Commission

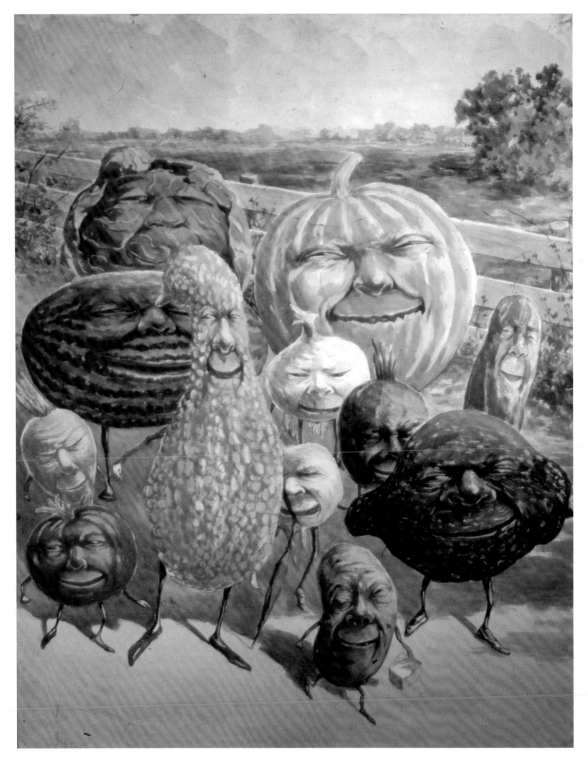

Vegetables are important to any agricultural fair though they seldom arrive under their own power, as this artwork suggests. Such whimsical art has long been used to promote fairs across the country.

Courtesy The Fair Publishing House, Inc. Collection, Michigan State University Museum

box. And when she takes it out, years later, and has her memories, we don't want them to be spoiled."

From pickles to pigs, the judging of entries is an essential ritual of the fair, and fairmakers are eager to engage qualified and communicative judges. Usually the superintendents in each department (horticulture, cattle, crops, and so on) line them up, and most are drawn from the region. Most judges volunteer their time, or at the most may receive a small stipend or reimbursement for travel. They perform their work because of an abiding interest in their subject area and, typically, a devotion to fairs.

A fair of any size must engage numerous judges, each qualified in a specific area, to evaluate a daunting variety of competitive categories: llamas, potatoes, cacti, Arabian horses, marigolds, leatherwork, crocheting, brownies, insect collections, hams, photographs, apples, wheat, and wine, to name a few. Judges often work professionally in the area at hand, or are teachers with expertise in the subject area. A master gardener or garden club president might judge the floral exhibits, while the ag teacher evaluates the rabbits for their prizewinning features. The retired home ec teacher can apply all that experience to scrutinizing the seams of the entries in "Clothing, K-290: Blouse (set-in sleeve)." Especially in livestock judging, where the premium stakes are often a bit higher, fairs prefer to engage judges from another county, providing them with the clout of the outside expert and a little helpful impartiality as well. Even in the earliest days of American fairs, Elkanah Watson encouraged the use of out-of-town judges to minimize the appearance of prejudice bred of familiarity.

Says Mary Crewel of the Sonoma County Fair, "We never judge in a county in which we present stuff. Otherwise, you become familiar with people's work, and it is hard to stay objective." Early in the conversation, Mary offers her qualifications. "I am a member of the National Council of Garden Club Flower Show Judges. In order to be one, you must go to school for three years." She explains that to become a member, you must win a minimum number of blue ribbons at flower shows and fairs to demonstrate your expert status.

Mary knows her credentials help establish credibility with the exhibitors, who expect to be judged fairly and

competently. The authority of a well-chosen judge is assumed by those competing, but must get reinforced by the judging process and in the quality of the selections made. Whether they win ribbons or not, exhibitors feel positive about their participation when the judging criteria are clear, the process is transparent, and judges communicate clearly about their choices. Exhibitors are very keen to hear just why this goat, layer cake, or porcelain doll earned blue and another just a red.

When judging is done in the absence of the exhibitor, as is usually the case with vegetables, flowers, and foods, this explanation comes in the form of comments written on the back of the exhibit entry card. "Lovely lines and great color combination. Your rhythm is fabulous," it might say for a flower arrangement entered in the "Tea Is Served" category. Or for zucchini bread: "Excellent cutability and texture, pleasing taste."

Mary explains, "You never want to say, 'This is good, this is bad.' You want to explain what it is that is good, what is exciting about it. Let the person know that they have captured some essence of the theme. You want to comment on things that are done differently than everybody else has done them."

Livestock judging is performed not only in the presence of the exhibitors but often with a larger audience to boot— parents of exhibitors, old-timers, city folk, and doubtless a few would-be experts. This is when a judge is most exposed and most accountable. A class of livestock is called into the arena, exhibitors attentively leading each animal around the ring. The nervous owners and their calves, or ewes, swine, dairy goats, or steers, parade by, once, twice, left, right. The judge considers, examines, strokes, compares, and eventually lines them up. Then the moment of truth.

With the animals and their handlers all watching intently, the judge speaks over the P.A. Usually he— sometimes she—starts by thanking the fair, or the county's FFA and 4-H clubs, for putting on such a good show, or he'll make a positive comparison with last year's competition, or to an unnamed fair he's recently judged. Then he'll certainly go on to praise the whole lot of animals he is judging, and commend all the hard work of the owners.

The judge then proclaims the winning animals, sometimes from first place down to runner-ups, sometimes

in the other direction, and details the exceptional attributes of their appearance, structure, and functionality. Much of his attention is directed toward the udder on a dairy cow, the muscle and ribs on a steer or market lamb, the hams on swine, the pelvis and legs on a heifer. He may talk of how the animal moves, stands, or, in the case of a heifer, its likely ease of calving. Like any expert, he uses jargon that's specific to the trade and familiar to most of his listeners.

Listen to the sheep judge at the Merced County Fair in California explain his choices: "When we're looking at these ewe lambs here, we're looking at futuristic. . . . We have a ewe lamb down here that's very stylish, a very eye-appealing kind of a ewe, that certainly has some length to her, but also she's got some top to her, a lot of meat and muscle here, and she's fairly elevated over the dock. The ewe that's second place is a little pinched around the girth. . . . This ewe, when you analyze and look at her from the side profile, she is tremendously long, especially from the thirteenth rib back, and a ewe that is fairly clean up through the front."

Despite the jargon, his goal is less to profess why he chose these animals as the winners than to educate the exhibitors and audience about what makes better quality animals. Judges often use gentle comparisons in detailing their selections, suggesting that one animal has a little too much of this, not quite enough of that. Such tempered criticism encourages exhibitors back for next year's fair.

Ideally a judge possesses a clear notion about community standards in the category she judges. It is unlikely, for example, for a floral judge from Oregon to be trusted to rate the arrangements in Indiana, lest there come some highfalutin suggestion to include some West Coast garden species in the bouquet. Similarly, a Hoosier canning judge might be hard-pressed to render an opinion about canned moose meat at a fair in Alaska.

Entry criteria are important. According to Mary Crewel, "The important thing is to follow the premium book. If the book says, 'two stems of one variety,' then you want them to put in two stems. If you put in one stem, even though it may be a perfect flower, it does not conform. It cannot win. Conforming and following the schedule is very important. What the schedule says is what we judge on."

As in Olympic figure skating, judging at the county fair is based on a standard of perfection. Certainly a blue ribbon signifies excellence, but the contestants know that their hand-stitched quilt or horse show performance or home brew beer likely didn't reach a level of flawlessness.

In contrast, an art fair has very different criteria. Art fair judges generally award ribbons and prizes for innovation, new creative territory, while county fair judges look for something of the same nature, just better. It's likely that county fair judges and participants alike have never seen the perfect Holstein or sampled the perfect pie, but most would claim to know it when they saw it or tasted it.

Agricultural fairs usually use either Danish or American judging methods. In the Danish system, sometimes called the Group System, an entry is judged against an established standard or ideal for the particular item. Typically used in the junior divisions, this system allows many youngsters to go home with blue, red, and white ribbons, rewarding their efforts and encouraging their participation in future fairs. The American system is also based on an ideal, but has judges directly compare exhibits to one another, ranking them and awarding only a single first, second, and third place ribbon.

Judges, fair officials, and exhibitors we talked with appreciate high standards, which inspire and motivate ribbon-hopefuls to enter their best, but unrealistically high standards could lead to a paucity of ribbon awards. Place or not, almost every exhibitor feels better if the standards are high. It glorifies the beribboned and assuages the ribbonless: good, just not quite good enough this year. Even experienced winners feel a sense of pride and belonging—and a bit of local celebrity. We saw winner's pride in the ribbon dangling from the back jeans pockets of the 4-H-er as she leads her steer out of the ring, in the smile of the Best of Show quilter whose neighbors have stopped by the home arts building to see her purple rosette, and in the many colored ribbons affixed to the stalls in the barn after the horse show.

This sense of pride and belonging is intensely concentrated and best seen at the livestock auction held toward the end of any vigorous county fair. At this sale the market animals—beef cattle, swine, market sheep, sometimes even rabbits and chickens—are sold for slaughter. Many other exhibited animals—bred heifers, for example—aren't sold for market and go home again after the fair. The livestock auction is usually a culminating event of the fair, often scheduled on Saturday night before the fair ends on Sunday, followed right afterward by a dinner or a dance. At the auction the bleachers are usually full of exhibitors' families, potential buyers, and the curious as the auctioneer calls the first of the exhibitors and his animal into the ring and begins his wavering chant. One by one exhibitors and animals parade through, with the 4-H

Everybody loves a colorful fair ribbon, including these tykes who just finished the baby contest at the Bourbon County Fair and Horse Show, Paris, Kentucky.

and FFA exhibitors working to keep their animal moving, all the while looking intently at the crowd, hoping to spark higher bids, as the auctioneer drones through the loudspeakers. The tension is palpable as the bids rise—or stagnate. A relative might buy a kid's market sheep; the big grocery store in town often buys beef cattle and swine. Whoever buys, the exhibitors are as eager for a good price as they were for winning ribbons.

The auction reinforces the bonds of community in important ways. Young exhibitors have often contacted potential buyers by letter prior to fair week to solicit bids, and they are trained to send thank-you cards to the successful bidders after the auction. And should the local clothing store or auto supply or supermarket buy a winning animal, it's a near-certainty that the fact will be displayed via a certificate or plaque hung for every customer to see. As the mother of a young animal exhibitor told us at the livestock auction at the Jefferson County Fair in Oregon, if the local supermarket buys her child's sheep, she's "sure as heck" going to shop there the rest of her life.

Some fairs make sure the young exhibitors are elsewhere when livestock trucks arrive to cart away their market animals after the sale. All the exhibitors have known this moment was coming and have been prepared for it by their parents, who use the experience as a lesson in where their food comes from. Nevertheless, they are often very attached to their lamb or calf or pig, a companion who depended on them for everything, a friend whom they named and raised almost from birth. That livestock pen at home will look especially empty after fair week.

ALL OF THE COMPETITIVE EVENTS of any county fair are governed by the one document that every fair publishes: the annual premium book. This essential reference guides fair exhibitors and judges alike, and is printed as many months as possible before the fair so entrants can have maximum time to plan, grow, and create their exhibits. Sometimes called the exhibitors' guide or handbook, it provides specific information about each entry category, and in content and function, they vary little from coast to coast. And as fairs embrace new ways of getting the word out, and as they look to save money, some have gone to publishing their premium books online.

Covers often boast what number fair this will be ("the 82nd annual"), and if the fair has a theme ("The West Is Simply the Best," "Scream and Moo and Lots to Do") it will appear in splashy text. Just under the cover will be a welcoming letter from the fair board president or a county com-

missioner and sometimes mug shots of the fair board, staff, and volunteers. Ads for local businesses (Grandma Hoffy's Restaurant, Vista Tire and Wheel, Jamboree Foods) follow, along with a complete schedule of fair events; toward the back are entry forms (one per entry, please).

But at the heart of any booklet are the pages and pages of entry categories in everything from Angus to zinnias. Any guide lists in detail the broad categories of competition, called departments, usually including Livestock, Horticulture and Agriculture, Floriculture, Domestic or Home Arts, and Arts and Crafts. Each of these then breaks down into sections, divisions, classes, and lots. Livestock competitions have the most detailed categorizations and consider multiple factors, including breed, gender, age, and reproductive status. For example, the Cattle Department is typically divided into Dairy and Beef; within Dairy, competing breeds might comprise, as it does at the Vernon

Manti, Utah.

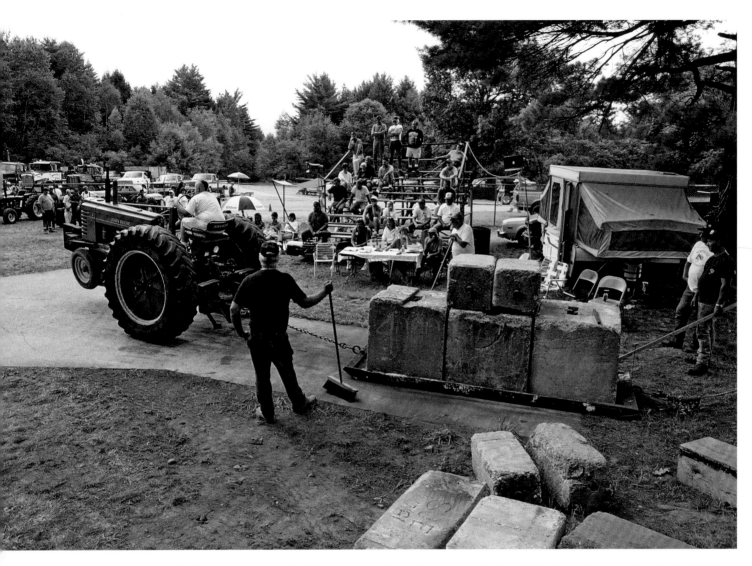

Competition at the fair takes many forms, including the ever-popular antique tractor pulls. Here a Mohawk-sporting competitor pits his John Deere against the sled at the Cheshire Fair, Swanzey, New Hampshire.

County (Wisconsin) Fair, Holstein, Guernsey, Jersey, Ayrshire, Milking Shorthorn, and Brown Swiss. Beef breeds there are Hereford, Angus, Shorthorn, Charolais, and Any Exotic. Many categories are further divided by gender and subdivided again by age of the animal (calf, heifer, yearling, or cow, for females), and so on. With this many categories in so many fields, even a modest fair can attract several thousand entries.

The premium book details specific requirements for a given competition, how the entry is to be displayed at the fair—"six cookies on a plate" or "zinnias, dahlia type, one color, three unbranched stems, stem length 12–15 inches." It explains the judging criteria, judging times, and locations, and, of course, it announces the prizes, ribbons, and cash premiums paid for each place.

A superintendent organizes each department. Superintendents are volunteers and expert in the area, and some have served for decades, their names long equated with the departments they supervise. Their responsibilities include receiving and recording all of the

exhibits; organizing the displays and judging; and handling grievances and medical and veterinary emergencies.

Like most fairmakers, superintendents see the end of the fair as simply the beginning of work for next year's fair. Through the coming weeks and months, they line up judges and scrutinize the premium book. They evaluate existing categories, trimming any that are outdated or unpopular, and add new ones that reflect trends or just seem interesting. While most superintendents, and fairs in general, aren't especially innovative regarding competitions, new contests for such things as computers and llamas appear in modern premium books, while categories for "Best Specimen of Darning" and "Hats, straw, six," are now understandably long gone.

For most competitions except open class, which is open to all ages, premium lists specify competitors' age ranges. Junior divisions are open to members of groups, like 4-H, FFA, and FHA (Future Homemakers of America), as well as unaffiliated youth, and generally cut off around age nineteen. Senior division is designed for exhibitors generally older than sixty-two.

Throughout the last two hundred years, entrants have usually followed along gender lines, but it wasn't unknown for women to enter open class livestock in the 1930s or men to bring pickles. Today, men and women, girls and boys, readily enter any contest, though we have seen the occasional "men's pie baking contest" to encourage those from the less-likely gender to try their hand. Of course, the fairs of the nation still see more girls competing in the home arts and more boys exhibiting in farm mechanics—but nobody is greatly surprised when the reverse occurs.

Fair exhibitors await their premium books each year as gardeners await seed catalogs. The book is also essential to the observant fair spectator. Like a football or symphony program, it guides fairgoers to the key events. Interested in sheep? Page five tells that ewes and lambs are being judged in the arena at eleven.

To spark fresh interest and encourage new competitors, fairs create special contests. For those tired of bringing zucchini or berry pies year after year, the Frying Pan Throwing Contest or the Dog-Owner Look-Alike Contest might just be the thing to renew interest. Thursday was

Super Senior Day at a recent Vernon County Fair in Viroqua, Wisconsin. That day the fair sponsored a special contest for seniors "for the oldest picture taken at the Vernon County Fair." At the same fair in 1866, when it was a mere eleven years old, the fair officers devised a contest to solve a problem: "A new premium is offered in view of the great increase of rats, viz: a premium of $5 for the best rat trap." Today and then, such contests run the gamut from silly to sentimental, from timely to novel, to infinitely practical.

Special circumstances and historical events give impetus to special contests. In 2000, the Winona County (Minnesota) Fair premium book offered two pages of one-time competitions for the "Millennium Year Only." The contests included both "What Grandpa and I Made" and its Grandma counterpart, and dove full into the new millennium with categories for Polarfleece garments and organic crops, the latter fetching premiums for first, second, and third prizes for $3, $2, and $1, respectively.

During the throes of World War I, an article in the May 1918 *Progressive Farmer* encouraged fair organizers to adjust some of their categories for upcoming fairs, citing "patriotic work." To support the war effort by minimizing the civilian use of goods needed by the troops, the publication suggested prizes for baked goods that used wheat substitutes; for cakes made with honey, corn syrup, and molasses instead of sugar; and for homemade soap, "one under cold process and another one boiled." It also urged that vegetable oil and oleo replace fat in food entries.

These days local sponsors support the fair by providing prizes for some of these special contests. Everett Shoe Sales and Repair provides two gift certificates to their store for the Smelly Sneakers Contest at the Great Bedford County Fair in Pennsylvania. At the Winona County Fair, winners of the Ugly Cake Contest received gift certificates from area businesses. The first-prize cake was taken home the day it won, and fairgoers who looked for it didn't know whether to be disappointed or a bit relieved.

Sponsorship by local merchants goes way back. In the premium book for the 1915 Fayette County Free Fair in Connersville, Indiana, blue ribbon winners in all categories of the Baby Show, including the Fattest Baby, the Best

Natured Baby during the Baby Show, and the Best Dressed Mother and Baby, took home boxes of Venus talcum powder, compliments of Ashworth Drug Store. On the other end of the age spectrum, the oldest couple attending that year's fair received a $10 fancy reed rocker, donated by Hackman-Heeb Company. Something for everybody—a tried and true way to bring people to the fair.

Not surprisingly, organizations that promote agriculture also find their way into contest sponsorship. The Ionia County Dairy Diplomats and the Dairy Farmers of Ionia County, Michigan, together sponsor the Best Dairy Delight Contest. The rules specify the use of three dairy ingredients, each of one quarter cup or more. Appetizers, dips, casseroles, quiches, and desserts piled in. Grand champion prize: one hundred dollars. Before fair season each year, the Oregon Wheat Growers League chooses a recipe for its contest. The official recipe is published in the premium books of all participating fairs in the state. All contestants follow the recipe, which may not be altered. Not long ago it was the Sauerkraut Chocolate Cake Contest, which we saw at several Oregon fairs and sampled, with a milk chaser, at the Curry County Fair on the coast at Gold Beach. First place winner Edna Riley said she made it three times before the fair. The first time, the sauerkraut was too wet, sinking to the bottom of the cake; the second, too dry. But on the third attempt, she got it just right and won first place. Would she make it again? "I might, I might; it isn't that bad."

And it must have been her recipe for fame. At the 2007 Curry County Fair, she was Grand Marshal.

National and regional brands get in on the action by sponsoring competitions as well. Coast to coast, product sponsors include Hershey's Cocoa, Land O'Lakes, Heinz Vinegar, SPAM, and Ball and Kerr home-canning products. The sponsors determine the specifics of the contest ("must be displayed on a doily-covered piece of cardboard"), the criteria for judging ("taste appeal 25%, appearance 20%, originality/creativity 30%, and ease of preparation 25%"), and provide the prizes. Across its home state of Pennsylvania, Hershey's sponsored the Greatest Cocoa Cookie, Brownie and Bars Contest. At Michigan fairs, Land O'Lakes invited "adult-child teams to create a special after-school 'sweet treat' and become the 'Sweet Treat Team Champions,'" with two hundred dollars for first prize.

Fair organizers love sponsored competitions, from local to national. They bring new people to the fair and cost only the overhead to put them in the premium book and to run them during fair week. Sponsors often have good ideas, and the prize money that they offer is often substantially greater than what the fair itself could ever afford.

At the Ionia Free Fair in Michigan, Betty Fuller, who was working as a security guard at the entrance to the exhibition hall, waxes enthusiastic about the National Best SPAM Recipe Competition at her fair.

"You should see the dishes that they make out of it—all kinds of stuff, anywhere from all kinds of pasta to pizzas, different casseroles," she exclaims. "You name it and they got it. And besides that, they have two ladies here from SPAM. They grill the SPAM, put it on hamburger buns, and serve it with that Dijon mustard." First prize was one hundred dollars, a ribbon, an award certificate, and a SPAM apron. The winning recipe was entered in the national competition, which offered an expense-paid trip to and a twenty-five-hundred-dollar shopping spree at the Mall of America.

And then there are the quirky contests found at individual county fairs across the country. Contestants "get five good licks" in the Nail Driving Contest at the Bourbon County Fair and Horse Show in Kentucky. The La Crosse Interstate Fair in Wisconsin pits teams of young farm husbands and wives against other couples in the Super Farmer Olympics, where they drive fence posts as fast as they can and throw hay bales for distance. In Minnesota there's a Mule Jumping Contest at the Nicollet County Fair, and at the Cheshire Fair in New Hampshire the antique tractors compete in a variety of pulling events and races, including the Cup of Water on Drawbar Race. Quirky, yes, but what each of them has in common is the connection to an earlier time in agricultural life when such skills were an everyday necessity.

FAIRMAKERS AND FAIRGOERS ALIKE know that their local county fair exists in part to celebrate and show off the community, the county, the home region. Many fairs express pride about the fairgrounds themselves, including their historic structures and the welcome shade from the mature trees; others remark on how much better the facilities are now at the brand new fairgrounds, complete with assurance that they'll be planting trees next spring.

This pride also gets expressed in claims of primacy. County fairs everywhere declare theirs to be the first, best, oldest, or biggest. The Boone County Fair in Missouri claims to be the first county fair in the state and, furthermore, the first west of the Mississippi River, having started in October of 1835. The Fayette County Free Fair says it is

Merced County (California) fairgoers in the 1950s could choose among the very best in modern appliances from this commercial exhibitor. Televisions were big sellers (two models to choose from), and no home in town or on the farm was complete without an electric organ, a tabletop radio, a sleek refrigerator, and a chest freezer. For decades American fairs provided consumers with an important venue for seeing the newest products, both agricultural and domestic.

Courtesy Merced County Fair

Indiana's Oldest Free Fair. With attendance of more than five hundred thousand in 1998, the Ionia Free Fair claimed to be the largest fair in Michigan, surpassing even the state fair. The Elkhart County 4-H Fair in Indiana even dares to jump the state borders by asserting itself as the second largest county fair in the country, after the Orange County Fair in California. Herb Maust, inner grounds entertainment coordinator for Elkhart, says the fair is the third largest yearly event in Indiana, after the state fair and the Indy 500.

Understandably, some fairs aren't as grandiose. In Tennessee, the Jefferson County Fair boasts AA Division Most Improved Fair. And in Wisconsin, the Calumet County Fair says it's the Biggest Little Fair in Wisconsin. Two hundred miles south in Illinois, Bill Diller talks lovingly about his Bureau County Fair. "We are extremely proud of the fair.

We're in our 141st year, the second oldest fair in Illinois. Knoxville is one year older. And yet, a little-known thing: we did not have a fair in 1862 because of the Civil War. They [Knoxville] broke in 1864 for the same reason. So we're two years *more consecutive* than they are."

Proclaiming fair superiority goes way back. Though there was no prior fair to compare it with, even Elkanah Watson couldn't help but use superlatives in reference to his first agricultural fair. And in New York State, the *Boonville and Adirondack Tourist Herald* puffed about the area's sixth fair in 1893: "No better field is offered in this state for the holding of a fair than that possessed by the home association."

Any county fair is the peculiar product of the people of that county—rural, town, and suburban—and fairs are a natural opportunity to promote the charms of the region.

Eagle County (Colorado) 1997 Fair and Rodeo Queen, Julie Faulkner.

Thus the fecund open class vegetable display says that "our soil is richer and our gardeners better"; the school art displays tell fairgoers that our kids are more creative; the local hospital display, complete with pictures of the helicopter on the helipad—or better yet, the actual machine on the fairgrounds—makes clear our medical care system is superior. The commercial exhibit area hosts not only local businesses but also often area churches, volunteer and social service agencies, the historical society, government agencies, and the senior center, all of which put their best face forward. Come to our fair and see how our churchgoers are more active, our police are more vigilant, our artists more talented, our horses better trained, our ice cream smoother. Because of this rosy reflection of home, we all feel better for having been to the fair.

The merchandise in the commercial booths speaks of our progressive home front. In days gone by, it was a gas-powered cream separator or electric washing machine that proclaimed our modernity. These days, it is the display of new tilt-in windows, a home water purifier system, or a six-person spa. The fair shows off the community, the county, to itself as it wants to be seen.

Baby contests are an irresistible choice for fairmakers; everybody loves a baby, and many parents are eager to show off theirs. The community celebrates the promise for the future and the idea of progress implied

by the cute tykes. In 1919, a fair in Kansas replaced its annual baby contest with a eugenics contest. In an almost-chilling twist of better-breeding more commonly seen in the livestock barns, the Kansas Free Fair sponsored a Fitter Families for Future Firesides contest. Its purpose: "to apply the well-known principles of heredity and scientific care which have revolutionized agriculture and stock breeding to the next higher order of creation—the human family." Competition classes included single adults, a married pair, and a married pair with varying sizes of family: one child, two to four children, or five or more children. "Prizes were awarded for the most perfect specimens of humanity in each class."

The naming of fair royalty, queen or princess, also reflects this underlying local pride: our girls are smart, attractive, talented, and what's more, *ours*. The Fairest of the Fair, as she is known in many places, promotes the fair to the news media, attends many fair events, and presents ribbons and premiums. The criteria for selection usually include personality, poise, leadership, beauty, citizenship, and overall appearance. But some fairs have less typical criteria, like the Eagle County Fair and Rodeo in Colorado, which judges its queen contestants in horsemanship (fifty points), public speaking (thirty points), and interview and written essay (twenty points). The tiara bestowed on that fair and rodeo queen befits the evening gown she wears, and looks terrific later with jeans and a dressy cowgirl shirt riding into the arena to kick off the night's rodeo.

As a sign of ideas that are a bit more modern than eugenics, some fairs have expanded their royalty competitions to include a broader age range and both genders. The Monongalia County Fair in West Virginia chooses a Little Mister, Little Miss, and Junior Miss, and holds a Diaper Derby as well. Contestants for Little Mister spend a Kings Day Out together bowling and eating ice cream and hamburgers, and the boy who wins gets decked out in a red velvet crown and faux ermine cape—and gets a bicycle. Senior queens and kings share the royal spotlight at many fairs, riding in the fair parade, waving from the back seat of a convertible. Such competitions are fun for participants and bring new faces, young and old, to the fair.

In 1998, the fortieth year of their fair queen competition, the Elkhart County 4-H Fair in Goshen, Indiana, hosted a queen reunion. Twenty-six former queens returned and were honored at the queen contest on stage once again.

Becci Field, 1979 fair queen, returns for the night's event and recounts her royal duties years earlier. "I opened all the grandstand shows, got to meet the entertainment. I attended as many events as possible. I helped judge the broad jump competition and the bubble gum–blowing competition. You try to make it around to as many events as you can, pass out ribbons, help wherever they're short. They give you a schedule for the day where people request that you go and help open their events. I believe that hasn't changed a bit."

She smiles as she recalls her year, and has advice for this year's soon-to-be-crowned queen. "Do it all. Get up, be here at seven thirty for the board meetings, and stay until they shut down the midway at midnight, which is really neat to see. There is a guy who stands at the end, and he goes *snap*, and everything shuts down. At least they did that twenty years ago. We'll see; things can change in twenty years."

"Don't pick up
or eat anything."

—*Father to his small son
on entering the horticulture building
at the Jefferson County Fair,
Port Townsend, Washington*

•

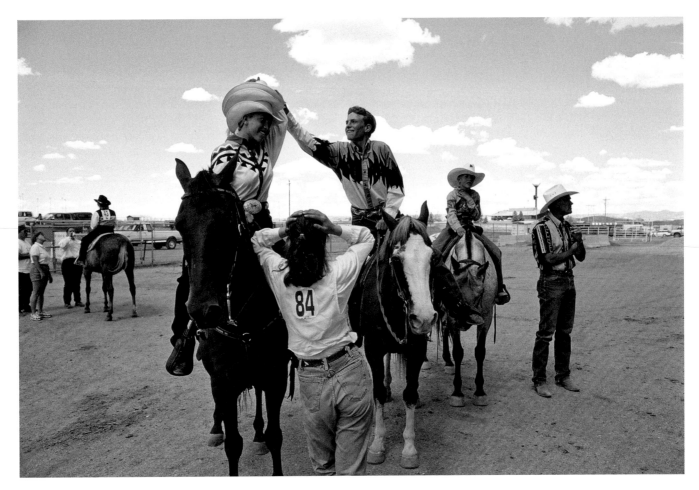

Sweetwater County Fair, Rock Springs, Wyoming.

13. Heritage

Everybody wants improvement, but nobody wants change.

—Fair manager in Missouri

LATE IN THE AFTERNOON, THE QUIETEST PLACE at the Elkhart County 4-H Fair in Goshen, Indiana, is the doorway of the century-old barn, moved in from the countryside some years ago, now the centerpiece of the Farmstead, a farm museum created along the north side of this sprawling modern fairgrounds. This part of the fair may have been busy sometime during fair week, but at the moment no one looks at the antique tractors outside or the barbed wire display and old harnesses hung inside. Despite its disuse, the barn still smells of cattle and hay.

Basketball is important in Indiana, and inside the barn hangs a billboard that reads "As Much a Part of Indiana as

Friday Night in the Hometown Gym. Farm Bureau Insurance." In front of it six boys practice their floor moves on rough planks that once felt the tread of heavy farm horses. Beyond the barnyard a P.A. echoes from the frog jumping contest, louder than the screams from the rides and cheers from the three-on-three basketball tournament over the fence. This is a busy fair in full swing, and distant noise from all quarters blurs into the quintessential sound of county fairs everywhere.

With the dribble and bang of the game behind us, we sat on folding chairs in the doorway and watched the gyrating fair from a distance. It struck us how this place and moment reflect the great change in the American agricultural fair. Not only are the barn and the old tractors obsolete, but, for this moment at least, they've even lost their value as museum curiosities, lost to the attraction of jumping frogs and the Zipper. We talked about how far county fairs have drifted from the center of agricultural life and from Elkanah Watson's idea of the "farmers' holiday." Real agriculture plays an important role in many fairs, including Elkhart County's, but at almost every fair, we've sensed its diminishment and the increasing gap between those who raise our food and the events at the local county fair.

The observation isn't new. As early as 1917 the *Orange Judd Farmer* complained about the shortage of good agricultural exhibits and the lack of competition at Illinois county fairs. "It is surprising to see how many of the fairs are largely made up of midway carnivals, horse races and 'red-hot' stands, and how little to show for the things that are uppermost in the agriculture of that community," griped the front page article. The author found fairs in the richest corn belt counties that had at most a dozen samples of corn; at another he saw only five entries for a whopping five-dollar premium.

Despite its agricultural focus, the modern county fair has little to do with the practices and economy of food production. Some are great shows of agricultural fecundity and help shape and select best animal attributes for breed associations, and all are social occasions for ranchers and farmers, but the practices and business of agriculture would change little should the local fair close for good. Farmers long ago stopped looking to the fair as an educational venue, and American agricultural fairs were never market fairs. More recently, and more important, year by year the business of agriculture shifts away from the diversified family farm toward corporate practice. Of course farmers and corporate agribusiness men and women may look at new machinery at the fair, sign next year's contract with their seed dealer, and might even arrange a livestock purchase, but today fewer people run ever-larger agribusiness operations and themselves interact with fewer ever-larger corporations, further concentrating the agricultural economy and marginalizing the fair.

Chicken raising in Rockingham County, Virginia, is perhaps an extreme example but illustrates the point well. When we visited this area in the Shenandoah Valley, Tyson Foods, Wampler-Longacre (WLR), Perdue, Rocco Poultry, and others made this county the number two chicken producer in the nation. Giant poultry barns dot the rural landscape, and large processing plants dispatch trailers of butchered chickens to distant markets. Farm families that raised a coop of broilers and hens for chicken and egg money are long gone here, as they are almost everywhere.

There were a lot of chickens at the Rockingham County Fair in Harrisonburg, Virginia, but not in the poultry building. Some 650 were under the care of Charles

A sand sculptor finishes his work for this Georgia fair.

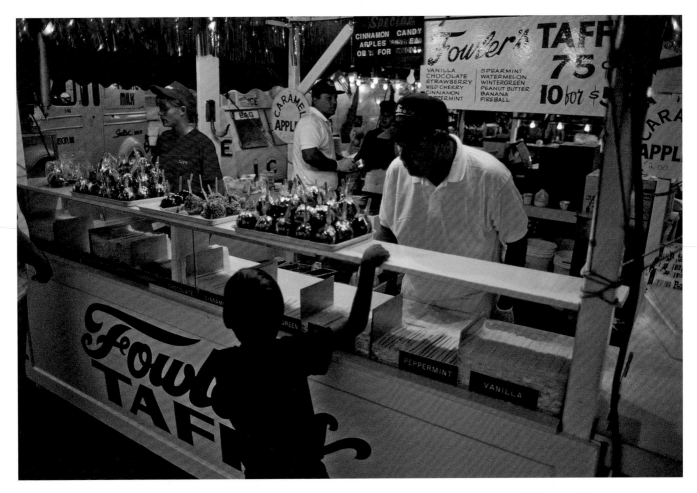

Dennis Fowler of Fowler's Taffy satisfies a young customer at the Chautauqua County Fair in Dunkirk, New York.

Bowman, fair board member, who used fifty gallons of sauce and five assistants to barbeque them for the popular two-night chicken feed.

"It turned out real good yesterday," he tells us. "Now, some days you have trouble with the fire. It is either too hot, or not hot enough. If it's too hot, the chicken has a tendency to dry out too much. But yesterday was just about right, I'll have to say."

Charles, who runs a plumbing and appliance business, also raises four big barns full of turkeys for the poultry producers in the area. He's been barbequing chickens en masse for fifteen years. He speaks of the big poultry companies and the fair.

"All of them have been good to us, but times have been a little tight in the poultry business. In years past,

Wampler and Rocco have donated the chicken to the fair—just gave it to us. But this year they gave us a good deal, but we had to pay a little something for it because times is tough."

And barbequed chicken is popular all over the region.

"There is more chicken done in the Shenandoah Valley than anywhere that I have ever known. We have a radio call-in talk show, *Candid Comment*, that comes on in the morning. There is always people calling from across the mountain one way or the other; you know, talking about how they're coming to the valley to get chicken, because where they live, they don't have any. You can pretty well pick up our local paper here in Harrisonburg any weekend like Friday or Saturday, and you can see at least four, five, six places doing chicken."

HERITAGE

Not far from the barbequing chicken is the poultry exhibit barn, where we meet Tim Smiley, chairman of the poultry, pigeon, and rabbit department. In the center of the barn are cages of flouncy, colorful chickens that remind us of Victorian ladies at Sunday tea.

"In chickens, we had 166 last year," he says. "Now, last count, before I brought in 13, I had 100 and—let's see—67; I now have 180 chickens. So we're up this year. In the rabbits, we have 35 exhibitors, and about 65 or 70 for the chickens."

Do the big poultry producers play any role in the poultry show?

"Not really. Not in this barn. A lot of the bigger companies—WLR, Perdue, Rocco—you'll see them in the commercial building; they'll each set up a commercial booth. If a family is into the large-scale chicken or turkey business, they won't have separate birds on the farm." He tells us that home flocks, because they're usually kept outside rather than in large buildings, are susceptible to diseases. "One could make contact and wipe out a whole barn full of chickens or turkeys. That's what we had here about five years ago with avian flu. It went from Pennsylvania to Virginia to North Carolina and wiped out quite a few of the growers in this area."

According to Tim, the big growers raise white rock pullets for their ample meat and rapid growth. The genetics of the birds are carefully managed. "Tyson brags about how golden their chickens are. They have been bred so their skin is golden." In contrast, the chickens here in the poultry barn represent a wide range of decorative breeds.

One of the few lucky chickens in Rockingham County, Virginia, that won't likely end up on somebody's dinner plate. Unlike the countless chickens raised in the county by the big poultry producers, this bird probably has a name.

"I've got a little girl in here who won the junior sweepstakes two years in a row. Those chickens are like pets to her, like your dog or mine."

To Dennis Cupp, general manager of the fair, we mention the disconnect between show chickens and slaughter chickens. "When you have forty thousand birds on your farm, you don't own them; you're just a contractor grower," he says. "The company provides the feed, you feed them, and if you take a bird off of the site, you don't bring him back because you might contaminate the rest of the birds."

He says that producers posted armed guards at their poultry buildings during the avian flu outbreak. "There aren't very many home flocks; some people have been frightened. This is the best year we've had in a long time. It's only been a few years where we've to been able to exhibit poultry again. The poultry chair and I were talking that maybe the threat of avian flu is history."

We comment that those who bring chickens to the fair aren't raising them as any real part of the agricultural economy; they're hobbyists.

"You are almost getting to that with the livestock," says Dennis. He talks about cattle breed associations and how some in the industry have observed that people who raise the purebred beef are really hobby farmers. "Even though you are talking about a lot of money, none of these people—oh, maybe one or two—depend on their living from raising that Angus. They are lawyers and doctors, and they've hired someone to run it. It's a part-time passion, maybe a tax gimmick, and maybe they love the animals. What's happening at the fair doesn't reflect exhibitors' everyday life as it once did; now it's a reflection of only part of what they do."

We found examples coast to coast of the gap between the fair and real agriculture. In Grand Junction, Colorado, in the heart of Western Slope peach country, the manager of the Mesa County Fair tells us that fruit is not much represented at his fair because fruit growing is now "so commercial." In Union County, South Carolina, the fair held a milking contest among local politicians, but since there are no longer any dairies in the county, they had to borrow cows from elsewhere.

In Wisconsin, Calumet County Fair board member Herb Harder uses the lack of new farm machinery at his fair as example. "It's tougher and tougher to keep the agricultural aspects," he said. With his hand he draws a broad arc. "Where the carnival ends, all the way around, in that area, it was all implement dealers at one time. If you walked around today, you saw some tractors, but that was only after a few people talked the implement dealers into bringing those big tractors and plows to set alongside the old machinery. We don't have much agriculture. There isn't the number of farmers here in the area to go and buy the machinery, not like years ago. Years ago, you go down the road, there'd be five farmers; now there's one farmer, and he's bought up the other four."

But the diminishment of agriculture doesn't necessarily mean diminishment in the fair, and paradoxically, it sometimes means full animal barns.

In the Maryland hills about fifteen miles west of Baltimore, the Howard County fairgrounds grassy parking lots fill with clean SUVs and minivans as parents plop hats and smear sunscreen on the kids and funnel toward the entrance gates. GAP and Banana Republic shirts, Dockers, denim shorts sets abound. A bumper sticker reads "My child is an honors student at . . ." The fair is packed with strollers on this late Sunday morning as the largely suburban crowd lines up for the animal barns and the petting zoo. Clearly this is not North Dakota.

In a pattern similar to that of many counties adjacent to large cities, Howard County is losing agricultural land to suburban development. According to fair vice president Ron Clark, this land use shift is having a considerable effect on agriculture in the county and on the fair. "This county has quite a bit of beef, but dairy is kind of on its way out," he says. "There are only a few dairy farms left, and they are quite large. Of course, hay is a very large crop right now because of all the horse farms. And grain: corn, wheat, soybeans, barley. The straw from the barley and wheat seems to be worth more to landscapers for mulch than the grain crop is worth."

But the big effect on the fair is in the animal barns—they're full. The sheep, swine, and cattle barns are crowded with kids and animals, noise and activity. In fact, they're so

"There hot! There good!

5 cents Potatoe Lotkiz Makes

a meal by their selves."

—Sign on food booth at
a county fair in central Ohio, 1938

•

A key indicator of active suburban fairs is the cloud of strollers that surrounds any kid-friendly venue. The Howard County Fair in West Friendship, Maryland, is about fifteen miles west of Baltimore and draws a large number of people who make their livings in nonagricultural fields.

full that some livestock classes have to come to the fair in shifts. Dale Bennett, 4-H leader from nearby Woodbine, says some fifteen years ago, they had only 8 hogs in the swine show. This year there are 240. Dale and his kids raised 7 hogs and 5 steers on their one-acre homestead for the fair this year.

It turns out the suburbanization of the county is largely responsible for the big turnout in 4-H animals and other projects. Tom Mullinix, superintendent of the sheep show, explains, "My grandfather's farm down here, it was 158 acres. Now it has probably fifty farmette homes on it, which are each 3 to 5 acres." As a single farm unit, that 158 acres might produce at best two or three kids with animal projects; as fifty farmettes, the area might produce fifty times the number of projects.

Instead of the more common small-lot subdivisions, much of the rural land here is being developed into parcels of a few acres each that sprout large homes, small fenced paddocks, sheds, and little barns where residents can live something of a rural—and faintly agricultural—lifestyle and still work in the city. It's happening across the country.

We heard about the trend at the Union County Fair in Union, South Carolina, from county agricultural extension agent Raymond Sligh. "I call them rancheros," he says. "We get calls every day. 'I just bought a ranch,' somebody says. 'How many acres?' 'Oh, I got three acres, five acres.' 'Wow, you got a ranch all right.'"

From one to twenty acres, these microestates are appearing from coast to coast as a distant reflection of Jefferson's yeoman farmer who tills the land and forms the

body politic. From the Great Plains west, they are usually "ranchettes," but the idea is the same.

The shift from real agriculture to recreational agriculture is evident in the sources of the animal projects crammed in the barns at the Howard County Fair.

"In all honesty, probably less than 10 percent are from farms; 90 percent are backyard projects," says Tom Mullinix. He sits on the top slat of a stall in the sheep barn and jokingly refers to himself as the world's only "federal shepherd," explaining his work for the USDA at the nearby Beltsville Agricultural Research Center. Tom and sons Michael Mullinix and Zach Todd raise lots of lambs that are then purchased by 4-H-ers in the county, and after several months raising them are brought here to show. He adds, "I have been showing at this fair since I was nine years old.

That puts it at thirty-five years. When I started showing, the fair had one little sheep barn that housed about sixty sheep. Right now we are housing about four hundred sheep, even though agriculture has gone down in this area. Sheep are one of those projects that even though you don't have a hundred-acre farm, you can have backyard projects. There are a lot of kids in this building right now that have maybe half an acre or an acre for a 4-H lamb project. That's why it has expanded.

"Your larger animals have definitely decreased. When I was first showing here, these barns were just full of dairy cows, maybe one or two barns full of each breed. If you wander through here now, the dairy is down to two barns total. Now, a lot of the beef cattle are raised at somebody else's place, giving nonfarm kids the opportunity to

Some fairs have partially empty animal barns in counties where fewer people farm more ground, reducing the number of agricultural families that might participate in the fair.

HERITAGE

Dairy show at the Butte-Lawrence County Fair in Nisland, South Dakota.

show." He explains that suburban and town kids rent space on friends' farms and do their animal chores there. Tom continues, "There are kids here who live in Columbia in townhouses that have projects, which is fantastic.

"I think most of the kids see the fun in it. They love 4-H. I was in 4-H for ten years and, I mean, I wanted my children to do it. Lambs and pigs are lovable animals. I believe that a lot of times those kids need that extra love because their parents are so busy. Sometimes there is something missing that these pets can give to them. If you are here Wednesday night, you'll see the sale, and you'll see a lot of emotion in the kids when these animals leave the sale barn."

And we found the trend in other parts of the country. While most fairs everywhere had plenty of poster and display projects in their 4-H display buildings, the fairs with

the fullest animal barns were often in counties where there has been new suburban and exurban development with a resulting decline in agriculture. Among other places, we saw similarly full livestock barns at the Washington County Fair near Portland, Oregon; at the Sonoma County Fair at Santa Rosa, California; and of course at the Merced County Fair in California where the Fagundes girls bring their animals from their twenty-acre place. Michele says they've lived there for some twenty years, but things are changing. "It's getting real urban now. Lots of people are moving out here to one-acre places because they want to experience this."

The reverse is true far from cities. We found some of the emptiest livestock barns in the most intensely agricultural counties in strong farm states, counties where farms and ranches have grown in size, declined in number, and

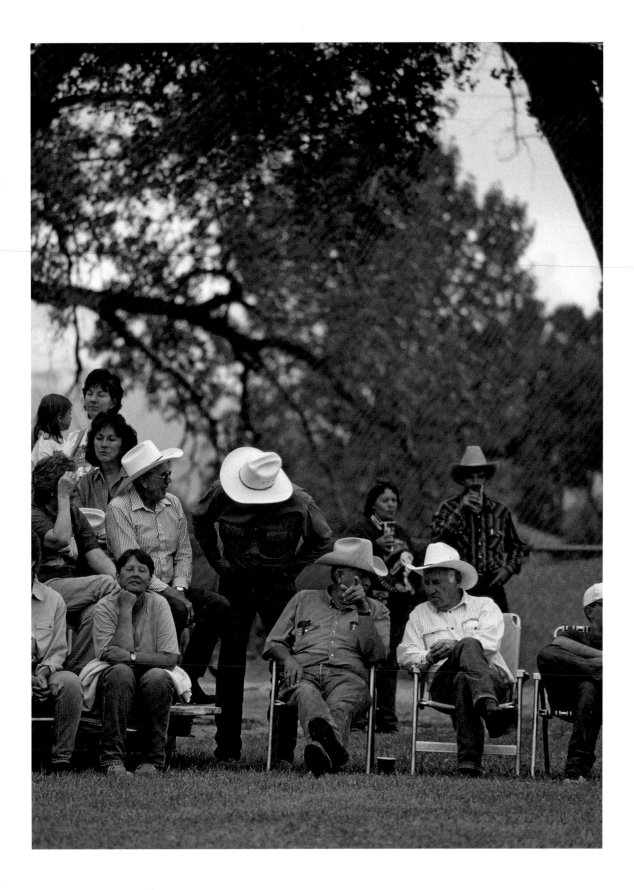

gone corporate. If Dad and Mom are contract feeders who feed out quarter-mile-long confinement sheds crammed with hogs, the kids aren't likely to hand-raise a pig for the fair. It's not a fair without animals, many people told us, and we talked to uneasy fair managers and livestock superintendents across the country about declining numbers. The diminishment seems worst at some small fairs between the Appalachians and the Rockies in intensely agricultural counties with no large towns nearby. Clearly there are hundreds of strong fairs in the Midwest, but it's ironic that some of the fairs with the fewest animals turned up in the parts of the nation where the agricultural fair had its greatest flowering a hundred years ago.

And by the end of the twentieth century, with fewer fairmakers and fairgoers coming from real farms and ranchers, a new educational mission had emerged for the fair. Increasingly fairs see the need to reconnect Americans with their agrarian roots.

Across the country fairmakers said it in so many words, but none better than Raymond Sligh in Union County. "Where does your food come from? It doesn't come from the grocery store. Each generation is further removed from the farm," he tells us. "Each generation loses more of the ability to respect the American farmer and what he or she does every day. And if we don't have people in each generation that still carry that word to them, they'll get further away. Next thing you know, we'll lose any kind of respect for what is happening in agriculture."

Reflecting on the changes in agriculture in Union County, he says, "Back in the '40s and early '50s, this county had forty thousand acres of cotton. Now the biggest planting of cotton is on the other side of this building," gesturing to his tiny fair exhibit plot. "That shows you how agriculture has changed."

At some fairs on the West Coast we found "barn tours" where knowledgeable guides toured nonag fairgoers around the grounds, pointing out relevant parts of livestock and providing statistics about food production and the importance of agriculture. At other fairs we found the Grocery Store Game and its variations wherein fairgoers, mostly children, eagerly matched food and fiber products with their source plants and animals, winning small prizes for their efforts. Just where do marshmallows come from anyway?

There are other positive signs. The burgeoning market for organic fruit, vegetables, grains, and meat has seen

some families returning to the land on smaller, diversified farms. With the related growth in community-supported agriculture farms, or CSAs, which deliver food to contracted consumers through the growing season, families learn where their food comes from when the farmer herself delivers the weekly box to the door. And because of their community focus, organic cooperatives, like the rapidly expanding Organic Valley Cooperative, with some eleven hundred organic farms nationally as of 2007, are showing up to sponsor booths and events at the local county fair.

In New York State, Newell Wagoner, who has been president of the Boonville Fair since 1964, has found an opportunity to connect people with their food. "Probably the greatest attraction on our fairground this year is the milking parlor," he says. At milking time every day during fair week, bored farm kids go through the routine while rapt townies watch. "People are dumbfounded about how milk comes out of cows."

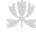

BUT LATE ON TUESDAY AFTERNOON OF FAIR WEEK at the Johnson County Fair in Buffalo, Wyoming, no one is thinking much about where their food comes from, because in this beef- and lamb-raising area, everyone already knows. On this, the first day of the fair, the sheep, swine, and cattle entries are all weighed in, and the horse show is over. Pickups and cars drift down Fairgrounds Road and Rodeo Lane from town and from the corners of the county to park under the sentinel cottonwoods and old willows that line the irrigation ditch at fairground's edge.

This is a small fair, a solid local fair, the oldest in Wyoming by most accounts, and a fair altogether focused on the area's ranching work and traditions. The grounds are alive with horses, cattle, sheep, a few swine. The Johnson County Fair has no carnival, no gate or parking charge, no commercial exhibits, no concerts, no demolition derby, no dairy cattle, and this year it sports a mere seven chickens. A cattleman at the fair tells us, "You won't find a chicken barbeque in this neck of the woods."

Johnson County was the site of the notorious cattle war of 1892, and the Big Horn Mountains to the west and rolling dry hills to the east are still home to thousands of cattle. With the arrival of the Basques, sheep moved in and dotted the large open ranges. Today the irrigated valleys raise considerable hay as well.

Tonight the fair is about sheep. It starts with the

(left) Folks catch up on the local news just before the sheep lead at the Johnson County Fair and Rodeo, Buffalo, Wyoming.

"sheep feed" and will be followed by a show called the sheep lead and, later in the grandstand, sheep dog trials. Later days will feature the swine and beef shows, and the fair finishes up on Saturday with a pro rodeo, the livestock sale, and a big dance in the city park.

Just outside a Quonset bearing a pair of bigger-than-life plastic Angus and Hereford steers perched on the roof like a couple of giant hood ornaments, delicious smoke curls from a trailer-built barbeque, attracting fairgoers to a line of folding tables. White summer straw cowboy hats cover many locals as they drop donations in the pickle jar and pick up their plates. First a big scoop of creamy coleslaw, then baked beans with jalapeno peppers, a soft roll with butter. And then the lamb. Near the cooker, barbeque boss and sheep man Peter John Camino supervises the serving of juicy slabs of roast lamb. Studded with garlic cloves and infused with spices, the rich dark meat falls into moist chunks as it's lifted onto plates.

Balancing their meals, people fan out to sit on flatbed trucks, lean on fences made of recycled oilfield pipe, or simply sit on the grass. People who work with the land aren't afraid to sit on the ground. The sun drops behind tattered clouds left over from afternoon thundershowers in the Big Horns to the west. Few fair moments are ever this good.

In the early years, American county fairs looked toward progress, toward the future of agriculture, but that matters less now. Many bigger fairs are a lot like amusement parks joined to big name entertainment venues—with some agriculture on the side. Smaller fairs, like Johnson County's, strive to remind us of the enduring importance of agriculture despite enormous change. But at the heart of every fair we visited, big or small—but especially the small ones—was the life force of remembering, of holding on to things that are passing, or at least changing quickly. From Watson's beginnings to now, fairs have always sought the ideal in agriculture, but today that ideal, instead of being purebred cattle or robust corn, is a tall farmhouse remembered but torn down long ago, the bleat of long-gone sheep on summer pasture, or maybe the way sunlight once glinted off shocked oats.

Most everybody knows most everybody else at this fair, which isn't to say that strangers are shunned. The rules of western hospitality make clear that visitors should be treated like guests. Being both hospitable and curious, a man walks up with his plate and says, "This is better-than-average sheep—this is *good* sheep."

But even here, in the middle of sheep country, agriculture and the fair have seen discomforting changes. Peter John tells us that the lamb we're eating is no longer from local raisers. Because of industry consolidation, there is no slaughter operation nearby, and these boneless shanks have been trucked in from Sioux City, Iowa, 625 miles east.

When we started out to take the measure of the American county fair, we wondered why it persists and even thrives in the face of so much change in agriculture, when so many other rural and small town institutions, like Chautauqua and town dances and quilting bees, have faded. At fairs across the country we asked fair managers and fair queens, vegetable superintendents and carnies, and their answers were always about the importance of tradition and of agriculture, about how six generations of this or that family have worked at the fair, and about getting the community together, but none, including our own musings, were ever quite satisfactory.

> "About this time every year the big County Fair was held on the extensive grounds near the thriving town of Oakvale. If wonderful promises meant anything at all, the coming exhibition of live stock, farm products, and the like would far surpass anything heretofore attempted. Besides, there would be racing on the track, amazing feats undertaken by an aeroplane aviator of national renown, balloon ascensions accompanied by parachute drops, 'and other attractions too numerous to mention.'"
>
> —*Robert Shaler,* The Boy Scouts as County Fair Guides, *1915*
>
> •

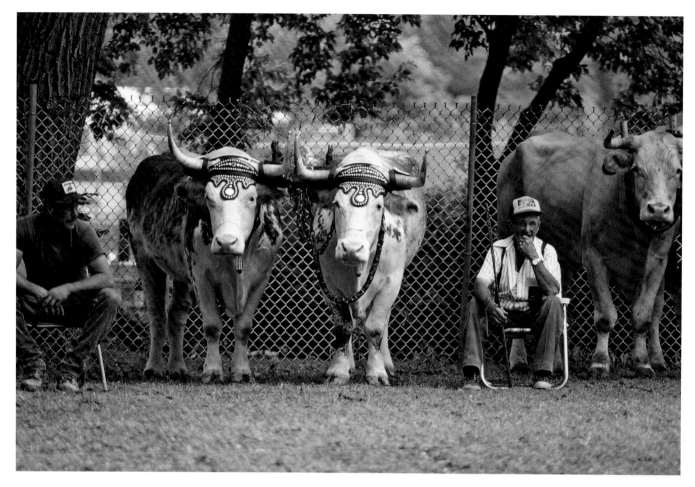

Hervy Ostiguy with Turk and Lion at the Adams Agricultural Fair, Adams, Massachusetts.

Here, in this timeworn and comfortable Wyoming fairgrounds, we found at least one answer. Every fair, year after year, generation to generation, carries forward the important story of how rural and small-town people are supposed to live. Like the oral traditions of the Lakota, the fair is about remembering who and what came before, about taking care of ourselves and others, about working for the future of a strong nation, about who we are and who we ought to be. Perhaps the greatest rural value of all is to have a fair every year.

Conversation is easy among neighbors old and young. In groups scattered across the grass, they catch up on news since last time they met. One old gent asks another, "Gee, have you heard anything about Boots?" The other man looks at the ground and slowly shakes his head, no, he hasn't. Nearby a woman asks, "Wasn't that nice? Did you get that big rain?" The evening is soft with familiar voices, with rest after long days of work, with unconscious gestures and words of belonging, the pleasure of seeing how much somebody's kids have grown, the time-tested comfort of growing older among people who've known you since you were too young to understand.

Certainly agriculture in Johnson County will be improved in some small measure this week as kids learn about bred heifers and market lambs, but lots of this event is about recalling the great days of ranching that probably weren't as great as people remember them, and acculturating the young into the way things are done today. In deep farm and ranch country like this, the passage of a year is still marked by birthdays, anniversaries, Christmas, and fair

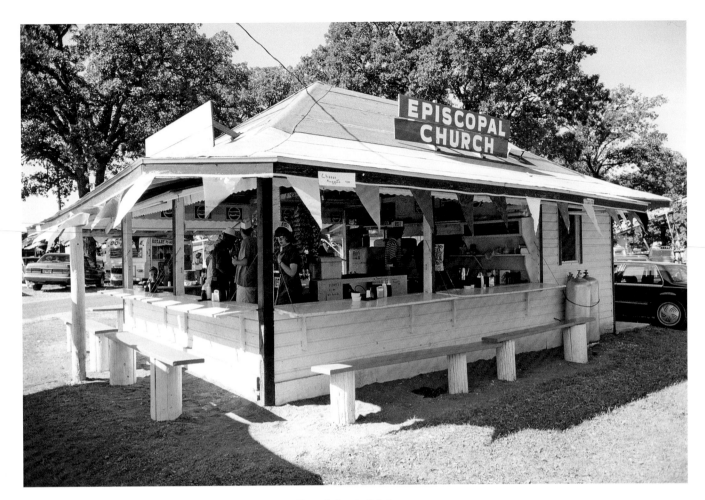

Kossuth County Fair, Iowa.

week. Tonight under the blue Wyoming sky, the annual cycle clicks forward a full interval as one season ends and the next begins, as summer wanes and fall approaches. After fair week people begin to look for the aspens to turn yellow in the Big Horns.

We found surprising vitality in the fairs across the country, the strength and durability of an institution well suited to a broad and once-new nation, a nation still blanketed with pastures, fields, vineyards, gardens, orchards— and farmettes. America's county fairs remain essential to those who understand the role of agriculture in building and keeping a nation, and in training the youth who will one day be in charge. And here tonight at the Johnson County Fair, we felt the source of this confidence just as we have so many other times on our travels. It came in the sound of the fair: the patter of laughter and the conversation of longtime neighbors mixed with the noise of livestock and the whisper of cottonwoods high above in the evening breeze.

2563. ROUTT. CO. FAIR GROUNDS. HAYDEN COLO.
PHOTO. BY McCLURE. DENVER.

The Routt County fairgrounds in Hayden, Colorado, offers little shelter from the open land and western sky in this 1916 photograph. Nonetheless, things are looking up: Autos outnumber horses, a new livestock barn holds the hillside, and on this day at the fair, the merry-go-round spins. And who could miss this fine event after another hard year on the land? These are our people, this is home, and this is our fair.

Denver Public Library, Western History Collection, photograph by L. C. McClure, Mcc2563

"The fair once was the center of activity in the
county. If you look at the pictures, people
came a gigantic distance of eleven or twelve
miles by horse and buggy, or by car, to go
to the fair and talk to their relatives and
have a good time. Now, well, how much is
going on in the last ten days in the area?
We have got to have something to
hang our hat on for the future, and it's got to
be agriculture. I don't know of anything else
that it could be. Probably the greatest
attraction on our fairground this year is the
milking parlor. People are dumbfounded
about how milk comes out of cows."

—*Newell Wagoner, president of Boonville Fair
Association, Boonville, New York*

•

Notes

Nearly all of the interviews for this book were tape-recorded and transcribed, and thus what we have quoted herein is as accurate as recording equipment can make it under sometimes noisy conditions. We edited quotes for length, corrected the occasional minor grammatical flaws common to casual speech, and endeavored in all cases to convey faithfully not only the speaker's words but the context as well.

Chapter 1. Fair Time
See Kennedy's *Pennsylvania Fairs and Country Festivals* for a good cross section of the variety of American outdoor events.

Analysis of the essential elements of a county fair comes from dozens of conversations on the topic with fairgoers and fairmakers across the nation.

Published for more than a century, *Amusement Business* was the leading fair industry publication until its demise in 2006. Its annual *Special Issue* listed upcoming dates, contact information, and carnivals booked at thousands of fairs (and festivals) across the country. Web sites for specific fairs and fair associations are now good sources. Consult Western Fairs Association (www.fairsnet.org) and International Association of Fairs and Expositions (www.fairsandexpos.com).

Chapter 2. Fair-mindedness
While oxen may best represent the deep traditions of the agricultural fair, the thread of historical patterns and events at fairs across the nation can be traced through elements as diverse as carnival rides, horticultural practices, rodeos, and beauty contests. People love their fairs in part because they connect them to something lasting, something important through generations. In one way or another, tradition came up in most interviews and conversations we had with folks at fairs.

Chapter 3. Some Tincture of Envy at the Farmers' Holiday
Elkanah Watson's life and work are well recorded in his books—the three listed in the Selected Bibliography are indispensable—and several subsequent articles are based primarily on them. Other valuable resources regarding Watson's work on the Pittsfield fair and early fair development are the writings of Smith, Flick, Mastromarino, and Neely, as well as the *Pittsfield Sun*. Neely's thorough history is vital to understanding most aspects of the fair up to 1935.

The two accounts of the first fair parade on September 24, 1811, differ somewhat in regard to the order of the procession. Because the version recorded in Smith's *History of Pitts-field* is more specific and based on sources more contemporary to the event, we relied more on it than on Watson's recollection of the event in his *History of Agricultural Societies*.

Chapter 4. Rural Felicity
The details of the Walworth County (Wisconsin) Fair are from Vergeront's 1914 bachelor's thesis, in the rare book collection of the Wisconsin Historical Society.

Hamlin Garland provides a detailed look at postbellum Upper Midwest life, including the fair, in his fictional *Boy Life on the Prairie* and his memoir *Son of the Middle Border*.

Bogue, Danbom, and Rasmussen's *Readings* are good sources for American nineteenth- and twentieth-century agricultural history.

Essential to understanding the fair during the nineteenth century and into the early twentieth are the writings of Neely, Ross, Kniffen, and Laning.

Avery offers detailed treatments of fairs as early arts agencies.

Also very helpful are individual fair histories from across the country and contemporary articles in the agricultural and general press. Among those we consulted were "Agriculture at 'Agricultural Fairs,'" McMahon, Morgan, and "The Spectator." See Neely, *The Agricultural Fair*, for an extensive bibliography.

Chapter 5. From Rickrack to Rockets
A great deal has been written about the development of Cooperative Extension, 4-H, and FFA, and resources we found to be most useful and reliable are listed in the "4-H, Youth Organizations, and Agricultural Extension" section of Selected Bibliography.

A handful of Web sites aided our understanding of the contemporary work and impact of 4-H and Extension work, including http://www.fourh.umn.edu, http://www.national 4-hheadquarters.gov, and http://www.extension.iastate.edu/ 4H/Hhhh.

While the Fagundes family is certainly unique in their 4-H and fair experiences, the story of their lives in 4-H and at the fair closely parallels the experiences of many 4-H families we met across the country.

Chapter 6. Symbols of Increase
Billboard, and later *Amusement Business*, followed fair issues and trends through the twentieth century. We also relied on numerous individual fair histories, old premium books and fair schedules, and various news and magazine articles to sketch an

outline of the fair through the century. Enterprising scholars eager for a Ph.D. topic might consider a thorough cultural history of agricultural fairs in the past century.

For rich discussions on what's American about America, see Kouwenhoven's essay "What's 'American' about America." Michael Aaron Rockland provided a copy of his essay updating these ideas in his "John Kouwenhoven's 'What's "American" about America,'" so far published only in Spanish.

Having lived in both cities and small towns, and having talked with and interviewed hundreds of people steeped in urban or rural traditions, we find the general differences in city versus small town/rural points of view quite evident. They are, of course, not universal. We met urbanites who make quilts and rural folks who love rap music.

Chapter 7. Fair Stories
George R. Stewart's *Names on the Land* (Boston: Riverside Press, 1958) and *American Place Names* (New York: Oxford Univ. Press, 1970) should be shelf companions for anyone interested in American history and places.

Thousands more fair stories await the scholar or journalist who is willing to go to the fair.

Chapter 8. Fair Fare
Food is one of the richest (and most fattening) subjects we discovered at fairs in the nation, a topic that could be a book in itself, a book quite beyond a cookbook or treatise on how bad some fair food is for you.

Laning only touches on late nineteenth-century fair food, and most fair histories give this important subject little attention.

Chapter 9. Born at the Fair
Our reading of individual fair histories makes clear that energetic fairmakers like Norris and Neva Wooley and Donna Speltz, who represent decades of commitment, have been the motivators and shapers of fairs for almost two centuries.

Chapter 10. Bossing the Fair
In addition to our interviews with fair management, key to understanding some of the current issues confronting fair operators were *Amusement Business*, the *Los Angeles Times* article, and the Illinois Association of Agricultural Fairs' *TentTalk*.

Chapter 11. The Show
A great deal has been written about the carnival, most of it by outsiders (journalists and scholars) and some by former insiders, who say that what insiders tell outsiders is often unreliable. See the two articles by Easto and Truzzi.

Haugerud's *Jailhouse Stories* provides a rare look at the relationships among law enforcement, fair operators, and the carnival. We suspect these situations and events were not especially unusual.

See "Tossing out the Tricksters," *Cleveland Plain Dealer*, August 19, 2004.

Chapter 12. Pride and Progress
The many fair premium books and individual fair histories we gathered were important sources for understanding the competitive aspects of the fair, as were Laning, Porter, and Prosterman. We also consulted Smith, *The History of Pittsfield*, 333; "Our Farm Women," 17; and Macdonald, "The Friendliest Fair," 7, 18.

Chapter 13. Heritage
We found the disconnect between agricultural production and the fair at many fairs across the country; Rockingham County and Elkhart County provided the best examples. Similarly, we found the growing connection between hobby agriculture and the fair at quite a few fairs, Howard County being the best example.

Selected Bibliography

General and Historical

"Agriculture at 'Agricultural Fairs.'" *Orange Judd Farmer,* September 15, 1917.

Amusement Business. 2002–5.

Anderson, Sherwood. *The American County Fair.* New York: Random House, 1930.

Avery, Julie A., ed. *Agricultural Fairs in America: Tradition, Education, Celebration.* East Lansing: Michigan State Univ. Museum, 2000.

———. "An Exploration of Several Early Michigan County Fairs as Community Arts Organizations of the 1850s, 1860s and 1870s." Ph.D. diss., Michigan State Univ., 1992.

Beeson, Sterling. "The County Fair." *World To-Day,* August 1909.

Bogue, Allan G. *From Prairie to Corn Belt: Farming on the Illinois and Iowa Prairies in the Nineteenth Century.* Chicago: Univ. of Chicago Press, 1963.

Buck, Solon J. *The Granger Movement: A Study of Agricultural Organization and Its Political, Economic and Social Manifestations, 1870–1880.* Cambridge, MA: Harvard Univ. Press, 1913.

Danbom, David B. *Born in the Country: A History of Rural America.* Baltimore: Johns Hopkins Univ. Press, 1995.

Dodge, Allen W. *A Prize Essay on Fairs.* Boston: Eastburn's Press, 1858.

Effland, Anne B. W. "When Rural Does Not Equal Agricultural." *Agricultural History* 74, no. 2 (2000): 489–501.

Falassi, Alessandro, ed. *Time out of Time: Essays on the Festival.* Albuquerque: Univ. of New Mexico Press, 1987.

Flick, Hugh M. "Elkanah Watson's Activities on Behalf of Agriculture." *Agricultural History* 21, no. 4 (October 1947): 193–98.

Francis, David R. "Agricultural Fairs and Expositions." In *Economic History, 1607–1865,* edited by J. C. Ballagh. Vol. 5 of *The South in the Building of the Nation.* Richmond, VA: Southern Historical Publication Society, 1909.

Garland, Hamlin. *Boy Life on the Prairie.* New York: Harper & Brothers, 1899.

———. *Son of the Middle Border.* New York: Grosset & Dunlap, 1917.

"Getting Up the Premium List." *Progressive Farmer,* May 11, 1918.

Illinois Association of Agricultural Fairs. *TentTalk.* December 1997–May 2004.

Kennedy, Craig. *Pennsylvania Fairs and Country Festivals.* Mechanicsburg, PA: Stackpole Books, 1996.

Kniffen, Fred. "The American Agricultural Fair: The Pattern." *Annals of the Association of American Geographers* 39 (December 1949).

———. "The American Agricultural Fair: Time and Place." *Annals of the Association of American Geographers* 41 (March 1951).

Kouwenhoven, John A. "What's 'American' about America." In his *The Beer Can by the Highway.* Baltimore: Johns Hopkins Univ. Press, 1988.

Laning, J. F. *How to Manage Agricultural Fairs, Industrial Institutes, and Similar Exhibitions.* New London, Ohio: The Fair Printing Company, 1881.

Levine, Lawrence W. *Highbrow / Lowbrow: The Emergence of Cultural Hierarchy in America.* Cambridge, MA: Harvard Univ. Press, 1988.

Lindstrom, David Edgar. *American Farmers' and Rural Organizations.* Champaign, IL: Garrard Press, 1948.

Los Angeles Times. "Tale of Two Fairs," July 29, 2004.

Macdonald, A. B. "The Friendliest Fair." *Country Gentleman,* August 19, 1922.

Martin, Edward Winslow [pseud. James Dabney McCabe]. *History of the Grange Movement; or, The Farmer's War against Monopolies.* Philadelphia: National Publishing, 1873.

Mastromarino, Mark A. "Elkanah Watson and Early Agricultural Fairs, 1790–1860." *Historical Journal of Massachusetts* 17, no. 2 (1989): 104–18.

McMahon, John R. "Making Fairs Fit the War." *Country Gentleman,* July 6, 1918.

Morgan, Tom P. "The Old County Fair." *Country Gentleman,* October 18, 1919.

Moritzen, Julius. "The Country Fair." *Cosmopolitan,* December 1900.

Neely, Wayne C. *The Agricultural Fair.* New York: Columbia Univ. Press, 1935.

Nordin, D. Sven. *Rich Harvest: A History of the Grange, 1867–1900.* Jackson: Univ. Press of Mississippi, 1974.

"Our Farm Women: How Women Can Make the Fair." *Progressive Farmer,* May 11, 1918.

Pittsfield Sun. August 8, 1810; September 21, 1811; September 28, 1811; October 5, 1811.

Porter, Maureen K. "The Bauer County Fair: Community Celebration as Context for Youth Experiences of Learning and Belonging." *Journal of Research in Rural Education* 11, no. 3 (Winter 1995): 139–56.

Prosterman, Leslie. *Ordinary Life, Festival Days: Aesthetics in the Midwestern County Fair.* Washington: Smithsonian Institution Press, 1995.

Rasmussen, Wayne D., ed. *Readings in the History of American Agriculture.* Urbana: Univ. of Illinois Press, 1960.

Ross, Earle D. "The Evolution of the Agricultural Fair in the Northwest." *Iowa Journal of History and Politics,* July 1926.

Rugh, Susan S. *Our Common Country: Family Farming, Culture, and Community in the Nineteenth-Century Midwest.* Bloomington: Indiana Univ. Press, 2001.

Shaler, Robert. *The Boy Scouts as County Fair Guides.* New York: Hurst, 1915.

Smith, J. E. A. *The History of Pittsfield (Berkshire County) Massachusetts.* Vol. 2, *From the Year 1800 to the Year 1876.* Springfield, MA: Boston, Lee and Shepard, 1876.

"The Spectator." *Outlook,* October 10, 1903; November 2, 1907; November 12, 1910.

Stewart, George R. *American Place Names.* New York: Oxford Univ. Press, 1970.

———. *Names on the Land.* Boston: Riverside Press, 1958.

Stoeltje, Beverly J. "Festival." In *Folklore, Cultural Performances and Popular Entertainments,* edited by Richard Bauman. New York: Oxford Univ. Press, 1992.

Stone, A. L. "The What and Why of County Fairs." *Hoard's Dariyman,* August 7, 1925.

Stong, Phil. "County Fair." *Hearst's International-Cosmopolitan,* November 1932, 106.

Turner, Victor, ed. *Celebration: Studies in Festivity and Ritual.* Washington: Smithsonian Institution Press, 1982.

Vergeront, Glen W. "History of the County Fair in Wisconsin." Bachelor's thesis, Univ. of Wisconsin, 1914.

Watson, Elkanah. *History of Agricultural Societies, on the Modern Berkshire System.* Albany, NY: D. Steele, 1820.

———. *History of the Rise, Progress, and Existing State of the Berkshire Agricultural Society, in Massachusetts.* Albany, NY: E. & E. Hosford, 1819.

———. *Men and Times of the Revolution; or, Memoirs of Elkanah Watson.* New York: Dana, 1856.

4-H, Youth Organizations, Agricultural Extension

Baker, Gladys. *The County Agent.* Chicago: Univ. of Chicago Press, 1939.

Duncan, Clyde H. *Straight Furrows: A Story of 4-H Club Work.* Albuquerque: Univ. of New Mexico Press, 1954.

McCormick, Robert W. and Virginia E. "4-H: A. B. Graham's Dream." *Timeline* 13, no. 1 (January/February 1996).

McCormick, Virginia E. and Robert W. *A. B. Graham: Country Schoolmaster and Extension Pioneer.* Worthington, OH: Cottonwood Publications, 1984.

Prepared and Engaged Youth: National 4-H Impact Assessment Project. 4-H, 2001.

Rasmussen, Wayne D. *Taking the University to the People: Seventy-five Years of Cooperative Extension.* Ames: Iowa State Univ. Press, 1989.

Reck, Franklin M. *The 4-H Story: A History of 4-H Club Work.* Ames: Iowa State Univ. Press, 1951.

Scott, Roy V. *The Reluctant Farmer: The Rise of Agricultural Extension to 1914.* Urbana: Univ. of Illinois Press, 1970.

"Some Reflections on the Fairs." *Ohio Farmer,* November 18, 1922.

Tenney, A. Webster. *The FFA at 50, 1928–1978.* Alexandria, VA: Future Farmers of America, 1977.

Carnival

"Confessions of a Fair Faker." *Country Gentleman,* April 8, 15, and 22, 1922.

Easto, Patrick C., and Marcello Truzzi. "The Carnival as a Marginally Legal Work Activity: A Typological Approach to Work Systems." In *Deviant Behavior: Occupational and Organizational Bases,* edited by Clifton D. Bryant. Chicago: Rand McNally, 1974.

———. "Towards an Ethnography of the Carnival Social System." *Journal of Popular Culture* 6, no. 3 (Winter 1972): 550–66.

Haugerud, Neil. *Jailhouse Stories: Memories of a Small-Town Sheriff.* Minneapolis: Univ. of Minnesota Press, 1999.

Lewis, Arthur H. *Carnival*. New York: Trident Press, 1970.

Macdonald, A.B. "Carnivals Must Clean Up or Be Cleaned." *Country Gentleman,* December 1, 1923.

———. "Hop-Scotch Grifters." *Country Gentleman,* May 10, 1924.

———. "It's Now or Never for the Carnival." *Country Gentleman,* June 2, 1923.

———. "The Nickel Nicker, the Gimmick and the Yap." *Country Gentleman,* May 1926.

———. "The Scrapbook of Fakery." *Country Gentleman,* February 17, 1923.

Wilmeth, Don B. "Circus and Outdoor Entertainment." In vol. 2 of *Handbook of American Popular Culture,* edited by M. Thomas Inge. Westport, CT: Greenwood Press, 1980.

Index